グッズの探し方

①

目次（P.4～）を見て、つくりたいグッズのカテゴリ（**製本紙モノ編／小型紙モノ編／くっつきモノ編／紙の入れもの編／いろいろ文具＆刷りモノ＆紙玩具編**）から探す

②

つくる数から調べたい場合は、P.8に掲載している「**最低ロット別インデックス**」から探す

③

1個あたりにかけられる金額（単価）から調べたい場合は、P.10に掲載している「**最低単価別インデックス**」から探す

本書は『デザインのひきだし』33号、36号、42号に掲載した特集記事の情報を最新版に更新して掲載した書籍です。

目次

最低ロット別インデックス

本書に掲載しているグッズの最低ロット別のインデックスです。
詳細はグッズ掲載ページでロットと金額の関係を確認の上、問い合わせ・発注をしてください。

最低単価別インデックス

本書に掲載しているグッズの最低ロットの最安単価のインデックスです。グッズ詳細ページには最低ロットでの単価しか掲載されていないものなどさまざまあります。ロットに記載されている金額で一番安い金額を記載していますが、ロットによって金額は大きく異なりますので、実際にグッズ掲載ページでロットと金額の関係を確認の上、問い合わせ・発注をしてください。

本書のスタートに、まずはデザインが素敵なだけでなく、紙や使いやすさにもこだわった、機能もすごい紙もの文具や玩具を集めてみた。どんな工夫が凝らされているのか？　一挙に紹介しよう。

お宝活字が角砂糖に

駿河版活字シュガー

2020年10月にリニューアルオープンした印刷博物館の新ミュージアムグッズのうちのひとつ。同館所有の"お宝"である重要文化財「駿河版活字」から8文字が角砂糖に。コーヒーとセットになったスリーブボックス入りと、シュガーだけの2タイプがある。「徳川家康がつくらせた駿河版活字は、木製の種字から母型をとり、銅を流しこんで鋳造されました。この砂糖も駿河版活字の複製から砂糖用の型をおこしたもので、駿河版活字の特徴である、薬研（やげん）彫りも忠実に再現されています」（同館・広報担当 式洋子さん）沖縄産さとうきびの原料糖のみを使ったこだわりのグッズだ。

スリーブ→紙：ダイワブラックS、印刷：特色4C（スミ、マットスミ、グレー、グロスニス）＋箔押し／身箱・仕切り→紙：ダイワブラックS、印刷：白2度刷り／構造デザイン：株式会社FPタイコー／グラフィックデザイン：株式会社 サンデザインアソシエーツ／企画開発：凸版印刷株式会社 印刷博物館

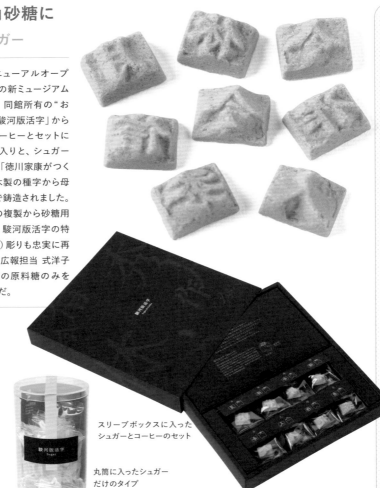

スリーブボックスに入ったシュガーとコーヒーのセット

丸筒に入ったシュガーだけのタイプ

注目のテープといえばこれ

OSAMU GOODS® 養生テープ

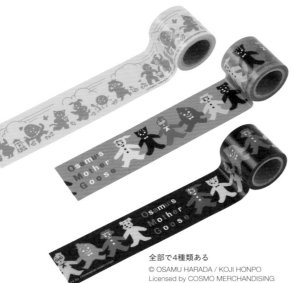

全部で4種類ある
© OSAMU HARADA / KOJI HONPO
Licensed by COSMO MERCHANDISING

原田治さんのキュートなイラストがカラフルに刷られた養生テープは、2019年7月から全国巡回している展覧会『原田治展「かわいい」の発見』で販売されていたグッズ。「展覧会のグッズとしてマスキングテープが主流でしたが、養生テープは貼って剥がせる上に、水に強く、印刷もくっきり見えてデコレーションにぴったりだと提案しました」（株式会社ブレイク・詠さん）過去のOSAMU GOODSを調べ、ノートの表紙やリボン等の柄を養生テープに落とし込みつつ、ポップな色展開で楽しく使えるようデザイン。マスキングテープやクラフトテープと並ぶ、新たな注目テープグッズだ。

素材：PEクロス／印刷：オンデマンド印刷／デザイン：詠 恵利／商品開発・製造元：株式会社ブレイク

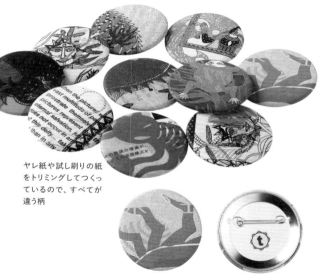

ヤレ紙や試し刷りの紙
をトリミングしてつくっ
ているので、すべてが
違う柄

絵柄がすべて違う紙の缶バッジ

Tara Books フルークバッジ

「イ」ンドの出版社タラブックスでは、シルクスクリーンのハンドメイド絵本の制作過程で、ミスプリントや試し刷りの紙が大量に出るのですが、偶然できる模様の面白さを生かして手帳やメモ帳などをつくっています。日本の私たちも、このチャーミングな紙で何かつくりたいなと思い、気軽に身につけられるバッジをつくることになりました」(ブルーシープ・大久保美夏さん)よく見ると『夜の木』や『水の生きもの』など見たことのある絵柄が見つかるのもたのしい。素材感も香りも(独特のインキの香り!)いい、モノ感あふれるグッズだ。

紙：シルクスクリーン印刷された手漉きの紙(タラブックス)／紙のトリミング・バッジ加工：株式会社East／発売元：ブルーシープ株式会社

昔ながらの本屋さん袋みたい

サザエさん紙袋

「長」谷川町子記念館で買い物をしたときに入れてもらえるのが、この薄くて白い純白ロール紙にサザエさんの印象的なコマが印刷された素朴でかわいい平袋。「お客様に喜んで持ち帰っていただきつつ、さらには、環境問題に少しでも目を向けていただくきっかけになるように、ごみ問題がテーマの4コマ作品をもちいたデザインになっています。この4コマが描かれた昭和46年にも、ごみの増加が社会問題となっていたようですが、町子さんが取り上げたこのテーマは、比較対象(霞ヶ関ビル)を除いて、そのまま現代にも通じてしまう内容となっています」(株式会社East)かわいいだけじゃなく、もらった人の心に響く紙袋だ。

サイズ：180×250mm／紙：純白ロール40g/㎡／フレキソ印刷／デザイン：株式会社East

コデックス装で
機能も見栄えもGOOD！

サザエさん昭和ファッションノート

「サ」ザエさんの多彩なファッションとその移り変わりが俯瞰できるこのノートは、長谷川町子記念館購買部(ミュージアムショップ)のオリジナルグッズ。表・裏表紙の色柄が異なり、製本は背が見えるコデックス装。強度を高めるために寒冷紗が手貼りされている。「表紙は、29年間すべての年代のサザエさんの姿を見ることができるように、計32人のサザエさんを掲載しました。表・裏表紙それぞれ、黄金色と群青色の『ケンラン』にスクリーン印刷しています。紙の色は、ショップのシンボルでもある、オリジナルの琺瑯製照明器具のカラーと連動しています。コデックス装にすることで180度平らに開いて書きやすいノートになっています」(株式会社East)

表・裏表紙→紙：ケンラン〈黄金〉〈群青〉四六判 225kg、印刷：スクリーン印刷／本文→紙：モンテシオン 四六判 69kg、印刷：オフセット印刷／デザイン：株式会社East

ぎゃああ！
頭をかかえる難しさ
明朝体神経衰弱

24 種類の明朝体フォントの「明」を篇と旁に分けて型抜き。それを正しい組み合わせではめ込んでいく神経衰弱パズル。「なんとなく『フォントの微妙な違いと各個人の敏感さのズレをゲームに落とし込めたらおもしろいかも』と思い立って、3Dプリンタで試作品をSNSに公開したのがきっかけです。こだわったところは正誤判定の方法です。一見同じ形なのに片方はスッと型にハマってもう一方は入る気配すらないみたいな『絶妙な違いだからこそ起きる不思議体験』をなるべく残したくて、"型にはめる"という方法にこだわりました」（ゐずみさん）製品化する際には、品質向上を目的にアクリル製のものに切り替え、正誤判定の型やピース用の箱を用意したり、ルールを設定したりと、ブラッシュアップを重ね、現在では自身が運営するオンライン雑貨店で発売中だ。

素材：アクリル板／加工：レーザーカット、レーザー刻印／デザイン・製造販売：ゐずみ

ピース収納用の
本型ボックスもセット

オフセット印刷のニスで透けをつくる

うさこちゃん　すけすけいっぴつせん
おばけ／うさこ

誕 生65周年記念ミッフィー展のために、コズフィッシュが企画・デザインしたオリジナルグッズ。展示のメインビジュアルであるおばけ姿のうさこちゃんの絵を使い、おばけらしい透け感のあるグッズになっている。「白インキで刷ったところは不透明に、ニス部分は透けるというしくみ。透けが活かせる『白夜』という純白ロール紙を使っています。透けが一番美しく見える塩梅をさぐるため、『白夜』のザラ面・ツヤ面どちらにニスを刷るか、紙厚はどの程度の薄さが良いのかなど、たくさんのテストをしていただきました」（脇田さん）

紙：白夜／印刷：オフセット印刷による特色3色（白＋黒＋ニス）／AD：祖父江慎／D：脇田あすか（cozfish）／印刷会社：サンエムカラー

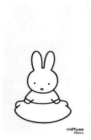
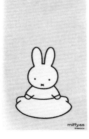

うさこちゃんは白、そのまわりが透けている一筆箋と、逆におばけ姿のうさこちゃんが透けているものの2タイプ。それぞれ写真右は透け感がわかるよう、グレーバックで撮影したもの

©Mercis bv

14

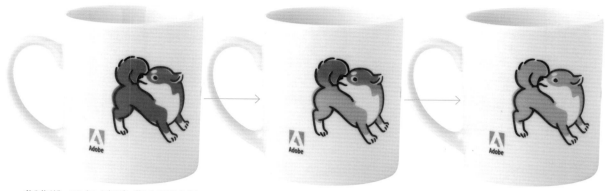

飲み物が入っていないと左の色、熱いものを入れると
メタモ印刷した部分が、右のように色変化する。
冷えれば元の色に

熱い飲み物を入れると色が変わる

貂明朝マグカップ 戌

ア ドビのイベント「Adobe MAX Japan」のグッズとして製作されたこのマグカップは、イベント登壇者のアドビ プリンシパルタイプデザイナー・西塚涼子さんがデザインした書体「貂明朝」に入っている犬のカラー絵文字が、熱い飲み物を入れると色が変わる。これはメタモ印刷という温度によって色変化する特殊なスクリーン印刷が施されているのだ。「メタモ印刷のカラーの選択肢が少なく、茶色→赤色くらいしか動物に使えそうなく悩ましかったのですが、結果的にお湯でパワーを溜める犬のようになり（笑）、かわいい仕上がりました。また通常印刷とメタモ印刷は別工程で印刷されるため、マグカップのような曲面へ刷る場合ずれる可能性があり、陶楽園工芸さんに頑張ってもらいました」（西塚さん）

印刷：スクリーン印刷（特色2色＋メタモ印刷）／デザイン：西塚涼子／印刷会社：陶楽園工芸

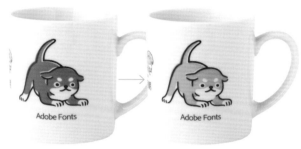

裏面。色変化しない部分は通常の
スクリーン印刷で刷られている

暗闇で絵柄や文字がピカッと光る

かづらきトートバッグ

上 のマグカップと同じく、「Adobe MAX Japan」のグッズとして製作されたこのトートバッグは、アドビ プリンシパルタイプデザイナー・西塚涼子さんがデザインした書体「かづらき」の文字や絵柄が暗闇で光る＝蓄光印刷された特殊印刷グッズだ。「黒いトートバッグに絵柄や文字の下にはすべて白を刷り、その上からロゴの赤、そして蓄光印刷をしています。蓄光インキは一番よく光るものを使っていますが、それでも1度刷りだと弱い。そこで3度刷りしてもらい、それが見当ずれしていないという職人技でつくってもらいました」（西塚さん）暗闇で光るこの文字。その文面は……イラストレーターを使う人にはおなじみ、テキストツールをクリックすると自動入力されるもの。そんな遊び心いっぱいのグッズなのだ。

印刷：スクリーン印刷（特色白、赤＋蓄光印刷）／デザイン：西塚涼子／印刷会社：ムラマツ工芸

スペシャルなキラキラシールや透明シールも含め、全13種類のシールがある

書店で『ドラえもん』関連本購入1冊ごとに封筒を1枚引くことができ、中にはコマが印刷されたシールが入っている（使用期間 2020.2〜）

シールが入った封筒は3種類。シールとの組み合わせは全39通りとなる

駄菓子屋さんのくじ引き
みたいなシールグッズ

ドラえもん
なんてことないシールくじびき

ドラえもん映画にあわせた書店でのブックフェア用につくられた、昔懐かしい駄菓子屋さんのくじ引きのようなグッズ。くじを引くと、封筒の中からシールがでてくる。小学館とデザイナーの脇田あすかさん（当時コズフィッシュ在籍）とが相談し企画立案。ただグッズがもらえるということではなく、くじを引くというそのこと自体を楽しんでもらえるようにと考えた。「『へろへろ』のシールは、ザラザラなタック紙を使ってへろへろな感じをだしています。でもザラザラなタック紙が予想以上に手配できず、大変でした。最後の最後にギリギリなんとかできましたが、量も多くつくったグッズで、封筒への袋入れもかなり大変だったと聞きました」（脇田さん）

カバーの紙：ゆるチップ／デザイン：脇田あすか(cozfish)／製作：小学館（今本統人）
ノベルティ配布は終了しています。ご了承ください。

どんな型抜きカードが
でてくるかは引いてのお楽しみ

ドラえもん
やっぱりなんてことないカードくじびき

上の「ドラえもん　なんてことないシールくじびき」に次いで、ドラえもん映画にあわせた書店でのブックフェア第二弾としてつくられたのがこのカードくじ引き。シークレット含め全12種類の型抜きカードが、4種類の封筒のどれかに入ったくじ引きになっている。「それぞれの絵に対しての用紙の質感、厚さなど、なるべく高級感あるように、ただのカードではないようにしようと頑張りました。普通の4C印刷に見えるカードも蛍光ピンクと蛍光イエローを入れたり、レアなふわふわカードは『ヴィベールP』を合紙し、そこに箔押しした、めちゃくちゃ高級なカードです」（脇田さん）

通常カード→紙：コラボファイン、印刷：蛍光ピンク＋蛍光イエロー＋C＋K／くらやみカード→紙：ブラックS、印刷：白／ふわふわカード→紙：ヴィベールP＋JETスター（合紙）、加工：黒箔押し／金カード→紙：オフメタルN金、印刷：K＋白／銀カード→紙：オフメタルN銀、印刷：K＋白／きらきらカード→紙：スペシャリティーズNo.714、印刷：K＋白／デザイン：脇田あすか(cozfish)／製作：小学館（今本統人）
ノベルティ配布は終了しています。ご了承ください。

右下の白いカードが「ふわふわ」、下中央が「くらやみ」、その上の鏡絵柄が「きらきら」、その右が「銀」、写真右上のドラえもんとドラミちゃんが「金」カードだ

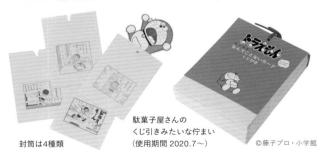

駄菓子屋さんのくじ引きみたいな佇まい（使用期間 2020.7〜）

封筒は4種類

©藤子プロ・小学館

ポケットティッシュもグッズになる！

ドラえもん　ちょっとしたシールつき
なんてことない ティッシュくじびき

右　ページのグッズに続いて、ドラえもん映画にあわせた書店での
ブックフェア第三弾でつくられたのがこれ。4柄のポケットティッ
シュの裏面には、全8種類のシールのどれか1種類が入っていて、書店
店頭でくじを引く要領でポケットティッシュをもらう。「レトロなくじびき
タイプは2度やったので、今度は泣ける映画のブックフェアだったため
『ティッシュで涙をふいてね』という気持ちでこのくじ引きをつくりました」
（脇田さん）ポケットティッシュ袋の印刷の色味を、やわらかく美しい色
合いにしたかったため何度も調整。またあたり！のシールは本誌前号で
も紹介した大和マーク製作所が担当。UVシルク印刷で微細な絵柄をシ
ビアな見当合わせすることで実現したスペシャルシールだ。

デザイン：脇田あすか（cozfish）／製作：小学館（今本統人）

ボックスには4種類のパッケージのポケットティッシュがいっぱい
詰まっている。ここから好きなものを引く（使用期間 2020.11〜）

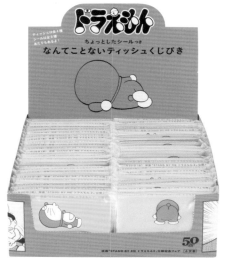

*ノベルティ配布は終了しています。ご了承ください。

ティッシュの背中には二つ折り
になったシールが入っている

きらびやかなあたり！のスペ
シャルシールがでることも！

他にもいろいろなシールが

コミックス特別版の豪華グッズ

『とっておきドラえもん』 特製お祝い袋・一筆箋・とっておきたい思い出ケース

て んとう虫コミックス『とっておきドラえもん　むね
いっぱい感動編（特別版）』（藤子・F・不二雄 著
／小学館）の特典としてつくられたのがこれ。「このコ
ミックスシリーズはこどもはもちろん、大人もジーンと楽
しめるものなので、大人が使ってうれしい高級感のある
グッズにしようと考えました。お祝い袋は、薄くマゼンタ
を刷ってから金をのせることで、安っぽくなく深みのあ
る金色になりました。便箋は、肌触りや書きごこちうれ
しい『モフル』を使用。書くところが斜めになっています。
紙ケースは『羊皮紙』で、大人っぽい洋風な高級感のあ
る仕上がりに。白インクがまるで銀のように光っています」
（脇田さん）素材も印刷にもこだわり抜いた、まさに大人
がもらってもうれしいグッズだ。

お祝いふくろ→紙：ニューこもん、印刷：M＋LR輝ゴールド＋ニ
ス／一筆箋→紙：モフル、印刷：CMYK／一筆ケース→紙：羊皮
紙、印刷：UVオフセット・コンク白2度刷り／デザイン：脇田あすか
（cozfish）／製作：小学館（石関暁）

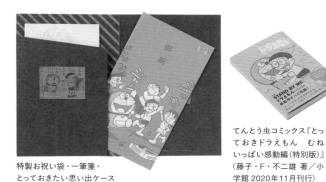

特製お祝い袋・一筆箋・
とっておきたい思い出ケース

てんとう虫コミックス『とっ
ておきドラえもん　むね
いっぱい感動編（特別版）』
（藤子・F・不二雄 著／小
学館 2020年11月刊行）

一筆箋は全6種類の絵柄！

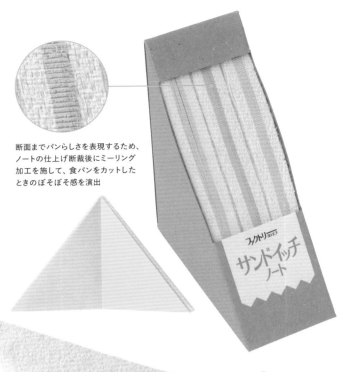

断面までパンらしさを表現するため、ノートの仕上げ断裁後にミーリング加工を施して、食パンをカットしたときのぼそぼそ感を演出

まるで本物みたいな質感

サンドイッチノート

中身のノートを取り出すと、表面はふわふわ。断面は本物のサンドイッチのようにちょっとギザギザになっていて、なんという細部のこだわり。これは紙工会社の篠原紙工が自社オリジナル製品としてつくっている、その名もサンドイッチノート。3冊の三角ノートが茶色い板紙のケースにセットされている。「以前"ヴィベール"を使用した際に『食パンみたい。美味しそう』と思った社員が企画をたて制作、販売に至りました。"私たちはパン屋さんになる"を合言葉に、より本物らしく、よりおいしそうに見えるように試行錯誤しました」ノートとしてもきちんと機能するよう紙の書き味も検討を重ねた、こだわりのノートは同社Webストアで販売中だ。

紙：ヴィベールP|0000（表紙）、モンテシオン 四六判69kg（パン部分本文）、色上質 厚口〈クリーム〉〈桃〉〈鶯〉（具材部分本文）、エースボール 270g/㎡（ケース）／デザイン・販売：Factory4F／製造：有限会社篠原紙工

ポリエステル100%の生地はとろみがあって光沢もよく、発色のいい昇華転写との組み合わせで美しい仕上がり

発色いい
昇華転写印刷のスカーフ

スカーフ　pink pepper

グラフィックデザイナーの栗原あずささんと脇田あすかさんによるブランド・pink pepperのスカーフ。「なるべく発色が美しく、そして手触りのよい質感の布でというところにこだわりました。また通常、布ものはロットが少ないとなかなか難しいのですが、繊維会社、印刷会社、縫製会社を全て自分たちで手配することで、かなりコストを抑え、手に取りやすい価格にすることができています。昇華転写印刷していますが、なんといっても発色が美しいです」（脇田さん）

デザイン：栗原あずさ+脇田あすか／繊維会社：宇仁繊維株式会社／印刷会社：株式会社グラフィッククリエーション／縫製会社：三興繊維株式会社

「身に纏えるグラフィック」としてスカーフを制作している

ついつい欲しくなるいいグッズ

無血絆創膏

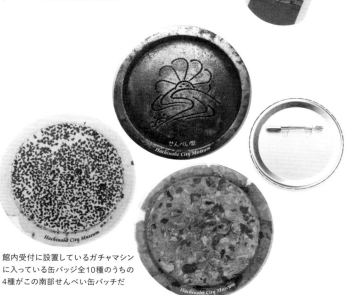

絆創膏なのに無血……こんなシャレの効いたミュージアムグッズをつくっているのは、令和元年にオープンした勝海舟記念館。江戸無血開城を成し遂げた勝海舟のことを少しでも知ってほしいという想いから誕生した。「"無血"と"絆創膏"をかけて商品化したのが、"無血絆創膏"です。実は、記念館のある洗足池も江戸無血開城にゆかりがあります。そのため、絵柄には歌川広重「名所江戸百景」から洗足池を描いた浮世絵「千束の池袈裟懸松（いけげさかけのまつ）」を使い、繋がりを感じていただけるようにしています」（大田区立勝海舟記念館）2枚セット100円というリーズナブルなところもうれしい。

台紙：オンデマンド印刷／絆創膏：オフセット印刷／企画・デザイン：大田区立勝海舟記念館

パッケージには江戸無血開城のストーリーを紹介

墨箔押しで入った名言

〈海舟名言入り〉五角えんぴつ

無血絆創膏と同じく、勝海舟記念館のミュージアムグッズ。勝海舟の"勝"に注目し、縁起の良い"五角（合格の語呂合わせ）"鉛筆だ。「たくさんある海舟の言葉の中から、前向きになれるような言葉を選んでいます。印刷できる範囲が限られていることもあり、1本の鉛筆に落とし込む作業にも時間を要しました」（大田区立勝海舟記念館）記念館周辺は自然豊かな環境が広がり、勝海舟もこの風光明媚な場所を気に入り、別荘を構えた。そんな背景もあることから、鉛筆本体は派手なものではなく、木目のままとした。

名言：箔押し／企画・デザイン：大田区立勝海舟記念館

館内受付に設置しているガチャマシンに入っている缶バッジ全10種のうちの4種がこの南部せんべい缶バッチだ

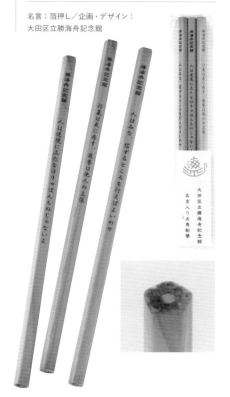

モチーフと丸い缶バッチの相性抜群

八戸市博物館オリジナル缶バッジ

八戸市博物館で設置しているガチャに入ったグッズとして製作された缶バッチ。丸い形にぴったりのご当地名物「南部せんべい」がモチーフになっている。「南部せんべいは八戸発祥といわれており、かつて市内には多くのせんべい店がありました。当館では、寄贈されたせんべいの焼き型や型の図案、看板などを収蔵しています。缶バッジの丸い形がせんべいに合ったことから、八戸の歴史文化に親しんでいただくためのミュージアムグッズとしてつくりました。イラスト化しないことで、少しでも本物の雰囲気を出せるよう努めました」（同館・山野友海さん）ちなみにこのガチャ、同館の手づくり。行ったときにはぜひやってみたいグッズだ。

直径54mm缶バッジ、4色カラー印刷／デザイン・企画・制作：八戸市博物館

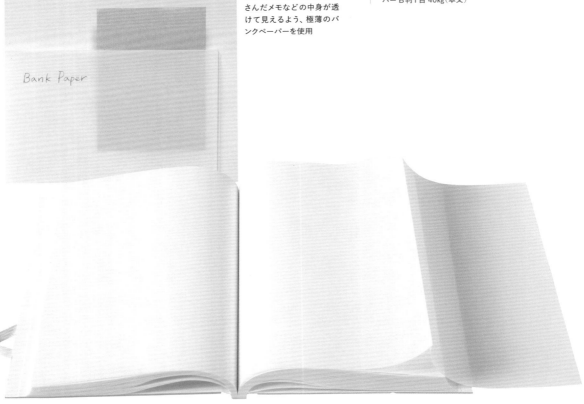

色の違う紙を6枚合紙して
Vカットを施し、デザインの
アクセントにしている

本文用紙には、袋とじには
さんだメモなどの中身が透
けて見えるよう、極薄のバ
ンクペーパーを使用

Bank Paper

本文は袋とじ。ミシン目で切ると広げられる。
バンクペーパーは筆記適性に配慮した、透
かし入りの紙だ

製本と加工に職人の技が、キラリと光る

紙のミルフィーユ「袋とじノート」

薄く繊細な本文用紙がすべて袋とじになっているという「袋とじノート」。これは、三洋紙業のオリジナル文具ブランド「紙のミルフィーユ」シリーズから発売されたものだ。袋とじの本文用紙には、中身が透けて見えるよう極薄のバンクペーパーを用い、表紙は6枚合紙でVカットが施された、ゴムバンドつきの製本。細部までこだわり抜いたデザインだ。

「本文は、ミシン加工や折り加工などの工程が多く、さらに用紙のバンクペーパーはギリギリ薄いものを使用しているので、気を抜くとヘコ（折り目）が出てしまいます。そんな難しい加工と製本の工程に、熟練の職人による豊富な経験とノウハウが生きています」（TUBUdesign久永文さん）

AD：久永文（TUBUdesign）／製造：三洋紙業／製本：鈴木製本／用紙：黒気包紙＋タント他（表紙）、バンクペーパーB判T目 40kg(本文)

箇条書きをするのに最適な
コデックス装のノート

日付ではなく、箇条書きでメモを書くという「箇条書き手帳術（バレットジャーナル）」が文具愛好家の間で流行中だ。これをするには日付入りの手帳ではなく、ページにノンブルが入ったノートが必要だということで開発されたのがノウトの「ノンブルノート『N』」である。「軽くて使いやすい、価格もおさえたノートをつくろうと思った」（新しい文具製作委員会の宮崎じゅんさん）。印刷、加工、製本を手がけたのは手帳の老舗メーカー菁文堂。表紙はオフセット印刷で白を2回、グロスニスを2回刷り、本文は1色刷りで仕上げている。本文用紙は菁文堂オリジナルの手帳用紙を用い、製本は開きやすさを重視したコデックス装。手帳メーカーの技術を存分に用いた製品だ。

AD：おおきひろみ（ノウト）／印刷・加工・製本：菁文堂／用紙：菁文堂手帳用紙四六判50kg（本文）、タントセレクト TS-5（見返し）、カラープラン-FS（表紙）

さまざまな色の
ノンブルノート「N」

表1（右）と表4（左）の色が違うバイカラーがかわいい

糸かがりして背固めした後、寒冷紗を巻いたコデックス装

ページにノンブルが入っているのが特徴

思う存分複写できる！
感圧紙を使用したコピペメモ

「社内で日常的に使っていた複写式の紙を使ったメモに女性スタッフが着眼し、商品化することになりました」というのは山本紙業の山本泰三さん。伝票などに利用される感圧紙を本文に使い、筆圧次第で何枚も（4枚程度が目安）複写可能な「コピペメモ」が誕生した。複写したい枚数の本文の下に下敷きをはさんで書けば、何枚も複写可能というしくみ。
「機械加工ではできないため、一冊ずつ手づくりで製本しています」

デザイン・印刷・加工・製本：山本紙業／用紙：コートボール（表紙兼下敷き）、感圧紙（本文）
2023年春リニューアル予定

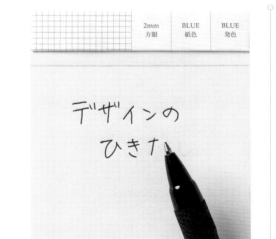

複写伝票に使われる感圧紙を本文に使い、何枚も複写可能にしたメモ帳

100%ORANGEさんのかわいい絵柄の
一筆箋を、いろいろな色つきの糊
で天糊製本

絵柄は12種類で、全11色の糊を使った
（蛍光ピンクは2冊）。上から、蛍光グリ
ーン、蛍光ピンク、蛍光イエロー、赤、緑、
茶、オレンジ、紫、薄紫、薄青、透明

色つきの糊がかわいい
天糊一筆箋

か わいらしくてクスッと笑える。世代を超え
て多くの人に愛されるイラストレーター・
絵本作家の100%ORANGEは、時代を超えた不
思議な雰囲気の絵の風合いを存分に活かした、
オリジナルの紙ものグッズを多数作成している。
「100%ORANGE カラー天糊一筆箋」は、12種
類の絵柄をそろえているが、イラストの絵柄に合
わせ、それぞれ天糊の色まで指定してつくったと
いうこだわりようだ。天糊とは、ペラの紙を重ね、
一辺に糊を塗って背固めする製本方法のこと。1
枚ずつはがしやすいので、メモ帳や伝票、一筆
箋などに用いられている。制作にあたっては本
誌編集部が少しお手伝いした。
「色が濃いものや蛍光色のカラーボンドは、製本
用途としてすでにあるものを使いましたが、この
一筆箋のために、色粉をボンドに混ぜてつくって
もらったものもあります。紙は、ざっくりとしたラ
フな質感ながら印刷適性・筆記適性の高いb7
バルキーをセレクト。b7バルキーは微塗工紙な
のですが、塗工量がかなり少ないため、水性ペ
ンや万年筆、ボールペン、鉛筆など、さまざまな
筆記用具で、意外なほど書きやすい紙です」（本
誌編集部）
1冊だけでも使うのがもったいないくらいだが、
数冊並べて置いた姿もまた愛らしい。

AD：100%ORANGE／印刷会社：藤和／製本会社：小林
断截／用紙：b7バルキー

使うごとに味わい深まる
ロー引き表紙のノート

食 品の包装材などとして用いられてきた、
水や油に強く独特な風合いを持つロー
引き加工の紙。使うごとにシワが入り、やわら
かく味わいが増す、ロー引き紙の魅力を存分に
味わうべく山本紙業が開発したのが「RO-BIKI
NOTE」だ。
「本文用紙は複数の筆記具で書き心地を重視し
て紙選びを行いました。また、製本方法は中ミシ
ン綴じをし、ほつれないよう背の糸を糊で固めた
『糸綴じ糊固め製本』を用いており、折り返して
360度開いても耐えられる強度で、かつ背に見え
る糸がデザインのアクセントになっています」（山
本紙業・山本泰三さん）

デザイン・印刷・加工・製本：山本紙業／加工：ロー引き含
浸加工／用紙：両更クラフト120g/㎡（表紙）、日本製紙 ニュー
シフォンクリーム（本文）

ロー引き加工の表紙が
独特の味わい

背に見える糸とじの糸がデザイン
のアクセントになっている

封筒に原稿用紙が!?
メッセージを書き込もう

こ れは便箋ではなく封筒、である。yurulikuの「原稿封筒」は、グレーの事務的な封筒に一色で原稿用紙の柄が印刷されている。サイズは角3と長3とCDサイズの3種類。使い方は自由だが、住所をきちんとマス目に埋めて書いてもいいし、メッセージを添える一筆箋代わりにもなりそうだ。「使う人を選ばない、シンプルでシックな雰囲気になるようこだわりました」(yuruliku DESIGN)

AD：yuruliku DESIGN／メーカー：yuruliku

誰もが見たことのある
リーガルパッドのようなポストカード

黄 色い用紙に青い罫線、アクセントに赤い縦線がピッと入った、だれもが見覚えのあるリーガルパッド。薄い紙でメモ用紙としてざくざく使うイメージのものを、ポストカードに仕上げた。「リーガルパッドのように気軽に使えるポストカードをとデザインしました」(yuruliku DESIGN)。ヘッダには実際にクロステープが貼られており、そこにはスタンプで文字が押されていて、活版印刷のような風合いもある。

AD：yuruliku DESIGN／メーカー：yuruliku／用紙：アラベール ホワイト・四六判 200kg（カード）、クロステープ

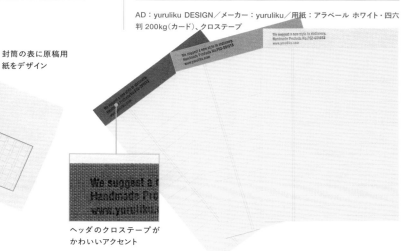

封筒の表に原稿用紙をデザイン

ヘッダのクロステープがかわいいアクセント

書き心地を重視した
メッセージカード

荷 札の形に原稿用紙や便箋のデザインが施されている「NIFUDA massege card」。カードは比較的厚みがあり、書き心地は抜群だ。「書きやすくて丈夫な紙を選びました。パンチ穴補強シールは封筒と同じクラフト紙でつくり、紐は手触りのいい麻紐にしました」(yuruliku DESIGN)。

AD：yuruliku DESIGN／メーカー：yuruliku／用紙：アラベール ホワイト・四六判 200kg（カード）、クロステープ

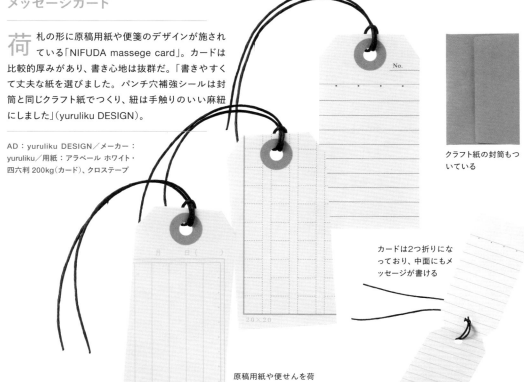

クラフト紙の封筒もついている

カードは2つ折りになっており、中面にもメッセージが書ける

原稿用紙や便せんを荷札型のカードにした

本物の足跡から製版してシルクスクリーン

マームとジプシー「sheep sleep sharp」パンフレット

劇団マームとジプシーの10周年記念公演のパンフレットは、一見すごく豪華。本物のタブロイド紙のような紙にモノクロ印刷されたチラシには、ロゴが大きく箔押しされ、さらに本物の足跡のようなビジュアルが白で刷り重ねられている。「豪華そうに見えるかもしれませんが、実はかなりリーズナブルにつくっていて、印刷はタブロイド印刷にしたので、端もギザギザなんです。そこに別手配で箔押しをして、最後に自分たちで足跡を白で手刷りしました。これはペンキで本物の足跡をつけて、それをスキャンしてシルクスクリーン製版し、それを使って白インキを刷っているんです」(名久井直子さん)印象深い濃い白の表現にはそんな秘密が隠されていた。

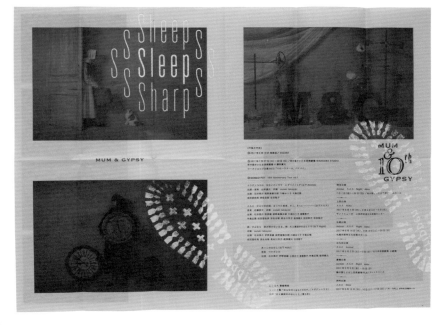

デザイン：名久井直子／印刷：ウェブプレス／箔押し：コスモテック／製作：マームとジプシー

1度刷りでの
グラデーションが美しい

シルクスクリーン和紙カード

イラストレーターのやまさき薫さんは、シルクスクリーンでのハンドプリント作品も数多く手がける。そんな中のひとつが、手漉きの耳付き和紙にシルクスクリーンで刷られたカードだ。「Tシャツやトートバッグなどの布へのシルクスクリーンもよくやりますが、紙にも刷ります。シルクスクリーンは良くも悪くも、インキがベタッとのり、印刷面がフラットになりますが、和紙に刷ると表面の質感をひろってくれるので、その雰囲気が気に入っています」(やまさきさん)スクリーンの版の上に複数色のインキを置き、混ぜて刷るとグラデーションになる。複数枚刷るとどれも微妙に異なったグラデーションになるのも魅力だ。

紙：手漉き耳付き和紙／印刷：スクリーン印刷／デザイン・印刷：やまさき薫

折りやすく発色のいい
片艶晒クラフト紙でつくられた
大人向け折り紙

カラフルな発色とポップなデザイン。形をつくって遊ぶだけではなく、ラッピングにも使えそうなミドリの「オリガミオリガミ」。折り紙はこどもが遊ぶときに口に入っても大丈夫なように、折り紙用の安全基準に従った専用インキが用いられるが、発色があまりよくない特徴がある。そこで、安全性を考慮したうえで鮮やかな発色にもこだわり、大人向けの折り紙を開発した。インキの発色を最大限に引き出すため、紙選びにも試行錯誤したのだという。「さまざまな紙を検討した結果、片艶晒クラフト紙の艶面に印刷することで、折りにも強く発色のいい折り紙をつくることができました。このほかにも、デザイナーによって紙を変えています」（デザイナー喜田雄亮さん）

AD・メーカー・印刷加工：デザインフィル／用紙：キャピタルラップ50g/㎡

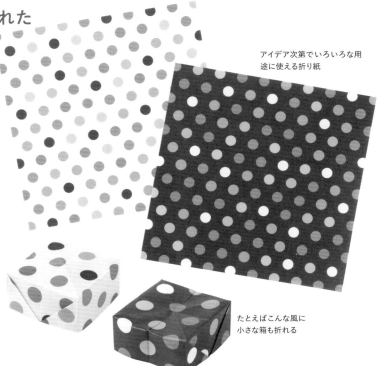

アイデア次第でいろいろな用途に使える折り紙

たとえばこんな風に小さな箱も折れる

ピリピリと切って使える
ロール式のメモ

大正・昭和のモダンなデザインを復刻したレトロ感のある色合い、風合いを大事に、布ものや紙ものの雑貨をつくる夜長堂。「デザインメモロール」は、ロール状に巻かれた用紙の3柄ごとにミシン目を入れ、メモ帳のようにピリピリ切って使えるものだ。6シート（18柄）で繰り返し印刷されている。「これまで紙もののデザインに使用してきた人気の柄を切手シートのように集めてみたいと思い、ロール式のメモを考えました。印刷ではレトロモダンな発色にこだわりました」（夜長堂・井上タツ子さん）。裏には、一筆箋としても使えるよう、薄グレーのボーダー柄が印刷されている。つながっている3柄を1枚1枚ハサミでカットしてシール代わりにしたり、ラッピングのアクセントに使ったり、さまざまな用途に重宝しそうだ。

AD、メーカー：夜長堂／加工：吉川紙商事／用紙：上質紙64g/㎡

ロール状のメモにミシン目が入っていて、ちぎって使える

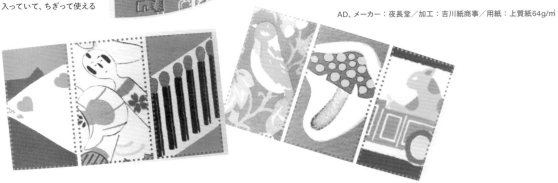

インデックス加工を活用してグラデーションを表現。
これは朝焼けをイメージした色

老舗手帳会社ならでは
インデックス加工を装飾に用いたノート

一見すると普通のノートのようだが、開くと美しいグラデーションが現れるノート「CHANNEL」。これは老舗手帳メーカーの田中手帳が手がけるノートブランド「TETO」の商品だ。手帳独自のインデックス加工技術を別の用途で使いたいという実験から誕生した。「色で引く」というコンセプトを実現するため、朝焼けと夕焼けのイメージでグラデーションの色を選択。「たとえば朝焼け色なら、水色とオレンジそれぞれ1色の刷り色の濃度を変えることで、グラデーションを表現しています。その数％の色の濃度を調整するのに一番時間がかかりました」（TETO担当者）とのこと。

AD：TETO／加工・製本：田中手帳／用紙：雷鳥上質70kg

表紙はごくシンプル

インデックス加工で階段状になった
小口がグラデーションになっている

エンドレス柄が印刷された
かわいいクラフトテープ

絵画やドローイング、陶器、FRPなど、さまざまな素材を用いて制作をする美術家の奈良美智さん。その時々の思いや感情が伝わるドローイングは、さまざまなグッズでも展開されている。これは2017年に豊田市美術館で開催された個展「奈良美智 for better or worse」の際に制作されたものだ。風合いのあるクラフトテープには、ドローイングと展覧会のロゴが連なっている。「美術館での個展だったので、単なるドローイングがのったグッズにするのではなく、より奈良さんの制作に近いスピリットを共有してもらえるようなものを目指し、クラフトテープにしました。チープな感覚を出すためスミ1色で、ドローイングはランダムに見えるよう配置しています」（デザインを担当した山本誠さん）

AD：山本誠（山本誠デザイン室）／
販売：日本テープ

エンドレスの絵柄が断ち落とし
で印刷されている

デスクの上でスッと立つ
使い勝手のいいフィルム付箋

折りたたみ式のスタンドで自立する付箋「SUTTO（スット）」。ロール状の付箋とボードが一体化したつくりになっており、付箋は12mmごとにミシン目がついて切り取れるようになっている。メモを立たせておけば掲示板代わりにもなる。「デスク上の限られたスペースでスマートにおけるサイズ感と見やすさを考慮し、立たせる角度を何度も調整し、現在の形にしていきました」（カンミ堂開発担当者）。台紙となる筆記用のマットには書き心地を重視して塩化ビニル素材が用いられ、ボード背面には滑り止め加工を施している。

メーカ名：カンミ堂／用紙：PPフィルム（付箋）、塩化ビニル（マット）
※「SUTTO」は2022年6月をもって製造、販売を終了

立てて使える

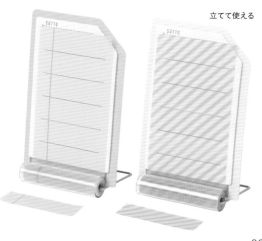

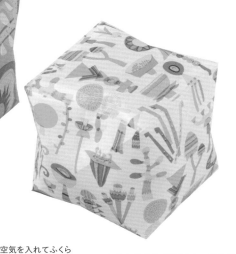

ひとつひとつ手作業でつくられる
昔ながらの紙ふうせん

プクッと膨らませて形を楽しんだり、手遊びを楽しむ紙ふうせん。富山では明治時代から売薬さんが家庭を訪ねる際に配る、こどもに向けたおまけとして、四角い紙ふうせんがつくられてきたという。手製でつくる紙ふうせんの技術と文化を継承しようと立ち上がったブランドが「cusuri」だ。玩具だけではなく、インテリア向けやギフトとしての紙ふうせんを発信。今回掲載したのは、ポップなテキスタイルなどを手がける炭酸デザイン室とのコラボレーションによるもの。他にもさまざまなデザイナーやクリエイターと協業し、アイテムを展開している。「TANSAN TEXTILEの鮮やかな発色を活かすために、一部蛍光インキを使用しています」（富山スガキ開発担当の跡治立多さん）。用紙には、薬袋にも使用されていたという包装材の純白ロール紙を使用。天面、底面、側面の3パーツを貼り合わせるのは、80歳を超えた熟練の職人の手作業。昔と変わらない製法で現在もつくられており、後継者の育成にも力を入れている。

空気を入れてふくらますと、四角になる

折りたたんだ状態。カラフルな絵柄を印刷した四角い紙ふうせん

こちらがパッケージ

AD：炭酸デザイン室（グラフィック）、名越恵美（紙ふうせん・パッケージデザイン、cusuri クリエイティブディレクター）／メーカー：cusuri／印刷：富山スガキ／用紙：純白ロール紙

コーヒー好きにはたまらない!?
フィルターがメッセージカードに

たとえばーヒーを贈るなら、こんなメッセージカードはどうだろうか。コーヒーが好き過ぎて市販のコーヒーフィルターに活版印刷をし、オリジナルメッセージカードをつくってしまったのは、活版印刷やペーパーアイテムの制作を手がけるデザイン事務所・AUI-AŌ Designだ。「フィルターには自社の手動式活版印刷機で印刷していますが、カードはベタ面の印圧を強くかけるため、ハイデルベルグの活版印刷機をもつ内田印刷さんにお願いしました。焙煎の風合いを出すためにマットニスを使ったり、わざとムラを出すようお願いしています」（AUI-AŌ Design佐藤一樹さん）

AD：佐藤一樹／メーカー：AUI-AŌ Design、カード印刷：内田印刷／用紙：特Aクッション1mm（カード）、フィルター市販品

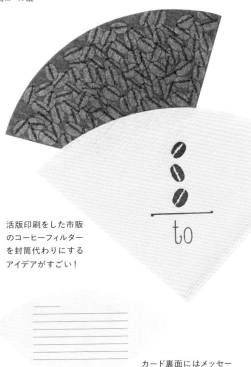

活版印刷をした市販のコーヒーフィルターを封筒代わりにするアイデアがすごい！

カード裏面にはメッセージが書ける

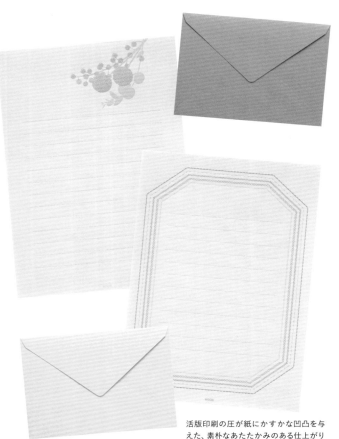

ていねいに出したい手紙に
活版印刷の風合いを

活版印刷の凹凸感のある手触りは、手紙というコミュニケーションに、さらなる味わいをプラスする。ミドリから発売されている「活版印刷のレターセット」は、シンプルなデザインながら味わい深いレターセットだ。用紙はふかっと空気を孕み、手触りもやわらかく心地いいハーフエアを使用。活版印刷機との相性はもちろんだが、筆記具ごとの書き心地を試行錯誤したうえで紙選びを行っている。「刷りムラやかすれなどの風合いも、活版印刷ならではの味わいとして楽しんでいただければ」(デザイナー半崎珠美さん)

AD・メーカー・印刷：デザインフィル／用紙：ハーフエア(レター)

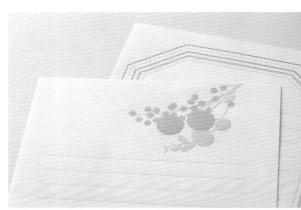

活版印刷の圧が紙にかすかな凹凸を与えた、素朴なあたたかみのある仕上がり

小さなマッチ箱の中に
68片のミニミニこけしシール

横35mm×縦56mm×奥行き17mmという小さな小さなマッチ箱を開くと、さらに小さなこけしたちがぎっしり！数種類の形に型抜きされたこけしには、シール加工がされている。この「マッチ箱シール」は、夜長堂と倉敷意匠計画室がタッグを組んでつくった人気アイテムだ。「近年、国内での需要が急激に減ってきたマッチ産業の生産技術を活かした別アイテムの開発をしようと考案しました。ノスタルジックな夜長堂の世界観を生かすため、紙選びと印刷の風合いにこだわりました」(倉敷意匠計画室)。シールとしてちょこんと手紙の隅に貼るのはもちろん可愛らしいが、手紙に数枚忍ばせても喜ばれる。そして何より使う自分がマッチ箱を開くたびに笑顔になるアイテムである。

AD：夜長堂／メーカー：倉敷意匠計画室

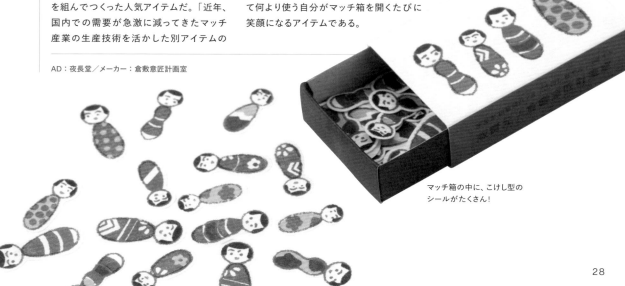

マッチ箱の中に、こけし型のシールがたくさん！

文具をつくるための専門知識

「使う」ことを主眼としてつくられることの多い文具。
「読む」ための本や「見る」ためのフライヤーなどとは、
求められる機能が違うことが多い。
そのためには適した紙や製本加工などの知識が必須。
そこでここから、知っておくと使い勝手のいい紙文具が
つくれる知識をご紹介していこう。

（１）書きやすい紙ってどんな紙？

紙もの文具の代表格といえば、手帳やノートなど、「書いて使う」ものだ。
ここではまず、どんな観点で紙を選べばよいのか、そのポイントを紹介しよう。

Point 1　紙の表面塗工

　紙には大きく分けて塗工紙と非塗工紙がある。塗工紙とは、アート紙やコート紙などのこと。紙の表面に塗料を塗布することで平滑度を高め、光沢をもたらす。なにも塗っていない非塗工紙と比べると、インキののりがよく、印刷がきれいに出るのが特徴だ。ところが、塗料がたっぷり塗られている分、特にアート紙やグロスコート紙は書きづらい。

　ノートや手帳、便せんやメモなど、「書く」文具には、筆記適性に配慮して開発された専用の手帳用紙やステーショナリー用紙が用いられることが多い。これらの紙は、次のポイントでも触れる「にじみ」防止のために、表面にデンプンを少し塗布している。

　専用紙以外を使う場合は、上質紙や書籍用紙などの非塗工紙だと、比較的書き味のよい文具をつくることができる。

コート紙に書いたもの。上から万年筆、油性ボールペン、鉛筆、蛍光マーカー、油性マジック。鉛筆ではかなり書きづらく、万年筆や油性ボールペンでもペン先が引っかかる

コート紙の場合、万年筆のインクが乾きづらい特徴もある。長めに時間をとらないと、こすって汚してしまいそう

上質紙（非塗工紙）は、どの筆記具でも比較的書きやすい

微塗工紙ぐらいの塗工量だと、好みによっては書きやすい。印刷適性、鉛筆や蛍光マーカーとの相性もよい

Point 2　にじみ

　次に大事なポイントとして、「インクがにじまないか」ということがある。「書く」文具は、万年筆や油性・水性ボールペン、鉛筆などで書かれることが多いだろう。ノートであれば、蛍光マーカーも使うかもしれない。こうした筆記具で書いたときに、インクがにじまないかが大事なポイントだ。実際に、文具メーカーの開発現場では、さまざまな筆記具でテストを行っている。

　手帳用紙やステーショナリー用紙といった専門紙は、表面にデンプンを塗布してサイズ度を上げ、にじみを防止している（サイズ度とは、インクや水に対する浸透への抵抗度のことで、数値が高いほどにじまない）。専用でない紙でも、書籍用紙や上質紙は比較的にじみが少ないものが多いが、実際に書いてみるのが確実だ。また、風合いがいいという理由でコースター用紙に活版印刷をしてカードに使うことがよくあるが、コースターはそもそも、コップについた水滴を吸うためのもの。これに万年筆で書くと、インキをどんどん吸ってしまうのだ！　ボールペンや鉛筆なら大丈夫なので、その旨カードにひとこと添えるのがよい。

コースター用紙は吸水性の高い紙。これに万年筆で書くと、みるみるうちにインクが吸われてしまう！

しかし、同じコースター用紙でも、筆記具を変えれば大丈夫。上から油性ボールペン、鉛筆、油性マジック

インクが裏に抜けてしまう。これだとノートや手帳の本文には難しい

たとえば、中質紙に万年筆と蛍光マーカーで書くと……

手帳専用紙は薄いが、サイズ度・不透明度を上げてつくられているため、万年筆や油性ボールペンで書いても、裏面にほとんど影響がない（写真は菁文堂手帳用紙）

Point 3　裏抜け（不透明度）

　ノートや手帳など、両面に書いて使うものの場合は、裏抜けしないか、つまり不透明度の高さも大事なポイントだ。これはポイント②の「にじみ」とも関わってくるが、紙のサイズ度が低くてインクをどんどん吸ってしまう場合、にじんでしまって裏のページが使えなくなる。また、そこまで裏抜けがひどくなくても、裏面の印刷や書いた文字が透けすぎると、やはり裏ページには書きづらい。この点も、手帳用紙やステーショナリー用紙といった専用紙では配慮されており、不透明度を上げるための内填剤を添加することで、裏への影響を最小限に抑えている。

　上質紙の場合は、専用紙に比べると不透明度は低くなる。一方、書籍用紙の場合、そもそも書籍も両面に文字を印刷することを前提としており、印刷の裏抜けを防ぐために不透明度を上げてつくられているものなので、書籍用紙と筆記専用紙に求められるポイントは似ているのだ。筆記専用紙に比べると書籍用紙のほうがコストがおさえられることもあり、実は文具でもよく使われている。

（まとめ）

　一言で「書きやすい紙」といっても、何を書きやすいとするかは、最終的には「好み」の問題でもある。また、使用する筆記具は万年筆なのか、ボールペンでも油性なのか水性なのか、鉛筆なのかによっても違ってくる。最近ではフリクションペンを使う人も多く、消したときに紙の表面が荒れないか（表面強度の強さ）も文具メーカーの頭を悩ませているポイントだ。ここに挙げた4つのポイントをふまえつつ、気になる紙に実際に試し書きをしてみて、好みの紙を見つけよう！

Point 4　平滑度

　紙の表面の平滑度も、「書く」文具をつくる紙には重要なポイントだ。一般的には平滑な紙のほうが書きやすいといわれるが、それがすべてでもないところが、このポイントの難しいところ。たとえば、万年筆に向けてつくられたステーショナリー用紙のなかでも、「ペン先に引っかかりがなく、スルスルと書ける、平滑でなめらかな紙」を目指すメーカーもあれば、「ペン先にある程度の引っかかりがあり、カリカリと書ける紙」を目指すメーカーもある。あるいは鉛筆であれば、マーメイドのようにあえて表面が凸凹した紙を使うことで、独特の風合いを活かせる場合もあるだろう。

　好みがかなり分かれるぶん、こだわりがいのあるポイントともいえる。用途をもとに求める書き味を定め、試し書きをして紙を選ぶのが良さそうだ。

平滑度が高い紙に書いた例。ペン先がなめらかに動き、するする書ける

微妙な凹凸にペン先が少し引っかかるのが好みという人も多い

マーメイドのような凹凸のある紙に鉛筆で書くと、独特の風合いが出る

COLUMN　**特抄きのオリジナル用紙を使っている手帳・ノートも多いのだ**

書き心地にこだわる

デザインフィルのオリジナル用紙「MD用紙」を使った「MDノート」

ぬらぬら書く

大和出版印刷のオリジナル用紙「グラフィーロ」を使ったノート

　「書く」文具では、本文用紙の書きやすさが、ユーザーにとって大きなポイントとなる。このため、独自の書き味を追求し、オリジナルの紙を特抄きしているメーカーも多い。

　デザインフィルの「MD PAPER PRODUCTS」シリーズは、「書くことにこだわった」プロダクト。使われている用紙は、1960年代に同社が開発したMD用紙。ノートや手帳、便せんなどに展開している。

　「万年筆で書いたときに、ペン先が少し引っかかることで、カリカリと心地よい音を立てて書けるように開発しました」（デザインフィル　高橋知可さん）

　一方、大和出版印刷が展開する文具ブランド「神戸派計画」のオリジナル用紙「GRAPHILO（グラフィーロ）」が追求した書き味はちょっと変わったもの。

　「紙の風合いを残しながら、かすれや引っかかりのない、なめらかな書き心地を目指しました。これを『ぬらぬら書く』と表現しています」（大和出版印刷　樋口香連さん）

　紙は抄造すると一度に大量にできてしまうため、オリジナル用紙をつくるのは、相当のこだわりがないとできないことだ。各文具ブランドこだわりの紙も、ぜひ試し書きしてほしい。

紙らしい風合いとあたたかな色み

イーストリーCoC

「万年筆のペン先のなめらかな走りを受け止める紙」として開発された。表裏差はほとんどなく、速乾性に優れている。あたたかなクリーム色も特徴のひとつ。

● 規格：菊判Y目 薄口、並口、中厚口、厚口
● 発売：松下

編集部がおすすめする

書きやすい紙紹介

ここからは、実際に「書きやすい紙」の紹介をしていく。4種の筆記用具で試し書きした結果を一挙公開。

※試し書きは、上から

万年筆 ……………………	ひきだし
油性ボールペン …………	ひきだし
鉛筆 ………………………	ひきだし
蛍光ペン …………………	

で書いたものです。

折り適性もあり封筒にも最適

ダンデレードCoC

「レターヘッドや封筒用に、筆記適性にこだわった和風の紙を」と開発。高品質なのにリーズナブル。レイド面が表のため、凹凸の適度な引っかかりを楽しめる。印刷適性にも配慮。

● 規格：四六判T目 60kg、69kg、86kg Y目86kg 他に900×1200mmあり
● 発売：富国紙業

和の表情も併せ持つ

サンレイド

《純白》《乳白》

1978年に発売され、40年以上使われ続けている紙。名前の通りレイド入り。優雅で品のある風合いで、便せんなどのステーショナリー用紙、和菓子の包装紙などに使われている。

● 規格：四六判T目 53kg、68kg 他に菊判あり
● 色：純白、乳白
● 発売：共同紙販ホールディングス

表面の緻密さとあたたかい風合い

バンクペーパー

なめらかさ、緻密さと、あたたかな風合いを兼ね備えた筆記事務用紙。もとは銀行業務用につくられた。レターヘッドなどに向いている。「THREE DIAMONDS」の透かし入り。

● 規格：B判T目 40kg、55kg、73kg 他に608×856mmT目あり
● 発売：三菱製紙

コットン配合の透かし入りの紙

スピカボンド

原料にコットンを25%配合した、上品な風合いのきめ細かな紙。耐久性と保存性に優れている。「SPIKA BOND」の透かし入り。レイド入りの「スピカレイドボンド」もある。

● 規格：888×625mm Y目 27kg、33.5kg、41.5kg、50kg
● 発売：三菱製紙

さらに軽くなっても、腰があってめくりやすい

ビューコロナ手帳用紙スリム

軽くて薄いが裏抜けしにくい、手帳用に開発された専用紙の新製品。従来のビューコロナ手帳用紙は52g/㎡だったが、さらに軽い47g/㎡で登場。パリパリとしっかり腰のある手触りが特徴。

● 規格：四六判T目40.4kg・A判Y目25.9kg
● 発売：王子エフテックス

伝統あるステーショナリーペーパー

コンケラーレイド

ステーショナリーペーパーのトップブランドとして知られるコンケラー。世界各国の企業やホテルが、レターヘッドや封筒に使用。しっかり入ったレイドと、ふかっとした高級感が魅力だ。

● 規格：四六判Y目 103.2kg、137.5kg、189.1kg 他に450×640mmあり
● 色：ハイホワイト、ダイヤモンドホワイト、ブリリアントホワイト、オイスター
● 発売：平和紙業、ヤマト

書きやすく、めくりやすいレイド入りの紙

特フールスN、TCクリームフールス

《白》《クリーム》

大学ノートで知られるツバメノートに使用されている、レイド入りの筆記専用紙。万年筆でも裏抜けせず、なめらかなペンの滑りが特徴。ノベルティ用途であれば使用できる（応相談）。

● 規格：1090×771mm Y目 68.5kg 他に880×625mmあり ● 色：白（特フールス）、クリーム（TCクリームフールス）● 発売：コスモ紙商事

レイドとOKマークの透かし入り

OKフールス

《純白》《淡クリーム》

イギリスをルーツにもち、万年筆でのなめらかな書き味を特徴とするフールス紙。ツバメノートなどの大学ノート、高級ノート、レターヘッドにも使われている筆記専用紙だ。

● 規格：1088×765mm Y目 67.5kg 他に625×880mm、765×540mm、858×612mmあり ● 色：純白、淡クリーム ● 発売：鵬紙業

上質紙ベースの平滑な手帳用紙

菁文堂手帳用紙

手帳用紙は通常、薄葉紙がベースだが、この紙は上質紙ベース。使いやすい価格と、しっかりした腰が特徴。手帳の製本会社・菁文堂のオリジナル用紙で、同社で製本する場合に使用可能。

- 規格：四六判T目 50kg
- 発売：菁文堂

しっかり書ける手帳用紙

オーク手帳

〈ホワイト〉 〈クリーム〉

手帳用紙ならではの薄さと軽さがありながら、少しふかっとした上品な仕上がりで、ペン先に適度な引っかかりのある書き心地。寸法安定性や強度も備えている。

- 規格：四六判T・Y目 44.7kg 他にA判、A判判あり ● 米坪：52g/㎡
- 色：ホワイト、クリーム
- 発売：日本製紙パピリア

多色印刷も得意なやわらかな紙

トモエリバー52手帳

〈白〉 〈クリーム〉

一般にもよく知られる手帳用紙。超軽量印刷用紙トモエリバーの裏抜けせず、多色印刷可能という特徴を活かしたまま、なめらかな筆記適性を加えた。ほんのりした地合ムラがいい。

- 規格：四六判T・Y目 44.7kg 他にA判、A判判あり ● 米坪：52g/㎡
- 色：白、クリーム
- 発売：巴川製紙所

するする書けてしなやかな紙腰

サンライズ手帳

〈ウスクリーム〉 〈白〉

一般の手帳用紙に比べて約10%の軽量化を図りながら、紙厚は57μmと、一般品と変わらない。するする書けるなめらかさと、整った地合、腰もあり、安定感のある薄葉紙だ。

- 規格：四六判T目 40.4kg 他にA判判あり ● 米坪：47g/㎡ ● 色：白、ウスクリーム
- 発売：三善製紙

インクのにじみにも配慮された上質紙

金菱

にじみ（サイズ度）にも配慮して開発された上質紙。白色度が高く、腰がある。平滑性はそれほど高くないが、ペン先の引っかかりは少なめだ。

- 規格：四六判T・Y目 45kg、55kg、70kg、90kg、110kg、135kg、T目のみ 180kg 他にB判、菊判、A判あり
- 発売：三菱製紙

実は文具好きにファン多し

淡クリームキンマリ

文具好きの間で書きやすい紙として実は人気の上質紙。パスピエクリームより平滑度は低いが、適度な引っかかりで書ける。

- 規格：四六判Y目 62kg、67.5kg、72.5kg、90kg、T目 72.5kg、90kg 他にB判、菊判、A判、新書判あり
- 発売：北越コーポレーション

平滑性の高い書籍用紙

パスピエクリーム

裏抜けしないよう不透明度が高く、めくりやすい特徴を持つ書籍用紙は、実はノートや手帳にも使いやすく、採用例も多い。パスピエクリームは、書籍用紙のなかでも平滑度がかなり高く、すべすべした手触りが特徴だ。

- 規格：四六判Y目 57kg、65kg、72.5kg 他にA判あり
- 発売：北越コーポレーション

実は書き心地のよい紙

専用紙以外にもいろいろ

しっとりとやわらかな嵩高紙

風光

あたたかな肌触りで、紙らしい風合いのあるやわらかい紙。その分、ペン先に適度な引っかかりがあり、書き心地に個性を加える。レターセットなどによく用いられる。

- 規格：四六判Y目 70kg、90kg、110kg、135kg、200kg
- 発売：竹尾

するする書けるマルチペーパー

ニュアージュCoC

平滑性が高く、なめらかで、落ち着いた風合い。オフセット印刷、スクリーン印刷のほか、レーザーやインクジェットなどのプリンター、オンデマンド印刷にも対応している。

- 規格：四六判T目 70kg、90kg、110kg、135kg、160kg、180kg、225kg 他に菊判あり
- 発売：リンテック

しっとり平滑なマルチペーパー

マシュマロCoCシリーズ

オフセット印刷だけでなくオンデマンド印刷や各種プリンターに対応のなめらかな表面が、するする・しっとりした書き味につながっている。

- 規格：四六判T目 70kg、90kg、110kg、135kg、160kg、180kg 他に菊判あり ● 色：マシュマロCoC、マシュマロCoCナチュラル ● 発売：王子エフテックス

塗り絵や画用紙にも使われる

ダイヤバルキー

嵩高の書籍用紙で、ラフな肌合いとナチュラルな白さが特徴。塗り絵にもよく使われている。万年筆ではインクをしっかり吸いながらも、にじみは少ない。

- 規格：四六判T・Y目 88kg、101kg、125kg、135kg、155kg 他に菊判あり
- 発売：三菱製紙

大人の塗り絵シリーズでも人気

スライト

ひきだし∞
ひきだし∞
ひきだし∞

きめ細かくやわらかな肌が特徴の高級印刷用紙。表裏にわずかな凹凸の特殊パターン加工がされており、鉛筆で塗ると、それが良い味となる。塗り絵や便箋によく使われている。

- 規格：四六判T目 70kg、100kg、130kg、Y目 100kg 他に菊判あり
- 発売：北越コーポレーション

色鉛筆の塗り心地のよさ

KMKケント

ひきだし∞
ひきだし∞
ひきだし∞

細密画を色鉛筆で着色する塗り絵が人気だ。こうした用途でよく使われているのが、KMKケント。平滑度がかなり高く、色鉛筆やマーカーでの塗り心地もするすると気持ちいい。

- 規格：四六判Y目 135kg、180kg、225kg 他にA判あり
- 発売：ミューズ

一筆箋によく使われる

ダイヤペーク

ひきだし∞
ひきだし∞
ひきだし∞

マットな印刷仕上がり、裏抜けしない不透明度の高さが特徴の高級印刷用紙。滑りすぎず引っかかりすぎもしない、書きやすい紙で、印刷品質も求めたい一筆箋によく使われている。

- 規格：四六判T目 90kg、110kg、130kg、150kg、180kg
- 発売：竹尾

紙らしい風合いの高級印刷用紙

アラベール-FS

ひきだし∞
ひきだし∞
ひきだし∞

繊細な風合いと優しい手触りの非塗工印刷用紙。高い印刷適性を持ち、発色もよい。適度な引っかかりのある書き心地だ。色や連量も豊富。

- 規格：四六判Y目 70kg、90kg、110kg、130kg、160kg、200kg 他に四六判T目、菊判あり
- 色：ウルトラホワイト、スノーホワイト、ホワイト、ナチュラル他
- 発売：竹尾

薄いけれど丈夫な透け感のある紙

チャンピオンコピー

※透け感がわかるよう、右端を黒バックで撮影

ひきだし∞
ひきだし∞
ひきだし∞

事務用紙として開発された紙で、透け感がかわいい。薄いけれど丈夫で腰があって破れにくく、印刷インキののりや乾きも上質紙と同等。万年筆のインクや鉛筆、墨ののりもよい。

- 規格：四六判T目 30kg、34.5kg、43kg 他にA判あり
- 発売：三菱製紙

製図用だから書きやすい

トレーシングペーパーN

※透け感がわかるよう、右端を黒バックで撮影

ひきだし∞
ひきだし∞
ひきだし∞

透ける紙の代表格・トレーシングペーパー。実は設計製図、事務用途で開発された紙なので、筆記適性がある。万年筆、ボールペン、鉛筆など、どの筆記具でも書きやすい。

- 規格：四六判T目 34.5kg、43kg、51.5kg 他にA判、L判、845×610mmもあり
- 発売：三菱製紙

油性ボールペンとの相性がいい

耐水耐油紙

※透け感がわかるよう、右端を黒バックで撮影

ひきだし∞
ひきだし∞
ひきだし∞

水や油が染み出しにくい紙で、主に食品用の包装材として使われているが、透け感のかわいさから、便箋としても使用可能。印刷適性もあり、油性ボールペンでの書き心地がよい。

- 規格：四六判Y目 34.5kg
- 米坪：40g/㎡
- 発売：リンテック

水に浮かべると消えてしまう！

溶ける紙・水

ひきだし∞
ひきだし∞
ひきだし∞

繊維の結合を弱くしてつくられた紙で、水につけると瞬時に溶ける。流し灯籠に使われているこの紙、実は筆記適性もある。ただし万年筆はインクを吸ってしまうので、ボールペンや鉛筆でどうぞ。

- 規格：546×788mmT目 26kg、52kg
- 発売：平和紙業

※ここで紹介しているのは、基本的に筆記適性のある・書きやすい紙のため、この写真のように裏抜けしないものが多い。実際の裏抜け度合いは、試して確かめてみてほしい。

（裏）

撥水ラップの注意点
※水性ボールペンや、サインペン、万年筆などを使用すると、筆記線が薄くなる可能性がある。
※水に長時間接したり、大量の水に触れたりした場合は撥水性能を発揮しない場合がある。

雨水が浸透しづらく封筒向き

撥水ラップ

ひきだし∞
ひきだし∞
ひきだし∞

特殊な薬剤を含浸することで、高い撥水性を実現したクラフト紙。雨に濡れても浸透しにくい撥水性と、オフセット印刷での印刷適性、鉛筆や油性ボールペンの筆記適性を併せ持っている。

- 規格：ハトロン判T目 92kg、108kg
- 発売：リンテック

青い色と表面の凹凸で脳を刺激

OKシナプス

ひきだし∞
ひきだし∞
ひきだし∞

「表面に凹凸がある青い色の紙は集中力を高め、脳を活性化する」という長岡技術科学大学との共同研究の結果をもとに開発された紙。鉛筆などの硬質筆記による、カリカリとした独特の書き味は、ノート用途に最適。

- 規格：四六判Y目 70kg
- 発売：王子エフテックス

(2) 開きやすく壊れにくい製本とは?

書いたり描いたりして使うノートやメモ帳。
そこに使われる製本技術は、書籍に使われているものと同じなのだろうか?
それとも特にむいている技術があるのだろうか?

製本と言われるとつい書籍や雑誌の製本を思い浮かべてまう。その製本についてはある程度知っているものの、ノートや手帳のように「書いて、使う」ための製本については、いつもあまり意識していないというのが正直なところだ。

そんな生半可な知識で、ノートや手帳をつくってはいけない。なぜか。

同じ「製本」とは言っても、読むものと使うものとでは、要求される機能が違ってくる。例えば開きやすさ。書籍でも開きやすさは重要だけれど、180度開いてかつ手で押さえなくても閉じない製本はある程度要求されないことがほとんど。でもノートや手帳の製本ではそれは必須だ。他にも、何度も開いて閉じてを繰り返しても壊れにくいことも重要だ。

そんな開きやすさや堅牢さを兼ね備えた製本は代表的に4タイプある。また他に「手帳製本」や「帳簿製本」など用途に特化した製本様式もある。

糸かがり製本

折丁（1枚の大きな紙を16ページなどに折りたたんだ状態のもの）をいくつか重ね、その背部分を糸で綴じ合わせる製本のこと。開きの良さ、堅牢さは抜群上製本の書籍にも使われる製本方法だ。

糸かがりされたノート。折丁の中央部分を見ると、かがった糸が見える。180度しっかり開く

リング製本

重ねた本文用紙の背側に穴を開け、そこにリングを通した製本方法。180度、360度しっかり開き壊れない。リングはダブルリング（写真のもの）とスパイラルリング（針金が螺旋状に巻かれたタイプ）とがある。

ダブルリング製本されたノート。しっかり開き、左右のページ位置も揃う（スパイラルリングはリングが螺旋状のため、開くと左右ページの縦位置が少しずれる）

中ミシン製本

見開き状態で中央のノド部分を一直線にミシンで縫い綴じ、二つ折りした製本。学習ノートなどにもよく使われる。中ミシン製本した後、背部分にクロスを巻くタイプもある。

ノートの真ん中を開くと、中央部分にミシンがかかっているのがわかる。しっかり180度開いて壊れにくい

中綴じ製本

見開き状態で中央のノド部分を針金のステッチでとめた製本。一番簡易で安価につくれるタイプながら、180度しっかり開くことができ、リーズナブルにノートがつくりたいときにうってつけだ。ステッチは基本はシルバーだが、銅色や金色などがある場合も。

ノート、便箋、手帳など――製本紙モノ編

角背で開きやすい上製本ノート

上質な雰囲気にあふれた、角背タイプの上製本ノート。表紙の背部分の芯を抜き、ハードカバーながら180度開く使いやすさ。角丸に仕上げた表紙も上質感を高めている。

紙

もの文具をつくりたいときに仕上がる。

ものはノートではないだろうか。一言でノートといっても、選ぶ紙、サイズ、厚み、製本方法などによって、つくれるタイプは多種多様だ。

高品質の上製本を得意とする渡邉製本が手がける「角背で開きやすい上製本ノート」は、その名の通り、180度ガバッと開けるノートとしての使いやすさを実現しつつ、角背で溝なし上製表紙を持った美しいノート。本文ページは折丁を糸かがりし、それを背部分のみ芯ボールが入っていない上製表紙で仕上げているため、ハードカバーながら開きやすく、かつ堅牢さも兼ね備えている。さらに表紙は角丸仕上げも可能で、通常、表紙の脇に入る溝もなくすことができ、フラットで上質感あるノートに仕上がる。

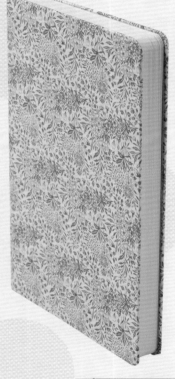

上製本タイプながら、角背に仕上げた背部分の芯ボールをいれていないため開きやすく、機能性と美しさを両立したノート

サイズや厚さ（本文枚数）は自由に変更可能。表紙は写真のものはあらかじめ印刷された紙を渡してつくってもらったものだが、オリジナル柄を印刷した紙でも、また、クロスや合皮、革素材など、上製表紙に使える素材なら、さまざまなものが使える。

上製本では、一般的に背の脇に溝が入ることが多いが、こちらのノートでは真っ平らで美しい表紙を実現するため溝なしで仕上げられている

の芯が入っておらずやわらかいこと、そして本文を糸かがりにしていることも相まって、非常に開きやすいノートになっている

芯ボールを紙やクロスで巻く上製本表紙ながら、角丸を実現。きれいに巻き込まれて貼られた美しい表紙をつくれるところは極少数

INFORMATION

最小ロット

500部〜。経済ロットは3000枚部〜

価格

A5変形・256頁・見返しあり・表紙角丸・芯ボール代含む製本代：500部で単価約480円、3000部で単価約270円（紙・印刷代は別途）

納期

製本のみ・3000部の場合、刷本支給から約14営業日

入稿データについて

基本的に印刷した刷本を納品して製本してもらう。印刷や紙手配から頼みたい場合は要相談

注意点

サイズや厚さ、本文枚数、角丸の有無など、仕様はいかようにも変えられるので、あらかじめ相談しておきたい

問い合わせ

渡邉製本株式会社
東京都荒川区東日暮里3-4-2
TEL：03-3802-8381
Mail：info@watanabeseihon.com
http://www.watanabeseihon.com

コデックスノート

糸かがりした背がそのまま見えている、無骨なその背が魅力的なコデックス装のノート。開きやすさも兼ね備え、本文用紙の色を折ごとに変えてみても、おもしろい仕上がりのノートになる。

色違いの本文折がそのまま見える、糸かがりしたままの背

糸かがりした本文に、表紙巻きしていない製本なため、180度フラットに開く

本文を2色の色上質紙（クリーム色と薄グリーン）で交互に丁合したコデックスノート。表紙は黒紙をベタ貼りしている

本文用紙を「トーンF」にしたコデックスノート。暖かみのあるグレーとクールなグレーが各7色ずつあるトーンF。その7色を1折ずつ使い、本文用紙がグレーのグラデーションになるノートをつくることもできる

書籍でもここ数年、使われることが多くなっているコデックス装。

無骨でプロダクト感溢れる仕様なため、人気がどんどんたかまっている製本だ。

渡邉製本では、この製本方式を上製本の本文と同じように、折丁を糸がかり。表紙は巻かずに見返し貼りなどで仕上げるため、背部分が糸でかがった状態のままで完成となる。

上製本の製本を得意とする同社ならではのきめ細かさで、背の糸かがりも、ビシッと揃った小口の完成度も高い。180度がっちり開くのも使いやすい。厚さやサイズなど、自由にオーダーできるコデックスノート、本文用紙がそのまま見える背をうまく利用して、本文用紙の色を折丁ごとに変えると、色がシマシマの背になったコデックスノートや、色がグラデーションになったものなど、さまざまなノートがつくれる可能性にあふれた紙もの文具だ。

上製本の製本を得意とする同社ならではのきめ細かさで、使いノートをつくってもらうことができる。

INFORMATION

最小ロット

500部〜。経済ロットは3000枚部〜

価格

B6・112頁・見返しあり・コデックス装の製本代：500部で単価約390円、3000部で単価約220円（紙・印刷代は別途）

納期

製本のみ・3000部の場合、刷本支給から約12営業日

入稿データについて

基本的に印刷した刷本を納品して製本してもらう。印刷や紙手配から頼みたい場合は要相談

注意点

サイズや厚さ、本文枚数、背に寒冷紗を貼ったりと仕様はいかようにも変えられるので、あらかじめ相談しておきたい

問い合わせ

渡邉製本株式会社
東京都荒川区東日暮里3-4-2
TEL：03-3802-8381
Mail：info@watanabeseihon.com
http://www.watanabeseihon.com

コデックス寒冷紗ノート

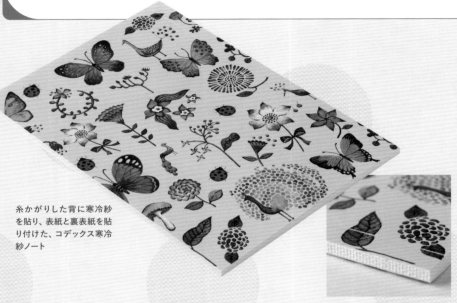

糸かがりした背がそのまま見えているコデックス装のノート。その上に寒冷紗を貼り、強度を高めたのがコデックス寒冷紗ノート。開きやすさと強度を兼ね備えたノートだ。

糸かがりした背に寒冷紗を貼り、表紙と裏表紙を貼り付けた、コデックス寒冷紗ノート

背は寒冷紗が見える。よく見るその奥に糸かがりされた折丁が覗く

コデックス装の特徴でもある開きやすさは健在。手で押さえなくても180度開いたまま

コスト削減のため、見返しをつけず、本文用紙1枚目のノド側1cmくらいに糊を入れ表紙を貼り合わせている

製本の製本工程を知っているひとなら見たことがあるだろう、背に寒冷紗が貼られた状態。強度を高めるために、糸かがりをした後に、薄い網戸のような寒冷紗を貼るのだ。

この製本途中にだけ見られた寒冷紗貼りした状態、改めて見るとカッコよく、このまま仕上げて欲しいと思ってしまうほど。

それを実現してくれるのが、渡邉製本のコデックス寒冷紗ノート。こちらもプロダクト感溢れ人気のあるコデックス装に、見栄えの良さと強度アップのために寒冷紗を貼り、表紙を貼り合わせて仕上げたノートだ。

コデックス装の特徴である180度しっかり開く仕様はそのままに、表紙が背に貼られず多少強度が落ちてしまうというコデックス装のデメリットを、寒冷紗を貼ることで補い、かつ見た目の良さも実現。コストをさげるために、見返しは使わず、本文ページにそのまま表紙を貼って仕上げている。

INFORMATION

最小ロット

500部〜。経済ロットは3000枚部〜

価格

A5・80頁・見返しなし・コデックス寒冷紗装・表紙筋入れ加工ありの製本代：500部で単価約360円、3000部で単価約200円（紙・印刷代は別途）

納期

製本のみ・3000部の場合、刷本支給から約12営業日

入稿データについて

基本的に印刷した刷本を納品して製本してもらう。印刷や紙手配から頼みたい場合は要相談

注意点

サイズや厚さ、本文枚数、背に寒冷紗を貼ったりと仕様はいかようにも変えられるので、あらかじめ相談しておきたい

問い合わせ

渡邉製本株式会社
東京都荒川区東日暮里3-4-2
TEL：03-3802-8381
Mail：info@watanabeseihon.com
http://www.watanabeseihon.com

2色ミシン綴じノート

中央をミシンで縫った中ミシン綴じは、開きのよい製本方法として、手帳やノートに用いられている。通常は白い糸で製本されているが、この糸を色糸に、それも2色づかいにすることでかわいいアクセントのあるノートになるのだ。

手帳についているアドレス帳のような薄いノートは、表紙と本文を重ねた中央をミシンで縫った中ミシン綴じで製本されたものが多い。開きがよい上、糸で綴じているので耐久性も高い製本方法だ。

糸がほつれないよう、背をクロスで巻く方法もあるが、あえて糸を見せるのもいい。それも、ミシンの上糸と下糸の色を変えると、ツートンカラーの縫い目が背に見えて、とてもかわいい仕上がりになる。

この2色ミシン綴じノートをつくってくれるのは、手帳とノートを得意とする糸かがり専門の老舗製本会社・菁文堂だ。名刺サイズの小さなものから最大A4サイズまで、最小2枚から一番厚くて束5ミリまで対応可能。四六判70キロの本文なら64ページぐらいまでのノートがつくれる。本文用紙

は、52g／㎡の薄い手帳用紙から、四六判90キロぐらいまで。表紙は本文にしてもよいし、210キロまでであれば、厚めの紙にすることもできる。また、菁文堂は、自社オリジナルの「菁文堂手帳用紙」を持っている。平滑性が高く、インクが裏抜けしにくい、手帳用途に特化した四六判50キロの上質紙だ。同社に製本を依頼すれば、このオリジナル用紙を使うことも可能だ。糸の色は、問い合わせをすれば見本帳画像を送ってくれる。

背の糸を見せたままの製本のため、ほつれないよう糊どめがされている。糊が汚く見えないように、おすすめは濃い色の表紙と、明るい色の糸の組み合わせだ。

INFORMATION

最小ロット
150冊〜

価格
記事に掲載のミシン絵柄の表紙のノート（B6判、8ページ、使用紙：ファーストヴィンテージ オーク 四六判103kg）を150冊製作した場合、表1のみ1色印刷で2万7000円（税別）、全ページフルカラー印刷で4万円（税別）

納期
校了後10営業日後に発送

入稿データについて
Illustrator、InDesign、PDFでデータ入稿。画像でも入稿可能だが、別途作業代が発生する。仕上がり線に画像がかかる場合は、必ず塗り足しをつけること

注意点
6〜8月、11月などの繁忙期には、一部製造が難しい時期がある。また、納期についても、必ず事前に問い合わせを

問い合わせ
菁文堂
東京都台東区小島1-12-9
TEL：03-3863-5101（担当：竹内）

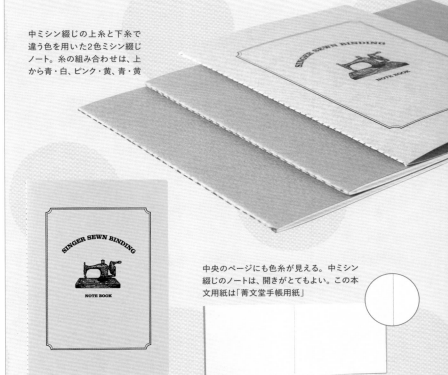

中ミシン綴じの上糸と下糸で違う色を用いた2色ミシン綴じノート。糸の組み合わせは、上から青・白、ピンク・黄、青・黄

中央のページにも色糸が見える。中ミシン綴じのノートは、開きがとてもよい。この本文用紙は「菁文堂手帳用紙」

すかし印刷ノート

ノートの本文ページに、いろいろなすかしが入っていたらどんなにかわいいか。

そんな夢を比較的小ロットで実現してくれるのが、オフセット印刷で擬似的にすかしを印刷できる藤和のすかし印刷を使ったノートだ。

ノートの本文は、罫線やドットなどが印刷されていることが多いが、そこに絵柄や罫線などが「すかし」で入っていたら、魅力あるオリジナル紙文具になる。

しかし、実際にオリジナルすかしを入れた紙を漉いてもらうのはハードルが高い場合が多い。そんなときに便利なのが、オフセット印刷ですかし模様を入れることができる、藤和のすかし印刷を使ったノートだ。

すかし印刷は、特殊な専用インキを使い、オフセット印刷で絵柄や文字を刷ると、その部分にインキが浸透して半透明になるというもの。あまり厚い紙だとすかしイ ンキが入っていきにくく、透け感が少なくなってしまうので、四六判55kg前後の紙を使うのがおすすめだ。

中綴じノートなので、本文への絵柄の入れ方はいろいろ考えられるが、全ページ同じ絵柄が続くより、例えば16ページごとに絵柄が違っている方が、よりおもしろい紙文具になること請け合い。面つけを考えればこうしたノートが500冊からつくることができるのだ。

下の囲み部分で紹介しているコストのすかし印刷ノート。B6サイズ中綴じ、本文48ページ（24枚）のノートで。表紙は大和板紙の「チョコレート」にLR輝ゴールドの1度刷り、本文ははまゆう（四六判56kg）。16ページ分の絵柄をつくり、それを3折分で1冊のノートにしているため、16ページごとに絵柄がループする

茶色い紙を挟んですかし印刷の絵柄を見てみる。16ページ分ちがう絵柄が入っている

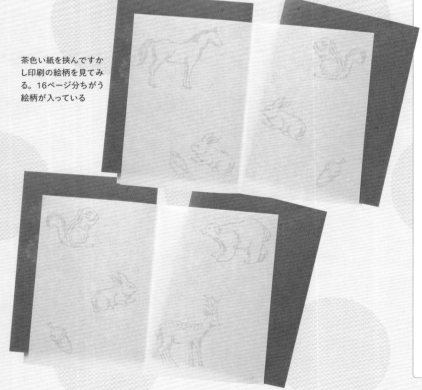

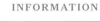

INFORMATION

最小ロット

500部〜。経済ロットは1000部〜

価格

記事に掲載のすかし印刷ノート（B6判、中綴じ、本文48ページ＋表紙）の場合、500部で27万5000円（単価550円）、1000部で30万3000円（単価303円）、2000部で35万6000円（単価178円）

納期

データ入稿から約2週間

入稿データについて

Illustratorなどによるデータ入稿

注意点

16ページ分の本文データは、片面印刷のため、実質8ページ分のデータとなる（おもて面から印刷すると裏面はその絵柄が透けて見えている状態）

問い合わせ

株式会社藤和
東京都新宿区天神町6番地 Mビル2F
TEL：03-5228-2351
https://towaprint.com/

クロス巻ノート

学習ノートや大学ノートというと真っ先に思い浮かぶのが、背にクロスを巻いた中糸ミシン製本のノートだ。開きがよく、丈夫で、針金を使わないため、子ども向けのノートなどに最適だ。

表

紙に本文を重ねて中央部分をミシンで縫い、それを二つ折りにして背にクロスを巻いた、クロス巻ノート。これは製本方式としては、中糸ミシンと呼ばれるもので、開きのよさが特徴のひとつだ。糸で縫われているため丈夫で、日々何度も開いたり閉じたりするノートや手帳に適した方式だ。

背にクロスを巻いているのは、ノートの中心部分を直線に縫ったミシン糸がほつれないため。クロスは黒が代表的だが、実は豊富な種類があり、見本帳に収録されているものであれば使用可能。寒冷紗や和紙テープを使うこともできる。また、別途料金はかかるが、縫い糸を白以外に変えることも可能だ。

クロス巻ノートを手がけるロクユーは、年間1千万冊以上ノートを製造している製本会社だ。一番多い仕様は、B5判30枚（60ページ）のノート。もちろんそれ以外にも、天地最小100〜最大800ミリ、左右最小90〜最大252ミリまでのサイズでノートの製作を頼める。

厚みは本文と表紙を合わせて2ミリまで。丁合機も持っているため、本文が全ページ同じデザインでなくても対応してくれる。どういうノートにしたいのか、ラフデザインの時点で相談すれば、最適な面付けを提案してくれるので、企画段階から相談を。12〜4月は学習ノートの繁忙期となるため、特にこの時期は納期の1カ月以上前に相談するとスムーズだ。

中糸ミシン製本で、背にクロスを巻いた「クロス巻ノート」。クロス部分に箔押しを入れることも可能

背に巻くクロスの見本の一部。寒冷紗も選べる。色を選びたい旨を伝えれば、見本帳画像を送ってくれる

真ん中をミシンで縫った中糸ミシン製本は、開きがよく耐久性が高いのが特徴

別途料金がかかるが、ミシン糸を色糸に変えることもできる。何百種類の色があるので、まずは「赤系」「水色系」などとイメージを伝えて、提案してもらうのがよい

INFORMATION

最小ロット

1000冊〜。ただし経済ロットは1万冊ぐらい

価格

B5ノート32枚（64ページ）製本代のみで、1000冊で単価150円以上、1万冊以上で単価30円前後

納期

製本のみで約2週間（12〜4月の繁忙期を除く）

入稿データについて

印刷も含めて依頼する場合は、Illustratorでデータ入稿（印刷済みの刷本を入れて、製本のみを依頼するほうがおすすめ）

注意点

中糸ミシン綴じは、表紙と本文を合わせて2mm厚ぐらいまで対応可能。上質紙なら四六判70kgで80ページぐらいまで

問い合わせ

東京都緑友印刷製本協業組合
ロクユー
東京都江戸川区下篠崎町13-5
TEL：03-3670-9653
Mail：info@rokuyu.or.jp
http://www.rokuyu.or.jp/

ダブルリングノート

真っ平らに開くのはもちろん、折り返して360度開けるのが特徴のリングノート。表紙デザインやサイズ、厚み、そしてリングの色など随所にこだわりを入れたノートをオリジナルでつくることができる。

ノートによく使われるリング製本。表紙と本文ページに穴をあけ、そこに通したリングによって開きが自由自在なのが最大の特徴だ。穴あけなど機械で作業するが、セットやリング通しなどは手作業の場合も多く、手間のかかる製本方法だ。

紙の短冊見本帳や手製本など、他でできない製本も引き受けてくれる鈴木製本では、このリング製本も得意。表紙や印刷の印刷加工からでも、印刷した刷本を納品して製本だけでも、どちらでもやってもらえる。

リング製本は現在多く使われて

いるダブルリングと、1本の針金をらせん状の巻いたスパイラルリングの2種類がある。スパイラルリングは開いたときに、左右ページの天地位置が少しずれてしまうという難点があることもあり、現在では1穴に2つの針金が通っているダブルリングを使うことが多い。リングはメタリックなものを含め、見本帳から自由に選べる。サイズや本文枚数、縦長・横長など仕様も自由に選べ、ゴムバンド付きにするなどオプションをつけることもできる。

表紙と本文に穴をあけ、ダブルリングを通して製本したダブルリングノート。もちろん180度、360度自在に開く

横長などサイズも自由にオーダーできる

ノート小口がカバンの中などで開いてしまわないよう、ゴムバンドをつけることもできる。表4側にハトメでゴムを手加工でつける

リングにはさまざまな色があり、この見本帳の中から自由に選べる。左側が通常色、右側がメタリック色

INFORMATION

最小ロット
1部〜。経済ロットは500部〜

価格
A5・160頁・表紙カード紙（表裏4色刷）・本文は上質紙（四六判70kg・表裏1色刷）・OPP個別包装あり・ダンボール梱包込み：500部で単価600円、ゴムバンドつきの場合は500部で単価700円。表紙が表裏4色印刷でなく箔押し1箇所にしたり、本文が無地の場合は単価が下がる

納期
データ入稿から約2週間

入稿データについて
表紙や本文に印刷を入れる場合は、IllustratorやInDesignなどで入稿データをつくる

注意点
リングは見本帳から選ぶことができる。ダブルリングではなくスパイラルリングにしたい場合は、リングが受注生産になることもありロットが多くなる場合があるので注意。

問い合わせ
鈴木製本
埼玉県草加市新里町1533-1
TEL：048-923-1513
Mail：seihon@fusuma.co.jp
http://www.suzuki-seihon.com

ななめリングノート

製本を手がける鈴木製本も一員の「印刷加工連」が開発し、製造販売している「ななめリングノート」（小サイズはななめリングメモ）。ノート上部の右か左部分を斜めにカットし、そこに穴をあけてリング製本している

ノートの上端に斜めにリングを通して製本する「ななめリング製本」。鈴木製本が得意とするこの製本でつくったノート、サイズや印刷内容、リングの色や紙の銘柄など、オリジナルオーダーでつくることができる。

印刷加工連のななめリングノートを裏返すと、本体とはサイズが違ったタグがついている。このように表紙の前や後、中身でも、サイズ違いのものが入れられるのもいい

単語帳のように表紙がななめに開く

一般的なリング製本のノートは、背側すべてにリングが通っている。しかしリングの位置も左右どちらでも可能。リングの数も最低2つ以上であれば、3つ5つなど、サイズに応じて数を決めることができる。ほぼ手加工でつくられるため、サイズの違う紙を入れられるなどといったことにも、比較的自由度高く対応してもらえるのもうれしい。

紙や印刷加工内容、リングの色なども、すべてを自由にデザインしてオーダーすることができる。

それをカード式単語帳のように、上部の右か左に斜めに通して製本したノートが「ななめリングノート」だ。もともと、この製本を手がける鈴木製本も一員の「印刷加工連（http://www.inkaren.com/）」で開発し、実際に「ななめリングノート」「ななめリングメモ」として販売されている。綴じてある部分を斜めに断裁しており、そこに穴をあけてダブルリングを通しているため、メモ帳のように開きやすく片手で持って使う場合などにも便利だ。

この「ななめリングノート」、サイズや本文枚数、表紙や本文の

リングにはさまざまな色があり、この見本帳の中から自由に選べる。左側が通常色、右側がメタリック色

INFORMATION

最小ロット
1部〜。経済ロットは500部〜

価格
A5・160頁・表紙カード紙（表裏4色刷）・本文は上質紙（四六判70kg・表裏1色刷）・OPP個別包装あり・ダンボール梱包込み：500部で単価800円。表紙が表裏4色印刷でなく箔押し1箇所にしたり、本文が無地の場合は単価が下がる

納期
データ入稿から約3週間〜1ヵ月

入稿データについて
表紙や本文に印刷を入れる場合は、IllustratorやInDesignなどで入稿データをつくる

注意点
リングは見本帳から選ぶことができる。リングは最小で2つ〜。1つだと不安定になるためだ。

問い合わせ
鈴木製本
埼玉県草加市新里町1533-1
TEL：048-923-1513
Mail：seihon@fusuma.co.jp
http://www.suzuki-seihon.com

平ミシンノート

ノートのノド側近くを、表紙から本文ページまですべて一緒にミシンで縫い綴じてしまう平ミシンノート。手で折り目をぎゅっと入れないと開きづらい側面はあるものの、見栄えのよさはグッズとして注目のひとつだ。

ミシン綴じ製本のノートといえば、本文見開き部分の中央を開いた状態で縫い綴じ、二つ折りにする中ミシン製本を思い浮かべるだろう。でもここでご紹介するのはそうではなく、表紙と本文用紙を重ねて上から一気に縫い綴じてしまう平ミシン製本によるノート。ノド側（背側）から数ミリ程度のところを縫うため、開くときに手でぎゅっと押さえる必要はあるが、ミシン糸が表紙からもしっかり見え、そこがポイントとなったかわいい紙もの文具になる。

製本用のミシンを持っている製本会社なら平ミシン製本はできるが、一般的なところでは厚さ3ミリ程度までしか綴じることができない。しかし鈴木製本では、今までの仕事で分厚いものに平ミシンをかける必要性があり、そのノウハウから、1センチ程度の厚みまで平ミシン製本することができる。

サイズや紙の種類、印刷などなど自分のつくりたいように決め、厚さ1センチ以内であれば、平ミシンノートをオーダーすることができる。

ただ、あまりに分厚かったり、また硬い紙でつくったりすると、ミシンをかけた裏側（裏表紙側）に見える、針が貫通した穴がきたなくなってしまうこともあるので、平ミシンノートをつくりたいときは、どんな紙を使いたいか、厚さをどのくらいにしたいか、事前に鈴木製本に相談し、試作してもらう方が安全だ。

ノートのノド側（背側）近くを、ミシンでダダダダッと縫って製本している平ミシンノート。糸の色は自由に選ぶことができる

表紙と本文を上から一緒くたに縫ってるため、手でぎゅっと折り目をつけて開く必要がある

INFORMATION

最小ロット

1部〜。経済ロットは500部〜

価格

A5・160頁・表紙カード紙（表裏4色刷）・本文は上質紙（四六判70kg・表裏1色刷）・OPP個別包装あり・ダンボール梱包込み：500部で単価550円。表紙が表裏4色印刷でなく箔押し1箇所にしたり、本文が無地の場合は単価が下がる

納期

データ入稿から約2週間

入稿データについて

表紙や本文に印刷を入れる場合は、IllustratorやInDesignなどで入稿データをつくる

注意点

最厚1cm程度までなら、鈴木製本で平ミシン製本できる（通常の製本会社だと約3mm程度までのところが多い）。それ以上は紙質にもよるが、綴じられても縫い目が汚くなってしまうことも多いので、基本的には1cm厚まで

問い合わせ

鈴木製本
埼玉県草加市新里町1533-1
TEL：048-923-1513
Mail：seihon@fusuma.co.jp
http://www.suzuki-seihon.com

くるみ表紙リングノート

リング製本したノートは、表紙も平たい状態のものに穴をあけて、本文と一緒にリングを通したペラ状態になる。しかし、より高級感を出したり、また背に文字や色柄を入れたい場合は、鈴木製本が手がけるくるみ表紙リングノートがオススメ。表紙をペラではなく折って、本文をくるんだ状態でリング製本するので、リングで少し隠れるものの、表紙が背まである状態でノートになる。

サイズや厚さ、表紙や本文の素材など、自由に決めてオーダーすることができる。

表紙は厚紙を折るタイプでも、上製本のように芯ボールを入れて紙やクロスで巻き貼った上製表紙を使ったタイプでもどちらでも可能。上製タイプの場合は、背に穴をあけてリングを通すのが無理な

リングノートの表紙は、通常平たい紙の状態で、背部分には表紙がない。しかしかし鈴木製本ではくるみ表紙タイプでもリング製本したノートをつくってもらうことができる。

ため、表4部分（もしくは表1部分）に穴をあけてリングを通す必要がある。

開きやすいリング製本にしつつ、上質感や背が欲しいという場合にうってつけなのが、くるみ表紙リングノートだ。

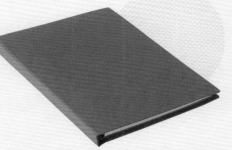

表紙の厚紙に穴をあけ、ダブルリング製本したくるみ表紙リングノート

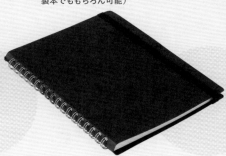

リング製本なので、もちろん開きはすごくいい

上製本のような芯に紙やクロスを巻き貼ってつくる表紙もくるみ表紙リング製本できる。その場合、背には穴をあけてリングを通すことが難しいので、表4側にリングを通す場合が多い

リングは途中で違う色に変えることなどもできる（くるみ表紙リングノート以外のリング製本でももちろん可能）

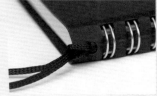

リング上部にスピンを結びつけて、栞紐付きのリングノートもできる

INFORMATION

最小ロット
1部〜。経済ロットは500部〜

価格
A5・160頁・表紙カード紙（表裏4色刷）・本文は上質紙（四六判70kg・表裏1色刷）・OPP個別包装あり・ダンボール梱包込み：500部で単価700円。表紙が表裏4色印刷でなく箔押し1箇所にしたり、本文が無地の場合は単価が下がる

納期
データ入稿から約3週間

入稿データについて
表紙や本文に印刷を入れる場合は、IllustratorやInDesignなどで入稿データをつくる

注意点
リングは見本帳から選ぶことができる。くるみ表紙は並製本タイプの板紙でも、上製本タイプの芯に紙やクロスを巻き貼ったものでもどちらもできる

問い合わせ
鈴木製本
埼玉県草加市新里町1533-1
TEL：048-923-1513
Mail：seihon@fusuma.co.jp
http://www.suzuki-seihon.com

中綴じ&リング綴じ活版ノート

風合いのある紙にキュッと圧をかけて活版印刷した表紙のノート。針金どめで製本する中綴じなら、軽やかなノートを手軽につくることができる。ページ数を多めでしっかりつくりたいときにはリング綴じがおすすめだ。

中綴じのステッチの色は、シルバー以外もある。ゴールドにすると、アンティーク感が出ていい！

活版印刷の圧による微妙な凹凸が、あたたかみを加える

活版印刷で表紙を刷ったノート。上が中綴じ、下がリング綴じ。アナログ感ある仕上がりがかわいい。なお、特にリング綴じの場合、リング穴をあける分、デザイン時に絵柄を右寄りに配置しないと、仕上がりが左に寄ってしまうので注意を（本書がデザインした作例は、少し左に寄ってしまった！）

凸

版にインキをつけて、紙にギュッと押し当てることで印刷する活版印刷。嵩高の少しフカッとした紙に圧をかけたときに生まれる微妙な凹凸で、あたたかみのある仕上がりになる。この活版印刷を表紙にしてノートをつくることができるのが、活版印刷・製本を手がける河内屋だ。最小A6～最大A4サイズまでのノートが製作可能。

手軽につくりたいのであれば、中綴じがおすすめ。表紙と本文を重ねた用紙を2つ折りにし、その背部分をステッチ（針金）でとめる製本方法。中央ページは開くとほぼフラットになる。コストを抑えられることも魅力のひとつ。ただし、厚すぎるとステッチで

められないため、表紙に四六判172キロ程度の紙を使用した場合、本文は四六判70キロの上質紙で40枚（80ページ）までとなる。もっとページ数を多く、しっかりしたノートをつくりたいときには、リング綴じもできる。リング綴じの場合は、本文が最大80枚（160ページ）まで対応可能。本文にある程度の厚みが持たせられるので、そこに天金加工を施して、さらに華やかな仕上がりにすることもできるのだ。

河内屋では、小口に箔押しをする天金加工を行うことも可能。金・銀・銅箔は常備、それ以外のメタリックカラーも取り寄せ可能。ただし天金加工を行う場合は、最小ロット1000冊～となる

INFORMATION

最小ロット

100部～

価格

本ページに掲載した中綴じノート（A5判80ページ、中綴じ製本、表紙活版1色印刷、両面表紙、使用紙：表紙ファーストヴィンテージ アッシュ 四六判172kg、本文 上質紙四六判70kg）を100部製作した場合、8万円～
◎同仕様のノート1000冊に天金加工を行った場合の価格は、加工代のみで8万5000円

納期

2週間～

入稿データについて

Illustratorでデータ入稿。活版印刷の場合、平網は80線となる。画像がある場合は、事前にデータを送り、表現可能か検証してもらうこと

注意点

中綴じのステッチの色、リングの色はともに選べるが、在庫によるため、シルバー以外の色を使いたい場合には事前に問い合わせを

問い合わせ

河内屋
東京都新橋6-11-8 1F
TEL：03-3431-3339
Mail：info@kawachiya-print.co.jp
http://www.kawachiya-print.co.jp/

小口塗装の分厚いノート

三方断裁された本の小口に色をつける「小口塗装」。デザイナーならいつかはやってみたいと思う憧れの加工であり、本の印象を大きく変え、色のかたまりとしてプロダクトのような存在感をもたらす。この装飾を用いて、分厚いノートをつくることができるのだ。

本の3つの断裁面に色をつけるのが「小口塗装」。表紙にくるまれた背以外にも色がつくことで、まるで美しいプロダクトのような印象を与えてくれる。

この加工を用いてノートをつくりたい！ ということでお願いしたのが、書籍やコミックなどの製本を手がける国宝社。自社開発した色つけラインによって、小口塗装を手がけている会社だ。色ムラのない安定した品質を誇っている。

今回つくってもらったのは、コミック誌に用いられているようなラフな本文用紙でつくった、無線綴じの分厚いノート。三方断裁した小口に色がつくだけで、存在感が大きく増す。

加工色は金銀と蛍光色以外であれば対応可能。特色はDICのカラーチップで指定すればよい。他社では対応が難しいことも多い、黒もOKだ。

判型は新書判からB5判まで。それ以外のサイズは手作業になるため、コストが上がる。

加工する際に背を下にして立てるため、厚み（束幅）は10ミリ以上必要で、最大で40ミリまで。コート紙のような塗工紙を本文に使用すると、染料が染み込まずに本の中に入り込んでしまうので、非塗工の上質紙や中質紙を使用するのがよい。

また、表紙は三方色つけと同色、またはそれより濃い色にしたほうが、表紙に染料が入り込んでしまっても目立たないので、きれいな仕上がりになる。

表紙を小口塗装の色より濃い色にした例。表紙にビオトープGA ダークブラウン 四六判210kg、小口はオレンジを指定した（本文は中質紙）。華やかな印象

表紙と小口塗装を同色にした例。表紙はOK AC カード 空 四六判222kg、小口は表紙の紙色に近い空色を指定（本文は中質紙）。ひとつの色の塊になり、プロダクト感が出る

本文用紙には若干インクが染み込む。自然なにじみが、いい味になっている

開いたときにも小口の色が見えて、かわいい仕上がり

INFORMATION

最小ロット
1500冊〜

価格
1冊50円〜
※塗装加工代のみ。製本代は別途

納期
塗装と製本で2週間

入稿データについて
表紙や本文への印刷は応相談。印刷がある場合は、Illustrator、Photoshopでデータ入稿

注意点
小口塗装を行う場合は、製本も合わせて依頼することが前提となる

問い合わせ
国宝社
東京都豊島区千早4-35-8
TEL：03-3958-2281
Mail：info_kokuhosha@kokuhosha.co.jp
http://www.kokuhosha.co.jp/

通帳ノート

本物の通帳とまったく同じサイズ、紙、製本方法でつくった通帳ノート。オフセット4色印刷で、サイズは約140×87.5mm、本文は32ページ

通帳ノートのデザイン例。スケジュール帳や旅行記録、買い物記録など、さまざまな用途で使われている

中ミシン綴じで開きがよい

通帳製本は、本文を中ミシン綴じした後で表紙でくるんでいるため、外から糸が見えない

金融機関で用いている通帳。手のひらにおさまる持ち歩きやすいサイズのこの冊子には、使用されている用紙から製本方法に至るまで、とことん耐久性を追求した精度の高い技術がぎっしりと詰まっている。通帳ノートは、これとまったく同じ体裁で、オリジナルでつくれる薄いノートだ。

　金融機関で用いる通帳の製本には、実はさまざまなノウハウが込められている。さらに、通帳の製本では精度が重要なため、方眼や横罫も見開きでずれず、ぴったり合わせて製本できるのも特徴だ。

　表紙には丈夫な紙クロスを用いているため、ケースに入れずにポケットに入れても、ぐちゃぐちゃにならない。角丸加工が施されていることも特徴のひとつだ。

　通帳専用紙を用いた通帳の印刷製本は、ごく限られた会社でしか行えない。そのうちの一つ、昌栄印刷でつくれるのが、オリジナル通帳ノートだ。たとえば表紙に箔押しやエンボス加工、スクリーン印刷をしたいとか、綴じ糸の色を変えたいなどのカスタマイズにも応じてくれる。

　サイズは、手のひらにおさまる約140×87・5ミリ。使われている紙は通帳専用紙で、機械による自動記帳・ページめくりが可能な耐久性と腰がある。平滑性が高く、裏写りもしにくい。通帳にはメモをするユーザーも多いため、万年筆、ボールペン、鉛筆での筆記適性も実は有している。

　耐久性の高さは、製本も同様だ。繰り返し機械に通しても壊れない、堅牢なつくり。製本方式は、本文を中ミシン綴じした後で表紙でくるむ、独自の「通帳製本」である。かつ、表紙でくるんでいるので、外側から糸が見えないのが特徴。

　中ミシン綴じ特有の開きのよさも兼ね備えている。

INFORMATION

最小ロット

1000冊〜

価格

1万冊製作した場合、1冊85円〜

納期

校了後3週間〜

入稿データについて

Illustrator、PDFでデータ入稿

注意点

使用紙、サイズ、ページ数は固定となる。角丸をなくしたい、穴あけをしたい、綴じ糸の色を変えたいなどのカスタマイズは応相談

問い合わせ

昌栄印刷　クリエイティブセンター
大阪府大阪市生野区桃谷1-3-23
TEL：06-6717-1179
Mail：shoei-info@shoei-printing.com
http://www.shoei-printing.com

色付き天糊一筆箋

コミック誌に使われる色更紙に絵柄を4色印刷し、色付きの糊で天糊製本してつくった一筆箋。使用した糊は、蛍光ピンクと蛍光緑。糊部分が目立って、かわいい!

一筆箋やメモ帳のような、1枚ずつはがして使うものに用いられる「天糊製本」。表紙でくるまないタイプでは、糊で接着した背がそのまま見える。この糊に色を付けることができるのだ。色付き天糊がアクセントになり、とてもかわいい仕上がりになる。

こちらは、色をつけずそのままの糊で天糊製本したもの。乾くと透明に近くなる

表

紙をくるんでしまう製本では、糊は基本的に見えなくなるが、一筆箋やブロックメモなど、表紙でくるまないタイプでは、糊の色がそのまま見える。だったら、色のついた糊で製本したらかわいいのでは? そんなわけでつくってもらったのが、色付き天糊一筆箋。天糊製本とは1枚ずつはがして使う一筆箋などに使われている製本方式だ。

製本に使う糊は、一般的には乾くと透明になるが、この糊に色をつけることで、一筆箋のデザインのアクセントにもしている。天糊製本はどんなに大量の場合でも、人の手で糊を塗ることがほとんどのため、こうした色付き糊を使うことができるというわけだ。

加工をお願いしたのは、各種紙加工から製本まで、品質の高い紙加工を行っている小林断截。なかでも天糊製本は、同社の得意とする加工だ。黒、茶、赤、青、黄、緑のカラーボンドが使えるほか、蛍光黄、蛍光緑、蛍光オレンジ、蛍光ピンクのボンドもある。蛍光色のボンドは、通常の白い製本用ボンドに、蛍光塗料や顔料を混ぜてつくったものだ。これらのカラーボンドを背に塗って製本すれば完成。ただし、糊は塗ったときと乾いたときで色の濃さが左右されることから、DICのカラーチップと同じ色に調色してほしいというようなオーダーには対応が難しい。

INFORMATION

最小ロット

500冊〜

価格

このページに掲載のサンプル(サイズ182×80mm、本文片面4色印刷、30枚綴りで短辺天糊製本、台紙つき、表紙なし)を製作した場合、天糊無色で500冊7万4000円〜、1000冊8万3000円〜
※カラーボンド1色追加につき＋6000円

納期

6〜7営業日

入稿データについて

Illustratorでデータ入稿(ai形式＋出力見本のPDFファイル)。刷本支給も可能。要打ち合わせ

注意点

用紙、色数、梱包などの変更や、表紙をつけると、価格が変動する。天糊側の仕上がり面に印刷ベタや表面加工があると、天糊がきれいにつかない場合がある

問い合わせ

小林断截
東京都墨田区緑2-11-18
TEL：03-3634-8351
https://www.k-dan.co.jp

すかし印刷一筆箋

「しらおい上質（四六判55kg）」の紙に、すかし印刷を施した紙を30枚綴りで天糊加工した一筆箋。すかすとより模様がでてきて美しい

オリジナルの絵柄が、色印刷で入っているのではなく、すかし模様で入っている一筆箋がつくれる。そんなことを実現できるのは、擬似的なすかし模様をオフセット印刷で入れられるからだ。

すかし印刷した紙と4色印刷した紙を交互に入れた一筆箋。重ねるとすかし印刷した一筆箋から下のカラー印刷が覗き美しい効果がでる

筆箋や便箋など、手紙を書く紙文具に、オリジナルのすかしが入っていると、ワンランク上のグッズになる。

しかし、実際にすかしを入れた紙をつくるとなると、ロットも多くなり、その分コストもかかる。そんなときに便利なのが、オフセット印刷で擬似的にすかし模様を入れられる藤和のすかし印刷だ。

すかし印刷は、オフセット印刷で専用のほぼ透明なインキを刷る

ことで、その部分がすかしのような半透明な効果を出せる。あまり厚い紙だとすかしインキが浸透しにくいため、四六判55キロ前後の厚みの紙を選ぶとよい。

入れたい絵柄や文字をレイアウトし、すかしインキで印刷。それを天糊製本すれば、オリジナルすかしの入った一筆箋になる。その際、より透け感を出すために藤和ではすかし印刷を2度刷りしてい

る。

すかし印刷だけのシートで丁合し、一筆箋や便箋にするのもいいが、すかし印刷したシートと4色印刷したシートを丁合することで、すかしと色絵柄を組み合わせた表現の一筆箋をつくることもできる。

INFORMATION

最小ロット

経済ロットは1000部〜。多少割高になってもOKならそれ以下の部数も可

価格

写真上のすかし印刷したシートのみの一筆箋（サイズ80×152mm、しらおい上質・四六判55kg、30枚綴り、台紙はチップボール、天糊製本）1000部で18万2000円（単価182円）
写真下のすかしシート＋4色印刷シートの一筆箋（サイズ130×130mm、はまゆう・四六判56kg、30枚綴り、台紙はチップボール、天糊製本）1000部で27万5000円（単価275円）

納期

データ入稿から10日程度

入稿データについて

Illustratorなどによるデータ入稿

注意点

すかし印刷は、上から水性ペンなどで書くと多少弾く場合があるので、それが気になる場合は裏面からすかし印刷を施す

問い合わせ

株式会社藤和
東京都新宿区天神町6番地 Mビル2F
TEL：03-5228-2351
https://towaprint.com/

活版・天糊メモ

素朴な風合いのある紙に活版印刷を施した本文を天糊で製本したメモ帳。どんどんめくりながら、気軽さがありながら、1枚1枚を大切に使いたくなるかわいさを併せ持つのが魅力だ。

メモ帳の表紙だけでなく、本文全部を活版印刷したい！ そんな要望にこたえ、活版印刷の天糊メモを製作できるのが、河内屋だ。最小A7サイズから、最大A4判までの天糊メモをつくることができる。

河内屋が行っているのは、金属活字を用いた活版印刷ではなく、データから直接作成する樹脂凸版を用いた活版印刷。このため、イラストや平網を用いることも可能だ。掲載した作例のように、ベタ部分があると、活版印刷のあたたかみがある風合いがより際立っていい。ただし、平網の表現は80線となる。また、あまりに細かい絵柄は凸版で再現することが難しく、半分空気を含んだよう

印刷時につぶれやすくなるので要注意だ。印刷の色数は最大で特色4色まで対応してくれる。

メモやノートの場合、筆記用の専用紙を使う場合を除き、本文は四六判70キロ程度の紙が使われることが多い。薄すぎると裏抜けしやすくなるし、厚すぎても使いづらいからだ。

今回の作例では、自然で柔らかな風合いを持つ嵩高の紙ハーフエアを使用。その名の通り、半分空気を含んだよう

なフカッとした紙のため、70キロの厚みでも、活版の圧力によるかすかな凹みが生じている。ほかにも活版印刷に合う紙を選びたい場合は、相談を。また、問い合わせをすれば、活版印刷や特殊印刷のサンプルも送ってくれる。

嵩高の紙を使うと、凸版での印刷時にかかる圧により、かすかな凹みが生じやすい

本文の天部分を糊でかためている。最大ページ数の目安は80枚

本文全ページを活版で1色印刷し、天のり製本したメモ帳。ざっくりとしたかわいさが魅力

INFORMATION

最小ロット
100冊～

価格
記事に掲載した天糊メモ（B7判80枚綴り、活版1色印刷、使用紙：表紙ハーフエア 四六判70kg）を100冊製作した場合、単価507円×100冊＝5万700円

納期
10営業日

入稿データについて
Illustratorでデータ入稿。活版印刷の場合、平網は80線となる。画像がある場合は、事前にデータを送り、表現可能か検証してもらうこと

注意点
用紙は活版印刷に合うものが他にもあるので、違うものを使いたい場合は問い合わせを

問い合わせ
河内屋
東京都新橋6-11-8 1F
TEL：03-3431-3339
Mail：info@kawachiya-print.co.jp
http://www.kawachiya-print.co.jp/

強いインデックスつき手帳

1年間の長い時間、カバンの中に入れ、取り出して開いて書きと、ヘビーに使われる手帳。だからこその強度が必要。型抜きされて使いやすいインデックス部分にさらにコーティングして強くした手帳は、品質にこだわるには必須の技術だ。

手帳をつくるとき、気をつけなければならないポイントがいくつもある。書くということにこだわった使いやすさ、開きやすさ、1年間の使用に堪えられる堅牢さ、見開きページにわたる横罫が左右ページでずれないよう特殊な折り方をする本文等々、書籍などはいつもつくっていても、一見「製本している」という紙ものとしては一致していても、細かい部分でかなりの違いがある手帳製本。

そんな手帳製本を専門に手がけるのが大阪の田中手帳。前述した手帳製本に必須事項はもちろん、それ以外に、該当ページを瞬時に開けるよう、手帳に採用されることが多い型抜きのインデックス。これを製本後に専用機械でいれることができる。本文を折る前に型

抜きしておくと、折る際にどうしてもズレが生じてしまうが、田中手帳は製本後に入れることで、美しい仕上がりになる。加えて、その表裏に樹脂コーティングすることができるため、何度も開いて触っても、折れたり破れたりしない強さを持ったインデックスを入れられるのだ。

糸かがり、薄い和紙による背巻きがされた田中手帳による手帳は、180度ぺったり開くのはもちろん、360度折り返して使っても壊れにくい、しっかりした強度を持っている

表裏とも樹脂コーティングされたインデックス。手で何度も触っても破れにくい

樹脂コーティングされた型抜きインデックス。インデックスに入った数字の位置がしっかり揃っているのも美しい

インデックスの角度や形は何種類もある

INFORMATION

最小ロット

300部〜。経済ロットは1万部〜

価格

表紙の仕様やページ数、インデックスをどのような形で入れるかにより大幅に異なるが、掲載写真(田中手帳株式会社オリジナル手帳:記す手帳A5・80頁)を例として、印刷物支給にてスクリーン印刷〜製本・インデックス加工(64頁分にインデックス加工あり)までで約40万円。5000冊の場合、単価90円、10000冊の場合、単価70円程度

納期

刷本納品から約3週間〜1ヵ月程度

入稿データについて

印刷からお願いすることも、刷本支給でお願いすることもどちらでも可能。印刷からの場合は、InDesignやIllustratorなどでのレイアウトデータと、別途インデックス用の印刷データを用意する

注意点

刷本支給でつくる場合、本文の面付方法など、あらかじめ手帳製本に沿った仕様にしておく必要があるため、印刷前に必ず打ち合わせをする

問い合わせ

田中手帳株式会社
大阪市住之江区平林南1-2-52
TEL:06-6681-8648
https://www.tanakatechou.co.jp/

ノートブロック

紙が分厚く丁合されたブロックメモのようなノートが「ノートブロック」。存在感あるこのノート、寒冷紗貼りされているのでブロックメモのようにピリピリ破けず、機能性もあり！

立方体のように分厚いブロックメモはよく見かけるけれど、そのくらい分厚く、かつ開きやすいノートが、鈴木製本が手がける「ノートブロック」。その名の通り、メモブロックのように分厚く重ねた紙を天糊製本しているが、途中でピリピリ剥がれてこないように補強の意味も兼ねて、背を寒冷紗貼りしている。その後、ドイツ装のように表紙を貼り合わせて製本されている。紙の1枚1枚に糊がついて製本されているため、開きは非常によく、180度しっかりと開いて使える。

これは鈴木製本と三洋紙業が一緒に開発した、「紙のミルフィーユ」ブランドから発売されている「Note block」をオリジナルオーダーできるもので、写真では本文用紙にオペラクリームを300枚重ね、正方形でブロックメモの大きい版（200mm四方）のように見えるが、オリジナルの場合は、長方形でももっと小さくても大きくても、厚さも自在に変えてつくってもらうことができる。

これだけ分厚いと、仕上げの三方断裁時に断裁の包丁が入る角度などテクニックが必要で難しいが、通常から紙の短冊見本帳などこうした難しい製本を多数手がけている鈴木製本だからこそ、美しい断面を持ったブロック型ノート「ノートブロック」をつくることができるのだ。

INFORMATION

最小ロット

1部〜。経済ロットは500部〜

価格

A5・350枚・表紙カード紙（表裏4色刷）・本文は上質紙（四六判55kg・表裏1色刷）・OPP個別包装あり・ダンボール梱包込み：500部で単価1200円。表紙が表裏4色印刷でなく箔押し1箇所にしたり、本文が無地の場合は単価が下がる

納期

データ入稿から約3週間〜1ヵ月

入稿データについて

表紙や本文に印刷を入れる場合は、IllustratorやInDesignなどで入稿データをつくる

注意点

サイズや厚さなど自由に変えられるため、つくりたい場合は事前に相談を

問い合わせ

鈴木製本
埼玉県草加市新里町1533-1
TEL：048-923-1513
Mail：seihon@fusuma.co.jp
http://www.suzuki-seihon.com

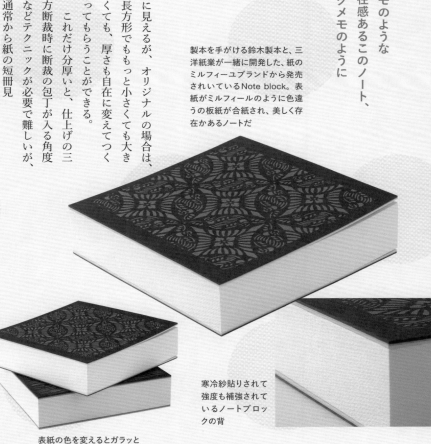

製本を手がける鈴木製本と、三洋紙業が一緒に開発した、紙のミルフィーユブランドから発売されているNote block。表紙がミルフィールのように色違うの板紙が合紙され、美しく存在かあるノートだ

表紙の色を変えるとガラッと印象がかわる

寒冷紗貼りされて強度も補強されているノートブロックの背

天糊製本のように1枚ずつが糊付け加工され、寒冷紗が巻かれているため、開きがすごくいい

丸メモ

たとえばボールや果物など、丸いものをモチーフにメモ帳をつくりたいとき、これまでは直線部分を設けて天糊製本にするか、あるいは裏面に粘着加工を施して付せんにしなくてはならなかった。

しかしマルモ印刷では、丸型にカットされたメモを製作可能なのだ。

ボールや地球、果物、木の断面、ピザ……。丸いモチーフはいろいろある。

こうしたモチーフでメモ帳をつくりたくても、従来の天糊製本では糊づけに直線部分が不可欠だったため、まんまるな形でつくることは難しかった。裏面に粘着加工を施した付せんであれば製作できるが、コストも上がってしまう。

そんななかで登場したのが、マルモ印刷の丸メモだ。最小ロット500冊から、丸型にカットされたメモをつくることができる。サイズは、直径75ミリであれば、既存型を用いて加工できるため、型代がかからない。それ以外のサイズは要相談だ。

綴り枚数は50枚と100枚の2種類となっている。

正円ではないオリジナルの形状でも、型代は別途となるが、形状によってはメモを作成することが可能。ラフデザインの段階で、一度相談してみるとよい。

オリジナルの形状の場合は、データ入稿の際、別レイヤーにカットラインデータを作成することが必要となる。カットラインと絵柄との見当精度は高いが、紙の伸縮などにより多少の誤差が生じるため、カットラインを絵柄の0・5ミリ内側に入れるか、裁ち落としでなく白フチをつけたデザインにするとよい。

丸型にカットされたメモを天糊製本した丸メモ。独自の手法で、糊づけに直線部がなくても製本可能にした。丸いモチーフを用いたデザインに最適

丸型をお皿に見立てたメモ帳。裁ち落としで絵柄を入れるのではなく、あえて余白を活かしたデザインもいい

INFORMATION

最小ロット

500冊〜

価格

直径75mm（表4色／裏1色印刷）50枚綴りを製作した場合、500冊で単価330円

納期

完全データ入稿または校了後、1ヵ月

入稿データについて

Illustratorでデータ入稿。既存型を使用しない場合は、別レイヤーにカットラインデータを作成のこと

注意点

カットラインと絵柄の見当精度は高いが、紙の伸縮などでも誤差を生じるため、最低でもカットラインを絵柄の0.5mm以上内側に入れるか、白フチをつけたデザインにしたほうが、仕上がりがきれいになる

問い合わせ

マルモ印刷
営業本部・工場｜香川県三豊市豊中町笠田笠岡3915-5
TEL：0875-62-5856
Mail：contact@marumo-print.co.jp
http://www.marumo-print.co.jp/

特殊カットメモ

オリジナルの形状に型抜きされたメモ帳は、それだけで見た目のインパクトが大きいが、さらに特殊なカットを施したメモをつくることができるのが、メモ帳制作を得意とするマルモ印刷だ。

マルモ印刷の型抜きメモがすごいのは、一般的なトムソンによる型抜き加工ではなく、印刷と同時に切り込みを入れるインラインダイカットを行っているから。トムソンの抜き刃よりも細かい加工が可能な腐食刃で抜くために、細かい形状にも対応できるのだ。

その型抜き加工を活かしてつくることができるなかでも、特にインパクトが高いのが、2段ダイカットメモだ。それぞれ形の違うダイカットメモを2段重ねることで、立体感を表現することができる。

厚みは四六判55キロが多い。

いずれも、最小A7から、最大A4サイズまで製作可能。メモ本文に使用される紙は上質紙が多く、厚みは四六判55キロが多い。

量産化に向いている。

（3段）ダイカットメモに比べると工程が少なく済むため、納期もシンプルなメモ帳と変わらず、大量生産に向いている。

として使うこともできる。2段くとして使うこともできる。2段くとして使うこともできる。2段(3段)ダイカットメモに比べると工程が少なく済むため、納期もシンプルなメモ帳と変わらず、大量生産に向いている。

絵柄に沿ってオリジナルの形状に型抜きし、それを2段、3段と重ねたダイカットメモや、一見シンプルな四角いメモだが、切り離した本文を2つ折りにすると立ち上がるダイカットスタンドメモ。特殊な形状にカットされたメモ帳は、インパクト大だ。

3段重ねることも可能だ。インパクトが大きい分、製造工程も複雑になるため、納期は校了後1カ月ほどかかる。

また、ダイカットスタンドメモは、一見普通の四角いメモ帳に見えるが、中央部分に絵柄に沿ったカットが入っており、切り離したメモを2つ折りにするとカットされた形状が起き上がるというもの。デスクに立てて伝言をわかりやすく伝えたり、本にはさんでしおりとして使うこともできる。2段（3段）ダイカットメモに比べると工程が少なく済むため、納期もシンプルなメモ帳と変わらず、大量生産に向いている。

形の違うダイカットメモを2段重ねた、2段ダイカットメモ

こちらは3段重ねた、3段ダイカットメモ。立体感がすごい

メモ本文の中央に、絵柄に沿ってカットが入っており、2つ折りにするとそれが立ち上がるダイカットスタンドメモ。マルモ印刷でつくれるメモ帳のなかでは、もっとも複雑な形状の型抜きが可能だ

問い合わせ

マルモ印刷
営業本部・工場｜香川県三豊市豊中町笠田笠岡3915-5
TEL：0875-62-5856
Mail：contact@marumo-print.co.jp
http://www.marumo-print.co.jp/

マーブル製本ノート

繰り返し開いては書いて使うノート。なかでも、手帳製本を応用してつくる「マーブル製本ノート」は、開きがよくて壊れにくい、高品質なノートだ。

糸かがり製本された本文は、気持ちがいいほどペタンと開き、かつ堅牢。使い勝手のよいノートになる。かがり糸の色を変えることも可能。写真のノートは、一部分だけ色糸を入れている

背は四角くカッチリした仕上がり

糸かがり製本した本文の背をクロス巻きで仕上げた「マーブル製本ノート」。表紙とクロスの色の組み合わせで、シックにもカジュアルにもなる。表紙には好きな紙を選ぶこともできる（要相談）

INFORMATION

最小ロット
最小ロット1000冊～、経済ロット3000冊～

価格
A5サイズ、160ページ糸かがり、両面1色印刷のノートを製作した場合、1000冊で単価700円～、3000冊で単価350円～
※使用する用紙や印刷の色数により価格は異なる

納期
校了後、約1ヵ月（時期により要相談）

入稿データについて
表紙や本文にオリジナルデザインを印刷する場合は、フォントをアウトライン化したIllustratorデータ（ai、またはpdf形式のファイル）にて完全入稿のこと。製作できるノートの最小サイズは70×105mm、最大サイズは148×210mm（A5判）、束の厚みは最大20mmまで

問い合わせ
株式会社新寿堂
東京都板橋区東坂下1-13-2
TEL：03-3558-0113
http://www.shinjudo.co.jp/

本文を背を糸でかがった後で糊をつけて背固めし、見返しと表紙を貼り、背をクロスで巻いて仕上げているこのノートは、製本会社・新寿堂が「マーブル製本ノート」と呼んでいるもの。新寿堂のマーブル製本ノートは手帳製本の技術を応用してつくられており、本文が180度開いて製本強度も高いので、何度開閉しても壊れない丈夫さを持つ。ノートや手帳は、ノウハウなしにつくると、ページがノドまで開かない、使い勝手の悪いものが出来上がってしまう。多少コストが高くなっても品質のよいノートをつくりたい人におすすめだ。ノート製作の手順としては、まずは問い合わせをして、サイズやページ数など、希望の仕様を伝える。本文は希望の紙を指定することも可能だが、ノートの場合は筆記適性が大切な要素となる。ここで紹介している新寿堂には、「新寿堂特別抄造紙」というオリジナルのクリーム系手帳用紙があるので、それを使ってみるのもよい。本文に印刷を入れる場合は、用意されている罫線や方眼などのベースデザインから選ぶことも、オリジナルデザインを入稿することも可能だ。製本仕様は糸かがりのほかPUR無線綴じも選択可能。PUR無線は糸かがりより価格はおさえられるが、十分な打ち合わせを行って決めることが必要だ。

小口色付／色磨きノート

並製本に小口色磨き加工を行なう場合は、加工後にもう一度別の表紙でくるむか、表紙と染料の色をそろえて染料の飛びはねが目立たないようにする必要がある

本文の天地小口の三方がさまざまな色で塗装したノートは、個性的な仕上がり。塗装後に磨いて光沢を出す小口色磨きノートは、さらに高級感が増す。

色とりどりの小口色磨きノート。天地小口の色付部分が非常に平滑で、光沢ある仕上がりが特徴。上品で、高級感ある仕上がり。染料は指定の色見本から選択

こちらは小口色付ノート。色付部分はマットで落ち着いた仕上がり

INFORMATION

最小ロット

最小ロット1000冊〜、経済ロット3000冊〜

価格

B6サイズ、128ページ糸かがり、両面1色印刷のノートを製作した場合、色磨きノートは1000冊で単価380円〜、3000冊で単価260円〜。色付ノートは1000冊で単価350円〜、3000冊で単価210円〜
※使用する用紙や印刷の色数により価格は異なる

納期

校了後、約1ヵ月（時期により要相談）

入稿データについて

表紙や本文にオリジナルデザインを印刷する場合は、フォントをアウトライン化したIllustratorデータ（ai、またはpdf形式のファイル）にて完全入稿のこと。製作できるノートの最小サイズは70×105mm、最大サイズは148×210mm（A5判）、束の厚みは最大20mmまで。小口色付の染料は、色褪せなどの問題が発生するため、指定の定番色の中から選択。本文用紙の断面に刷毛で染料を塗るため、再生紙や、書籍でよく使用される嵩高紙などの染み込みやすい紙、ツヤのあるアート・コート紙は向いておらず、上質紙や、にじみの少ない手帳用紙が向いている。使用実績と経験値のあるおすすめの紙は、新寿堂特別抄造紙（手帳用紙）、淡クリームキンマリ、キンマリSW、OK上質、金菱

問い合わせ

株式会社新寿堂
東京都板橋区東坂下1-13-2
TEL：03-3558-0113
http://www.shinjudo.co.jp/

長く使い続けていると、ノート本文の天地や小口が汚れてきてしまうことがある。こうした汚れを防ぎ、本文を保護する目的で行なわれるのが、天地小口の三方を染料で塗装する小口塗装（色付）だ。しかしそうした機能面はもちろん、側面から色が見える仕上がりは、装飾的な要素としても魅力的。ノート本文に加工すれば、存在感を増すことまちがいなしだ。

背固めと三方断裁をした本文を数十冊、万力にセットして締めながら、その断面に刷毛で染料をつけて塗装するのが小口色付。さらに、色付けした本文を、今度は色磨きの機械にセットして、メノウ（石）で磨いて平滑にし、光沢を出すのが小口色磨き加工だ。硬いメノウで磨くと、紙の断面とは思えない艶が出て、小口色付よりさらに高級感のある仕上がりとなる。この加工ができる会社はあまりない。

メノウをセットした小口色磨きの機械で磨いているところ。メノウは非常に硬い石のため、研磨に向いている

中ミシン糸どめノート

本文の中央をミシンで縫った中ミシン製本のうち、背の糸を見せたままにするのが「中ミシン糸どめノート」だ。背に見える糸がデザイン的なアクセントになる。

中ミシン糸どめノートは、背の糸がそのまま見えるのがチャームポイント。色糸を使うと、アクセントになる

中央ページにも縫い糸が見える。ミシンの糸は、いろいろな色を選べる

表紙と本文を重ねた中央をミシン縫いし、背の糸を見せたまま仕上げる「中ミシン糸どめノート」。A6～B4判まで制作可能（それ以外のサイズも応相談）

表紙と本文ページを開いた状態で重ねて、その中央部分（ノドに部分）をミシンで一直線に縫った後、二つ折りにして仕上げるのが、中ミシン糸どめ製本のノートだ。中ミシン糸どめ製本の中身（本文）だけともいえるが、大きな特徴は、表紙も一緒に縫っていること。このため、背に糸が見える仕上がりになる。製本には通常、白い糸が使われるが、外から見えることを考えて色糸を使うと、チャーミングな仕上がりになる。糸の色は多種類あるので、赤系、青系などだいたいの希望を伝えて相談するとよい。本文を見開きの状態でミシン縫いして綴じているので、開きがともよく、使いやすいノートにもよく、使いやすいノートになる。また、糸で綴じているため、耐久性が高く壊れにくいのもうれしい。

重ねた本文が厚すぎるとミシンで縫えないため、厚み3ミリ以内におさまるページ数に設定することが必要。目安としては、四六判70キロの本文であれば64ページぐらいまでとなる。

ページは180度開く

INFORMATION

最小ロット
最小ロットは1部～、経済ロットは3000部～

価格
経済ロット単価50円（印刷・紙代別途）

納期
約7営業日～

入稿データについて
フォントをアウトライン化したIllustratorデータで、完全データ入稿のこと。ま本文が厚すぎるとミシンで縫うことができないため、縫う本文の厚みは3mm以内（四六判70kgの上質紙で64ページ程度）。それ以上の厚みの場合は、糸かがりなど別の製本方法にしたほうがよい。糸処理のため、天地に通常の3mmのドブ＋白ドブ9mm（計12mm）が必要

問い合わせ
大村製本株式会社
東京都板橋区前野町3-43-7
TEL：03-3969-2361
Mail：info@omuraseihon.com
https://www.omuraseihon.com

中ミシン・クロス巻ノート

学習ノートや大学ノートで真っ先に思い浮かぶのが、背にクロスを巻いた中ミシン・クロス巻ノートだ。クロスの色は、いろいろ選ぶことができる。

中ミシン・クロス巻ノートも、開きのよさが特徴。背をクロスで巻いているので、綴じ糸がほつれにくくなり、中ミシン糸どめノートよりもさらに堅牢性がアップする

中ミシン綴じした後、背をクロスで巻いて仕上げた「中ミシン・クロス巻ノート」。A6〜B4判まで制作可能（それ以外のサイズも応相談）

大学ノートなどでは黒い背クロスが定番だが、クロスには何種類かのカラーバリエーションがある。カラフルなクロスを用いると、それだけで華やかな表情のノートになる

INFORMATION

最小ロット
最小ロットは1部〜、経済ロットは3000部〜

価格
経済ロット単価56円〜（印刷・紙代別途）

納期
約7営業日〜

入稿データについて
フォントをアウトライン化したIllustratorデータで、完全データ入稿のこと。本文が厚すぎるとミシンで縫うことができないため、縫う本文の厚みは3mm以内（四六判70kgの上質紙で64ページ程度）。それ以上の厚みの場合は、糸かがりなど別の製本方法にしたほうがよい。糸処理のため、天地に通常の3mmのドブ＋白ドブ9mm（計12mm）が必要

問い合わせ
大村製本株式会社
東京都板橋区前野町3-43-7
TEL：03-3969-2361
Mail：info@omuraseihon.com
https://www.omuraseihon.com

中は、中ミシン糸どめノートと同様、表紙と本文を開いたまま重ねて中央部分をミシンで縫い、それを二つ折りにして製本する。大きな違いは、最後に背にクロスを巻いて仕上げることだ。クロスを巻くことによって、背の糸がむき出しにならず、ミシン糸がほつれにくくなって、堅牢性が上がる。クロスの色はいくつかのバリエーションがあり、色を

ミシン・クロス巻ノートは、子ども用の学習ノートによく使われるのは、中綴じのように針金を使わないので安全で、しかも、糸で縫っているので丈夫だということ、開きがよく、見開きが完全に水平な状態になるという使い勝手の良さから。他の中ミシン製本と同様、重ねた本文が厚すぎるとミシンで縫えないため、厚み3ミリ以内に設定することが必要となる。

変えるだけで見た目の印象が大きく変わる。表紙の紙色やデザインとの色の組み合わせを変えれば、背が覆われている印象のノートになる。凝った印象のノートになる。背が覆われているため、縫い糸の色が見えるのは中央ページのみになるが、色糸を使用することも可能。

中ミシン・クロス巻ノートが

SOWALABO蛇腹ノート

ただの蛇腹ノートではない。蛇腹ページが長くなっても「継ぐ」部分がなく、最大3000メートル程度まで可能！もちろん印刷もでき、なおかつ型抜きやハーフカットなども入れられるのだ。

3mの蛇腹ノート。1面が107.156mm×28面で蛇腹折りされているので、すべてのばすと3000.368mmに。平判用紙からつくる通常の蛇腹本文だと、3メートルにするためには最低3箇所は糊付けして繋がないとできないが、SOWALABO蛇腹ノートは継ぎなしでつくれる

こちらの表紙は大和板紙のNVC 750g/㎡に、コスモテックにてマット銀の箔押ししたもの。板紙そのままをカットして貼り合わせているタイプもできる

印刷以外に腐食刃による型抜きも入れられる。ミシン目を入れることも可能

ロール原紙の長さいっぱい（約3000m）継ぐことなく蛇腹折りできる

京都で「墨が裏面に染み出ない御朱印帳」の製造販売をメインに行なっている早和製本。その製造加工技術を転用したSOWALABO蛇腹ノートは、上質紙の本文用紙に印刷や型抜き加工を施し、それを蛇腹折りにして表紙をつけることができるノートだ。こう聞くと「他でもつくれるのでは？」と思うかもしれないが、同社の蛇腹ノートの大きな特徴は本文がかなりの長さになっても、紙を繋ぎ合わせることなく仕上げられるということ。ロール原紙を使って、そこに輪転印刷機で印刷や抜き加工を施し、後工程で蛇腹折りができる特殊な機械を有するため、どこまでも、極端に言えばロール原紙1本、ずっと繋ぎ合わせることなく蛇腹に折り続けられるのだ。そうした場合3000メートル超！　壮大だ。

印刷や型抜きは18インチ送りの輪転印刷加工なため、印刷や抜き型のデータ長さ452ミリで用意する。18インチは457.2ミリだが、版のくわえ部分が5〜6ミリ印刷できないためだ。ノート幅は大小2種（幅117ミリ、107ミリ）。印刷時に版のくわえ部分があるのでエンドレス柄はNG。印刷と抜き加工は位置合わせすることはできる。1冊のノートの蛇腹の長さ（ページ／面の数）も自由に設定できる。

印刷は表裏とも特色1色刷りが可能。SOWALABO蛇腹ノートに使える紙は上質紙（四六判135キロ）のみ。印刷や抜き加工は18インチ送りで連続加工され、折りは1ページのサイズごとに折られていくため、基本的には絵柄をペ

ロール原紙の長さ約3000mまでは際限なく
長い蛇腹折りができる。すごい!
写真は「御朱印帳蛇腹和紙ライト」

早和製本が製造販売している
「ハートフルノート」。くるみ表紙がついたタイプ

一般的な製本では何かを貼り付けると片方
だけ膨れてしまう

蛇腹加工だとこのように全体が膨れるた
め、持ち運びしやすい

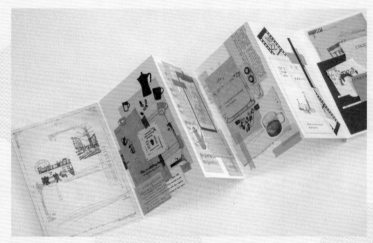

蛇腹折りだと、何かを貼り付けてもすべてのページが均等に膨れるため、
コラージュノートにも最適

INFORMATION

最小ロット

最小ロット300冊〜、経済ロット5000
冊〜

価格

全長3m28面タイプの場合、300冊で
単価500〜2000円、5000冊以上で
単価300〜1000円。初回のみ型代4
万〜10万円。ただし表紙の意匠性や
頁数により変動する

納期

校了後20〜40日程度

入稿データについて

アウトライン化したillustratorデータ
かPDFデータ。原則として色校正は
なし

問い合わせ

早和製本株式会社
京都府京都市南区吉祥院池田町21
TEL：075-693-3131
Mail：sowa@nozakiinsatu.co.jp
https://sowaseihon.co.jp/

ージ単位で合わせることはできな
い。つまり蛇腹折りした本文部分
の常に左下にキャラクターを印刷
するなどということは不可能だ。
印刷や抜き加工なしの無地原紙の
蛇腹加工ももちろんお願いできる。
表紙の有無はどちらも選べ、あ
る場合は芯ボールを印刷紙などで
くるみ貼りしたくるみ表紙でも、
板紙そのままでもどちらでもOK。
仕上がりイメージや予算によって
相談しよう。

コデックス装ノート

上製本の製本途中のままのような、糸かがりの背がむきだしになった「コデックス装」のノート。ちょっと無骨な独特の見た目と、開きのよさが魅力だ。

糸かがりした本文を表紙巻きしていないため、背がやわらかく、180度水平に開いて書きやすい

糸かがりした本文を背固めし、表裏に別仕立ての紙をつけて表紙としたコデックス装ノート。かがり糸や背がむき出しの仕上がり

かがりの糸は白のほか、色糸を使うことも可能。むきだしの背や、本文の折の中央ページに色糸が見えて、アクセントになる

この数年、書籍で使われることが多くなったコデックス装。上製本の製本工程のなかで、本文を糸かがりして背固め（糸かがりした背に糊を塗布して固めること）をした後、天地小口を三方断裁したところで完成とした製本方法のことだ。通常の上製本では、その後、別仕立てした表紙で巻く作業に入るが、コデックス装ではそれをしないため、かがり糸や背がむき出しになった状態となる。その様子がちょっと無骨でプロダクト感あふれる仕上がりであることから人気となっている製本方法なのだ。

コデックス装のもうひとつの特徴は、糸かがりした本文を表紙巻きしていないため背が柔らかく、本文が180度フラットに開くこと。開きがよいということは、ノートとしても使いやすいということだ。

かがりに使う糸は、白や黒だけでなく、赤や黄、青など、色糸を選べる場合も多い。色糸のバリエーションは豊富にあるので、頼むときに「何色系の糸」などと伝え、問い合わせるとよい。

INFORMATION

最小ロット
最小ロットは1部〜、経済ロットは3000部〜

価格
経済ロット単価80円〜（印刷・紙代別途）

納期
約7営業日

入稿データについて
最少でも64ページ以上ないと、かがり糸がゆるむため、64ページ以上で設計すること。印刷した表紙をつける場合は、あらかじめ表紙寸法表などをもらい、それに合わせてデータを作成するとよい。A6〜B4判まで制作可能（それ以外のサイズも応相談）

問い合わせ
大村製本株式会社
東京都板橋区前野町3-43-7
TEL：03-3969-2361
Mail：info@omuraseihon.com
https://www.omuraseihon.com

コデックス装は基本的に本文部分のみだが、表裏に別の紙で表紙をつけることもできる

四方金・天のりブロックメモ

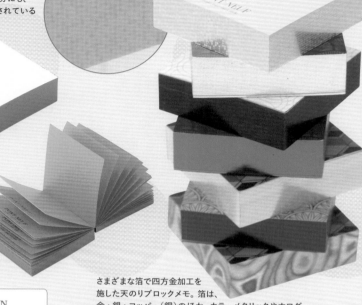

糊のついた背部分にも、きれいに箔押しされている

側面を二面ずつ違う色の箔で加工することもできる

赤い色上質紙と緑のカラーメタリック箔の組み合わせ。色の組み合わせを工夫すれば、よりインパクトの強いブロックメモがつくれる

さまざまな箔で四方金加工を施した天のりブロックメモ。箔は、金・銀・コッパー（銅）のほか、カラーメタリックやホログラムもある。メタリックブラック（上から3個目）も大人っぽくてかっこいい仕上がり。本文には印刷が入れられる

1枚ずつ簡単にはがして使える天のり製本のブロックメモは、デスクに置いておいていつでも使える便利な文具だ。これに四方金を施すと、高級感と存在感が格段にアップする。

紙

をある程度の厚みに重ねて製本したブロックメモは、側面を活かしたデザインができることが魅力のグッズだ。

ブロックメモの側面に印刷で絵柄を入れる方法もあるが、金銀やカラーのメタリック箔、ホログラム箔などで側面全面に箔押し（天金加工）をすると、より華やかで存在感のあるグッズになる。なかでも、糊のついた面も含めた四方の側面すべてに箔押しをする「四方金」で仕上げたブロックメモの美しさは圧巻だ。

ブロックメモは一般的に、背となる一面に糊をつけて製本する「天のり製本」が用いられてお

り、糊の上には箔がつきづらいため、四方すべての面に天金加工を施すのは難易度が高かった。印刷加工会社の河内屋では、糊の配合を工夫し、箔がきれいにのる糊を独自に開発。これによって、背にもきれいに箔がつけられるようになり、四方金・天のりブロックメモの制作が可能になった。紙を重ねて天のり製本した後、万力にセットして締めながら側面を磨いて平滑にし、天金加工を行う。

メモの本文には、オフセットや活版で印刷を入れることも可能。本文用紙は、コート紙はNGだが、上質紙や書籍用紙といった非塗工紙なら使用可能だ（厚みは四六判70〜90キロ）。

INFORMATION

最小ロット

最小ロット10個〜。経済ロットは1000個〜

価格

62×62mm、160枚綴りで単価650円〜。本文印刷可能（オフセット印刷＋活版印刷・オンデマンド印刷対応可能。本文に印刷がある場合には単価＋150円〜）

納期

約30日

入稿データについて

印刷を入れる場合は、フォントをアウトライン化したIllustratorデータで入稿。本文のフチにベタがあると天金加工が転写しづらくなるため、フチには印刷を入れないようにすること。コート紙などの塗工紙はNG。色上質紙、上質紙、書籍用紙などの非塗工紙で四六判70〜90kg程度の厚みの紙が向いている

問い合わせ

株式会社河内屋
東京都港区新橋5-31-7
TEL：03-3431-3339
Mail：info@kawachiya-print.co.jp
https://kawachiya-print.co.jp/

中ミシン上製ノート

絵本など、子どもの本に使われることの多い中ミシン上製本。開きがよく堅牢なつくりで、実はノートにも向いている製本方法だ。

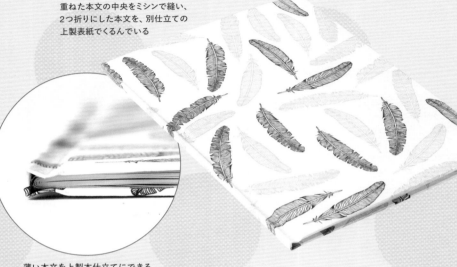

重ねた本文の中央をミシンで縫い、2つ折りにした本文を、別仕立ての上製表紙でくるんでいる

薄い本文を上製本仕立てにできる「中ミシン上製」のノート

180度フラットになる開きのよさ。ミシン縫いに色糸を使うと、アクセントになる

本文ページを見開きの状態で重ねて、その中央部分（ノドにあたる部分）をミシンで一直線に縫い、それを二つ折りにして、別仕立てにした上製表紙でくるむのが、中ミシン上製本だ。

上製表紙とは、ボール紙などの芯を入れてつくった硬い表紙のことをいう。

本文を見開きの状態でミシン縫いをしているため、180度完全にフラットに開く、開きのよい製本となる。しかも、しっかりと糸で縫ってあること、硬い上製表紙がついていることで、強度も高い。薄い本文を上製本仕立てにしたいというときにもおすすめだ。

絵本の製本を数多く手がける大村製本では、この中ミシン製本を用いたノートをつくることができる。上製本の表紙データのつくり方は、ノートに用いられることの多い中綴じや並製本とは異なるため、製作を決めたら、まずは希望の仕様を伝えて表紙の寸法表（展開図）を送ってもらい、それに合わせてデザインデータをつくると、間違いがなく安心だ。

中ミシン上製本は、多少手荒く扱っても壊れない丈夫さが求められる絵本や子どもの本でよく用いられている製本方法だが、「開きがよくて壊れにくい」は、実は使いやすいノートに求められるポイントと共通する。

INFORMATION

最小ロット

最小ロットは1部～、経済ロットは3000部～

価格

経済ロット単価60円～（印刷・紙代別途）

納期

約7営業日～

入稿データについて

フォントをアウトライン化したIllustratorデータで、完全データ入稿のこと。まず、使用する紙や本文ページ数などの仕様を伝え、表紙寸法表を送ってもらってから、それに合わせてデザインするとよい。本文が厚すぎるとミシンで縫うことができないため、縫う本文の厚みは3mm以内。それ以上の厚みの場合は、糸かがりなど別の製本方法にしたほうがよい

問い合わせ

大村製本株式会社
東京都板橋区前野町3-43-7
TEL：03-3969-2361
Mail：info@omuraseihon.com
https://www.omuraseihon.com

カード、封筒など──

小型紙モノ編

四方金カード

カードの断面にメタリック箔や顔料（色）箔などを加工して、細部にまでこだわったカード。メッセージカードや名刺用のカードなど、さまざまな紙もの文具をつくることができる。

名刺サイズの紙100枚に四方金加工したもの。箔は見る角度によって水色から紫への変化するポーラライト箔を使用。1枚にしても小口がキラリと輝く

角丸加工して四方金加工したもの。角丸はあらかじめ型抜きしておくのではなく、四方金加工するときに専用機で角丸にする

美箔ワタナベの四方金加工は、四方の断面それぞれ色を変えた箔を加工することもできる。これは蛍光イエローと蛍光ピンクの箔を加工したもの

書籍や手帳、ノートの小口に箔押しで天金加工してあるものがある。それと同じ技術を使って、ペラもののカードや名刺の断面にも箔押し加工することができる。

箔押し会社の美箔ワタナベでは2018年から本格的にこの加工を始めた。日本国内で四方金加工ができる会社があまりなく、困っていた声を多く聞いていたこともその理由のひとつ。

美箔ワタナベの四方金加工は、最初に紙の断面をこれでもか！というほど磨くため、その後に加工する箔が非常にきれいにつき、仕上がりの輝度感がかなり高くなるというすぐれもの。使える箔も、金銀などのメタリックはもちろん、ホログラムや顔料（色）箔、蛍光箔まで幅広い。専用機を使って、角丸にして四方金加工することも可能だ。

ともできるし、断面に四方金加工するだけでも、どちらもOKなため、自分でつくりたい四方金カードをオーダーできる。

紙の表裏に箔押し加工をいるこ

四方縁色つきカード

絵柄をオフセット2色印刷し、エンボス加工で浮き上げたカードに、2色のボーダード加工を施したもの（ボーダード加工色：カナリア・ピスタチオ）

THANK YOU

カードの四方に均一な幅でカラーリングを施すことで、華やかさが加わる。文字は活版印刷（ボーダード加工色：バーミリオン）

四辺の縁にカラーリングを施した四方縁色つきカード（ボーダード加工）。色はゴールドやシルバー、蛍光色などからも選べて、かわいいアクセントの効いた、個性的なカードをつくることができる。

四辺の縁に色をつける「ボーダード加工」は、ステーショナリーの装飾として欧米では定番の加工だ。カードの縁に鮮やかな色が施されることで、上品で華やかな印象が加えられるし、なによりとてもかわいい。名刺に用いて個性的な特徴を出したり、インビテーションカードやレターシート、一筆箋を装飾するのに用いられたりしている。

羽車のボーダード加工は、印刷ではなく職人が手作業で彩色した四方の色縁の幅を彩色した四方の色縁の幅をそろえるのはなかなか難しいが、均一にそろえるのが職人技。インキの発色がいいのも特徴だ。ゴールドやシルバー、蛍光色なども含んで、全部で21色から好きな色を選ぶことができ、2色を組み合わせることも可能。ただし2色の場合は、同色は必ずL字型に施される。平行する線の組み合わせを同じ色にすることはできない。また、活版印刷やオフセット印刷と組み合わせることが可能。ワンポイントのロゴや絵柄にエンボス加工を施して、ぷっくり浮きあげることもできる。

ボーダード加工は21色のラインナップから選べる。本番を注文する前に加工色を確認したい場合は、加工色サンプルをハグルマオンラインストアで購入できる（1枚33円・税込）

INFORMATION

最小ロット

100枚〜

価格

四辺1色の場合、100枚で8580円、1000枚で1万6500円（すべて税込）

納期

ボーダード加工の納期は4営業日。印刷やエンボス加工と組み合わせる場合は、別途問い合わせを

入稿データについて

印刷やエンボス加工と組み合わせる場合は、Illustratorでデータ入稿

注意点

最小は名刺サイズ、最大でA4まで加工可能。用紙選択は、羽車の紙見本の中から。線幅の指定はできない。有料で加工テストを依頼することも可能

問い合わせ

羽車
大阪府堺市東区八下町3-50
TEL：0120-890-982
Mail：info@haguruma.co.jp

シルク印刷カード

オフセット印刷や活版印刷に比べて、インキを厚く盛ることができるシルクスクリーン印刷。このため、こってりと色鮮やかに絵柄を刷ることが可能だ。このシルクスクリーンで印刷すれば、オフセット印刷とはまた違う、版画のような味わいのカードになる。

版印刷の一種であるシルクスクリーン印刷は、細かい網戸のような紗を製版して、インキが通過するところ（絵柄）と通過しないところをつくり、インキをのせてゴム製のスキージで上から押し当てると、印刷物に絵柄が転写されるという印刷方法だ。オフセット印刷や活版印刷に比べてインキを厚く盛れるため、色鮮やかに印刷できることが特徴。金銀や蛍光色をはじめ、こってりとインキを盛って、きれいに色を見せたいときにおすすめの印刷方法である。下地の隠蔽力も高いので、濃色の紙に白を刷りたい場合にも効果的だ。シルクスクリーン印刷の場合、

孔

本は1色ごとの特色印刷となる。紙は、1ミリ、2ミリなどの厚いものにも印刷できるのが特徴だ。ただし薄い紙は難しく、四六判90キロ以上の紙が望ましい。

数多くのシルク印刷カードを手がけている繁岡美術では、対応できるサイズは最小60×60ミリ、最大は542×788ミリまで。蓄光インキや香料インキなどの特殊なインキも、別途料金はかかるが、使用可能。同じ白インキでも、隠蔽力がより高いタイプや、下地の色を活かせるタイプなどがあるので、どんな効果を出したいのかを伝えて相談すると、思い通りの仕上がりに近づけることができる。

CMYKの4色印刷ではなく、基

厚手のボール紙に、シルクスクリーンの生成り、白を2色印刷したカード。ラフなボール紙に、こってりとインキののった感じがかわいい

上のカードの一部拡大。あえて下地の色が見える白インキを使用。1色目の生成り、2色目の白が重なる部分と重ならない部分があることによって、3色で刷られているかのような効果が出ている

クラフト風の紙（ファーストヴィンテージ オーク 四六判206kg）にシルクスクリーンで3色印刷したカード。手摺り版画のようなアナログ感が出るように、ベタ面や文字部分にわざとデザイン上でかすれをつくっている

INFORMATION

最小ロット

1枚から可能（ただし印刷代は1～20枚まで同額）

価格

はがきサイズ100枚を印刷する場合、1色につき版代7000円＋印刷代7000円。A4サイズ100枚を印刷する場合は、1色につき版代8000円＋印刷代8000円（すべて税別）
※用紙代は別途。また、特殊なインキ（蓄光、香料など）を使う場合はインキ代別途

納期

約2週間

入稿データについて

Illustratorデータ入稿。絵柄を墨1色（100％）で作成。2色以上の場合は、レイヤーを分けて作成のこと

注意点

線幅0.15mm以下の線は、印刷がかすれる可能性があるため、線を太めに調整することが望ましい。また、用紙の厚さは四六判90kg以上を推奨。それより薄いと作業性が低下し、コストアップの原因となる

問い合わせ

繁岡美術
東京都世田谷区宮坂3-5-7
TEL：03-3429-2083
Mail：info@shigeoka-bijyutsu.com
http://shigeoka-bijyutsu.com/

竹尾デザイン封筒・イージーオーダーシステム

竹尾のファインペーパーから好きなものを選び、フラップのかたちやサイズなどを指定して、全紙1枚からイージーオーダーできる。

洋1封筒・洋2封筒・DL封筒・洋長3封筒・スクエア封筒などさまざまな大きさの封筒を、自分の使いたい紙でオーダーすることができる

INFORMATION

最小ロット

全紙1枚でつくれる数〜（例：四六判Y目の紙で洋1封筒をつくる場合は8袋）最大200袋まで

価格

紙代＋加工料金（1袋につき税抜55円）例：「ポルカ（色：モモ）四六判Y目90kg」で洋2封筒を60袋つくる場合：四六判Y目の全紙1枚からは洋2封筒が10袋できるため、必要な全紙枚数は6枚＋予備5枚＝11枚となり、紙代が2640円、加工料金が55円×60袋＝3300円で合計5940円＋消費税となる

納期

1〜100袋の場合、約5営業日後に出荷。101〜200袋場合、約8営業日後に出荷

入稿データについて

基本的に印刷加工は入れられないため、データは必要なし

注意点

薄い紙や特殊な紙は、取り扱いが難しく強度に問題があるため封筒にすることができない。 https://products.takeopaper.com/pages/order_envelope こちらの問い合わせメールフォームから申し込む

問い合わせ

株式会社竹尾
ウェブストアproducts.takeopaper.com
TEL：03-3295-7500
https://products.takeopaper.com/

サイドに糊しろがある貼り方「スミ貼」

フラップ（ふた）のかたちが長方形な「カマス貼」

展開したかたちがダイヤ型の「ダイヤ貼」

市販されている封筒では、気に入ったものがない。でも抜き型からつくるほど大量に必要じゃない。そんなときにおすすめなのが、竹尾デザイン封筒のイージーオーダーシステムだ。竹尾のファインペーパーの中から好きなものを選び、サイズやかたちも指定。カマス貼、ダイヤ貼、スミ貼の3種類から好きなかたちを選ぶことができる。このシステムで使える紙の連量は、四六判換算70〜130kgまで。形によって製袋できる規格（洋1封筒・洋2封筒・DL封筒・洋長3封筒・スクエア封筒など）が異なる。全紙1枚からつくれる枚数からオーダーできる。例えばカマス貼の洋2封筒は四六判Y目の紙から10袋とれるため、最低ロットが10袋となる。最大は200袋まで。印刷加工は基本的に入れられないが、紙にこだわった封筒を気軽につくりたいときに便利だ。

色付き天糊封筒

横型の封筒を蛍光ピンクのカラーボンドで天糊製本

一辺を天糊して、1枚ずつぺりぺりとはがしながら使う天糊封筒。これを色付きの糊でつくってみたら、とてもかわいい封筒ができた！はがした後の封筒に色付き糊が残るのもいいのだ。

カラフルな封筒を、無色の糊で天糊製本してみた。これもいい！

こちらは縦型の封筒を青のカラーボンドで天糊製本したもの。1枚はがした封筒にもカラーボンドが残るのがいい

INFORMATION

最小ロット
封筒10枚の天糊を10セット〜

価格
10枚天糊100セット（1000枚分）製作の場合で単価200円〜
※カラーボンド1色追加につき+6000円
※封筒支給として

納期
5〜6営業日

注意点
支給する封筒は、洋型、長型、角型問わず同額。ただしダイヤ貼りの封筒は不可。ベロをたたんだ状態での天糊となる（伸ばしたベロに天糊は不可）。封筒は1枚のなかで場所により厚みが異なるため、カラーボンドがはみ出してついてしまう場合がある

問い合わせ
小林断截
東京都墨田区緑2-11-18
TEL：03-3634-8351
https://www.k-dan.co.jp

ブ ロックメモや伝票などの天糊製本を得意とする小林断截だ。封筒はぺラ（1枚）の紙に比べ、ベロや貼り合わせ部分があるために、場所によって厚みが変わり、天糊製本がやりづらい。このため、カラーボンドがはみ出してつく場合があるが、それがまた味となっていい。はがした後の封筒にカラーボンドが残るのも、デザイン的なアクセントとなる。

ロックメモや伝票などの製本に使われる天糊製本。天糊製本とは、ペラもの（1枚）の紙を複数枚重ねて、その一辺の断面に糊を塗り、接着する製本形式だ。特徴は、1枚ずつはがしやすいことと、接着部分がそのまま外から見えること。その特徴を活かして、塗料や顔料で色をつけたカラーボンドを使ったのが「色付き天糊」だ。

一筆箋やメモに使うとかわいい手法だが、同じ方式を使って、封筒を綴じてしまったのがこちら。こんなふうに封筒の一辺を天糊製本して、1枚ずつぺりぺりとはがして使うものを、本書編集部は海外で見たことがあったのだ。

加工を手がけてくれたのは、ブ

使えるカラーボンドは、色付き天糊一筆箋と同様、黒、茶、赤、青、黄、緑、蛍光黄、蛍光緑、蛍光オレンジ、蛍光ピンクの10色。DICのカラーチップと同じ色に調色してほしいというようなオーダーには対応できないとのこと。

厚紙封筒

書類や薄めの冊子、CDなどを送りたい、しかし中身が折れないようにしたいというときに重宝するのが厚紙封筒だ。イムラ封筒の厚紙封筒は、製袋前に印刷するので全面印刷が可能。よく使われる4種類の規格サイズもそろえている。

中身を折れと衝撃から守りたい、というときに便利なのが厚紙封筒。名前の通り厚紙でできた封筒なので、書類や薄めの冊子などを送るときに、中身をしっかり守ってくれる。送料のコストをおさえたり、再配達の手間が起こらないためにも、荷物をポストに届けたいというニーズは多い。厚紙封筒は、そんなニーズに応えてくれるパッケージなのだ。

封筒メーカーのイムラ封筒では、角5サイズ〜角0サイズまでの好みのサイズで、全面にオフセット印刷を施したオリジナル厚紙封筒をつくることができる。また、よく使われる角0（B4サイズ用）、角2（A4サイズ用）、角5（A5サ

イズ用）の4サイズを規格品（白無地）として用意しているので、社名やロゴをワンポイントで印刷することも可能だ。規格品は数百枚の単位で購入することができるので、手軽につくれるというメリットがある。

厚紙封筒といえば、かつては輸入品がほとんどで、粗雑な製品も見受けられたが、最近は国内生産の厚紙封筒も増え、全体的に品質が向上してきている。イムラ封筒が使用しているコートボール紙は国産原紙で、白色度が高く、印刷適性に優れており、金銀もきれいな刷り上がり。封緘に便利な口糊つきで、

角2（A4サイズ用）、角5（A5サイズ用）、角A4（A4サイズ用）、角0（B4サイズ用）、角5（A5サイズ用）の好みのサイズで、全面にオフセット印刷を施したオリジナル厚紙封筒をつくることができる。

剥離紙を剥がしてベロ部分を折れば、すぐに封をすることができる。イムラ封筒の角2封筒用のエアークッション袋も別途扱いがあるため、中身をより保護したい場合には、それを組み合わせるとよい。

剥離紙を剥がしてすぐに封のできる口糊つきで、使いやすい

銀と特色赤の2色で、全面にUVオフセット印刷を施したサンプル。白色度の高いコートボール紙を使っており、印刷の発色もいい

INFORMATION

最小ロット
5000枚〜（オリジナル製作の場合）

価格
角2サイズ（コートボール紙230g/㎡、片面2色印刷、口糊つき）を製作した場合、5000枚で単価48円＋別途製版代
※印刷色など仕様によって変動する。また、安価な規格品（白無地）もあるので、まずは問い合わせを

納期
完全データ入稿後、2〜4週間

入稿データについて
Illustratorでデータ入稿（CC2020以下）。文字は必ずアウトライン化すること

注意点
ベタが多いデザインの場合は、ニス加工が必要となる

問い合わせ
イムラ封筒
◎東京本社｜東京都港区芝浦1-2-3
シーバンスS館10F
TEL：03-5419-2270
◎大阪本社｜大阪市中央区難波5-1-60
なんばスカイオ18F
TEL：06-6586-6421
https://service.imura.co.jp/

ガセット封筒（V底袋）

側面にマチがついていて、少し厚みのあるものを入れることができるのがガセット封筒だ。

たとえば、金融機関の現金袋などに使われている製袋方法である。

角底袋よりも手軽につくることができるのも魅力のひとつだ。

子などの厚みのあるものを手軽に梱包したいというときに重宝するのがガセット封筒（V底袋）だ。側面を折り込んでマチをつくり、奥行きを出す製袋方法をガセット貼りという。これを用いたのがガセット封筒。角底袋と異なり、底にマチがなく、V字型になっているため、別名V底袋とも呼ばれる。

ガセット封筒は、すっきりしてかさばらない見た目でありながら、側面のマチの分、厚みのある中身にも対応でき、丈夫なつくりであるのが特徴だ。底にマチのある角底袋に比べ、製作コストも安くできる。イムラ封筒では、角2（A4サイズ用／240×332ミリ、マチ幅20ミリ）と角A4（A4サイズ用／229×312ミリ、マチ幅25ミリ）の規格品があり、数百枚から手軽に購入もできるが、オリジナルの製造も可能だ。

また、イムラ封筒では防水ラミネート紙でガセット袋をつくることも可能だ。配送中の雨や水滴から荷物を守るにはビニール封筒を使うという手もあるが、紙製封筒であれば透けることがなく、印刷しやすいという点が好まれている。防水ラミネート加工は、常備在庫の未晒クラフト紙に施されることが多いが、数がまとまれば（角2サイズ換算で2・2万枚など）好みの原紙にラミネート加工を施して封筒を作成することもできる。

INFORMATION

最小ロット

5000枚〜

価格

角2サイズ（半晒クラフト紙100g/㎡、口糊付き、片面2色印刷）の封筒製作コストを100としたとき、マチ20mmのガセット袋のコストは＋約50%程度
※数量・仕様により変動するため、まずは問い合わせを

納期

完全データ入稿後、3週間程度

入稿データについて

Illustratorでデータ入稿（CC2020以下）。文字は必ずアウトライン化すること

注意点

ガセット封筒（V底袋）は、封筒の底面が角底貼りではないため、厚みいっぱいの荷物を入れた場合、底部分が厚みの分だけ引っ張られて、若干丈が短くなるので注意

問い合わせ

イムラ封筒

◎東京本社｜東京都港区芝浦1-2-3
シーバンスS館10F
TEL：03-5419-2270
◎大阪本社｜大阪市中央区難波5-1-60
なんばスカイオ18F
TEL：06-6586-6421
https://service.imura.co.jp/

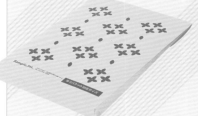

底にマチがあるタイプは「角底袋」という。こちらは底がある分、厚みのあるものへの対応幅も広い

ガセット封筒（防水ラミネート加工タイプ）。写真は、ベロを伸ばした状態のもの。一見、マチなしの封筒のようにすっきり見える

ガセット封筒は、側面にマチがあるため、厚みのあるものを入れることもできる。底はV字型なのが特徴

エンボス加工封筒

高級感のある封筒をつくりたい。でも特殊紙は高くて予算に収まらない。そんなときの強い味方が、イムラ封筒のエンボス加工封筒だ。独自の加工方法で、コストを抑えながら凹凸柄の封筒をつくれるのだ。

エンボス加工の入った紙でつくられた封筒は、高級感を与え、受けとった人の印象を強める。しかし、封筒をつくるとき、紙代はコストの大きな比重を占めるため、凝った紙はなかなか使いづらいということも多い。

そんなときに検討してみたいのが、イムラ封筒のエンボス加工封筒だ。同社は、エンボス加工封筒をつけた独自開発の製袋機を持っているため、製袋しながら同時にエンボス加工を行うことができる。これを使えば、普通の上質紙などがエンボスペーパーに早変わりするのだ。

エンボス加工前に全面にオフセット印刷を行うことも、もちろん可能。

エンボス柄はドット、ライン、ウェーブ、ヘリンボーンなど、同社所有の既製の凹凸柄から選ぶことができるほか、オリジナルデザインのエンボス柄をつくることも可能。たとえばロゴタイプやマークをエンドレス柄で入れたり、幾何学模様を用紙全面に入れるなど、好みの柄のエンボス加工封筒が製作できるのだ。しかも型代が3万円からというコストでつくれるのがうれしい。

ただし、極端に細かいデザインだと、エンボスでの再現が難しい場合があるので、事前の打ち合わせや、エンボス版を試作する場合には、別途2万円が必要となる。

白い紙にピンクをベタ印刷し、「Thank you」の文字のオリジナル柄でエンボス加工をした封筒。90〜120g/㎡の厚めの用紙だと、凹凸がきれいに出やすい

エンボス加工の既存柄の一部。ヘリンボーン、フロー、ライン、ドット、スロープ、ウェーブなどの柄があり、それぞれ柄の大きさでSMLの種類がある

INFORMATION

最小ロット

5000枚〜

価格

洋長3サイズ（片艶クラフト紙100g/㎡、片面2色印刷、口糊付き、宛名窓付き）を5000枚製作する場合を100とすると、エンボス加工封筒は＋約40％程度
※数量・仕様により変動するので、まずは問い合わせを

納期

完全データ入稿後3〜4週間。オリジナルエンボス版の場合はプラス2〜3週間

入稿データについて

Illustratorでデータ入稿（CC2020以下）。文字は必ずアウトライン化すること

注意点

オリジナルエンボス柄で作成する場合は、校正テスト版＋本機用の2種類が必要。既製のエンボス柄で封筒制作する場合は、版代や柄の校正の手間が不要になる。封筒は原則、定形内サイズ（235×120mm）、内カマス貼に限る。また、条件によって加工できない部分があるので、問い合わせを

問い合わせ

イムラ封筒
◎東京本社｜東京都港区芝浦1-2-3シーバンスＳ館10F
TEL：03-5419-2270
◎大阪本社｜大阪市中央区難波5-1-60なんばスカイオ18F
TEL：06-6586-6421
https://service.imura.co.jp/

しかけ封筒

DMなど、封筒の開封率を上げたい場合、コピーやデザインとともに試してみたいのが「しかけ」だ。

「なんだろう？」と興味を引く封筒なら、開封し、中身を一気に読んでもらうことができる。

たとえば、どんなしかけの封筒がつくれるのだろう？

受け取った人が思わず開けてしまうような、インパクトのある封筒をつくりたい。普通の封筒に、ちょっと変わったデザイン性やメッセージを加えたい。そんなとき、さまざまな加工をした「しかけ封筒」をつくってみてはどうだろう。

封筒メーカーのイムラ封筒は、シンプルな封筒に付加価値を加えるような、いろいろな加工技術を持っている。ハサミやカッターがなくてもきれいに封筒を開けられるという機能面だけでなく、工夫次第ではデザイン的な活用も考えられる加工技術だ。

たとえば、簡単に封筒を開けられるよう開封口にミシン目を入れるクイックオープナー。これを、横向きや上向きに開封できるよう、三角形にした三角ミシンを入れることもできる。三角ミシンは、左右2カ所に入れることも可能だ。

中身を大きな窓で見せるワイドウィンドウは、たとえば本などど、外から見せたいものを贈りたいときのパッケージ封筒にぴったり。窓は四角だけでなく、ハートや丸など変形でつくることもでき

る。また、型抜きして開けた穴にフィルムを貼った窓ではなく、紙をトレーシングペーパーのように透けさせる特殊な加工で、封筒のほぼ全面を透けさせる、ということもできるのだ（プラ窓）。

もちろん、印刷と組み合わせることができるので、三角ミシンを入れて開封した内面にメッセージを入れるといった活用法も考えられる。紙も一般的な紙見本帳から、好みのものを使えるので、まずは相談してみるとよい。

受け取った人が思わず開けて、そして笑ったり、唸ったりしてしまうような「しかけ」ある封筒を、ぜひ考えてみては？

ワイドプラ窓。型抜きしてあけた穴にフィルムを貼るのではなく、紙をトレーシングペーパーのように透けさせる特殊加工を用いて、大きな窓のある封筒をつくることもできる

変形窓。写真のハート型のように、変形の窓をつくることもできる。ハートのように鋭角部分がある形の窓は、加工会社に難しいと言われることも多いが、きれいに加工できている。すごい！

INFORMATION

最小ロット

5000枚〜

価格

洋長3サイズ（片艶クラフト紙100g/㎡、表2色／裏1色印刷、口糊付き、宛名窓付き）を5000枚製作する場合を100とすると、ミシン目のオープナー入り封筒は＋約30%程度
※数量・仕様により変動するので、まずは問い合わせを

納期

完全データ入稿後3〜4週間

入稿データについて

Illustratorでデータ入稿（CC2020以下）。文字は必ずアウトライン化すること

注意点

内容物（ブロシュアなど）が極端に重くかさばると、郵送中の破袋リスクが高まってしまう。紙の厚みや種類からご相談すれば、提案してくれるので、問い合わせを（薄い原紙や再生紙など、強度が低い紙を希望の場合は、ミシン目の強度を調整する必要がある）。また、郵便局のバーコード割引を利用する場合も、紙やミシンの形状にガイドラインがあるので注意が必要

問い合わせ

イムラ封筒
◎東京本社｜東京都港区芝浦1-2-3
シーバンスS館10F
TEL：03-5419-2270
◎大阪本社｜大阪市中央区難波5-1-60
なんばスカイオ18F
TEL：06-6586-6421
https://service.imura.co.jp/

封筒を簡単に開封できるミシン目を三角形に入れた三角ミシン。横や縦に引っ張って開封するタイプがある。左右・上下を入れ替えることも可能。横タイプは開封口が大きく開き、中身が取り出しやすい。上タイプは、開くと同時に内容物のタイトルが目に入る

封筒にすごく大きな窓をつくって内容物を見せるワイドウィンドウ。外側から15mmぐらい縁があれば、窓をつくることができる。複数の窓をつくることも可能だ（窓と窓の間には、糊付け分の間隔をあけることが必要）

三角ミシン（両サイド）タイプ。左右2カ所にミシン目が入っており、どちらからでも開封できる。写真のように、質問を投げかけて開封口を選択させるなどのしかけができる

クイックオープナーは、このようにミシン目が入っていて、近くにハサミがなくても、簡単に封筒を開けることができる

すかし印刷封筒

すかし印刷封筒。長3サイズ。写真の4つはすべて同じものなのだが、中に入れる色紙を変えると雰囲気がこれだけ変わるということがよくわかる

中に何も入れてない状態のすかし印刷封筒

INFORMATION

最小ロット

経済ロットは1000部〜。多少割高になってもOKならそれ以下の部数も可

価格

長3（W120×H235mm）サイズで紙は「はまゆう（四六判56kg）」、すかし印刷（2度刷り）、センター貼り封筒（上写真のタイプ）で1000部14万円（単価140円）、2000部で15万円（単価75円）
上と同じ素材でサイズが角7（W142×H205mm）の場合、1000部14万7000円（単価147円）、2000部で16万円（単価80円）

納期

データ入稿から約2週間

入稿データについて

Illustratorなどによるデータ入稿

注意点

中にいれた宛名印刷が透けて見えるような窓封筒としては、すかし印刷では透け感が足りないので、使用できない。模様などを入れるためのすかし印刷となる

問い合わせ

株式会社藤和
東京都新宿区天神町6番地 Mビル2F
TEL：03-5228-2351
https://towaprint.com/

絵柄がすかし模様で入っていたらすごくいいオリジナル紙文具になる。でもすかしを入れた紙をつくるのはハードルが高い……というときに便利なのが、オフセット印刷によるすかし印刷。これを使えば、オリジナルすかし模様がはいった封筒がつくれる！

角7サイズのすかし印刷封筒。花の絵柄以外の部分すべてをすかし印刷したもの。こうした使い方もいい

オリジナルのすかしが入った紙をつくるのはある意味夢。それをオフセット印刷で擬似すかしをほどこすことでいい風合いになる。ただ、あまり厚みのある紙だと、いいすかしの効果が出にくいため、透け感高い効果が出せるのが藤和のすかし印刷。

すかし印刷した部分は、少しロール引き加工したような独特の質感になるが、糊付けすることができるため、封筒に仕立ててオリジナルすかし印刷が入った封筒をつくることができる。

すかしの入った封筒といえば、中に入った宛名部分が透けて見える、窓ばり封筒などを思い浮かべるかもしれないが、オフセット印刷によるすかし印刷は、そこまでの高い透け感にはならないため、あくまですかし模様を入れたいという場合におすすめの紙文具だ。

リジナルのすかしが入った紙をつくるのはある意味夢。それをオフセット印刷で擬似すかしをほどこすことでいい風合いになる。ただ、あまり厚みのある紙だと、いいすかしの効果が出にくいため、透け感高い効果が出せるのが藤和のすかし印刷。

すかし印刷を施した封筒にしたい場合は、比較的薄い紙を選ぶ方がいい。四六判55kg前後の紙を使うのがおすすめだ。

ろな紙を使うことができ、薄めの色上質紙やはまゆうなどの純白ロール紙、未晒しクラフト紙などいい色合いになる。

すかし印刷に適した紙ならいろいろな紙を使うことができ、薄めの色上質紙やはまゆうなどの純白ロール紙、未晒しクラフト紙なども味夢。

ぽち袋

お正月にお年玉を渡すときに使われる、ぽち袋。それ以外にも、ちょっとしたお礼を渡すとき、気持ちを包むときに活躍する定番グッズだ。紙もの文具をつくるなら、まずはつくってみたいグッズの一つでもある。

ち

ょっとした心づかいを贈るときに、便利なぽち袋。ぽち袋をつくることができる。4色印刷なので、デザインの自由度は高い。

形状は和封筒（縦型）が一般的だが、洋封筒（横型）でつくることもできる。通常の封筒と異なり、無地の既製品はない。また、白い紙だけでなく、色上質紙やクラフト紙、風合いのある紙など、好みの紙でつくることも可能だ。その場合は、どういう紙を使いたいのか、具体的な銘柄名などイメージを添えながら、相談するとよい。

とにかくたくさんぽち袋をつくりたい、というときにおすすめだ。

紙もの文具としては定番といえる、よく使われるグッズだが、小さなサイズの封筒をつくるところは意外と限られている。通常サイズの封筒をつくる製袋機では対応できないこともあるので、場合によっては手作業になり、時間とコストもかかってしまうのだ。封筒メーカーのイムラ封筒では、オフセット印刷によるオリジナルぽち袋をつくることが可能だ。

裏面の貼り合わせはこんな感じ

INFORMATION

最小ロット

5000枚〜

価格

上質紙（90g/㎡）60×100mm（片面4色印刷）でぽち袋を製作する場合、5000枚で単価18円＋別途製版代
※印刷色など仕様によっては安価になる場合がある。まずは問い合わせを

納期

完全データ入稿後3週間程度

入稿データについて

Illustratorでデータ入稿（CC2020以下）。文字は必ずアウトライン化すること

注意点

製袋するときに糊がつく部分には、印刷が入らないようデザインすること。また、特殊な紙を使いたい場合は、一度相談を

問い合わせ

イムラ封筒
◎東京本社｜東京都港区芝浦1-2-3
シーバンスＳ館10F
TEL：03-5419-2270
◎大阪本社｜大阪市中央区難波5-1-60
なんばスカイオ18F
TEL：06-6586-6421
https://service.imura.co.jp/

ポケット付きカレンダー

ちょっとしたメモやレシート、とっておきたいハガキやプリント。そうしたものを、カレンダーや冷蔵庫にペタペタと貼りつけている人も多いのではないだろうか。

ポケット付きカレンダー「メモルダー」は、そうしたメモ類を手軽に保管できるカレンダーなのだ。

シートや買い物メモ、領収書など、カレンダーまわりに置いておきたいメモは意外と多い。テープで貼り付けたり、マグネットでとめたりする人も多いだろう。そんなカレンダーまわりをすっきりと、メモを手軽に収納しておけるのが、イムラ封筒のポケット付きカレンダー「メモルダー」だ。発売以来42年間のロングセラー商品だという。

なぜ封筒メーカーがカレンダーを？ その疑問は、製品をよく見てみると、すぐに解ける。実はこれ、「封筒をリング製本してカレンダーにした」ものなのだ。

ノベルティとして人気というこのポケット付きカレンダーのオリジナル版をつくることもできる。形は卓上タイプと壁掛けタイプがあり、これらをオリジナルでデザインして製作することが可能。オーダーメイドの場合は1万冊からつくれるが、もっと手軽に安価につくりたいという場合は、5種類の既製品を活用する方法がある。この既製品への名入れであれば、50冊から対応してくれる。

ポケット付きカレンダー「メモルダー」(卓上型・上質紙タイプ)。ポケットが付いており、メモの保管に便利

こちらは卓上型・未晒クラフト紙タイプ。カレンダーを印刷した封筒がリング製本されているのがわかりやすい

大判の壁掛け型もある（半晒クラフト紙タイプ）

INFORMATION

最小ロット

1万冊〜(オリジナル)
50冊〜(既製品への名入れ)

価格

既製品の場合、卓上タイプ 単価430円〜、壁掛タイプ 単価730円〜(いずれも上代価格)
※名入れ加工の場合、ケース単位の場合と、条件によって大きく変動する。まずは問い合わせを

納期

オーダーメイドの場合、完全データ入稿後1〜2カ月程度

入稿データについて

Illustratorでデータ入稿(CC2020以下)。文字は必ずアウトライン化すること

注意点

オーダーメイドの場合、最小ロット1万冊からつくれるが、単価がある程度落ち着く経済ロットとしては3万冊以上となる

問い合わせ

イムラ封筒
◎東京本社｜東京都港区芝浦1-2-3 シーバンスＳ館10F
TEL：03-5419-2270
◎大阪本社｜大阪市中央区難波5-1-60 なんばスカイオ18F
TEL：06-6586-6421
https://service.imura.co.jp/

水に溶けるメモ

ちょっと内緒にしたいこと、忘れたいことを、メモに書いて水に流してしまおう。

そんなユニークなグッズが、昇文堂の「水に溶けるメモ」だ。

好きなデザインに型抜きして、楽しい形のメモをつくることができる。

水性ボールペンなどでメモに文字を書き、水に浮かべると、あっという間に紙が崩れていく。しばらくおいてスプーンなどでかき混ぜると、メモは水に溶けて、消えてしまう。

そんな不思議な「水に溶けるメモ」をオリジナルデザインでつくることができるのが、昇文堂だ。

紙は完全に水に溶けてしまうので、トイレットペーパーと同様、水に流しても問題ない。

メモは基本的にオリジナルの形状に型抜きしてつくる。天糊などはせず、ペラの状態。これをオフセット印刷で絵柄を刷った2つ折りカバー（サイズは125×90ミリ、80×60ミリなど）にはさんで、OPP袋に入れるのが、基本のパッケージ。

メモに印刷を入れることもできるが、オフセットで1色まで。細かい絵柄はつぶれてしまう恐れがあるので要注意。

忘れたいことを水に流すだけでなく、願いごとを書いて水に溶かしたら、かなうかも？　いたずら心あふれるユニークなグッズ。

ゴーストの形に型抜きした「水に溶けるメモ」

オフセット4色印刷した2つ折りのカバーにはさみ、OPP袋に入れるパッケージ

かきまぜるとどんどんほぐれ、メモは完全に消えてしまう。ただし油性ボールペンで書いた文字は、若干残りやすいので要注意

水に入れると、メモはすぐに崩れ始める

INFORMATION

最小ロット

1000セット〜

価格

ゴースト型の水に溶けるメモ（カバーサイズ125×90mm、1セット16枚入り）を製作した場合、1000セットで単価176円、3200セットで単価121円、6500セットで単価105円
※オリジナルの抜き型をつくる場合、別途型代が3万5000円〜
※今後値上げの可能性あり

納期

校正まで2〜3日。校了後、20日間程度

入稿データについて

ウェブからカバーの版下データをダウンロードした上で、Illustratorでデータ入稿。メモのデザインはカットラインをスミ100％で作成

注意点

メモに文字などを書いた場合、油性インキは文字が水に残ることがあるので要注意

問い合わせ

昇文堂
東京都千代田区神田佐久間町4-6
齋田ビル
TEL：03-3862-0045
http://www.shobundo.org/

粗野な紙のロールチケット

海外で販売されているロールタイプのチケット。このかわいい紙ものをつくりたい。でも日本だと……いや、できるんです！漫画雑誌みたいな粗野な紙でロールチケットがつくれるのだ。

漫画雑誌に使われるような日和色（緑）のザラ紙に特色印刷、ナンバリング印刷、そして箔押しした粗野な紙のロールチケット。ミシン目を入れられるかは紙質による

漫画雑誌のザラ紙にはミシン目が入れられなかったので、ガムテープカッターをつけてちぎるといい感じになる

イベントに使ったり、かわいい紙モノとしてクラフトワークに使ったりと、した紙やわら半紙などを細いロール状にして、そこに特色印刷（3色まで）やナンバリング印刷、さらに箔押しを施すことができる。また型抜きやチケットごとに切れるようなミシン目も入れてもらったが、これは使う紙によってできるできないがある。漫画雑誌の紙の場合は基本NG。わら半紙はできる可能性あり。ミシン目や型抜きを入れたい場合は、事前にコスモテックに相談し、テストしてからにしよう。

海外のロールチケットは日本でも人気がある。でも日本でつくっているところはあまり見かけることがない。それにチャレンジし、以前『デザインのひきだし』でご紹介したのがコスモテックのロールチケット。そのときは比較的厚めな白板紙を使っていた。それよりもっと薄くてざらっとした粗野な紙でつくれないか。

そんな編集部からのさらなる欲望に、またしてもコスモテックが応えてくれたのがここでご紹介する粗野な紙のロールチケット。漫画雑誌に使われるようなザクッと

わら半紙に特色印刷、ナンバリング印刷、箔押しをしたもの。こちらは型抜きとミシン目を入れたが、ミシン目部分にちょっと不備がでることもある。こうしたい場合は事前のテストや確認が必須だ

INFORMATION

最小ロット

最小ロット50m巻き1ロール〜、経済ロットは100m巻き1ロール〜

価格

50m巻き1ロール（特色印刷＋ナンバリング印刷＋箔押し）で50000円〜。20m巻き50ロールで単価5000円〜（材料費、校正代別途）

納期

校了から約3週間程度

注意点

Illustratorデータ。フォントはアウトライン化必須。特色印刷は3色まで可能。型抜きやミシン目が入れられるかは、紙質や紙厚次第なので、まずはつくる前に問い合わせを

問い合わせ

有限会社コスモテック
東京都板橋区舟渡2-3-9
TEL：03-5916-8360
Mail：aoki@shinyodo.co.jp
https://note.com/cosmotech

強圧活版印刷の一筆箋

グッズとして根強い人気の一筆箋。和紙にギュッと圧をかけて印刷した一筆箋は、よりこだわりを感じさせるグッズになること間違いなし。

裏から見ると罫線部分が盛り
上がっており、印刷時に強く
圧をかけたことがわかる

「うづき」の表面は、キラキラ
光る繊維が抄き込まれている

和紙「うづき〈きなり〉」に強圧活版印刷で
特色を刷った一筆箋(73×175mm)
デザイン：根津小春(STUDIO PT.)

印刷に使用した銅版。耐久性が高いの
で、リピートのある印刷物には特に向いて
いる

INFORMATION

最小ロット

最小ロットは1000〜1200セット。経済ロットは1万〜1万2000セット

価格

10枚の活版特色1色印刷一筆箋本文＋オフセット特色1色印刷の表紙のOPP袋入りセットの場合、1000〜1200セットで単価120円、1万〜1万2000セットで単価100円(使用する紙によって異なる)。ほか、銅版代別途15万円。または樹脂版代別途1.6万円

納期

立ち会いによる校了から約4週間

注意点

長井紙業ウェブサイトから一筆箋のテンプレート(73×175mm)をダウンロードしてデータを作成すると確実。フォントをアウトライン化したIllustratorデータ、またはPDFにて入稿のこと。線の細さは0.3mm以上ないと、印刷時にかすれる可能性がある。特色はDICやPANTONEなどで指定できるが、使用する紙と圧圧によって、仕上がり色は変わってくる。和紙はインキを吸いやすく色が沈みやすいので、それを想定した色選びを。一筆箋で使用できる紙の厚さは60〜150g/㎡まで

問い合わせ

長井紙業株式会社
東京都台東区蔵前4-17-6
TEL：03-3861-4551
Mail：h-ogura@nagai-tokyo.com
https://nagai-tokyo.jp/

物

理想的に出っ張った版にインキをつけ、紙に押し付けて印刷する活版印刷(凸版印刷)。版にはいろいろな種類があるが、和紙の卸と印刷加工を手がける長井紙業が、一筆箋でいま一番おすすめしているのが、銅版による強圧活版印刷だ。耐久性が高い銅製の版を使うことで、長井紙業の一押し和紙は、「うづき」。キラキラと光る繊維が平滑な表面に抄きこまれた機械抄き和紙で、万年筆やボールペン、筆など、どんな筆記用具でも書きやすい。

仕上げ断裁の後、表紙とともにOPP袋に入れたり、天糊製本やくるみ製本で仕上げることも可能だ(いずれも料金は別途)。

印刷部分が盛り上がっていることがわかる。印刷によって紙面に生まれる凹凸も、この印刷方法の魅力だ。

和紙を用いることで、よりこだわりのある仕上がりになるが、「書記適性にもこだわりたいところ。

種類があるが、和紙の卸と印刷加工を手がける長井紙業が、一筆箋でいま一番おすすめしているのが、「書く」文具である一筆箋としては、筆記適性にもこだわりたいところ。

銅版は樹脂版や活字に比べてギュッと強い圧をかけて印刷することができ、刷り上がりはシャープ。印刷時に凸状の版を紙に押し付けた際、わずかにはみ出たインキが「マージナルゾーン」と呼ばれるにじみとなって、一筆箋の罫線に手書きのようなニュアンスを加える。刷り上がった一筆箋を裏から触ると、

おてがみメモ

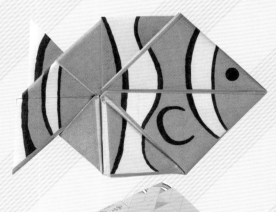

使いやすい表紙付きメモ帳。でもこれはただのメモ帳ではない。折るとさまざまな形になる、一工夫あるオリジナルメモ帳なのだ。

折るとバスになるメモ帳は京急ストアが京急グッズショップやエキナカの売店での販売用にオーダーしたオリジナル品

表紙の裏に折り方の説明が入る

大阪にある、「生きているミュージアム・ニフレル」のミュージアムショップ販売用につくられたもの。折るとカクレクマノミに

小さいころ、ともだちに渡すメモを洋服型などに折ったことはないだろうか。

デザインフィルのおてがみメモは、そんなこどものころのワクワク感を思い出させてくれるメモ帳。メモ裏面に刷られたビジュアルはそのままでもかわいいが、これを表紙裏に印刷されている折り方にしたがって折ると、さまざまな形にしあがるのだ。

多くつくられているサイズは幅105ミリ、高さ148ミリのA6サイズ。40枚綴りで表紙でくるむ製本が基本だ。

デザインは自分でデータをつくり入稿もできるし、イメージをデザインフィルに伝えてつくってもらうこともできる。特に自分でデザインする際に気になるのが、折り方をどうするかということ。でもご安心。あらかじめ用意されている10種ほどの中から選ぶこともできるし、形によってはデザインフィルに相談し、アレンジして提案してもらうこともできるのだ。

ハウス食品株式会社のオンライン工場見学等のノベルティとしてつくられたもの。よく煮込んだカレーを再現したデザインにもこだわりが

INFORMATION

最小ロット

最小ロット、経済ロットともに3000冊〜

価格

H148×W105mm・40枚綴り・3000冊の場合、単価180円〜

納期

色校正に7日、校了後5週間程度

注意点

アウトライン化したIllustratorデータで入稿（ai形式＋出力見本のPDF）、もしくは打合せ後、デザインフィルでデザイン

問い合わせ

株式会社デザインフィル
コマーシャルデザイン事業部
東京都渋谷区恵比寿1-19-19
恵比寿ビジネスタワー9階
TEL：03-5789-8060
Mail：btob@designphil.co.jp
https://www.designphil.co.jp/btob/

額縁封筒

額縁封筒は、ポストカードサイズの封筒に四方10mmの縁を残して窓加工をした封筒。窓にはグラシン紙のほか、透明フィルムを貼ることができる。大きな窓で、中に入れたカードなどのデザインが外から見えることが特徴

印刷、窓加工後に製袋するので、内側の全面に絵柄が入れられる。窓越しに絵柄が見えるのがいい

封筒の一部を型抜きして透明フィルムやグラシン紙を貼った窓つき封筒の窓加工の多くは、宛名を見せるために用いられている。しかし、ほんの少し縁を残した大きな窓加工をしてみると、まったく違う用途が生まれる。

タントセレクトTS9〈H-70〉を使用した額縁封筒。紙自体に柄の入ったものを使うと、印刷を入れなくても個性的な封筒に。グラシン紙の雰囲気がよく合っている

封筒

筒の一部に穴を開けて透明フィルムなどを貼り、ポストカードを飾るのにも使えそう。また、中身が見えるので、パッケージとしての活用も考えられそうだ。

窓加工は、中に入れた書類の宛名をそこから見せて、封筒自体の宛名印刷（またはラベル貼り）をしなくていいように活用されることがほとんどだ。

しかし、大きな窓加工をすると、絵柄を印刷し、封入したカードを取り出すとその絵柄が現れるデザインにすることもできる。

製袋前の平判紙の状態で両面印刷を入れることができるので、窓から見える部分（封筒の内側）に絵柄を印刷し、封入したカードを取り出すとその絵柄が現れるデザインにすることもできる。

また違う楽しい使い方ができる封筒になる。

額縁封筒はポストカードがすっぽり入るサイズの封筒で、縁に10ミリほどを残した全面が窓になっているのが特徴。このなかにポストカードを入れると、まるで額縁めに入れたように見えることから「額縁封筒」と名付けられた。写

封筒屋どっとこむでは、窓を抜くための刃型を3種類、窓タガネ（抜き型）は大きさや形の多様な約1000種類を所有しているため、額縁封筒以外にも、さまざまな窓加工に対応可能だ。まずは問い合わせを。

真やイラストを入れたり、店頭で

INFORMATION

最小ロット

特注の場合は最小ロット1枚〜、規定の紙（未晒クラフト）を使った既製品の場合は10枚〜。経済ロットは3000枚〜

価格

未晒クラフト紙、透明フィルム窓の既製品は10枚で220円、100枚で2200円。紙を自由に選ぶ特注製作の場合は、たとえばコニーラップ〈ホワイト〉に4色印刷100枚製作で単価712円、1500枚で単価52円

納期

既製品は注文・入金確定後、翌営業日の発送。特注製作は、8〜9営業日後の発送

注意点

印刷ありの場合は、まず問い合わせをしてテンプレートを送ってもらい、そこにデザインを作成。フォントをアウトライン化したIllustratorデータ（CS2以下）で入稿のこと。線や文字の大きさは0.1mm以上ないと、印刷時にかすれやつぶれの原因となる。ベタ印刷は、折り部分で紙色が見えてしまったり、他の部分にインキがつきやすくなる。窓が大きいため、加工中にシワや傷が入る可能性がある

問い合わせ

封筒屋どっとこむ
大阪府大阪市平野区喜連東5-16-15
TEL：06-4302-7740
Mail：support@fuutouya.com
https://www.fuutouya.com/

好きな紙でつくれる封筒

多種多様な紙でつくった、形状も多彩なオーダーメイド封筒の数々。いろいろな紙が使えるだけでなく、印刷も依頼したり、あるいは、印刷済みの紙を持ち込むことも可能だ

表面に星をちりばめたような紙、新・星物語〈クロウ〉の封筒

正方形の幾何学的な凹凸が入ったICHIMATSU〈緑〉のダイヤモンド貼封筒

表面に上品なパール加工を施した紙キラキラ〈未晒クラフト〉〈蛍光グリーン〉のチケット封筒

しこくてんれい抹茶CoCの名刺サイズ封筒

INFORMATION

最小ロット

最小ロット1枚〜。仕上がり枚数で請求という形も可能

価格

キラキラ〈未晒クラフト〉を用いたチケット封筒を製作した場合、100枚で単価1043.80円、1200枚で単価110.71円（製作サイズと使用する紙、印刷の有無や色数によって異なる）

納期

印刷なしの場合は注文・入金確定後、約5〜6営業日で発送。印刷ありの場合は、注文・入金確定・データの確定後、約7〜8営業日で発送

注意点

まずはwebの封筒シミュレーターで見積もり依頼をすると、その仕様での封筒展開図テンプレートを送ってくれる。紙を持ち込みする場合は、製作前に必ずサンプルを送るか、紙の銘柄名を知らせること。刷元紙を持ち込む場合は、事前に印刷データを送り、確認をとること。用紙は折ったり丸めたりせず、平の状態で、送料負担にて送ること。製袋には500枚程度の加工予備が必要となるため、用紙必要枚数は事前に確認を。また、封筒加工時に多少のズレが生じるため、見当合わせの厳しいデザインは注意が必要。ベタ印刷がある場合、折り目部分で紙の色が見えてしまったり、インキが他の部分につきやすくなる

問い合わせ

封筒屋どっとこむ
大阪府大阪市平野区喜連東5-16-15
TEL：06-4302-7740
Mail：support@fuutouya.com
https://www.fuutouya.com/

好きな紙を選んだり、印刷済みの紙を持ち込んで、封筒をつくりたい。そんなときに便利なのが、紙や寸法、形状など、すべてを自由に選べるオーダーメイド封筒だ。

注

封筒をつくりたいという場合、まず文フォームの一覧に入っている紙だけでなく、好きな紙を選んだり、持ち込んだりして封筒をつくりたい。あるいは、たとえばラッピングペーパーなど、他社で印刷した紙で、封筒をつくりたい。そんな要望に応え、好きな紙で封筒をつくれる会社は限られているが、封筒屋どっとこむはこうした要望に応えた「オーダーメイド封筒」の作成を請け負っている。

好きな紙で封筒をつくりたいという場合、まずは同社のウェブサイトにアクセスし、封筒シミュレーターで見積もり依頼を行なうと便利だ。つくりたい封筒の形やサイズ、貼り方、窓や口糊加工の有無を細かく選び、「封筒に使用できる紙一覧」として300種類以上から紙を選ぶことができる。一覧にない紙を別途指定したり、刷元紙（他社で印刷済みの紙）を選ぶことも可能だ。

封筒シミュレーターで見積もりを依頼すると、見積もりとともに、仕様に応じた封筒展開図のテンプレート（ai形式）が届く。印刷を行なう場合は、これに合わせてデザインを作成し、入稿するとスムーズだ。

テトラ型封筒

昔よく見た牛乳の三角パックのような形のテトラ型封筒は、封筒の応用でつくれるパッケージだ。

組み立てる前のテトラ型封筒。平袋の上半分をエキセン抜きするという、シンプルな加工

テトラ型封筒を裏から見たところ。これはセンター貼りで仕上げているが、左貼りで製作することも可能。位置合わせが必要な絵柄の場合は、左貼りのほうが合いやすくなる

上から、クラフトペーパーデュプレN、色上質紙〈やまぶき〉、コニーラップ〈ホワイト〉で作成したテトラ型封筒。クラフトペーパーデュプレNは表裏で色が違うので、角度によってフタの裏側の紙色が見えるのが、いい風合いとなっている

角に丸みを帯びた三角錐の、テトラポットのような形をしたパッケージ。これは封筒屋どっとこむのテトラ型封筒だ。立体的な形状で、一見つくるのが難しそうだが、実は封筒の応用で、比較的簡単につくれるパッケージなのである。

つくり方は、平袋に仕立てた封筒の上部を、半分の位置で型抜きするだけ。型抜きには「エキセン抜き」という封筒のフタ部分を加工する際に用いられる金型を使っており、抜き型をそのつどつくる必要がないため、コストを抑えられるのもうれしい。組み立て方は、封筒の口をふくらませて中にものを入れてフタを折り、フタの一部を入れてフタを折り、フタの一部

分をシールや糊でとめるだけ。絵柄を入れたテトラ型封筒は、平の状態でデザインする際、組み立て後のイメージがわきづらいかもしれない。まずは問い合わせをしてテンプレートを送ってもらい、そこにデザインを入れた後、プリンターで出力して実際に組み立ててみると、イメージ通りにデザインしやすい。

INFORMATION

最小ロット

最小ロット1枚〜、経済ロットは製作サイズと使用する紙によって異なる

価格

紙にコニーラップ〈ホワイト〉を用い、幅85×天地105mmのテトラ型封筒を製作した場合（4色印刷）、100枚で単価656円、3000枚で単価24円（製作サイズと使用する紙、印刷の色数によって異なる）

納期

印刷なしの場合は注文・入金確定後、約5〜6営業日で発送。印刷ありの場合は、注文・入金確定・データの確定後、約7〜8営業日で発送

注意点

印刷ありの場合は、まず問い合わせをしてテンプレートを送ってもらい、そこにデザインを作成。フォントをアウトライン化したIllustratorデータ（CS2以下）で入稿のこと。線や文字の大きさは0.1mm以上ないと、印刷時にかすれやつぶれの原因となる。ベタ印刷は、折り部分で紙色が見えてしまったり、他の部分にインキがつきやすくなる。窓が大きいため、加工中にシワや傷が入る可能性がある

問い合わせ

封筒屋どっとこむ
大阪府大阪市平野区喜連東5-16-15
TEL：06-4302-7740
Mail：support@fuutouya.com
https://www.fuutouya.com/

テトラ型封筒のテンプレート

天地：105mm
巾：85mm
貫：17mm

変形窓つき封筒

おもての一部分にフィルムを貼った穴があいており、中身が見える封筒や平袋は、見た目が個性的なだけでなく、内容物を見せるパッケージとしても活躍する。

右写真のサンプルは、中に赤い表紙の中ミシン綴じ冊子を入れている

未晒クラフト紙に墨1色印刷し、りんごの形に型抜きした平袋。窓部分には透明フィルムを貼っている（グラシン紙にすることも可能）。窓から中が見えるので、果物の色に合わせた中身をパッケージすると、いい感じだ

それぞれ、紫、薄緑色の表紙の冊子をパッケージした、果物の型抜き平袋。とてもかわいい！

封

筒や平袋は、手紙やカードを入れて使えるだけでなく、冊子やハンカチ、スカーフ、ワッペンなど、厚みがあまりないもののパッケージとしても使えるグッズだ。おもての一部分に型抜きで穴をあけて裏からフィルムを貼った「窓つき封筒」なら、より内容物の一部が見えるため、よりパッケージ用途に向いている。

この窓を好きな形状で型抜きしてつくれるのが、羽車の別注封筒「変形窓つき封筒」だ。窓の形状は、抜き型の特性から、鋭角すぎるもの、複雑すぎるものは表現が難しい場合もあるが、果物や動物など、好きな形状でつくることができる。ただし紙を発注して一からつくるため、最小ロットは1000枚〜と多めだ。

制作工程は、まず平判の紙にダイカット（型抜き）加工をした後、窓部分にフィルム貼りをし、最後に製袋する。このため、封筒の中面（窓から見える部分や、ベロの裏側を含む全面）に印刷を入れることも可能。封筒のおもて面には、オフセットおよび活版印刷、エンボスや箔押しも施すことができる。

平判の紙に印刷加工してから製袋するので、中面全体に柄を印刷することもできる

INFORMATION

最小ロット

最小ロットは1000枚〜（500枚単位）、経済ロット10000枚〜（大口数量も可）

価格

りんご形の窓つき平袋（未晒クラフト100g/㎡、サイズ160×240mm）を作成の場合、1000枚で85800円（単価約86円）、10000枚で199100円（単価約20円）、ちょうちょ形の窓つきカマス形封筒（コットンスノーホワイト116.3g/㎡、サイズ160×160mm）1000枚作成の場合112420円（単価約113円）、10000枚の場合253000円（単価約26円）。いずれも税込、印刷・紙代込み

納期

7営業日後〜（内容により異なる）

注意点

フォントをアウトライン化したIllustratorデータで入稿のこと。窓の形状が細かいものは作成できない

問い合わせ

株式会社羽車
大阪府堺市東区八下町3-50
TEL：0120-890-982
Mail：info@haguruma.co.jp
https://www.haguruma.co.jp/store

ラッピングペーパー

紙色は、写真上・左からシルバー、コ
コア、ホワイト。写真下・左からマリン、
カナリア。包装紙のほか、緩衝材とし
て使用してもいい

ふんわり薄くて、はかなげなラッピングペーパー。薄い紙は平判での印刷が難しく、
大ロットでないとつくれないことが多いが、平判で印刷してくれるところなら、
比較的小ロットで制作可能なのだ。

ラ

ッピングペーパーに用い
られる「薄葉紙（うすよ
うし）」と呼ばれるごく
薄い紙は、巻取の状態が魅力の
印刷できないことも多く、その場
合はまるまる1巻分をつくらなく
てはならないという最小ロットの
大きさが、製作のハードルの高さ
につながっている。しかし平判で
印刷してくれるところであれば、
数百枚からの印刷が可能になる。
封筒や名刺・カードなどの紙も
の製作を手掛ける羽車が取り扱う
ラッピングペーパーは、平判印刷
い。

のため、200枚という小ロット
からつくられるのが魅力的だ。
紙は2種類。片艶でシャリシャ
リとした手触りと透け感が魅力の
tカラペ（わずか19g／㎡！）と、
薄葉紙ホワイト（25g／㎡）。t
カラペの色はシルバー、ココア、
カナリア、マリンの4色だ。サイ
ズは545×788ミリ、394
×545ミリの2種類展開。
印刷はオフセットで、片面1色
または2色印刷が行なえる。印刷
色は、羽車の基本色のほか、DI
CやPANTONEなどの特色を
指定して刷ることも可能。金銀、
蛍光色でも印刷できるのがうれし

INFORMATION

最小ロット

最小ロットは200枚〜、経済ロットは
1000枚〜

価格

サイズ545×788mmの紙に1色印刷、
200枚の場合、32120円（単価約161
円）、1000枚の場合55000円（単価約
55円）。いずれも税込。紙の種類によっ
て異なる

納期

校了後、約7営業日後〜出荷

注意点

フォントをアウトライン化したIllustrator
データで入稿。ロゴマークなどのデー
タを支給したり、羽車のイラストを使用
したデータ作成を依頼することも可能。
印刷は、片面2色まで。ベタ面の印刷は
できない

問い合わせ

株式会社羽車
大阪府堺市東区八下町3-50
TEL：0120-890-982
Mail：info@haguruma.co.jp
https://www.haguruma.co.jp/store

グラシン封筒

オリジナルサイズで表裏
印刷したグラシン封筒
デザイン：水縞
mzsm.jp

グラシンワンポイントプリントサービスで作成したグラシン封筒を用いてラッピング。ワンポイントプリントサービスの場合は、印刷できるのは封筒の表のみ、フチなし印刷は不可となっている

シャリシャリとした独特の手触りと半透明感で、触っているだけできゅんとしてしまうかわいさのグラシン紙。これにフルカラー印刷した封筒をつくることができるのだ。

昔なつかしい紙風船や、書籍のカバー、ケーキの型紙やカップなどに使われてきたグラシン紙。シャリシャリとした手触りと光沢のある表面、ほんのり透き通る感じの独特の素材感がたまらない魅力の紙だ。しかし薄い素材だけに平判で印刷ができる会社は限られている。

吉田印刷所ではグラシン紙への平判印刷を得意としており、なおかつ、グラシン紙にフルカラー印刷した封筒までつくれてしまうのだ。扱う印刷会社の少ない紙であるため、他にはない封筒をつくることができる。

封筒に仕立てる製袋加工は、厚みにより異なるが、半透明感が引き立つ薄口の場合はハンドメイドで仕上げていく。一般紙の封筒に比べ、その薄さから加工精度は若干劣り、サイズは0・5〜1ミリ程度のズレがあるが、それを差し引いても余りある魅力の封筒になる。

さらに吉田印刷所では、もっと手軽にグラシン封筒がつくれるよう、昨秋、グラシンワンポイントプリントサービスを開始した。A5変形サイズ（160×220ミリ）またはポストカードサイズ（114×162ミリ）、厚みは特厚40のみだが、「ワンポイント」といっても印刷範囲はかなり広く、両サイズとも封筒の表側四方10ミリを除いた全面に印刷可能だ。対応している印刷は、フルカラー（CMYK）またはホワイト1色。ブランドロゴやキャラクターなどを刷ったグラシン封筒がつくりやすくなる、うれしいサービスだ。

INFORMATION

最小ロット

オリジナルサイズは100枚〜、ワンポイントプリントは50枚〜

価格

オリジナルサイズで表裏印刷する場合、114×162mmのポストカードサイズ封筒1000枚で20万円前後（印刷、型代、加工費込）／ワンポイントプリントサービスの場合、ポストカードサイズ50枚で15000円、100枚で21000円、200枚で32000円、A5変形サイズ50枚で16000円、100枚で23000円、200枚で36000円（税別／フルカラー印刷・ホワイト印刷とも同額）

納期

データ入稿後、約1ヵ月。ワンポイントプリントはデータ入稿約1週間程度

注意点

グラシン紙は通常の用紙に比べて印刷後の乾燥時間が大幅にかかるため、オリジナルを作成するには1ヵ月以上のスケジュールが必要となる

問い合わせ

株式会社吉田印刷所
新潟県五泉市今泉902-1
TEL：0250-43-6144
http://www.ddc.co.jp/store/

薄紙包装紙（オフセット4色印刷）

グラシン包装紙を使ったラッピングの例。半透明感を活かして包むと素敵だ

グラシン紙の包装紙。透け感がたまらない

商品を包む包装紙。はかなげな薄い紙でふわりと包んだ様子には心ときめくが、薄紙の場合、巻取でなければ印刷できないことも多い。しかし薄紙への平判フルカラー印刷を得意とする吉田印刷所では、小ロットから印刷できる。

た

とえば、米坪20g／㎡以下の薄紙は、巻取の状態でグラビア印刷をしなくては印刷できないことも多く、その場合は1巻分をつくらなくてはならなくなってしまう。しかし平判で印刷できれば、全紙で数百枚からの印刷が可能になる。

吉田印刷所は、平判での薄紙印刷、それもオフセット4色のフルカラー印刷を得意としている。包装紙用途の場合に多い、全紙で500〜1000枚ぐらいの注文に対応してくれる、うれしい会社だ。対応している紙のラインナップも、一番薄いもので「薄葉紙菊」。なんと米坪14g／㎡だ。そのほかにもグラシン紙やtカラペ、パレットカラー（102ページに掲載）など、平判で印刷できる会社がめったにないような薄い用紙へのフルカラー印刷に対応している。

薄紙印刷の場合、気をつけなくてはならないのは納期だ。通常の用紙より乾燥日数を要する紙もあり、特にグラシン紙はデザインによっては10日ほどかけて乾燥させなくてはならない場合もある。また、紙ぞろえも、紙によっては手作業で1枚1枚行う必要があるため、スケジュールには余裕をもって発注したい。

しかし時間がかかっても、透けるほどに薄い紙で商品が包まれた様子はとてもかわいく、ぜひともつくってみたくなるラッピングツールだ。

INFORMATION

最小ロット

500枚〜

価格

tカラペ（菊判11.3kg 米坪19g/㎡）にオフセット4色印刷した場合、500枚で9万円前後／純白ロール紙（菊判18kg 米坪30g/㎡）にオフセット1色印刷した場合、500枚で6万円〜）

納期

データ入稿後、約3週間

注意点

グラシン紙は通常の用紙に比べて印刷後の乾燥時間が大幅にかかる。また、薄紙は紙ぞろえを1枚ずつ手作業で行なうこともあり、余裕をもったスケジュールが必要となる

問い合わせ

株式会社吉田印刷所
新潟県五泉市今泉902-1
TEL：0250-43-6144
http://www.ddc.co.jp/super-light-print/

薄紙包装紙（オフセット特色印刷）

特色2色印刷の包装紙、左が5リーフN、右が純白ロール。同インキ・同濃度で印刷しているが、紙によって色の出方がかなり変わるのがわかる。今回、この包装紙を実物サンプルとして本誌に綴じ込んでいる

5リーフNの包装紙は、落ち着いた発色とパリパリした硬めの触感が特徴的

INFORMATION

最小ロット
1000枚〜（100枚も応相談）

価格
純白ロール（米坪：40g/㎡）菊全判に特色2色印刷した場合、1000枚で約4万円

納期
データ入稿後、約1週間

注意点
純白ロール30g/㎡より対応可能（特色、カラー）。薄葉紙（グラシン、パレットカラー等）対応可能（特色、カラー）。特色、金、銀、白印刷も対応可能（割増料金）。ベタ、写真の場合は応相談

問い合わせ
カワセ印刷株式会社
東京都荒川区荒川8-23-16
TEL：03-3801-4477
http://www.kawase-p.co.jp

オリジナル包装紙研究所
TEL：03-5811-6032
https://housoushi.tokyo-usugami-p.jp/

純白ロール紙などの薄紙でつくる包装紙。特色1色や2色で印刷すると、昔ながらの包装紙の雰囲気が出て、レトロなかわいさがある。平判での薄紙印刷を得意とするカワセ印刷では、特色印刷の包装紙を数多く手がけている。

昔ながらの菓子店や土産店などで見かける包装紙は、片艶がかわいい純白ロール紙などに特色1色または2色で印刷されているものが多い。こうした特色印刷の薄紙包装紙を得意としているのが、カワセ印刷だ。

純白ロール紙などに特色1色または2色で印刷されているものが多い。こうした特色印刷の薄紙包装紙を得意としているのが、カワセ印刷だ。

未晒クラフト紙、耐水耐油紙、それから5リーフNなどだ。5リーフNはコピー適性を備え、印刷・製本適性に優れた事務用紙で、紙腰が強く、パリパリした独特の手触りが魅力の紙である。

特色印刷以外に、プロセス4色印刷もちろんできるが、カワセ印刷では薄紙の場合、4色印刷ができるのは米坪37g／㎡以上。ただし純白ロールや耐水耐油紙といった硬めの紙についても、米坪30g／㎡でも可能。

別途校正代はかかるが本機校正をとることもでき、色校データを管理しているので、色にこだわる人にはおすすめだ。

巻取ではなく平判での印刷なので、少ないロットから発注できるのがうれしい。印刷最大サイズは菊全判（636×939ミリ）までで、1000部からが経済ロットだが、100部でも応相談。包装紙によく使われるのは純白ロール、

ロウ引き封筒

熱で溶かしたロウを紙の繊維の間に染み込ませるロウ引き加工。

紙の色や風合い、質感が変わり、独特の魅力がある。

羽車ではこのロウ引きをさまざまな封筒に加工することができるのだ。

ロウ引き加工は、もともとは袋や紙に耐水性をもたせ、強度を高めるために行なわれる加工だが、ロウを染み込ませた紙は色がぐっと濃くなり、半透明になって、しっとりとした質感となることから、アンティークな風合いを出したいときなどにも用いられるようになった。

した後にロウ引きを行なうと、濃い色の紙であればインキの色に深みが出るし、淡い色の紙であれば印刷部分が浮かんでいるような印象になる。濃い紙にゴールドやシルバー、ホワイトインキを印刷していた場合も、インキがよりくっきりと紙の上に浮かび上がるような、不思議な印象に仕上がる。ロウ引き後の紙にわざとシワをつけたり、ダメージを与えると、表面のロウが細かく割れて、シワの部分が白くなる。使い込むうちに自

然につくこのシワも、ロウ引き封筒の大きな魅力のひとつだ。

加工する紙は、クラフト、未晒クラフト、コニーカラーなどのクラフト系が適している。紙の繊維が長くロウが浸透しやすいので、紙表面の風合いの変化をよりいっそう楽しむことができるからだ。

ただし、ロウの浸透には若干のムラがあるため、加工後の仕上がりイメージは一定ではない。しかし、そのことも手作業のようなアナログさを感じさせ、人気の理由となっている。

ロウ引き加工後も切手や宛名シール、封緘シールを使うことができるが、弱粘性のものやシールの種類によっては剥がれてしまうこともある。強粘性のものでも、貼り付けた直後は剥がれやすいので、30分以上置いておくとよい。

INFORMATION

最小ロット

100枚〜

価格

ホワイトクラフト洋2タテ封筒、オフセット印刷1色（特色：蛍光レッド）＋ロウ引き加工の場合、100枚14465円（税込）

納期

6営業日〜（他加工がある場合は別途相談）

注意点

オフセット印刷、エンボス加工とロウ引きの併用は可能だが、箔押し・活版加工、封筒蓋の口糊加工との併用は不可。封筒の紙の貼り合わせ部分は、ロウの浸透度合いに差が出るため、色の濃淡が出ることがある

問い合わせ

株式会社羽車
大阪府堺市東区八下町3-50
TEL：0120-890-982
Mai：info@haguruma.co.jp
http://www.haguruma.co.jp/store/

クラフト系の紙コニーカラーレッドに金インキで印刷後、ロウ引き

片面が白（晒）、もう片面がクラフト（未晒）と表裏の色の違いが魅力的な紙ホワイトクラフトの封筒に、蛍光インキで印刷後、ロウ引き加工している

ロウ引き前（写真左）と後（写真右）で、紙の色が劇的に変わる

ロウ引き後の紙は、うっすらと中身が透ける

紙をわざと揉んだりしてダメージを与えると、シワ部分が白くなり、アンティーク感が増す

パッケージ封筒

別注で作成すれば、封筒の内側に印刷することもできる

封筒に使える紙は、質感と色にこだわったラインナップ

パッケージ用によく使われる封筒の一例。形が変わっていたり、蓋の形やつき方、長さが変わっているものが多い

ハンカチを入れるパッケージとしてつくられた、ちょうちょの形のオリジナル窓付き封筒

ビジネスなどでよく見かける形の封筒ではなく、正方形や蓋の長いものなど、少し変わった形の封筒ならば、小さな雑貨などのパッケージに使いやすい。羽車では、変わったサイズのパッケージ封筒も豊富にそろえている。

たとえば正方形の封筒や、洋2サイズでも蓋がタテに開くものなど、変わった形の封筒は、凝った印象を与えるもの。紅茶や入浴剤、タオルやハンカチといった、あまり立体的でなく、しっかりとした保護をしなくても大丈夫なものの包装・パッケージに、実は封筒は重宝する。

オリジナルサイズの封筒を別注でつくろうとすると、ロットも大きく、コストも高くついてしまうが、羽車はもともと封筒メーカーなので、パッケージ用途に使える規格サイズを豊富にそろえている。製袋済みの既製封筒に活版印刷や箔押しなどを行なうことが可能なため、価格を抑えてつくることができる。

らば、別注として、封筒の内側に印刷をしたり、封筒の表面の一部を型抜きして透明フィルムを貼り、窓付きの封筒をつくることも可能だ。この場合は製袋前に印刷するので、封筒の表から裏にまたがるデザインなども行なうことが可能。

印刷色は、プロセス4色、金・銀・蛍光・白といった特色のほか、26色のオリジナル色を基本色としてラインナップ。基本色については、特色代はかからない。印刷・加工の色見本や封筒見本帳、紙見本帳は、同社Webから購入することができる。

コストをある程度かけられるな

きる。

INFORMATION

最小ロット

100枚〜（既製品の場合）

価格

正方形トレーシングペーパーSE16封筒（オフセット特色2色印刷〈白、蛍光レッド〉）100枚で16775円（税込）

納期

4営業日〜（既製品に印刷の場合）

注意点

ベタ面の多いデザインの印刷の場合、汚れがつきやすくなるので、要相談。窓を貼る際や、封筒をつくる際の糊つけ部分には、全面のベタ印刷はできない。また、窓つき封筒では、窓の形に合わせてフィルムを糊付けしているが、糊付けできるのはおおまかな輪郭のみとなる

問い合わせ

株式会社羽車
大阪府堺市東区八下町3-50
TEL：0120-890-982
Mail：info@haguruma.co.jp
http://www.haguruma.co.jp/store/

シール、テープなど――くっつきモノ編

パチカシール／特殊紙シール

凝ったシールやステッカーをつくりたい。でもシール紙の見本帳を見ても、ベーシックな素材しかない。そんなときは竹尾のさまざまな紙をシールにしてくれるサービスをぜひオーダーしてほしい。

たとえば加熱型押しすると、その部分が半透明化する特殊紙「パチカ」を使ったシール。原紙にまずタック加工（シール面の糊を引く加工）するのだが、パチカそのままにタック加工すると糊を吸い込んでしまうので、一度PPフィルムを貼り、その後からタック加工。あとは通常のシール製作同様、加工し、ハーフカットや型抜きをすれば完成だ。

パチカ以外にも、例えば分厚いGAファイルやGAクラフトボー

加熱型押しすると透け感が出せる特殊紙「パチカ」。その美しい加工をシールにして、紙ものグッズをつくりたい。他にも竹尾が扱っている紙ならほぼなんでもシールにして加工してもらえる必見の紙ものグッズが誕生だ。

ド・FSなどを使って、存在感あるシールをつくったりと、竹尾の紙であればほぼなんでもシールにしてもらえる。紙にこだわったシールをつくりたいときに必見の紙もの文具だ。

INFORMATION

最小ロット
500枚〜。経済ロットは1500枚〜

価格
直径50mmの丸型で、加熱型押ししたパチカシール（四六判130kg）500枚の場合、一式17万円程度。1500枚の場合、一式22万円程度

納期
データ入稿から約2週間〜1ヵ月程度

入稿データについて
パチカに加熱型押しする際と同様、凸版用データを作成。またシールの型抜きデータも必要だ

注意点
竹尾が扱っている紙はほとんどすべてシール加工してもらうことが可能だが、つくるシールのサイズによって最小ロットなども変わってくるため、つくる前にまずは問い合わせを

問い合わせ
竹尾紙工株式会社
東京都板橋区高島平6-6-2
高島平アネックスビル1F
Mail：info@takeo-sk.co.jp

パチカシール。加熱型押しした雪の結晶部分は、カラフルな封筒などに貼ると、下地が透けて美しい

「グムンドゴールド-FS（リッチゴールド）680×1000mm 211kg」に空押し加工したシール。ゴージャスで品のあるシールができた

「GAファイル（チャコールグレー）四六判900kg」に箔押ししたシール。まるで牛乳瓶の蓋のような厚みと存在感のあるシールもつくれる

パチカだけではなく、竹尾の紙はほぼなんでもシールにしてもらうことができる。右上オレンジのものは「プライク-FS」に空押し、一番下は「GAクラフトボード-FS（アース）L判27kg」に箔押しなど、加工や印刷も自在だ

ロールシール

紙もの文具としてつくりたいもの上位にくる「シール」。さまざまなタイプがつくれるが、おすすめのひとつがロールタイプのシール。シールとテープ両方で使えるすぐれものだ。

ガムテープを切る金具をつけてカットし貼ると、オリジナルテープのように使える。今回20cmごとにミシン目も入れてもらっているので、そこで切って長細いシールとして使うこともどちらも可能だ（写真上）

今回試作してもらったロール状のシール

型抜きのハーフカットを入れておけば、じゃんじゃん使えるシールロールとしても便利。写真のものはシアンと黄色の特色2色刷りシール。緑は掛け合わせで表現

梱包テープがわりに、また袋や箱、封筒などさまざまなサイズのものに合わせて、自由にサイズを変えながら使える。そんな便利なシールがロールシールだ。通常のシールは、型抜きされて決まった形・サイズに仕上がっているが、ロールシールはテープ状のシールなので、ハサミやガムテープのカット金具をつけてビリっときれば、自由な長さにカットして使えるのだ。「それならオリジナル柄のテープをつくればいいのでは？」と思うかもしれないが、1巻からつくれたり、また多色印刷できたり、素材が選べたりするオリジナルテープはなかなかない。でもコスモテックのロールシールなら、そのどれもが叶う。

もちろん、通常のシールとして使うために型抜きを入れたタイプのロールシールとしてつくることも可能。どんな風に使いたいかによって、自由に素材や仕様を決めたシールをオーダーできるのだ。

INFORMATION

最小ロット

1ロール（約100m巻／幅48mm）〜

価格

型抜きなしロールシール（上質シール・2色印刷・ロール加工）1ロールで一式5万円＋税。型抜きありロールシール（上質シール・丸型型抜き・2色印刷・ロール加工）で一式6万円＋税

納期

データ入稿から約1週間（校正は含まず）

入稿データについて

エンドレス柄の場合、長さ最長20cm程度までで柄をつくる

注意点

上質タック以外、例えばコート紙タックや金銀などのメタリック紙タック、透明フィルムタックなど、さまざまな素材でつくることもできる

問い合わせ

有限会社コスモテック
東京都板橋区舟渡2-3-9
TEL：03-5916-8360
Mail：aoki@shinyodo.co.jp
https://note.com/cosmotech

トレペシール

透け感のあるシールをつくりたい。でも透明フィルムの感じではない……。そんなときはトレペシールがおすすめ。独特の半透明感が魅力のトレーシングペーパーでシールがつくれるのだ!

オリジナルシールをつくるとき、どんな紙(もしくはフィルム)を使うか。

タック紙(シール用紙)の見本帳から選ぶとかなり選択肢が少ないのだが、メーカーによってはちょっとすてきなタック紙がある。編集部がオススメなのは、半透明で独特の硬質な質感をもったヨシモリ株式会社のトレーシングペーパーのタック紙(通称トレペタック)。これを使えば半透明のシールが手軽につくれる。

箔押しで定評のあるコスモテック、実はシール製作も得意。トレペタックを使ったシール製作もお手の物だ。今回、掲載用につくってもらったサンプルは、白印刷(凸版印刷)に、つや消し金の箔押し加工を施し、さらに型抜き加工をしたもの。貼るとベースの紙が半透明なため、白印刷が浮き立ち、紙ものならではの良さ満載。自分のオリジナルシールとして、またグッズ製作としてもオススメのシールだ。

トレーシングペーパーのタック紙(シール用紙)に白印刷+箔押しし、型抜き加工したシール

薄い色のうえではささやかに、濃い色の上に貼ればより目立って、今までにないシールがつくれる

1シートに何枚入れるかなど、自由に指定してつくれる。これは5枚同じシールを1シートに入れたタイプとして作成

INFORMATION

最小ロット

50mm四方サイズで500枚〜。経済ロットは1000部〜

価格

50mm四方サイズ、白印刷+箔押し、型抜きありの場合、総額で約5万2000円+税

納期

データ入稿から約1週間(校正は含まず)

入稿データについて

Illustratorなどで、印刷と箔押しをわけたデータを作成

注意点

1シートに何枚入れて仕上げるかなど、あらかじめ確認を

問い合わせ

有限会社コスモテック
東京都板橋区舟渡2-3-9
TEL:03-5916-8360
Mail:aoki@shinyodo.co.jp
https://note.com/cosmotech

紙の幅広テープ

左は白いテープに特色青1色で印刷したもの。右はクラフトテープに黒1色で印刷したもの。クラフトテープを使用する場合、印刷色が地色の影響を多少受ける。思い通りの印刷色にしたい時には、白色ベースがおすすめ

梱包用にもっともよく使われるのが、紙の幅広テープではないだろうか。いわゆるクラフトテープと呼ばれるものだ。

これに2色までの印刷をしてオリジナル柄のテープを作成できる。

自社名やロゴを印刷してもいいし、絵柄を印刷してもかわいいのだ。

箱や封筒に商品を入れて梱包するときによく用いられる、紙の幅広テープ。強粘着タイプのテープなので、ダンボール梱包に最適。

自社名やロゴ、ウェブのURLを印刷して広告媒体として活用したり、オリジナルの絵柄を印刷してノベルティやグッズに使うなどの活用がされている。

ベースとなるテープは、白とクラフトの2色。印刷は凸版印刷の一種である、フレキソ印刷で行う。2色までの印刷が可能で、1色印刷から2色印刷の場合はコストがプラス10%程度上がる。

色は、黒、白のほか、DICまたはPANTONEのカラーチップで特色を指定してもOK。色見本

なら オリジナルデザインのものを無地のものでもいいが、せっかく使いたい。日本テープでは、オリジナルの印刷テープをつくることができる。

（印刷物など）を渡して、それに近い色で印刷してほしいという頼み方でも大丈夫だ。ただし、金銀、蛍光は不可。フレキソ印刷は樹脂凸版による印刷となるため、細かすぎる絵柄はつぶれる可能性がある。また、平網も50%より濃いとつぶれる原因となる。ベタで作成するのがきれいだ。

テープの製作工程は、原紙の幅に合わせて面付けし、印刷した後、裏面に糊づけをし、仕上がり幅にスリットを入れて完成する。スリットが多少ずれたときに、必要な絵柄がカットされないように、デザインでは天地8ミリに空きが必要だ。ただし、上下左右がつながった、どこでカットされても成り

立つエンドレス柄の場合は、テープに裁ち落としで印刷を入れることができる。

また、絵柄はある程度の長さで繰り返しながら印刷されることになる。この繰り返しのピッチは21種類あるので、そのどれかにおさまるようにデザインすればよい。種類が多いため、詳しくは問い合わせを。

テープの幅は38、50ミリの2種類。一般的な幅は50ミリで、一度の注文で50ミリ幅×50メートル巻のテープが約1350巻できる。

原反のサイズや巻の長さが決まっており、各工程で若干のロスが出るため、出来数に最大15%程度の上下が生じる。

INFORMATION

最小ロット

50mm幅×50m巻の場合約1350巻

価格

白色テープに特色1色印刷で、50mm幅×50m巻を約1350巻製作した場合、約48万円（クラフト色テープのほうが若干価格が抑えられる）

納期

校了後、約8〜10週間

入稿データについて

Illustratorでデータ入稿（ai形式）。絵柄を黒1色でデータ作成。2色以上の印刷の場合は、レイヤーを分けて作成のこと

注意点

文字サイズは8ポイント以上、線幅0.3mm以上にすること（白抜きの場合は、線幅0.5mm以上）。基準以下の場合、印刷がかすれることがある。また、細かすぎる絵柄は印刷がつぶれる可能性がある。試作や校正はできないので、デザインデータ入稿後に一度チェックしてもらい、つぶれの可能性がある部分を修正などしてから、印刷に進む

問い合わせ

日本テープ
東京都板橋区双葉町35-10
TEL：03-5943-4480
https://nihontape.com/

めくれるマスキングテープ

27×27mmの基本サイズの「めくれるマスキングテープ」。1枚1枚めくりながら、シールのように使える

包装までしてもらうことも可能。写真はフィルム包みで天地にシールを貼ったもの。このほか、OPP袋入れ、OPP袋＋台紙などの包装がある

かわいくデコレーションできるグッズとして、すっかり定番となったマスキングテープ。和紙からつくられていて、うっすらとした透け感がかわいい粘着テープだ。なかでも、紙管に巻かれたマスキングテープを、1枚1枚シールのようにめくることができるのが「めくれるマスキングテープ」だ。

ラッピングに用いたり、封筒やカード、手帳などを飾ったり。透け感のある和紙にカラフルな絵柄を印刷したマスキングテープは、さまざまな場所のデコレーションに大活躍の人気アイテムだ。テープ状になっていて、手でちぎったり、ハサミで切ったりして使うことが多いが、絵柄の形に型抜かれたマスキングテープが紙管に巻かれていて、1枚1枚シールのようにめくりながら使うことができるタイプが登場している。

アンリの「めくれるマスキングテープ」もその一つ。和紙にオフセットで4色印刷し、裏面に糊引きをした後、型抜きして、紙管に巻いている。175線のオフセット印刷なので、グラデーションやベタ、細い線もきれいに印刷でき、写真の印刷も可能なのが特徴。ま

た、箔押しを入れることもOKだ。ただし糊との相性から、使える箔テープをつくることもできる。

はツヤ金のみとなる。サイズは27×27ミリが基本で、ひとまわり小さな25×25ミリもある。絵柄は、10種の形が何回か繰り返される。よくある仕様は10種×各6枚、合計60枚だ。オリジナルの形でも作成可能。紙管は内径30ミリと40ミリのどちらかから選ぶことが可能だ。

また、マスキングテープは筆記性がないものが多いが、アンリでは書けるようにする表面加工も行える。ボールペン、蛍光ペン、鉛筆、マジックなどの筆記具に対応。この加工を行った場合は、表面がマット調になる。1枚ずつめくれるタイプのほか、マイクロミシン目入りでちぎりやすいマスキング

INFORMATION

最小ロット
1000個～（2種×各500も可能）

価格
基本サイズ（27×27mm）を1000個製作した場合、単価500～600円

納期
校正約1週間、校了後約35日（約5000個まで）

入稿データについて
Illustratorでデータ入稿

注意点
トムソン型での型抜きとなるため、細かい形に抜きたい場合は要相談。箔押しを入れたいときは、ツヤ金のみとなる

問い合わせ
アンリ 東京支店（担当：松澤）
東京都千代田区内神田2-16-8
TEL：03-3252-7711
Mail：d_matsuzawa@anri.ne.jp
https://anri.ne.jp/

ロールふせん

裏面全面に糊のついた、ロールふせん。ミシン目が入っており、きれいにちぎることができる

貼ってはがして使えるふせん。かわいい絵柄の印刷された裏面全面に糊のついたタイプなら、カードやノートのデコレーションにも使うことができる。

マイクロミシンによるミシン目が入っているので好きな場所できれいにピリッとちぎることができるのもうれしい。

ロールふせんは筆記性が高く、ボールペンや蛍光ペンなど、いろいろな筆記具でメッセージを書くことができる

デザインのひきだし

気

気になる場所に貼って目印として使うことが多いふせんだが、全面糊のふせんをロール状にしたのが、ロールふせんだ。

アンリのロールふせんは、紙にせんなら、ラベルとして使ったり、カードやノートに貼りつけたり、ラッピングに使ったりと、いろいろなもののデコレーションに使うことができる。この全面糊のふせ

印刷した後、裏に糊引きをし、小巻にした上で、仕上がり幅にカットしてつくられる。上質紙ベースの特注ふせん紙を使用しているため、水性・油性ボールペンや鉛筆、蛍光ペンなど、さまざまな筆記具で書くことが可能。四六判70キロ程度の厚みがあるので、貼った後に四隅が浮いてこないので、ハガキに貼って郵送することもできる。

印刷はオフセット4色印刷。グ

るよう、マイクロミシンによるミシン目入り。マイクロミシンは目が細かく目立たないので、必ずしも1枚でちぎらなくても、2枚目、3枚目とつなげて、好きな場所でカットして使ってもいい。

また、1枚ずつきれいにちぎれ

ラデーションをきれいに再現でき、細い線や白抜き、ベタにも強い。写真印刷も可能だ。

ミシン目は、63・5ミリまたは50・8ミリごとに入れられる。オリジナルのミシン目ピッチをつくることも可能(ただし、別途型代がかかる)。ミシン目なしでつくることも可能だ。

幅は20ミリ、38ミリ、40ミリから選ぶことができ、総枚数は30〜100枚までで設定できる。

INFORMATION

最小ロット

500個〜(2種×各250も可能)

価格

幅40mm・総枚数30枚を製作した場合、500個で単価600〜650円

納期

校正約1週間、校了後約30日(約2万個まで)

入稿データについて

Illustratorでデータ入稿。つくりたい幅とミシン目ピッチを伝えれば、テンプレートを送ってくれる

注意点

印刷・カット時のズレに備え、切れてはいけない文字や絵柄は、天地から各1.25mm逃げて配置すること

問い合わせ

アンリ 東京支店(担当:松澤)
東京都千代田区内神田2-16-8
TEL:03-3252-7711
Mail:d_matsuzawa@anri.ne.jp
http://anri.ne.jp/

インレタ

金・銀・蛍光も含め、好きな特色を指定して製作可能

HIKIDASHI

こんな風に、紙などに好きな文字をきれいに転写することができる

透明シートに文字を印刷し、好きな場所に簡単に転写できるインスタントレタリング

フィルムに印刷された文字を軽くこするだけで、紙に簡単に転写できるインスタントレタリング、通称「インレタ」。かつてカセットテープなどのタイトルをラベルに入れるのに使ったことがある、という人も多いのではないだろうか。多少の曲面でも手軽に文字を転写できるのがうれしい。

透明なフィルムの裏面に文字を印刷し、糊を塗布したインスタントレタリング、通称「インレタ」。文字を入れたい場所に置き、上から軽くこすると、簡単かつきれいに転写することができる。紙以外にプラスチックなどにも転写可能で、模型やデザインなどの場面でも用いられていた。

このインレタをつくってくれるのが、転写シールを手がける扶桑だ。扶桑のインレタは、スクリーン印刷でインキと糊を刷ってつくられている。

使い方は、まず使いたい文字をハサミで切り取り、裏面についている剥離紙(透明フィルム)をはがしてから、文字を転写したい紙の上に置き、上から軽くこすれば、紙に簡単に転写できるという文字部分だけが簡単に転写できるというもの。紙以外に、樹脂や革などにも転写可能だ。

印刷色は、DICのカラーチップなど、色見本を渡せば、それに合わせた特色でつくってくれる。黒や紺などの濃い色の場合は1色刷りで大丈夫だが、白や黄色、ピンクなどの薄い色の場合、そのままだと転写したときに下地が透けてしまうため、色の下に白を敷いて転写できるよう、2色印刷となる。シートのサイズはA5が基本だが、それ以外のサイズを希望する場合は応相談だ(最小50×50ミリ、最大500×400ミリ)。ぜひ、好きなデザインの文字でつくってみてほしい。

INFORMATION

最小ロット
A5サイズ(148×210mm)100枚～

価格
A5サイズを製作した場合、100枚で単価600円程度(製版などの初期費用を含む)

納期
発注から3週間程度

入稿データについて
Illustratorでデータ入稿(aiまたはeps)。必ずアウトライン化したデータを送ること

注意点
A5シートの中に好きに文字を配置することができるが、文字と文字の間には3mm程度の間隔が必要(理想はハサミで切れる間隔)。また、推奨文字サイズは12pt以上、線幅は1mm以上となる。

問い合わせ
扶桑
東京都葛飾区立石8-41-2
TEL：03-3691-6490
Mail：fusou@kkfusou.co.jp
http://www.kkfusou.co.jp

金色折り紙みたいなシール

ヨシモリのタック紙「セルフペーパー33 神社BP」に、コスモテックで白箔押ししたシール

スペシャル感のあるシールをつくりたい。そんなときにぴったりなのが、折り紙に入っている金色みたいに少し赤みのあるゴージャスな金色シールだ。

ヨシモリには他にもさまざまなタイプの金・銀のタック紙がある。それらが一堂に見られる見本帳も含んだ全6種類が、同社Webサイトから入手できる

金銀ピカピカした素材のタック紙（裏に粘着加工が施されたシールの原紙のこと）をたくさん製造販売しているのが、加工紙メーカーのヨシモリ。「コズピカ」や「キラキラ」など多くの魅力ある加工紙をつくっている同社だが、タック紙のラインナップもすごい。金銀のタック紙はたくさんあるが、中でも「セルフペーパー33 神社BP」は、よく見かける金色より少し赤みが強く、折り紙セットに入っている金色のような神々しい色。ゴージャスなシールをつくりたいときにぴったりだ。

「セルフペーパー33 神社BP」も含め、ヨシモリのタック紙（セルフペーパーというのがヨシモリのタック紙ブランド名）を一覧したいときは、同社Webサイトから見本帳を入手できるのでぜひ。

「セルフペーパー33 神社BP」に印刷や箔押し、型抜き加工などを施してくれたのが、箔押し会社コスモテック。同社に「セルフペーパー33 神社BP」を使ったシールをつくりたいとオーダーすれば、印刷なら特色3色まで、箔押しは白はもちろん銀など他の色ももちろん加工可能だ。

ロールシール

ジャイアントパンダ「シャンシャン」のシールが7柄リピートする、恩賜上野動物園の園内ショップで販売していた「ロールシール シャンシャン」※現在は販売終了

文具の中でも人気のあるグッズ「シール」。何柄かがロール状になったシートに連なっているロールシールは、グッズとしての特別感も高い注目グッズだ。

ロールシール メッセージ 黒
ROLL STICKER メタリック
message / 11 designs
贈り物、お土産などを彩るシール
180枚入り

クラフトやメタリック素材のロールシールもできる

ヤマハ発動機ビズパートナー株式会社のノベルティとしてつくられたロールシール

ロールシール ハート 赤
ROLL STICKER メタリック
heart / 11 designs
贈り物、お土産などを彩るシール
180枚入り

こうしたパッケージ入りでの製造も可能

オリジナルグッズやノベルティグッズとして昔から大人気のシール。中でも最近、本書編集部が注目しているのが何柄かがリピートしているロールタイプのシール。それをグッズとしてちょうどいい長さにパッケージしてつくってくれるのがデザインフィルのロールシールだ。

ロールシールの幅は30ミリ、60ミリなどさまざまに変えることができる。長さもある程度自由に設定できる（もちろん価格は長さによって変動する）。シールの送りピッチ（シールと次のシールの位置）は原則均等となり、巻きの長さは大まかなため、多少の余剰がつく「○枚保証」の考え方となる。指定枚数より少なくなることはないので、おまけがついている可能性があるという感じだ。

シール素材は上質紙、アート紙、クラフト紙などから選定。他にもメタリック紙など、スペシャルな素材を使いたい場合も相談することができるが、素材によって価格が変わる。パッケージも簡単なOPP袋詰めから紙パッケージまで予算や仕上がりイメージによって選ぶことができる。

INFORMATION

最小ロット
最小ロット、経済ロットともに3000個〜

価格
上質またはアート紙で、幅30mm・11柄180枚程度入り・3000個の場合、紙パッケージ入りで単価260円〜

納期
色校正に2週間・校了後5週間程度〜

入稿データについて
打合せののちデザインフィルでデザイン、またはアウトライン化したIllustratorデータで入稿（ai形式＋出力見本のPDFが必要）。仕上がったロールシールの巻きの長さは大まかなため、多少の余剰がつく「○枚保証」の考え方となる

問い合わせ
株式会社デザインフィル
コマーシャルデザイン事業部
東京都渋谷区恵比寿1-19-19
恵比寿ビジネスタワー9階
TEL：03-5789-8060
Mail：btob@designphil.co.jp
https://www.designphil.co.jp/btob/

蓄光ウォールステッカー

壁に貼った蓄光ウォールステッカー

Sanei O

角度を変えて、よく目を凝らさないと、蓄光印刷がどこに入っているのかわからない

蓄光印刷は、蛍光灯の光など、紫外線を当ててから部屋の灯りを消すと、黄緑色に発光する。オフセット印刷で下地の絵柄を印刷した後、スクリーン印刷で蓄光インキを刷り、その上からマットPPをかけると、蓄光印刷部分が目立たなくなる

インテリアのアクセントとして、壁に貼って楽しめるウォールステッカー。蓄光印刷を組み合わせると、部屋の灯りを消したときにも楽しめるステッカーになる。

部屋の壁に貼り、インテリアのアクセントとして楽しめるウォールステッカ ー。貼ったときには簡単にはがれず、しかしはがしたときには糊が残って壁を傷めることのないよう にするには、プロに相談し、再剥離の糊を用いてつくりたい。

ここで紹介するのは、蓄光印刷を組み合わせたウォールステッカ ー。蓄光印刷に使われるインキは、日光や蛍光灯の紫外線を吸収し、暗い所で発光するのが特徴。オフセットで4色印刷した上に蓄光印刷を組み合わせれば、部屋が明るいときと暗いとき両方で楽しめるウォールステッカーになる。蓄光インキの発光は時間の経過

とともに減衰するが、再び紫外線を当てれば繰り返し何度でも発光する。インキの盛りが厚いほど発光強度が強く、時間も長くなるため、インキを厚く盛れるスクリーン印刷が使用される。通常、蓄光印刷をすると、その部分が白くざらっとして盛り上がり、発光していない状態でも印刷の絵柄がなんとなく見えるが、この上にマットPP加工を行うと、蓄光印刷が目立たなくなる。よく目を凝らさないとわからなくなるので、暗がりのなかで見たときのサプライズをいっそう大きくすることができる。ステッカーの台紙は四角だが、絵柄に合わせて好きな形にハーフカットを入れることが可能だ。

INFORMATION

最小ロット

最小ロット1000枚〜、経済ロット3000枚〜

価格

オフセット4色印刷＋蓄光印刷＋マットPPのステッカー（55×91mmの名刺サイズ）1000部で単価264円、3000部で単価93円、5000部で63円（印刷サイズや色数、蓄光インキの使用面積により、金額が異なる。校正費用は別途）

納期

校了後2週間〜

入稿データについて

フォントをアウトライン化したIllustratorデータで入稿。オフセット4色印刷、蓄光印刷、ハーフカットのラインはレイヤーを分けて作成のこと（白インキ印刷も可能。その場合は、白版も別レイヤーで作成）。蓄光印刷の線幅は0.5mm以上必要。また、蓄光印刷は、光らせたい部分の下地が黒などの暗色だと発光が弱まる。下にオフセット印刷の絵柄が入る場合は、下地を白か淡色にすると、明るく発光する

問い合わせ

サンエーカガク印刷株式会社
千代田区内神田2-14-6
神田アネックスビル5F

ほわほわシール

箔押し面積を少なくし、起毛素材ヴィベールのほわほわ感を活かしたデザイン

広い面積に箔押しをすることで、残った部分のほわほわ感をより強調した仕上がりにしてもかわいい

起毛素材の紙「ヴィベールP」でつくったシール。箔押しすることで生まれる立体感が、たまらない魅力だ。

白いヴィベールPに赤・黒2色の箔押しで仕上げた「ほわほわシール」（シールの形状がわかりやすいよう、水色バックで撮影）
デザイン：根津小春（STUDIO PT.）

ふ

わふわ、ほわほわした手触りの「ヴィベールP」は、ベルベットのような触り心地が可能だ。ほんの少しだけ箔押しをしてヴィベールPの素材感を活かすのはもちろん、広い面積を箔押しで平坦に潰すことにより、箔押しされていない部分のほわほわ感をより強調したデザインにしても楽しい。

ヴィベールPの色は、白（0000）のみで、原紙の在庫は要確認となる。印刷の場合は特色3色まで対応可能。箔押しの場合は、加工できる箔色が限定されるため、使用したい色が決まったら、あらかじめ在庫確認の問い合わせを。黒と赤は比較的在庫が安定している。

わふわ、ほわほわした手触りの「ヴィベールP」しをしてヴィベールPの素材感を活かすのはもちろん、広い面積を箔押しで平坦に潰すことにより、箔押しされていない部分のほわわ感をより強調したデザインにしても楽しい。

これを使ったシールが酒井マーク製造所の「ほわほわシール」。大きな特徴は、ヴィベールPを使っていること、そして、絵柄を印刷ではなくカラー箔で箔押ししていること。起毛素材に箔押しをすることで生まれる凹凸が、シールに立体感を与え、いっそう愛らしい仕上がりになる。

箔押しの線幅は、0.2ミリぐらいからOK。動物やキャラクターの目や顔のパーツなど、かなり細かい表現が可能だ。ほんの少しだけ箔押パイルに紙を裏貼りした素材だ。

INFORMATION

最小ロット

1色箔押しの場合、最小ロット500枚〜、経済ロット5000枚〜

価格

ヴィベールPの白（シートサイズ60×130mm）にカラー箔1色で500枚作成の場合、単価130円。同じく5000枚作成の場合、単価24円。いずれも、版代・型代は別途

納期

約14日

入稿データについて

Illustratorデータ（フォントをアウトライン化し、塗り足しやカット線を入れたもの）で入稿。シールにするためのデータ修正にも対応してくれる。カラー箔は色が限定されているため、事前に希望の色の在庫を要確認。赤や黒は在庫が比較的安定している

問い合わせ

株式会社酒井マーク製造所
大阪府大阪市中央区上町1-21-17
TEL：06-6777-8242
Mail：info@sakaimark.co.jp
https://sakaimark.co.jp/

箔押しマスキングシール

シールを水色の紙に貼ったところ。うっすらとした透け感が、マスキングシールの大きな魅力

©YUKI ANAN

ホログラム箔を使用した箔押しマスキングシール。再剥離の糊を使用しており、貼って剥がせるのが大きな特徴（シールの形状がわかりやすいよう、水色バックで撮影）
デザイン：YUKI ANAN

透け感が素敵と人気のマスキングテープの素材でつくったシール。箔押しを加えると、さらに魅力的なグッズになる。

貼ってはがせるマスキングシールは、マスキングテープに使われているのと同じ和紙素材をシールにしたもの。再剥離の糊を使っているので、貼り直しがきれいにできるし、うっすら透け感があるのがかわいく、手帳やノート、カードや手紙をデコレーションするのに便利なシールだ。印刷適性が高くカラーの絵柄が美しく印刷でき、素材の透け感から、特に水彩イラストとの相性がいい。そしてここにワンポイントで金銀やホログラムの箔押しを加えると、ますます心ときめく仕上がりになるのだ。

酒井マーク製造所では、シールの印刷加工から箔押しまですべてするとスムーズだ。

一貫して社内で行っているため、これだけ凝った加工でありながら約10日間の短納期でつくれるのもうれしいところだ。

箔は、箔メーカー・村田金箔のカタログに載っているものであれば基本的に使える（要事前確認）。

剥離紙は紙タイプもあるが、透け感のあるマスキングシールの場合は特に、透明シートにしたほうが仕上がりの雰囲気が格段にいいのでおすすめ。たとえば65×135ミリのシート内だと、シート端からの余白は5ミリ、シールとシールの感覚は3ミリが必要。シート内のパーツ数がいくつまで可能かも、事前に確認してデータを作成するとスムーズだ。

INFORMATION

最小ロット

オフセット4色印刷＋箔押しの場合、最小ロット1000枚〜、オフセット4色印刷（オンデマンド）のみの場合は最小ロット500枚〜。いずれも経済ロットは5000枚〜

価格

オフセット4色印刷（シートサイズ60×130mm）500枚作成の場合、単価165円、5000枚作成の場合単価30円。オフセット4色印刷＋箔押し1色の場合（シートサイズ60×130mm）、500枚で単価240円、5000枚で単価42円。版代・型代別途

納期

約10日

入稿データについて

Illustratorデータ（フォントをアウトライン化し、塗り足しやカット線を入れたもの）で入稿。シールにするためのデータ修正にも対応してくれる。小ロットの場合、オンデマンド印刷も可能。箔押しの箔はメタリックやホログラムなどを豊富にそろえているので、まずは問い合わせを。台紙は通常、白い剥離紙となるが、透明シート（剥離紙）に仕上げることも可能

問い合わせ

株式会社酒井マーク製造所
大阪府大阪市中央区上町1-21-17
TEL：06-6777-8242
Mail：info@sakaimark.co.jp
https://sakaimark.co.jp/

フレークシール

絵柄に沿って一つずつカットされたフレークシールは、手帳や手紙のデコレーション用に、近年、人気急上昇のグッズだ。

フレークシールのパッケージ例。葉っぱの形に穴を開けた型抜き台紙の印刷加工も一緒に注文し、OPP袋にセットするアッセンブリ作業まで行なったもの

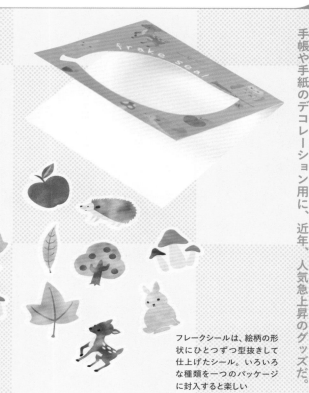

フレークシールは、絵柄の形状にひとつずつ型抜きして仕上げたシール。いろいろな種類を一つのパッケージに封入すると楽しい

INFORMATION

最小ロット

最小ロットは10枚〜。経済ロットは300枚〜。オンデマンド印刷なので小ロットから注文しやすい

価格

上質タック紙で1片30×30mmのフレークシールを作成する場合、10枚1664円、300枚2805円(同じ外寸で、複数種類のデザインを作成する場合は、ボリュームディスカウントあり)

納期

5営業日〜

入稿データについて

データは、フォントをアウトライン化したIllustratorデータ、またはPhotoshopなど画像編集ソフトでの入稿も可能。カットラインは絵柄周囲に1〜2mmの白フチで作成のこと(カットラインは穏やかなカーブが望ましい。ノコギリ状や、極端に鋭角なものは、抜き加工時に破れる可能性があるのでNG)。また、カットラインは±0.2mm程度の誤差が生じる場合がある。台紙印刷や、OPP袋へのセット(アセンブリ作業)は別途料金が必要(納期も要相談)

問い合わせ

藤井印刷株式会社
和歌山県和歌山市西高松1-5-17
Mail：info@fujii-pt.com
http://www.fujii-pt.com/

フレークシールとは、絵柄に沿って剥離紙ごと一つずつカットされた、小さなシールのこと。フレーク(Flake)とは「薄片(はくへん)」という意味。手帳や日記、手紙やカード、ノートなどをデコレーションするグッズとして、この数年、人気を集めているシールで、数種類〜十数種類のフレークシールが一つのパッケージに封入されて販売されることが多い。

一つひとつは小さいシールなので、手帳などに挟んで持ち運びやすいし、普段づかいがしやすいことが、人気を集めている理由。数々の種類のシールからどれを使うかを選ぶワクワク感もある。

シール用紙は、表面が非塗工の上質タック紙や、表面に光沢があるアートタック紙、キラキラ光る繊維の入った和紙タイプ、水に強いユポなどから選択可能。表面にグロスPPやマットPPのフィルムを貼ることも可能だ。

せっかくフレークシールをつくるのであれば、10種類前後のシール類を混ぜてパッケージした形で仕上げたい。通常の注文では、シールの種類ごとに型抜きされた状態で箱詰めしての納品だが、台紙をつくり、複数種類を混ぜてOPP袋に封入するアッセンブリ作業も、別途費用で注文することが可能だ。上写真のような型抜き台紙を作成してパッケージするのもいい。

静電ウォールステッカー

窓ガラスにスッと貼れ、ストレスなく剥がせる

本誌に実物付録しているのがこれ。透明タイプにCMYK＋白、そしてスクリーンホイル（マット金）が入った豪華版

白タイプの静電ステッカーもつくれる

貼ってもはがせて、糊も残らない。その理由は静電気の力でくっつくから。窓や鏡、平坦な壁はもちろん、近頃よく使われるアクリル仕切りやビニールシートなどにもしっかりくっつくスグレモノ。

九堂印刷所では糊などの粘着剤でくっつけるのではなく、静電気の力でウォールステッカーに入れることも可能だ。スクリーンホイルは高温の金属凸版で箔を圧着させる箔押しとは違い、スクリーン印刷で糊を刷って箔を貼り付けて転写するという加工なので、シートが高温で波打ってしまうこともなく、美しく仕上がる。

長方形や正方形仕上がりなら最後に断裁を、いろいろな形にするには型抜きや、1シートにいくつものステッカーを入れるならハーフカットにするなど、抜き加工も用途に応じて入れられる。

することもでき、この加工を静電ウォールステッカーに入れることも可能だ。スクリーンホイルは高温の金属凸版で箔を圧着させる箔押しとは違い、スクリーン印刷で糊を刷って箔を貼り付けて転写する

用して窓ガラスや凸凹の少ない壁紙、木製家具、プラスチック、金属板など平滑なものにくっつけられる、re fit+（静電ウォールステッカー）をオーダーできる。

ベースとなるシートは透明と白の2タイプ。どちらもUVオフセット印刷でさまざまな絵柄を刷れるが、透明タイプはCMYKの下に白を刷ることも可能だ。

また同社ではスクリーンホイルという糊を印刷して上から箔を転写する加工を

INFORMATION

最小ロット

直径150mmのサイズなら、最小ロット100枚〜、経済ロット1000枚〜

価格

直径50mmの透明タイプでCMYK＋白（丸に型抜き）100枚のとき単価1200円〜、1000枚のとき単価240円〜

納期

校正に5日、校了後2週間程度〜

入稿データについて

透明タイプの場合は、CMYKの下に白をいれるかどうかを決める。入れる際は白版もつくって入稿。スクリーンホイルを入れる際は、モノクロデータで用意し、箔の色を決める

問い合わせ

株式会社一九堂印刷所
東京都中央区築地1-9-5
TEL：03-3542-0191
Mail：info@ichikudo.co.jp
https://ichikudo.com/

POPテープ

印刷はグラビア印刷

透明テープに白ベタ印刷＋黒で2色印刷した細幅のPOPテープ。テープの天地3mmにはロゴや文字の印刷はできないので要注意

INFORMATION

最小ロット

50mm幅（100m巻）の場合、最小ロットは約240巻（テープ幅によって異なる）。これが1ロットとなり、ロット単位での注文になる
※出来高数量に10％程度の増減あり（全数引き取りとなる）

価格

50mm幅×100m巻（地色1色＋ロゴ1色＝2色印刷）を1ロット（約240巻）製作の場合、約27万円。テープ幅や使用する色数によって単価は異なる。また、注文ロット数によっても単価が変わる

納期

最終デザイン確認後、約5週間

注意点

テープ幅は12、15、20、24、30、40、50mmの7種類から選択。長さは100m巻のみとなる。デザイン時は、文字サイズ8ポイント以上、線幅0.2mm以上にすること（基準以下の場合、印刷がかすれる可能性がある）。天地3mmはロゴ印刷不可。印刷ピッチは470mm。紙管内径サイズが90mmという特殊なサイズになる。POPテープはOPP素材のため、手ではカットできない。また、使用状況によっては糊残りする可能性があるので、必ず事前に実際の使用状況でのテストを行なうこと

問い合わせ

日本テープ株式会社
東京都板橋区双葉町35-10
TEL：03-5943-4480
Mail：staff@nihontape.com
https://nihontape.com/

POPテープは、弱粘着タイプのポリプロピレン製（OPP）テープだ。

たとえば「BIG BARGEN」などの文字を印刷したり、ブランド名を印刷したテープを店頭の棚に貼るなどして使われている。ベースのテープは透明色のみ。これにグラビア印刷を行なう。多色印刷が可能で、DIC指定など

による特色や、ベタ印刷にも対応している。特色指定の場合、印刷できるのはベースを含んで5色までだ。金銀印刷も可能。テープが透明なので、ベースに色を敷きたい場合は、1色分となる。また、網点やグラデーションの印刷にも、デザインによっては対応している。

その特徴は、はがしやすく、糊残りしづらいということ。このため、壁面や棚に貼っても、貼った場所を傷めることなく、はがすことができる。

このテープ、実はもともと、小物野菜の結束用などに使われていたもの。テープの粘着面同士を貼り合わせると強い粘着力が生まれるが、束ねた野菜などには付着しないようにつくられていることに着目した日本テープが、イベント時の店頭装飾など、POPとして使えるのではと思いついたのがPOPテープなのである。

弱粘着タイプなので相手面を傷めずきれいにはがせて、店頭装飾などPOPとしても使えるのが「POPテープ」だ。

P

目新しいテープを探している人は、試してみてほしい。

養生テープ

テープの中でもこのごろ注目を集めているのが「養生テープ」。本来、建築現場などで使われるテープだが、これに絵柄を印刷すると、おしゃれなテープに早変わりするのだ。

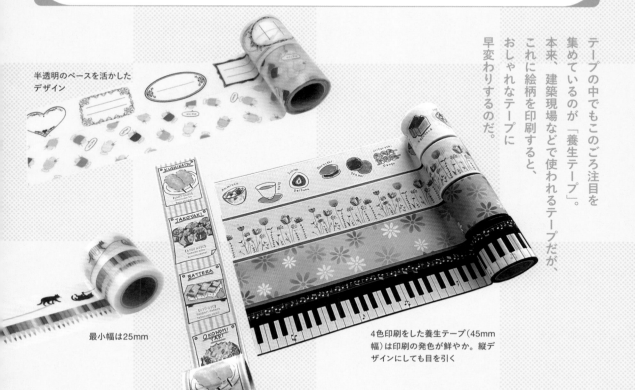

半透明のベースを活かしたデザイン

最小幅は25mm

4色印刷をした養生テープ（45mm幅）は印刷の発色が鮮やか。縦デザインにしても目を引く

建

築現場や引っ越しのときに養生シートを固定したり、家具の扉や引き出しを仮止めするときに使われる、緑や白の養生テープ。ガムテープのように貼った場所に糊が残ることもなく、きれいにはがせること、手で簡単に切れること、そしてPETクロス素材のため水に強く丈夫なことが、その特徴だ。

便利で使いやすい養生テープに「絵柄を印刷した、かわいいものがあればいいのに」というクラフト系手づくり作家の声にこたえ、新建新聞社の運営する小屋女子DIYカフェが2年半がかりで開発し、オリジナルデザインを印刷できるようにしたのが、こちらの養

生テープ（YOJOTAPE）だ。半透明ベースのテープに4色印刷を行なうことができる（特色印刷は不可）。印刷の発色性がよく、きれいな色に仕上がること、テープ自体に透け感があり、重ね貼りが楽しめることも大きな魅力。幅は25ミリから5ミリ単位、巻きは3メートル以上から製作可能だ。

水に強いので、キッチンやガーデニングまわりを飾ったり、キャリーケースのデコレーションに使ったり。テープ芯が小巻なので、女性にも扱いやすく、持ち運びにも便利だ。展覧会やイベントの販売用グッズ、企業のノベルティなどで人気を呼んでいる養生テープ、ぜひ一度つくってみたい。

INFORMATION

最小ロット

最小ロットは300個〜（25mm幅のみ500個〜）

価格

45mm幅×4m巻きで300個製作の場合、約9万円（色校正1回分含む）。サイズ、個数により価格は異なる

納期

色校正に1週間〜10日。校了後、約50日。数量、仕様により変動

入稿データについて

フォントをアウトライン化したIllustratorデータで入稿。デザインピッチは最長1020mm。4色印刷で、特色印刷は不可

問い合わせ

小屋女子DIYカフェ
（新建新聞社　DIY事業部）
長野県長野市南県町686-8
TEL：026-219-1081
Mail：info@diycafe.jp
http://yojotape.com/

水貼りテープ

裏に水をつけると、あらかじめ付いていた乾糊が作用して貼り付けられる水貼りテープ。ロールタイプのこのテープにオリジナル印刷や箔押しをすることができる。

ミシン目で切るとこれが1枚。コスモテックの匠が！

未晒クラフト紙の水貼りテープに印刷＋箔押し＋ミシン目加工を入れたオリジナル品

裏に水をつけるとしっかり貼れる

シ

ール印刷機はロール状の原紙をセットして、印刷やナンバリング印刷、箔押し、型抜きなどができる機械。

であれば、ロール状の紙ならシール原紙であるタック紙以外でも印刷加工できるのでは？

そんなひらめきから本書編集部が思いついたのが、パネル貼りやカルトナージュなどで使う水貼りテープ。そのままだと普通の紙テープに見えるが、裏面に水をつけるとそこが糊になって貼ることができるもの。これにオリジナル印刷ができたらすごくいいグッズになるではないか！

そんなオーダーにまたしても応えてくれたのが、箔押し会社のコスモテック。まだ加工したことがなかったというものの、すぐにテストしてくれて、結果も上々。印刷だけでなく、箔押しやミシンも問題なく入れられるという結果だった。

水貼りテープは茶色い未晒クラフト紙タイプをはじめ、白や深緑、黒などがあり、最初はテストが必要だが基本的にはどれでも加工可能。素朴なシールグッズとして、またこだわった梱包資材としてつくってみたいグッズだ。

INFORMATION

最小ロット

最小ロット10〜30m巻き1ロール〜。経済ロットは10m巻き100ロール〜

価格

未晒クラフト紙タイプに印刷＋箔押し＋ミシン目を入れた1ロール（10〜30m巻）で45000円〜。10m巻き100ロールの場合で単価2000円〜（共に材料費・校正代別途）

納期

校了から約3週間程度

入稿データについて

Ilustratorデータ。フォントはアウトライン化必須。特色印刷は3色まで可能。

問い合わせ

有限会社コスモテック
東京都板橋区舟渡2-3-9
TEL：03-5916-8360
Mail：aoki@shinyodo.co.jp
https://note.com/cosmotech

アルミエンボス シール

クッキリ、しっかりと入ったエンボスが物質感の高さを醸し出している

アルミそのものがシールになっているので、めくった裏側もアルミそのもの

試作してもらったアルミエンボスシール。金銀2色ある。写真は艶タイプだが素材をつくっているヨシモリではつや消しタイプもあり
イラスト：辻優子

貼ってみても紙とは一味違った硬質な仕上がりになっている

金属であるアルミそのものをシート状に伸ばして、片面に粘着加工を施した素材。印刷もできるが特にいいのがエンボス加工。凸凹のエッジがキュッと際立ち、アルミならではの物質感あるシールができる。

シ

ールの素材は一般的には紙もしくはフィルムが使われているのがほとんどだ。金銀メタリックのものでも、アルミを蒸着加工したり、表面に塗ったりと加工してそう見せているのだ。

しかし本物の金属そのものでできたシールがある。シールの元となるそのタック紙をつくっているのがヨシモリ（株）。シート状にしたアルミに粘着加工を施してシールにしている。金銀の2色でそれぞれ艶タイプと艶消しタイプの全4種類のラインナップだ。

このアルミそのもののタック紙を使ってエンボス加工を施すと、本物のエンブレムのような、物質

感溢れるシールになる。エンボス加工すると、紙よりもキュッとシャープに凹凸が入り、紙と違ってそれが戻ってしまうことが少ないので、エンボスが際立つのだ。

紙面掲載用につくってくれたのは、箔押し加工とシール印刷を得意とするコスモテック。過去に、実際にこの素材にエンボス加工してシールをつくったこともある。エンボス加工だけでなく、空押し（デボス）加工や印刷も入れてもらうことができる。

エンボスが際立ったモノ感の高いこのアルミエンボスシールは注目の一品だ。

INFORMATION

最小ロット

4000枚〜

価格

エンボス加工＋型抜きタイプのアルミエンボスシール→4000枚で25万円（版代、紙代、加工賃込み）

納期

データ入稿（校了）から約2週間

入稿データについて

エンボスデータ、型抜きデータの2つが必要。上記の価格は参考価格なので、加工の難易度などによって価格は異なる。校正が必要な場合は別途費用・工期がかかる。

問い合わせ

有限会社コスモテック
東京都板橋区舟渡2-3-9
TEL：03-5916-8360
Mail：aoki@shinyodo.co.jp
https://note.com/cosmotech

レッテルシール／封緘シール

金のホイル紙を使い、そこに活版2色刷り＋エンボス加工＋型抜きした封緘シール。豪華でかわいい

最初にテストでつくってもらった、活版1色刷り、エンボス加工、型抜き加工した封緘シール。際まで入った細い色縁がいい！

葛西臨海水族園のマグロのレッテルシール。コインやメダルを思わせる、立体感のある仕上がり。つや消し金のタック紙を使用し、紺とブルーの活版2色刷り＋エンボス加工＋色入りエッジ型抜き
デザイン：齋藤未奈子（葛西臨海水族園）／印刷加工：コスモテック

昔のデパートの包み紙の留め部分などに貼られていた、裏に水をつけるタイプのレッテルシール。封緘シールとも呼ばれるこのシールは、細かなエンボスや型抜き部分ギリギリまで入った色縁など、独特のかわいさがある。

素

朴な紙に活版印刷で店名やキャッチコピー、所在地などが配されたレッテルシール。裏に水をつけるとくっつくタイプのこの封緘シールは、つくりたいという本書編集部の願いを叶えてテストし、現代風封緘シールをつくってくれたのがコスモテックだ。コスモテックのこのレッテルシールは、昔のものと同様、型抜きのギリギリにまで入った色縁（レトロ技法）が本当にいい！裏は水糊タイプではなく、現在の一般的なシールタイプでつくられているので使いやすい。ぜひオリジナルシールとしてつくってみたい。

朴な紙に活版印刷で店名やキャッチコピー、所在地などが配されたレッテルシール。そして最大の特徴はシールの縁ギリギリに細い色が入っていること。これをどうしてもつくりたいという本書編集部の願いを叶えてテストし、現代風封緘シールをつくってくれたのがコスモテック

昔、デパートやお店のシールとして、包装紙で包んだ最後に貼られたり、商品に貼られたりとよく使われていた。

しかし、今よく使われている、もともと粘着加工されているタイプのシールが登場すると、レッテルシールもそのタイプが使われはじめ、現在では昔の封緘シールと同じ製法でシールをつくることはできなくなっている。

でもこのレッテルシール、エンボスが入っていたり、活版での素朴な刷りだったりが本当にかわいい。

INFORMATION

最小ロット

1000枚〜

価格

上写真の金のホイル紙＋活版2色刷り＋エンボス加工＋型抜きタイプの封緘シール→1000枚で69000円（版代、紙代、加工賃込み）

納期

データ入稿（校了）から約2週間

入稿データについて

印刷用データ、エンボスデータ、型抜きデータの3つが必要。上記の価格は参考価格なので、使う素材や加工の難易度によって価格は異なる。校正が必要な場合は別途費用・工期がかかる

問い合わせ

有限会社コスモテック
東京都板橋区舟渡2-3-9
TEL：03-5916-8360
Mail：aoki@shinyodo.co.jp
https://note.com/cosmotech

活版＋箔押し強圧シール

ふっくらとした風合いの紙に、活版印刷と箔押し加工とがキュッと深く押し込まれて印刷加工されたシール。

こんなのあったらいいなと思う風合いあるシールは、箔押し加工とシール印刷を専門とするコスモテックの得意技だ。

活版印刷や箔押し加工でギュッと強く押して、アナログ感ある仕上がりにしたい。シール印刷は現在でも活版（凸版）印刷でつくることはよくあるが、現状シール台紙（タック紙）のラインナップには堅く締まった板紙タイプは多少あるものの、ふっくらした風合いのものはほぼない（本当は「クレーンレトラ」やコースター原紙のような紙のタック紙が欲しいのだが、残念ながら現状はない）。そのため、活版や箔押しを強く押しても、凹みのついたアナログ感あふれる仕上がりにはなりにくい。

しかしシール印刷＋箔押し加工を手がけるコスモテックでは、その両方を手がける強みを生かして、ふっくらした素材に強圧で活版＋箔押ししたシールをつくることができる。その秘密はまず和紙素材

を合紙してオリジナルのシール紙をつくること。そうすることで紙自体に厚みをもたせることができるので、そこに通常より大きな圧をかけて活版印刷と箔押し加工を施すと、凹凸を感じる仕上がりの、アナログ感あふれるシールができるのだ。

和紙素材とタック紙を合紙してから活版印刷＋箔押し加工。合紙することで厚みをつけ、強圧で印刷加工している。コスモテックならではの微細な美しい箔押しと印刷がしっかりと入っている
デザイン：◎今友マーヤ

デザイン：molly's　　　デザイン：鹿間そよ子

INFORMATION

最小ロット

1000枚〜

価格

写真の和紙素材＋活版墨1色刷り＋箔押し＋型抜きタイプ→1000枚で64000円（版代、紙代、加工賃込み）

納期

データ入稿（校了）から約2週間

注意点

印刷用データ、箔押しデータ、型抜きデータの3つが必要。箔押しする際、手描きの線はデジタルの線よりもやや「バリ」が多めにつく感があり、箔押しの力強さがでるのでオススメ。

問い合わせ

有限会社コスモテック
東京都板橋区舟渡2-3-9
TEL：03-5916-8360
Mail：aoki@shinyodo.co.jp
https://note.com/cosmotech

フチドリシール

きらきらしていたり、繊細な加工がかわいいファンシーシール。なかでもフチドリシールは、縁に金銀の箔押しがされ、その縁部分だけが盛り上がっているシール。繊細な絵柄もバッチリ加工できる。

臼井印刷のフチドリシールは、透明なタックフィルムに印刷された絵柄の輪郭部分に箔押しされているシール。よく見ると、その縁部分が少し盛り上がって、立体的になっているのが特徴だ。

通常、シールを絵柄の形に抜く場合は抜き型が必要で、型代が固定費としてかかってくる。しかしこのフチドリシールは、絵柄を多色印刷した後、その輪郭に箔押しする際の熱を利用して、タックフィルムを溶かして盛り上げ、同時に基材を溶かし切っているのだ。

このため、抜き型不要で、縁とハーフカット（剥離紙は抜かず、シールだけを型抜きすること）がずれることももちろんない。

さらに進化系として、絵柄の輪郭だけでなく、絵柄の中にも箔押ししたタイプもある（写真下のスヌーピーがそのタイプ）。絵柄の中の箔は、縁の箔とは同時に押せないため、実は二度にわけて箔押ししているのだ。進化系はセアールと臼井印刷の共同開発だ。

作業には熟練の技を要し、細かい柄になればなるほど難易度は上がる。

これがフチドリシール。縁の金の箔部分が少し盛り上がっている。カエルの指先の細かい部分もきれいに抜けている

こちらは進化バージョンのフチドリシール。縁部分と絵柄の中部分の2回に分けて箔押ししている

©UFS

INFORMATION

最小ロット

1万シート～

価格

75×180mmのシート内に数点のフチドリシール付け合わせの場合、1万シートで単価54円。別途、版代（CMYK＋白）5500円×5、箔版代12000円

注意点

凸版間欠輪転印刷となるので、薄い平網の表現には向かない。一番薄い色で5％、それ以降、10％刻みにするとよい。印刷が少々つぶれる可能性があり、あまりに小さい文字は再現が難しい場合があるので、要確認

問い合わせ

臼井印刷株式会社
東京都台東区蔵前3-9-1
TEL：03-3864-0601
Mail：u-seal@nifty.com
http://www.usuiprint.co.jp/

リボンシール

リボンの見本帳。
さまざまな色のリボンがある

よく見かけるリボンシール。
左はコート紙に凸版印刷、
右は金のタック紙に箔押し
している

リボンをくるりと丸めてシールの下に挟
んでいるように見えるが、裏返すと（写
真左）、上下に型抜きされたサテン地が
貼り付けてあることがわかる

記念日やイベントのギフトに、ワンポイントとして貼りたいリボンシール。帯状のリボンを挟んでいるのかと思いきや、実は型抜きでリボンがつくられていることが多いのだ。

ギフトパッケージのワンポイントとして、イベントでの作業となるので、納期は早く、コストを抑えることができ、仕上がり品質も一定だ。

リボンシールの製作を得意とする臼井印刷では、型抜きしてもほつれにくい特殊なサテン地をリボンに使用。色も、赤や緑、金銀などよく見かけるものだけでなく、見本帳のさまざまな色から選ぶことができる。リボンの付け方も、よくある2枚タイプだけでなく、1枚だったり、上にもリボンがついているタイプなども可能だ（特殊な形の場合は、別途型代が必要になる）。リボンにも箔押しすることができるため、より高級感を出すことも可能だ。

付けのリボンシールに比べ、機械を問わずよく使われるリボンシール。帯状のリボンを手作業で入れる場合もあるが、実は、タック紙の下にサテンの布をはさみ、シールを型抜くと同時にリボンも型抜きをして、帯状リボンのように見せているものが多い。手

INFORMATION

最小ロット

5000枚〜

価格

付録の直径40mmのシール（ミラコートタック）＋幅12mm・長さ25mmのリボンに凸版1色印刷の場合、5000枚で単価9.20円、1万枚で単価6.60円。別途、版代3000円、抜き型代12000円

納期

データ入稿後、約7〜10営業日

注意点

作成可能なサイズは最小で直径10mm、最大で直径100mm。凸版印刷となるので、薄い平網の表現には向かない。一番薄い色で5%、それ以降、10%刻みにするとよい。印刷が少々つぶれる可能性があり、あまりに小さい文字は再現が難しい場合がある。ただし、平圧凸版、間欠凸版輪転印刷であれば細かい網点表現も可能なので、事前に確認を。多色印刷、エンボス加工、箔押し加工に対応。リボン部分にも箔押し可能

問い合わせ

臼井印刷株式会社
東京都台東区蔵前3-9-1
TEL：03-3864-0601
Mail：u-seal@nifty.com
http://www.usuiprint.co.jp/

POPアップシール

商品を紙袋に入れた後、中が見えないように、口をシールで留めるときに使えるのがPOPアップシールだ。

リ

ボンシールの技術を使って、違う用途のシールがつくれないか？　そんなアイデアから生まれたのが、紙袋の口留め用シール・POPアップシールだ（特許取得商品）。つくりはシンプルで、2枚のシールの間にリボンをつけ、紙袋の口部分に貼るというもの。ただしこれだけだと開けるのが大変になるので、開けやすいように、リボン部分にミシン目が入っている。これによって、簡単にリボンを破き、袋を開けることができるというしくみだ。

型代はかかるが、シール部分は絵柄に合わせ、好きな形に抜くことが可能。通常は強粘着タイプだが、貼ってはがせるタイプ（CoCoアップシール）もある。

シール部分はいろいろな形で型抜きすることが可能

紙袋の口留め用シール・POPアップシール

INFORMATION

最小ロット

5000枚〜

価格

直径50mmのシール（ミラコートタック）＋長さ25mmのリボンでつないだタイプ、凸版1色印刷の場合、5000枚で単価11.30円。別途、版代30000円、抜き型代20000円

納期

型抜きデータ入稿後、約7〜10営業日

注意点

作成可能なサイズは直径20〜80mmの間。多色印刷、エンボス加工、箔押し加工に対応。リボン部分にも箔押し可能

問い合わせ

株式会社プレブ
神奈川県横浜市緑区寺山町620-10
TEL：045-933-8951
http://www.p-v.co.jp/

臼井印刷株式会社
東京都台東区蔵前3-9-1
TEL：03-3864-0601
Mail：u-seal@nifty.com
http://www.usuiprint.co.jp/

スクラッチシール

銀色などで隠された部分をコインで削ると、下から「当たり」などの文字が現れるスクラッチカードを手軽につくれるシールだ。

ス

クラッチカードの多くは、スクラッチインキをスクリーン印刷して加工されている。しかし版代の固定費がかさむため、100枚や200枚といった小ロットでは高くついてしまうのが現状だった。

小ロット用途のときに、少ないコストで手軽にスクラッチカードがつくれるよう、臼井印刷が開発したのがスクラッチシールだ。実はこれ、糊のついていない箔の裏側の銀色面を表になるようにして透明フィルムに貼り合わせているというもの。絵柄を印刷した紙にこのシールを貼れば、スクラッチカードの出来上がりだ。

透明フィルムに「当たり」「ハズレ」といった印刷をあらかじめ入れることも可能。また、銀色の表面に印刷することも可能だ。

箔の裏面を表になるよう、透明フィルムと貼り合わせてシールにした「スクラッチシール」。写真上のように、削ると、下の紙に印刷した文字や絵柄が現れる

INFORMATION

最小ロット

1000枚〜

価格

直径20mmの丸型シール5000枚で単価7円、1万枚で単価4.20円。別途、抜き型代4000円

納期

型抜きデータ入稿後、約7〜10営業日

注意点

作成可能なサイズは直径15〜150mm。銀無地ベースだが、CMYK＋白印刷も可能。また、隠れている透明フィルム面にも1色印刷が可能だ

問い合わせ

臼井印刷株式会社
東京都台東区蔵前3-9-1
TEL：03-3864-0601
Mail：u-seal@nifty.com
http://www.usuiprint.co.jp/

表面には、CMYK＋白で絵柄を印刷することも可能

シールの裏側を見ると金色が。金の箔を裏返しにして使っているのだ

ロイヤルタック

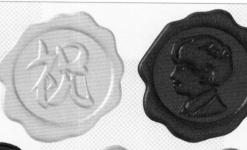

ロイヤルタックL型（写真上）と
ロイヤルタックS型（写真下）

白金化成の各種シート見本帳から、
素材を選んでオーダーできる

封筒に貼ると、立体感も質感も本物の封蝋（シーリングワックス）のように見える

古くからヨーロッパで手紙の封筒などに封印として使われている封蝋（シーリングワックス）。これを模し、手軽に量産できるシールタイプのものが「ロイヤルタック」だ。

封蝋（シーリングワックス）はもともと、ヨーロッパで封筒や文書の封印に使われているもので、中身が手付かずであるということの証明も兼ねて、溶かした蝋を封部分に垂らし、その上から印璽（シール）で刻印して使われるもの。現在では元の用途以外に、結婚式の招待状の封筒に使われたり、パッケージに意匠性から使われたりもする。

しかし実際の封蝋をするのは手作業で手間がかかる。そのため、より簡易に使えるようつくられているのが、白金化成の「ロイヤルタック」だ。一見すると本物の封蝋のように見えるが、素材に同社が売するPVCなどの合成樹脂シールを使用し、型抜き＋エンボス加工でつくられたシールなのだ。シートの種類や色と、中心に入るエンボスデザインをオリジナルにしてオーダーすることができる。シール自体の形は決められており、サイズ違いでL型とS型の2タイプがある。

ロイヤルタックL型は、外形サイズが横幅約30ミリ、内側（オリジナルデザインが入れられる部分）が直径約22ミリの円形。S型は外形サイズの横幅が約23ミリ、内側が直径約16ミリだ。印刷は入らず、エンボスのみで表現する。結婚式の招待状はもちろん、これなら大量に使うパッケージなどにも使える便利なシールだ。

INFORMATION

最小ロット

1000個〜

価格

L型1000個の場合、単価26円程度。版代別途

納期

データ入稿してから3〜4週間程度

注意点

外形はL型・S型ともに定型で決まっているため、内側の円内に入れるエンボスのみオリジナルにできる。サイズや外形からオリジナルにしたい場合は、抜き型代などの初期費用がかかってくる

問い合わせ

白金化成株式会社
東京都台東区元浅草4-1-12
TEL：03-3847-8953
http://www.shilogane.co.jp/

クリアカットシール

型抜きに刃型を使わず、非常に細かく複雑に入り組んだ絵柄でも、その形の通りにきれいに切り抜くことができるのが、ミラクル工業の特許技術、クリアカットシールだ。

シールをつくるときには、絵柄を印刷した後に、刃型を使って型抜きをすることが多い。しかし金属でできた刃型だと、細かすぎるものや複雑なものは、型抜きするのがどうしても難しかった。

ミラクル工業のクリアカットシールは、抜き型を使わずに、絵柄や文字など、印刷されたインキ部分だけを残してシールにできる技術だ。原反メーカーと共同で独自開発した透明シートに絵柄を印刷し、その上にクリアニスをスクリーン印刷して「クリアカット加工」の工程を経ると、印刷した部分のみがシールとして残るしくみ。クリアニスはスクリーン印刷で盛るので、フラットに仕上げることもできれば、一番厚くて0・3ミリぐらいにぷっくりとした仕上がりにすることも可能だ。下地の絵柄印刷は、オフセット、凸版、デジタルのいずれも可能で、箔押し

シルバーのメタリック紙に貼ったところ。絵柄の形にきれいにシールが切り抜かれているのがわかる。印刷はCMYK＋白で、色を透けさせたいところには、白を入れないようにするとよい

加工もOK。線幅は0・2ミリまで可能という精度の高さだ。細かな絵柄の中も抜けるのがすごい。

また、抜き型でカットしたシールは鋭角な切断面が引っかかりやすく、剥がれの原因になるが、クリアカットの場合はエッジが滑らかで引っかかりが少なく、剥がれにくいというのも大きな特徴だ。絵柄だけを転写できるので、立体物や湾曲面にも貼ることができ、転写後は印刷したような仕上がりになる。ファンシーシールやロゴ

マークシール、ネイルシール、ルアー装飾シールなど、いろいろな用途が考えられる。

転写前のクリアカットシール。裏面に剥離紙、表には透明シート（アプリケーション）がついている。非常に細かい絵柄も、オフセット印刷で繊細に刷り上がっている

INFORMATION

最小ロット

特に設けていないが、ロットが少ない場合は割高となる

価格

付録のクリアカットシール（50×50mm、オフセットCMYK＋白印刷＋クリアインキ）の場合、100枚で単価650円、500枚で単価150円、1000枚で単価80円、2000枚で47円、4000枚で単価29円、1万枚で18円。製版代別途12000円、要校正の場合は別途校正代20000円

納期

データ入稿後、量産納期は約10日

注意点

作成可能な最大サイズはA4まで。線幅は0.2mmまで。1枚のシート内に絵柄を複数入れることも可能だが、絵柄間のアキは3mm以上開けること。仕様上、絵柄に対して0.3mmの透明の淵がつく。入稿はai形式で

問い合わせ

ミラクル工業株式会社
◎本社　大阪市平野区加美南2-4-24
TEL：06-6792-0204
Mail：osaka@miracle-kogyo.jp
◎東京営業所　東京都千代田区神田須田町2-7-10
ブライティング神田ビル5F
TEL：03-6206-9324
Mail：tokyo@miracle-kogyo.jp
http://www.miracle-kogyo.jp/

クラフトデコレーションテープ

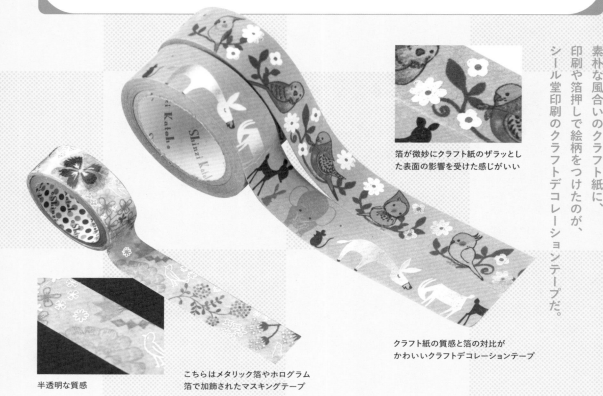

箔が微妙にクラフト紙のザラッとした表面の影響を受けた感じがいい

クラフト紙の質感と箔の対比がかわいいクラフトデコレーションテープ

こちらはメタリック箔やホログラム箔で加飾されたマスキングテープ

半透明な質感

素朴な風合いのクラフト紙に、印刷や箔押しで絵柄をつけたのが、シール堂印刷のクラフトデコレーションテープだ。

和紙素材をベースにした独特の風合いのマスキングテープが人気だが、シール堂印刷のクラフトデコレーションテープは、また違ったかわいさをもっている。素材は名前の通り、クラフト紙。未晒の素朴な紙に、オンデマンドで絵柄を印刷し、箔押しも行なえるのだ。素材感ある紙の上に箔が光る様子は、なんともかわいい。通常のメタリック箔だけでなく、ホログラム箔にも対応してくれる。

ただし素材にクラフト紙を使用しているため、一般的なマスキングテープより粘着力は弱く、付箋程度の粘着力となる。最大有効幅

は180ミリで、そこに何列とるかにより、テープ幅もさまざまに対応可能。10種類まで同時につくれる。長さも3〜15メートルまでの実績をもっている。デザインは150ミリのピッチでループするため、150ミリ分のデータを作成。テープの上下には各1.5ミリの塗り足しが必要だ。箔は、印刷の後加工となる。

クラフトデコレーションテープのほかにも、メタリック箔やホログラム箔で加飾されたマスキングテープが制作可能だ。こちらは、マスキングテープならではの透け感がかわいい仕上がり。

INFORMATION

最小ロット
オンデマンド印刷なので何巻からでも可能だが、経済ロットは10種×100巻＝1000巻程度

価格
15mm幅×長さ5mのクラフトデコレーションテープを10種×500巻で計5000巻つくった場合、単価195円〜

納期
約1.5〜2ヵ月

注意点
素材がクラフト紙のため、通常のマスキングテープより粘着力の弱いタイプとなるので要注意。印刷はCMYK4色、テープの上下には各1.5mmの塗り足しをつけること

問い合わせ
株式会社シール堂印刷　埼玉事業所
埼玉県幸手市大字上宇和田521-20
幸手ひばりが丘工業団地
TEL：0480-48-3051
http://www.seal-do.co.jp/

ぷくぷくシール

中にスポンジが入っているかのようにぷっくりとしたファンシーシール。
そんな「ぷくぷくシール」は、2種類の素材でつくることができる。

まるでスポンジのように膨らんだ、ぷくぷくシール。シール製造会社のタニダでつくれるぷくぷくシールは、素材に2種類ある。

一つは「ぷくぷくシールEVA」と呼ばれるもの。素材はウレタンを発泡させたシートだ。絵柄はあらかじめ転写シートに印刷しておき、ウレタン発泡シートに転写して、タック紙と貼り合わせ、型抜きをする。ウレタン発泡シートは1枚で約2ミリの厚さだが、重ねることも可能で、最大で6ミリの厚みまで製作したことがあるという。ふかふかした柔らかい触感で、表面がややマットで上品な仕上がりになるのが特徴だ。

もう一つは「ぷくぷくシールPVC」と呼ばれるもの。こちらは、まず塩ビシートに絵柄を印刷し、その塩ビシートとタック紙の間にある程度の製作期間が必要となる。

薄めのウレタン発泡シートを挟み、型抜きをするというもの。こちらはEVAに比べて少し硬く、ツヤツヤと光沢のある表面が特徴だ。コストはこちらのほうが安い。

こうした素材の型抜きは、高周波ウェルダー加工と呼ばれる熱処理加工で行なわれる。細いところや鋭角の型抜きは難しく、最小で7ミリ角ぐらいが限界だ。裁ち落としとしデザインは可能。

ぷくぷくシールでは、オフセット4色印刷のほか、金銀、蛍光などの特色印刷は可能だが、箔押しは行なえない。型抜き後のカス取りがすべて手作業となることから、

左がぷくぷくシールEVA、右がぷくぷくシールPVC

ぷくぷくシールPVCは少し硬く、ツヤツヤした表面

ぷくぷくシールEVAはふかふかと柔らかく、マットな表面で人気

INFORMATION

最小ロット

1000枚〜

価格

シートサイズ100mm角、同サイズ台紙（4色／1色印刷）つき、OPP袋入れの場合、1000枚で単価460円、3000枚で単価240円、5000枚で単価175円、10000枚で単価110円

納期

データ入稿後、校正まで15日、量産45日

問い合わせ

タニダ株式会社
◎本社　島根県松江市乃木福富町735-208（松江湖南テクノパーク）
TEL：0852-27-1333
◎東京営業所　東京都千代田区神田佐久間町3-22 小林ビル2F
TEL：03-6852-8973
http://www.tanida-kk.com/

キャンディポップシール

これがキャンディポップシール。フチのあたりが少し盛り上がっているのがわかる。透明素材なので、透けさせたくない部分には、印刷で白を敷くことが必要

厚めの透明シートで、縁がほんの少し盛り上がっている。そんなシールが、タニダのキャンディポップシールだ。

縁が少し盛り上がった厚い透明シートがまるでキャンディのように見えることから名付けられた、キャンディポップシール。これは0・5ミリぐらいの厚めの塩ビシートに絵柄を印刷し、高周波ウェルダー加工という熱処理加工で材料を溶かし切ってつくっているシールで、熱で溶かし切ることから、フチが少し盛り上がって仕上がっているのだ。

印刷は凸版印刷。CMYK＋白の5色が可能で、箔押しもOK。塩ビ独特の少し硬い、しっかりした質感も特徴的だ。

INFORMATION

最小ロット

1000枚〜

価格

シートサイズ100mm角、同サイズ台紙（4色／1色印刷）つき、OPP袋入れの場合、1000枚で単価360円、3000枚で単価200円、5000枚で単価152円、10000枚で単価94円

納期

データ入稿後、校正まで15日、量産45日

注意点

作成可能なサイズは、1ピース最大100mm角、最小7mm角。1シートだと最大A4、最小20mm角となる。各ピースはシート仕上がり線から5mm内側に配置し、ピースとピースの間隔は3mm以上開けること。鋭角な形状はできない

問い合わせ

タニダ株式会社
◎本社　島根県松江市乃木福富町735-208（松江湖南テクノパーク）
TEL：0852-27-1333
◎東京営業所　東京都千代田区神田佐久間町3-22　小林ビル2F
TEL：03-6852-8973
http://www.tanida-kk.com/

ポッティングシール

こちらはメタリックシートにポッティングしたサソリのシール。細いシッポの先の突起やハサミのギザギザも見事に表現

紅型の模様を印刷し、ポッティング加工をした、ヤモリの形のシール。細い指の先まできちんと樹脂が盛られている

透明な樹脂が絵柄の上に盛られたポッティングシール。複雑で細かい形をやってくれるのが、そてつの森（ドロップスアート）だ。

INFORMATION

最小ロット

1点〜

価格

粘着付き塩ビシートに溶剤型インクジェット出力した複雑な絵柄にポッティング加工の40×40mmの場合、50枚で単価210円、200枚で単価190円／60×60mmの場合、50枚で単価370円、200枚で単価280円

納期

データ入稿後、1〜2週間

注意点

絵柄印刷がない場合はカット用アウトラインデータを入稿。樹脂が染み込んでしまうので、紙は不向き。また、ラミネートフィルムを貼った部分は樹脂盛り不可能。入稿データはIllustrator（CS4）にて作成のこと

問い合わせ

ドロップスアート
沖縄県那覇市古波蔵3-16-11
TEL：098-995-7020
Mail：info@drops-art.com
http://www.drops-art.com/

絵柄の上に樹脂を厚く盛るポッティングは、機械で行なう場合、複雑な形状は難しい。しかしドロップスアートでは、就労継続支援B型事業所「ドリームワークそてつの森」の皆さんの手作業により、従来は無理と言われてきた複雑で細かい形のシールでも、樹脂を盛ることが可能なのだ。透明度の高いポリウレタン樹脂を使用しており、立体感、光沢感があるのが特徴。

シールに絵柄を印刷し、そこに透明樹脂を盛るのが基本。使えるタック紙は、白や色付きシートのほか、透明、銀、ホログラムなどの特殊フィルムもある。1点から作成可能なのもうれしい。

多層シール

たとえば、小さな瓶のフタや箱など、小さなものにシールを貼り付けられるスペースは、とても限られている。そのなかでたくさんの情報を伝えたいというときに便利なのが、複数層をたたんでコンパクトにした多層シールだ。

メッセージや商品説明、多言語対応など、伝えたいことがたくさんあるのに、それを貼ることのできるスペースは限られているというときに、小さな本のように複数層になった多層シールが活躍する。多層シールとは、折りたたまれた印刷物をタック紙に貼り合わせた、多層状のシールのことだ。たとえば、小島ラベル印刷が製作した写真下の多層シールは、食品のレシピを掲載したミニレシピブックで、200×40ミリのコート紙を40×40ミリの大きさに収納。右側のミシン目から開くと、全11ページで構成されている。このミシンタイプは一度開封したらそのままだが、何度か開閉可能なオーバーラミネートタイプもある。ボトルのような平面でない部分に貼付したいときは、オーバーラミネートタイプのほうがおすすめだ。ただしコストはオーバーラミネートのほうが高くなる。

多層シールの構造は3層。表面はPETでラミネートされており、中央にコート紙四六判73キロ、そして最下層にタック紙（ユポ）。ラミネートとタック紙は変更も可能。ただし、オフセット印刷をする中の紙は、コート紙推奨。小さな面積への印刷となる分、文字も小さくなりがち。できるだけ文字がつぶれず鮮明に印刷できるコート紙が望ましいということだ。仕上がりは、シートでもロールでもロールでも可能だ。多層シールをつくりたい場合は、希望の寸法とページ数を伝えると、イラストレーターのフォーマットデータが送られてくる。ここにデザインを行ない、入稿する。形状は長方形がスタンダードだが、丸やハートの変形タイプも製作できる。

瓶のフタに貼られた多層シール

↓

右側のミシン目を開くと……

↓

中から複数層に折りたたまれた紙が現れる。写真はグラスフェッド・バター「GHEE EASY（ギーイージー）」の瓶に貼付するレシピシールとして作成されたもの

INFORMATION

最小ロット

10000枚〜

価格

40×40mm、11ページ、ミシンタイプの場合、1万枚作成で144000円、2万枚で216000円、3万枚で288000円。初回は別途イニシャル費用（フォーマットデータ作成費用・版代・抜き型代）として18000円が必要

納期

データ入稿後、校正まで15日、量産45日（多層ラベルは製造工程が多いため、ロットが少ないと単価が高くなることから、最小ロットが大きくなっている）

注意点

オフセット印刷→折り加工→貼り合わせ加工→検品というように、通常のシール印刷より多くの工程が必要となるため、納期が長めとなる。また、複雑な構造のため、校正をとることを推奨している。校正では本番とほぼ同じものを作成。試作でも55000円〜の有料となるが、印刷の色味やページ位置などを事前に確認し、ミス防止につなげるねらいがある

問い合わせ

株式会社小島ラベル印刷
神奈川県伊勢原市石田414-1
TEL：0463-93-8555
http://www.kojima-label.co.jp/

アテンションシール

パッケージにPOPのように貼り付けて、注目を促し、キャッチコピーやメッセージを伝えて手にとってもらう。そんな役割を果たすのが、アテンションシール。部分的な糊付けを活用したシールなのだ。

お店の店頭で思うようにPOPを貼ってもらうのは、意外と難しいもの。商品そのものに伝えたいメッセージやアイキャッチとなるシールを貼付すれば、確実に店頭に並べてもらうことができる。アテンションシールは、目を引き、手に取ってもらいたいというときに効果を発揮する、パッケージから飛び出すように貼り付けられるシールだ。

合成紙のユポやテトロンフィルムといった、ハリのあるタック紙を使用し、シールの糊面を透明なフィルムで部分的に糊止め（糊殺し）をして、糊のあるところと、ないところを設けてつくられる。糊を残す範囲はミリ単位で指定でき、変形の糊止め加工や、糊止めした部分にも印刷することが可能だ。店頭でよく見かけるのはテトロンフィルムという銀ツヤのフィルムだろう。コストを抑えたいな

ら、ユポを推奨。

アテンションシールは、商品から飛び出すように貼付されるので、ハリのある素材でないと、時間が経つうちに紙がおじぎしてしまうので注意が必要だ。

店頭POP以外にも、アイデア次第で活用法が広がりそうなアテンションシールだ。

飛び出すように貼ることができるアテンションシール。このシールは、吹き出し口部分、左下だけ糊を残し、それ以外は糊止めしている

INFORMATION

最小ロット

1000枚〜

価格

50×50mmのシールを1万枚つくった場合、約96000円。初回は別途イニシャル費用（フォーマットデータ作成費用・版代・抜き型代）として11000円が必要

納期

7営業日〜（土日祝を除く）

注意点

ハリのない素材では、時間が経つにつれシールがおじぎしてしまうので、推奨のユポやテトロンフィルムを使用するのがよい。箔押し加工も可能

問い合わせ

株式会社小島ラベル印刷
神奈川県伊勢原市石田414-1
TEL：0463-93-8555
http://www.kojima-label.co.jp/

布用転写シール

布にロゴや絵柄を入れたいときは、スクリーン印刷かアイロン転写が一般的だった。しかし布転写用シール「irodo」は、アイロン不要、こするだけで簡単に転写できる。

用転写シール「irodo」は、扶桑が開発したノンアイロンシール。綿や麻、化学繊維、合成繊維などの布製品、そして革や紙などさまざまな素材に転写ができるシールだ。

大きな特徴は、布に転写する際、こするだけで簡単に貼れるということ。これまで、布用の転写シールといえば、アイロンで熱をかけることが一般的だったが、irodoでは一切不要。貼りたい場所に剥離紙から剥がしたシールを置き、フィルムの上から絵柄の部分をコインや爪などで強くこすった後に、絵柄を押さえながらフィルムを静かに剥がすだけで、転写ができる。

さらに、あて布をして手で少し押さえて定着させ、絵柄の部分をもみ込むだけで、洗濯も可能な状態になるのだ。糊の調合により、すぐに取れるものと長持ちするものなど調整してもらうこともできる。

ベタのあるデザインも可能

生地へのなじみがよく、特に細かい絵柄では、スクリーン印刷と見紛うほどの仕上がりになる。絵柄はスクリーン印刷による単色〜多色印刷のほか、グラデーションや写真を使ったデザインも、UVオフセット印刷にすれば可能だ。転写シール加工自体はスクリーン印刷で行なう。500×400ミリが扶桑での最大サイズなので、印刷の版の最大サイズ内であれば作成できる。

このシールを使えば、ラッピングに布を使いたいというときなどに手軽にロゴなどを入れられそうだ。

こするだけで布に絵柄が転写できる。こんなふうに細かい絵柄も可能で、印刷したかのような仕上がり

裏面についている剥離紙から剥がしたirodoを貼りたい場所に置き（事前にホコリを取ること）、コインなどでまんべんなくこすった後、透明フィルムを静かに剥がすと転写できる

INFORMATION

最小ロット
100枚〜

価格
500×400mmのシートで100枚つくった場合、単価約3500円

納期
データ入稿後、約3週間

注意点
データはIllustrator（CS6）で作成。デザイン、トンボ、ベタでレイヤー分けをする必要がある（ベタは、粘着や透明樹脂を刷る際の版データとして使用。基本的には、絵柄のデザインの中を塗りつぶした原寸黒ベタを作成すればよい）。シールを貼る際は、剥離紙から強く剥がすとシールが曲がってしまう場合があるので、静かに剥がすこと。また、貼り直しはできないので、事前にシールを貼る位置を決めること

問い合わせ
株式会社扶桑
東京都葛飾区立石8-41-2
TEL：03-3691-6490
Mail：fusou@kkfusou.co.jp
http://kkfusou.co.jp/

128

盛り上げシール

印刷＋箔押しした絵柄の上に透明インキで厚みをもたせた「盛り上げシール」。0.2〜0.3mm厚盛りすることが可能

印刷や箔の絵柄の上を透明インキで盛り上げた「盛り上げシール」。ぷくぷくした質感がかわいいシールだ。

スクリーン印刷の透明インキによって、表面に厚みをもたせた「盛り上げシール」。

まず、剥離紙の上に糊とウレタン樹脂を印刷。さらに絵柄を印刷してUV硬化の透明インキでコーティング加工を行ないシールを仕上げているため、抜き型不要でつくれるシールだ。

基本的にはできない形はなく、アルファベットの筆記体のような細かい文字から、1、2ミリの点や線のような形状でもつくれるが、透明インキは小さい面積ほど盛り上がり、広い面積だと真ん中が若干凹む特徴がある。

絵柄の一部に箔押しすることも可能（ただしその場合は、箔押しの版代が必要）。箔押し＋透明インキ盛り上げで、ラインストーンのようにすることもできる。

INFORMATION

最小ロット

100枚〜

価格

500×400mmのシートで100枚つくった場合、単価約3000円

納期

データ入稿後、約3週間

注意点

データはIllustrator（CS6）で作成。つくれない形はないが、貼りやすい形・貼りにくい形はあるので、まずは仕様を伝え、相談するとよい

問い合わせ

株式会社扶桑
東京都葛飾区立石8-41-2
TEL：03-3691-6490
Mail：fusou@kkfusou.co.jp
http://kkfusou.co.jp/

香料シール

印刷部分を軽くこするると、ほんのりと香りを発する香料シール。いろいろな香りのシールをつくることができるのだ。

サンエーカガク印刷がレシピを持つ香料インキで作成したシール。「墨汁の香り」なんていう珍しいものも

絵柄をオフセット印刷した上に、香料インキをドット状に印刷している。香料インキ部分はマットな質感になり、香料によって色のつき方や濃さが異なる

香

香りの成分をマイクロカプセルに閉じ込め、インキに混ぜてスクリーン印刷する香料印刷。この手法を使えば、香りつきのシールをつくることができる。印刷部分を軽くこするとカプセルが壊れ、ほんのりと香りを発するしくみ。

香料シールをつくるには、①過去に実績がある香料インキのなかから香りを選ぶ、②オリジナルで香りをつくる、③香料持ち込みでインキをつくる、の3つの方法がある。

香料インキのラインナップ例

フローラル系	イランイラン、さくら、カーネーション、カトレア、カモミール、桔梗、キンモクセイ、くちなし、コスモス、ジャスミン、水仙、スイートピー、すずらん、なでしこ、ハイビスカス、藤、ベゴニア、ユリ、ラベンダー、バラ、蓮の花
フルーツ系	りんご、ぶどう、グレープフルーツ、すいか、オレンジ、ストロベリー、トマト、パイナップル、パッションフルーツ、バナナ、ピーチ、マンゴー、メロン、ラ・フランス、レモン、マスカット、ライム、シークワーサー
フード系	カレー、キャラメル、グリーンティー、ココナッツ、コーラ、シナモン、紅茶、レモンティー、ソース焼きそば、ソーダ、チョコレート、バニラ、プリン、ポテトチップス、肉まん
ハーブ系	グリーンフローラル、森林浴、ペパーミント、シトロネラ、ひのき、ムスク、ユーカリ、レモングラス、ローズマリー
ライフ系	新札の香り、伽羅（きゃら）、墨汁、ソープ

INFORMATION

最小ロット

100枚〜

価格

1000枚作成した場合、約15万円〜（抜き型代別途5万円前後）

納期

校了後、約10〜14日

注意点

香料インキを刷った場所はマットな質感になるので、メインの絵柄に香料印刷を重ねたい場合などは注意が必要。また、インキを吸う紙は向いておらず、塗工紙系のタック紙がよい。メタリック系タック紙はインキが定着しないので使用不可。下地印刷は油性オフセット印刷のみ可能

問い合わせ

サンエーカガク印刷株式会社
東京都千代田区内神田2-14-6
神田アネックスビル5F
TEL：03-3256-6117
http://www.saneikagaku.co.jp/

箱やファイルなど——紙の入れもの編

おどうぐばこ

学校で使う文具の整理に、小学生の必需品「おどうぐばこ」。なんとなく懐かしくてかわいいデザインで、大人だって使いたい！と、人気のアイテムだ。オリジナルの貼箱で、おどうぐばこをつくってみよう。

こどものころ、学校の机に入れて引き出し代わりに使ったり、文具をしまうために使ったおどうぐばこ。多くは、蓋と身の箱で、蓋にネームプレートがついた形のものだったのではないだろうか。

貼箱を得意とする加藤紙器製作所では、オリジナルのおどうぐばこをつくることができる。貼り紙は、色紙やエンボス紙などのファンシーペーパーでも、絵柄を印刷した紙でもいい。もっと高級感を出したいなら、布クロスを使うことも可能だ。外側は無地、内側に絵柄を印刷した紙を貼ると、より凝った印象の箱にすることができる。印刷を入れたい場合は、その旨を伝えれば、デザインテンプレートを送ってくれる。

絵柄を印刷しなくても、外側と内側の色をガラリと変えると、箱を開けたときに大きく雰囲気が変わって楽しい。また、ロゴを箔押しで入れることも可能だ。

サイズは名刺サイズ、ハガキサイズ、B5、A4、B4、A3の5種類。ネームプレートは、銀、アンティークなどの種類がある。

貼り紙にカラフルなファンシーペーパーを使ったもの。貼り紙は四六判70〜100kgぐらいのものがよい

箱の内側の貼り紙にオフセット印刷で絵柄を入れたり、外側とまったく違う色の紙を貼って、色の組み合わせを楽しんだりできる

おどうぐばこ（布クロス製）。高級感ある仕上がり。ネームプレートがアクセント。箔押しでロゴなどを入れることも可能

INFORMATION

最小ロット

50個〜（50個より少ない場合は、要相談）

価格

このページに掲載のB5サイズ（内寸220×290×高さ60mm）のおどうぐばこで、①貼り紙は外側、内側ともファンシーペーパー（ジャガードGA 四六判100kg）の場合、50個で単価1450円〜、300個で単価900円〜。②貼り紙は布クロス、内側はオフセット4色印刷をした上質紙の場合、50個で単価2100円、300個で単価1250円〜（価格は目安）

納期

受注より約4週間〜（受注状況により変わる）

入稿データについて

外や内側の貼り紙にオフセット印刷を施したり、箔押しすることも可能。その場合は、Illustratorでデータ入稿

注意点

貼り紙に印刷したい場合や、箔押しを入れたい場合は、その旨を伝えればテンプレートのデータを送ってくれる。オリジナルサイズでの製作も可能（箔版代、抜き型代別途）

問い合わせ

有限会社加藤紙器製作所
東京都立川市一番町4-42-2
TEL：042-520-8583
https://www.box-katou.co.jp/

ツールボックス

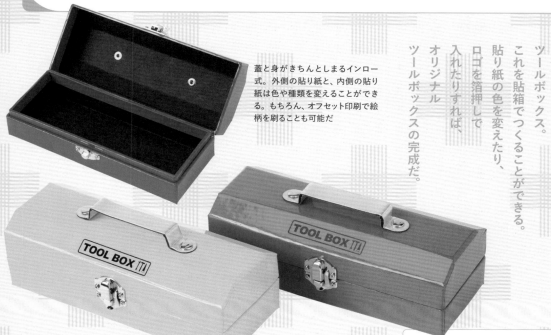

蓋と身がきちんとしまるインロー式。外側の貼り紙と、内側の貼り紙は色や種類を変えることができる。もちろん、オフセット印刷で絵柄を刷ることも可能だ

工具をまとめてしまっておいて、持ち運びもしやすいツールボックス。これを貼箱でつくることができる。貼り紙の色を変えたり、ロゴを箔押しで入れたりすれば、オリジナルツールボックスの完成だ。

貼箱でできたツールボックス。写真の作例は、貼り紙に光沢のあるルミナカラーを使っているため、金属製のツールボックスに近い雰囲気。ロゴは箔押しで入っている

工具の持ち運びに便利な、取っ手のついたツールボックスといえば、金属製のものがおなじみだが、これを紙でつくってくれるのが、加藤紙器製作所だ。どんなものでも貼箱でつくってしまう紙器会社である。

このツールボックス、取っ手も金具もついていて、見た目は金属製のツールボックスそのものでありながら、紙製なのでとても軽い。

また、貼り紙にオフセット印刷で絵柄を入れたり、箔押しでロゴなどを入れることも可能だ。その場合は、連絡をすればデザインテンプレートを送ってくれる。

サイズもオリジナルでつくりたい場合は、抜き型代が別途かかるが、応相談だ。

蓋と身がきちんとしまるインロー式で、しっかりしたつくりだ。その名の通り、工具を入れて使うだけでなく、ペンなどを入れて、筆箱や小物入れとして使うのもおすすめだ。

サイズは170×59×高さ55ミリ（内寸）。

貼り紙は、四六判70～100キロであれば、好きなものを指定することも可能だ（ただし向かない紙もあるので、必ず事前に相談を）。

INFORMATION

最小ロット

50個～（50個より少ない場合は、要相談）

価格

記事に掲載のもの（サイズは内寸170×59×高さ55mm、貼り紙はルミナカラーハトロン判 113.5kg、内側はコニーラップ黒ハトロン判75.5kg）の場合、50個で単価4000円～、300個で単価2300円～、500個で単価1700円～（価格は目安）

納期

受注より約1ヵ月程度～（受注状況により変わる）

入稿データについて

外や内側の貼り紙にオフセット印刷を施したり、箔押しすることも可能。その場合は、Illustratorでデータ入稿

注意点

紙製品のため、あまりにも重いものを入れると金具の部分が取れてしまうことがあるので要注意

問い合わせ

有限会社加藤紙器製作所
東京都立川市一番町4-42-2
TEL：042-520-8583
https://www.box-katou.co.jp/

紙フォルダー

リーフレットや薄い冊子などを入れてきれいに持ち運びができる紙フォルダー。ファンシーペーパーを使い、箔押しをすれば高級感のある仕上がりになる。糊を使わない上開き横型フォルダーは日乃出紙工のオリジナルだ。

会社案内やカタログなどの薄い冊子やリーフレット、企画書などの書類が入れられる紙製のフォルダー。日乃出紙工では、NTラシャやタント、ディープマット、アラベール、ビオトープといったファンシーペーパーにロゴマークなどを箔押しした、上品で高級感のある紙フォルダーをつくることができる。市場で流通している四六判135キロから310キロの紙であれば、使用可能だ。

箔は30色ぐらいのラインナップから選ぶことができる。白系の紙であれば、オフセットでフルカラー印刷や、特色1色、2色印刷を行うこともできる。

広い面積のベタ印刷が入る場合は、汚れ保護のためにニス引きも行うことになる。

紙フォルダーといえば定番は縦型タイプだが、糊を使わず組み立てる上開き横型フォルダーは、日乃出紙工のオリジナル。マチのないタイプと6ミリ幅のマチ付きいタイプがある。マチ付きタイプの場合は、四六判210キロ以上の厚さの用紙が望ましい。

定番の縦型ポケットフォルダーは、片側だけにポケットがつくタイプ、両側にポケットがつくタイプ、変形ポケットやマチありタイプなど、形状を豊富にそろえている。ポケット部分だけ違う紙にすることも可能だ。

糊なしで組み立てられる上開きの横型タイプは、日乃出紙工のオリジナル

こちらは定番の縦型タイプ

片ポケット、Wポケットのどちらも製作可能。写真のような変形ポケットをつくることもできる

INFORMATION

最小ロット

200枚～（サイズ・用紙限定で20枚からOKのオンデマンド印刷タイプもあり）

価格

A4横型フォルダー、（使用紙：タントグレー 四六判180kg）にロゴを箔押しした場合、200枚で7万円、500枚で10万円、1000枚で15万6000円。箔押し用の初回版代は、最小サイズで別途6000円（すべて税別）

納期

箔押しデザイン500枚で、8営業日程度（枚数が増えると、納期も延びる）

入稿データについて

つくりたい紙フォルダーの展開図をウェブからダウンロードした上で、Illustratorでデータ入稿

注意点

箔押しの場合、線幅は0.8ポイント以上にすること。オフセット印刷の場合は0.3ポイント以上（白抜きデザインは0.5ポイント以上）

問い合わせ

北陸サンライズ
石川県白山市五歩市町424-1
TEL：076-275-3535
http://www.pocket-folder.net/
フォームより問い合わせのこと

プチ袋

手のひらにすっぽり収まるミニサイズの封筒「プチ袋」。幅35mm×天地55mm（フタを入れると67mm）という小ささは、インパクト大！

手のひらにすっぽりおさまる小さなサイズの封筒「プチ袋」。しかもこんなに小さいのに、機械で製造できるから、コストを抑えて大量生産も可能なのだ。

平判の紙を印刷した後に製袋するため、全面印刷が可能。ただしチェックのような絵柄の場合、折りや貼り合わせ時に生ずるちょっとしたズレが目立ちやすく、難易度が高い。
デザイン：中澤耕平（STUDIO PT.）

長3封筒（A4三つ折りサイズ）との比較。左がプチ袋。小さい！

切

手や小銭を入れるのにちょうどよく、名刺サイズよりもさらに小さい手のひらサイズの小さな封筒「プチ袋」。あまりの小ささに、手に取らずにはいられないインパクトだ。

通常、とても小さかったり大きかったりする封筒は機械では製袋できず、手貼りとなることが多く、その分、コストが上がることも多い。ところが「プチ袋」は、機械に特殊な治具をつけ、独自の工夫を凝らしたことにより、機械での製造が可能なのだ。気になる寸法は、幅35×天地55ミリ。抜き型があるため、この寸法でつくるのであれば、型代不要で製作可能。基本の紙は上質紙と未晒クラフトで、小ロットの場合はオンデマンド印刷だが、他の紙を指定し、オフセット印刷することも可能。オフセットはプロセス4色と特色のどちらにも対応してくれる。

不向きな紙は、表面が毛羽立った和紙など糊がつきにくいもので、紙の厚みは105g/㎡以下のみ。これより厚い紙の場合は手貼りになる。

プチ袋と一緒にプチチラシをオプションとして注文することも可能。折りたたむとプチ袋にフィットするサイズのチラシ（160×184mm）。通常、折らない状態での納品となるが、折り加工を別途注文することもできる

INFORMATION

最小ロット

規定の紙（上質紙、未晒クラフト）に印刷ありの場合、最小ロットは100枚〜。紙を自由に選び印刷もする特注制作の場合、最小ロットは1枚〜、経済ロットは9000枚〜（紙の取り都合により、枚数は変動）

価格

上質紙、未晒クラフトとも、オンデマンド印刷の場合で100枚9900円（税込）。特注の場合は、使用する紙や印刷色数によりコストが変わる

納期

上質紙、未晒クラフト（印刷あり）の場合、毎月第2月曜日に受注締め切り→翌週末に出荷（月に一度まとめて生産を行なう）。特注制作の場合、目安として1万枚までは7〜8営業日後の発送、1万枚以上は要相談

注意点

フォントをアウトライン化したIllustratorデータ（CS2以下）で入稿のこと。線や文字の大きさは0.1mm以上ないと、印刷時にかすれやつぶれの原因となる。紙は必ず縦目で加工し、厚みは105g/㎡まで。加工時に多少のズレが生じるため、位置合わせの厳しいデザインの場合は、注意が必要。ベタ印刷は、折り部分で紙色が見えてしまったり、他の部分にインキがつきやすくなる。印刷は基本オンデマンドだが、特注制作の場合はロットにより、オンデマンド印刷またはオフセット印刷となる

問い合わせ

封筒屋どっとこむ
大阪府大阪市平野区喜連東5-16-15
TEL：06-4302-7740
Mail：support@fuutouya.com
https://www.fuutouya.com/

ポリクラ

封入した商品をしっかり見せながら、環境にも配慮したい。そんな要望に応えて登場したのが、多層フィルム（PET＋L-LDPE）とクラフト紙を組み合わせた「ポリクラ」というパッケージ袋だ。

片面がクラフト紙（内側：ポリエチレン）、もう片面が多層フィルム（PET＋L-LDPE）になっているポリクラ。両面に印刷を入れられる。写真はラージサイズ

左）ポリクラは3サイズ展開。こちらはペンなどに適したスリムサイズ。

上）墨1色であれば、3ptの小さな文字からきれいに印刷可能

ポリクラの中に冊子を封入しているところ。一辺が封入口となっており、商品を入れた後、ヒートシーラーで接着できる

ポリクラは、片面が熱融解した低密度ポリエチレン（LDPE）のラミネート樹脂を貼合したクラフト紙、もう片面が多層フィルムでできたパッケージ袋だ。「従来よりプラスチックの使用量を削減しつつ、中の商品をしっかり見せたい」というクライアントの要望に応えて誕生した。閉じられていない一辺は、中に商品を封入した後、ヒートシーラーで接着することができる。フィルムとクラフト紙を組み合わせたパッケージ袋は他にもあるが、オリジナル印刷を行なえるものはあまりない。ポリクラを製造する太成二葉産業は、巻取紙やフィルムを印刷できるフレキソ印刷機を保有しており、クラフト紙面、フィルム面の両方に印刷することが可能だ。印刷後に製袋するので裁ち落としとギリギリまでデザインができるのも特徴。印刷可能色は、表裏合わせて7色。175線でフルカラー印刷を行ない、オフセット印刷と遜色のない仕上がりとなる。インキメーカーのカラーチャート指示による特色印刷もOKだ（ただし特色使用の場合は印刷代が2割増となる）。500部程度の小ロットでつくりたいときは、製袋済みの既製品をオンデマンド印刷する。この場合はCMYK＋白の5色印刷が可能だ（裁ち落としデザインは不可、印刷はクラフト面のみ）。

パルプモールド・ワインバッグ

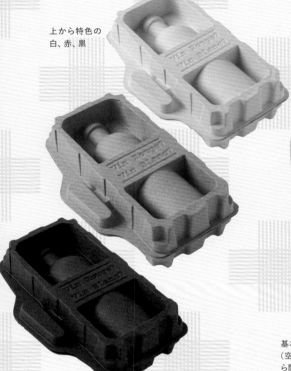

上から特色の
白、赤、黒

紙袋や箱のかわりに、持ち運びもできるパッケージはいかが？パルプモールド製で見栄えもよく、オリジナルロゴなども入れられる。

基本色であるライトブラウン。「vin Rouge?」と上下線のデボス（空押し）加工部分がオリジナルデザインにできる。持ち手部分から開いて、ワインをしっかり固定して収納できる

金型を使って、ドロドロなパルプ原料を成型してつくるパルプモールド。オリジナル品をつくるには高価な金型からつくらないといけないため、通常はロット数千単位でないと大変に単価が高いものになってしまいがちだ。しかし名古屋モウルドでは、自社オリジナルの金型を持ち、その一部にロゴなどオリジナルデータをデボス（空押し）加工で入れられ、また色も選んでオーダーすることができる、画期的なグッズをつくっている。

このワインバッグはパルプモールドのよさが大きく発揮されており、紙袋や通常の紙箱に比べ、衝撃に強い。箱とバッグ両方の機能を併せ持っており、ワイナリーやワインショップ（ワインボトル程度の他の瓶ももちろん入る）のオリジナルロゴを入れて、販売グッズとしても箱＋紙袋かわりにも使うことができる。

このワインバッグのサイズは縦350×横（持ち手まで込み）230ミリほど。オリジナルのデザインをデボスで入れられるのは115×50ミリサイズまで。色は基本色であるライトブラウン（ダンボール古紙と新聞古紙からつくる）、それ以外に特色として白、赤、黒があり、好きな色を選べる。それ以外の色にしたい場合は要相談だ。

INFORMATION

最小ロット

最小ロット100個〜（特色の場合は1000個〜）、経済ロット3000個〜

価格

基本色（ライトブラウン）100個で単価450円、3000個で単価230円。特色1000個で単価350円（白）、400円（赤、黒）、特色3000個で単価280円（白）、330円（赤、黒）。ロゴ変更は作成費別途2万円が加算（運賃別）

納期

基本色2週間　特色4週間程度

注意点

エンボス加工するロゴ等はDXFデータで入稿する。その際、線の太さ0.7mm以上、線などのオブジェクト同士の間隔も0.7mm以上必要

問い合わせ

株式会社名古屋モウルド
愛知県丹羽郡扶桑町高雄宮前161
TEL：0587-93-2771
Mail：nagoya@mould.co.jp
http://www.mould.co.jp/

パルプモールドケース／シェルパック

アクセサリーなどを入れてふたつに折り、ゴム留めやシール留めして使うのがおすすめなシェルパック

ブルー

ピンク

スカイブルー　　基本色であるホワイト

既存の金型を使うことで、かなりの小ロットからオリジナル色でパルプモールドのパッケージがつくれるのが名古屋モウルド。汎用性の高い長方形ボックスと、アクセサリーなどにぴったりのシェル型を紹介する。

上がケース大（閉じたときの外寸200×320×70mm）、下がケース小（同150×200×60mm）

内側の方が表面が平滑

右｜ページでも紹介した名古屋モウルドは、ベーシックな形の角丸型ケースや、らオリジナル色でパルプモールドボックスをつくってもらうことができる。

ェル型パックも、同社が所有する金型を使って、比較的小ロットからオリジナル色でパルプモールドボックスをつくってもらうことができる。これはシェルパックだけでなくケースも可能だ。

パルプモールドは風合いも自然素材感にあふれ、手触りもナチュラル。使い捨てでないパッケージやこれ自体が箱グッズとして、大きな魅力ある製品だ。

アクセサリーのパッケージなどにぴったりのコンパクトのようなシェル型パックは、同社が所有する金型を使って、比較的小ロットからオリジナル色でパルプモールドボックスをつくってもらうことができる。

基本色は白物古紙を使ったホワイトだが、ピンクやブルーなどさまざまな色でつくってもらうことができる。

INFORMATION

最小ロット

ケース大・小／最小ロット50個〜、経済ロット3000個〜。シェルパック／最小ロット3000個〜、経済ロット30000個〜

価格

ケース大／50個のとき単価400円〜（ホワイト）、3000個のとき単価222円。ケース小／50個のとき単価250円〜（ホワイト）、3000個のとき単価115円。シェルパック／ホワイト3000個のとき単価48円、30000個のとき単価31円。特色ピンク、ブルー30000個のとき単価36円（運賃別）

納期

4週間程度（在庫状況による）

入稿データについて

ケースやシェルパックは基本的には色を選んでオーダーする。ここにある色以外も製造可能

注意点

製袋するときに糊がつく部分には、印刷が入らないようデザインすること。また、特殊な紙を使いたい場合は、一度相談を

問い合わせ

株式会社名古屋モウルド
愛知県丹羽郡扶桑町高雄宮前161
TEL：0587-93-2771
Mail：nagoya@mould.co.jp
http://www.mould.co.jp/

ピンクマスター平袋

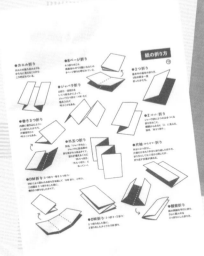

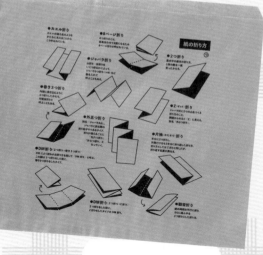

本書編集部がテストでつくってもらった平袋。江戸堀印刷所で用意されているサイズとは違うが、こうした別サイズも別途料金とテスト印刷でOKだった場合に限り受けてもらえる

オリジナル印刷をした紙製の平袋をつくりたい！　そんなとき100枚からの小ロットで刷ってくれるのが江戸堀印刷所。クラフト紙と純白ロールの2タイプに印刷でき、リーズナブルなのにかわいい平袋がつくれるのだ。

従来は印刷してから製袋する場合が多かったため万単位での製造が必須だった。でも江戸堀印刷所ではピンクマスターという紙版を使った簡易オフセット印刷機を使い、袋の状態で印刷することができるため、100枚というかなりの小ロットからオリジナル印刷を入れた平袋をつくることができる。

標準対応している平袋は2種。

純白ロール紙タイプは、

・小（140×200ミリ）
・中（180×260ミリ）
・大（235×320ミリ）

未晒クラフト紙タイプは、

・小（140×180ミリ）
・中（180×230ミリ）

・大（215×290ミリ）の各3サイズで、印刷できる色は25色（左写真参照）。別料金になるがそれ以外の特色もつくってもらうことができる。ピンクマスター印刷のため、濃色ベタは色ムラが生じる可能性があるので注意。

袋のサイズで上写真のように標準対応品以外を頼みたい場合は、印刷可能か事前確認が必須だ。

INFORMATION

最小ロット

最小ロット100枚〜、経済ロットは1000枚〜

価格

大1000枚、特色1C印刷の場合で一式20,000円〜（税別）

納期

校了から1〜2週間程度

注意点

フォントアウトライン化したIllustratorデータ。袋の端から10mm以上の余白が必要（既製品に刷り込み対応のため）

問い合わせ

江戸堀印刷所
大阪市西区江戸堀1-26-18-104
TEL：06-4803-8106
Mail：ep2011@edobori--printing.jp
http://www.edobori-printing.jp

江戸堀標準色から色を選べる。この表は江戸堀印刷所のWebサイトからダウンロードできる

紙の名刺入れ

名刺より一回り大きな
65×103×20mmの外寸

身箱と蓋部分に磁石が
仕込まれているので、蓋
はぴったりしまる

身箱と蓋の色（紙）を
変えることができる

名刺やカード類を入れて
おくのにぴったりな加藤
紙器製作所がつくる紙の
名刺入れ。芯となるボール紙はも
ちろん、身箱（写真の黄色い部
分）も蓋の表面に貼られているも
のもすべて紙でできている。

表面部分に貼る紙（上貼紙）を
オリジナルデザインにすることが
できる。

もちろん希望があれば蓋だけで
なく身箱も印刷や箔押しなどオリ
ジナル柄を加工したものを使える。
上貼紙は上質紙四六判70〜110
キロ程度が最適。もともと色やエ
ンボス柄がついたファンシーペー
パーや紙クロスを使ってもかっこ
いい。

名
刺入れ。芯となるボール紙もも
ともできるし、データを渡して印
刷や箔押しなどの印刷加工から加
藤紙器製作所にお願いすることも
可能だ。

紙製と聞いて、しっかり蓋が閉
まらなくて、カバンの中で名刺が
バラバラでてしまうのでは……と
不安に思うかもしれないが、大丈
夫。蓋部分とそれが合わさる身箱
部分にマグネットが仕込まれてい
るので、蓋を閉めるとピタッとく
っつき、自然と開いてしまうこと
はない。

現状は通常の名刺50枚ほどが入
るサイズだが、厚みも縦横寸法も
変更してオーダーすることもでき
る。

上貼紙は好きな紙を持ち込むこ

INFORMATION

最小ロット

最小ロット100個〜、経済ロット500個〜

価格

100個の場合、単価1100円〜。500個
の場合、単価710円〜（すべて抜き型・
上貼紙代・送料別途）

納期

校了から3〜4週間程度

注意点

上から貼る紙（上貼紙）への印刷から頼
む場合は、フォントをアウトライン化した
Illustratorファイルで入稿。手貼り加工
のため、商品によって個体差がでる

問い合わせ

有限会社加藤紙器製作所
東京都立川市一番町4-42-2
TEL：042-520-8583
Mail：office@box-katou.co.jp
https://www.box-katou.co.jp/

スマートエッジボックス®

芯となる生地（上の箱とは別のもの）。折り目が
Vカットされているのがわかる

角がスキッとシャープ
なのがわかる

蓋と身箱とになった身
蓋箱タイプのスマート
エッジボックス

角がスキッとシャープで、従来の貼箱とは一味違うスマートな箱が、三光紙器工業所の手がける「スマートエッジボックス」。芯となるチップボールでつくる「生地」をVカット加工するこの箱を、機械で大量生産できるのだ。

貼

箱づくりに定評のある三光紙器工業所では、従来からの貼箱づくりはもちろん、常に新しい箱づくりにチャレンジしている。「スマートエッジボックス」は貼箱の一種で、通常、貼箱の生地（芯となるチップボール）は、折り目に半切りを入れ、組み立てるときには角を紙テープで仮留めするが、スマートエッジボックスは、生地をVカットし、Vカットの断面同士を貼り合わせて組み立てることで、上から紙でくるんで仕上げ貼箱になった状態でも、角に余計な丸みがでにくく、シャープに仕上がった貼箱のことだ。このタイプの箱を日本でつくろうとすると、手作業となる場合がほとんどだが、同社は機械

製造が可能なため、このシャープな貼箱を量産したいという希望も叶う。小ロットの場合でも、生地をVカットできるサンプルカット機で製造するなどして、対応してもらえるのもうれしい。

生地の工夫以外にも、上から貼る紙の糊代（紙どうしが重なる部分）を面全体にオーバーラップさせることで、折り返しが見えない工夫をしたり、箱内側に見える紙の折り返し部分を、箱の底までのばす深折り込み（ディープ・ターン・イン）方式も可能。角止めテープを使わず、特殊糊で角を接着する技術もありハイクオリティの貼箱をつくってもらうことができる。

INFORMATION

最小ロット

1個〜。部数によってVカットをサンプルカット機で対応するなどつくり方を変えてもらえる

価格

例として、一般的な貼箱が100だとすると、生地をVカットした場合130程度

納期

通常の貼箱と大きく変わらない

注意点

印刷や紙にこだわりがある場合は、持ち込み対応も可能

問い合わせ

三光紙器工業所
東京都新宿区西落合1-31-21
TEL：03-3952-5823
http://sanko-shiki.co.jp/

すごく大きい・小さい貼箱

こんなに大きな箱から小さい箱まで可能。大は555×485×135mm、小は29×29×33mm。正方形でなく、長方形の箱ももちろん可能（隣のiPhoneはサイズ比較用）

どちらも身と蓋の箱。貼り紙できれいにくるまれている

INFORMATION

最小ロット

50個〜（1個〜も応相談）

価格

大（555×485×135mm、貼り紙にエスプリコートFPを使用した箱）を100個作成した場合7万2600円（税別）／小（29×29×33mm、貼り紙にタントN-1を使用した箱）を300個作成した場合5万6300円（税別）。有料でサンプル作成も可能（3000円〜）

納期

仕様や個数によって異なる

注意点

だいたいのサイズには対応できる。中に入れるものや用途によって設計が異なるので、まずは問合せを。貼り紙は四六判70〜90kg程度の紙が望ましい。それより薄い・厚い紙、特殊な紙を貼りたい場合は相談を

問い合わせ

西脇製函株式会社
東京都足立区青井3-2-10
TEL：03-3849-3578
Mail：info@nishiwaki-seikan.com
http://www.nishiwaki-seikan.com/

ものすごく大きなものを入れたい、あるいは、指輪のような小さなものをジャストサイズの箱に入れたい。極端に大きかったり小さかったりする箱はつくれる会社が限られているが、応えてくれるところもあるのだ。

板

紙の生地でつくった箱を、色のついた紙や絵柄を印刷した紙で包む「貼箱」。

生地に貼り紙を貼る作業は機械でできる場合もあるが、極端に大きかったり小さかったりすると、人の手でなくてはできない。このため、そうした箱をつくりたいときに相談できる会社は限られているのが実情だ。

西脇製函は、特殊な寸法や形状、小ロットなどへの対応に力を入れている製函会社だ。貼箱をメインで手がけている。寸法への対応は柔軟で、かなり小さい寸法であろうと、かなり大きい寸法であろうと「だいたいつくれます！」という心強い答え。ここに写真を掲載しているのは身と蓋の箱だが、他の形状も要相談。そのほかにも、たとえば布を貼りたいというときや、糊が接着しづらいPP貼り加工をした印刷物にも対応してくれる。ただしPP貼り加工をする場合は、易接着タイプのフィルムを使用することが条件。企画段階から相談すれば確実だ。

凝った貼箱

あるカードゲーム用につくられた貼箱。手前2つはカード収納用で、取り出しやすいように切り込み入り。奥はサイコロなどが入れられるよう引き出しに

フタにはマグネットが仕込まれていて、きちんと閉まる

フタを上下にパタンと開くと、メモスタンドになる箱。箱とペン立て部分にマグネットが仕込まれている

オリジナルな形状の箱がつくりたい、商品に合わせた複雑な形の箱がつくりたいなど、凝った貼箱をつくりたいときは、中に入れるものを見せながら相談すると、その寸法や重さ、用途に合わせて箱を設計してもらうことができる。

写真上は、とあるカードゲーム用につくられた貼箱。や、配送するものなのかどうかといったことでも、使用する生地のよう切り込み入りで、一番左はサイコロなどを入れるため、引き出しになっている。フタにはマグネットが仕込まれており、閉めようとすると自然にパチンとくっついて気持ちいい。

こんな風に、収納したいものの大きさや用途に合わせたオリジナルの貼箱をつくりたいときは、まずは中に入れるものを見せて相談するとよい。寸法だけでなく、どういう使い方をするのかを伝えれば、最適な形状で設計してもらうことができる。重さ、厚みなどが変わってくる。凝ったつくりの箱をつくるならば、そうした情報も含めて相談し、見積もりをとるとよい。

もうひとつの例は、メモスタンドになる箱（写真下）。これもマグネットが仕込まれていて、フタがきちんと閉まる。このほかにも、たとえば三角形だったり、複雑な段差を組み合わせた箱だったり、さまざまな形状の箱をつくることが可能。ただし、凝ったつくりの箱の場合は手作業になるので、その分、コストや納期はかかることになる。

INFORMATION

最小ロット

50個〜（1個〜も応相談）

価格

写真上のカードケースを100個作成した場合、単価1500円程度（税別）。有料でサンプル作成も可能（3000円〜）

納期

仕様や個数によって異なる

注意点

中に入れるものや用途によって設計が異なるので、まずは問合せを。貼り紙は四六判70〜90kg程度の紙が望ましい。それより薄い・厚い紙、特殊な紙を貼りたい場合は相談を。貼り紙に箔押しをしたいときは、箱に貼る前に押したほうがコストが抑えられる。また、マグネットを使用したい場合、手で貼り込むため、工賃が高くなる

問い合わせ

西脇製函株式会社
東京都足立区青井3-2-10
TEL：03-3849-3578
Mail：info@nishiwaki-seikan.com
http://www.nishiwaki-seikan.com/

リボン・金具つき貼箱

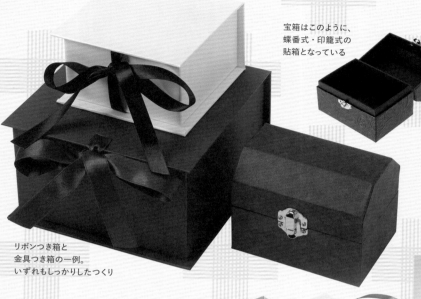

宝箱はこのように、蝶番式・印籠式の貼箱となっている

リボンつき箱と金具つき箱の一例。いずれもしっかりしたつくり

リボンつき箱を開けたところ。片開き式になっている

リボンの色は見本帳から選ぶことができる

美しい貼箱にリボンや金具がついていると、より高級感ある凝った印象になる。高級品のパッケージや、大切なものをしまうために、ぜひつくってみたい箱だ。

ブック型のケースのフタの留め具や、宝箱型の留め具として、リボンや金具を使うこともできる。生地となる板紙をファンシーペーパーなどでくるむ、もともと凝った印象の貼箱に、リボンや金具をつけることで、より高級感を増した箱をつくることができるのだ。

こうしたリボン・金具つけは、通常の貼箱に比べ一手間、二手間とかかるが、加藤紙器製作所はそうした「手間がかかって機械だけではできない貼箱」を得意とする会社だ。

たとえば写真左上のリボンつき箱は、ブック型とも呼ばれる片開き式。ボール紙を合紙して台紙をつくり、とてもしっかりしたつくりで、化粧品やジュエリーボックスなどに人気の型だ。

もうひとつの金具つき箱（写真右上）は、本格的な宝箱を貼箱で再現したもの。貼り紙にはクロス紙を使用し、皮革のような雰囲気をもたせていて、インテリア、ディスプレイ用としても使える。

いずれも、サイズや素材、箔押しなどの印刷加工にも応相談。

引き出しの取っ手として金具をつけるなど、さまざまな形状・用途の金具つけが可能

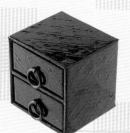

INFORMATION

最小ロット

50個～（それ以下の数も応相談）

価格

100×100×60mmのリボンつき貼箱の場合（貼り紙はタント四六判70kg、生地はチップボール）100個で単価720円、300個で単価660円、500個で単価540円（別途型代＋箔版代 約6万円～）／70×100×高さ50mmの宝箱の場合（貼り紙はタント 四六判70kg、生地はチップボール）100個で単価2000円、300個で単価1500円、500個で単価1100円

納期

約1ヵ月（受注状況により変わる）

注意点

外や内側の貼り紙にオリジナル印刷を施すことも可能。その旨を伝えれば、デザイン用の型図面データをメールで送付してくれる

問い合わせ

有限会社加藤紙器製作所
東京都立川市一番町4-42-2
TEL：042-520-8583
http://www.box-katou.co.jp/

ハトメ箱

むきだしの紙の素朴さとハトメとの対比がかわいいハトメ箱。写真はディープマット四六判360kgで制作したもの。真ん中1カ所留め（右、中央）と四つ角留め（左）の2種類がある

箱

素材むきだしの留め箱は、針金で留められているものが主流だが、留め金をハトメに変えると、それだけでかわいい箱になる。留め方にも、1カ所と2カ所の2種類があるのだ。

の生地がそのままむきだしになり、その素材感を楽しめる留め箱。材料となる板紙を針金で留めるものが主流だが、ハトメで留めて箱に仕立てることもできる。板紙の素朴な素材感と金属のハトメとの対比がデザイン的なアクセントになり、お

すすめの箱だ。
留め方には、真ん中1カ所ずつと、四つ角で留めるタイプとがある。使用する板紙は、0・5ミリ程度の厚みがあるのが望ましい。写真のサンプルでは、ディープマット四六判360キロを使用している。ハトメは大きさや色でいくつかの

種類があるので、イメージを伝えて選ぶとよい。
板紙の素材感をそのまま活かしつつロゴなどを入れたいときには、箔押しがおすすめ。また、オリジナルの絵柄をオフセット印刷することもできる。印刷する場合は、その旨を伝えれば、テンプレートをメールで送ってくれる。

ハトメは、主に金、銀、アンティークの3色。大きさにもいろいろな種類がある

カジュアルな印象の真ん中1カ所留め

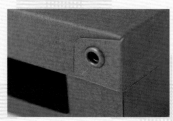
しっかりした印象の四つ角留め

INFORMATION

最小ロット

50個〜（それ以下の数も応相談）

価格

真ん中1カ所留め（ハガキサイズ155×105×高さ50mm）の場合、100個で単価600円、300個で300円、500個で単価280円／四つ角留め（ハガキサイズ155×105×高さ50mm）の場合、100個で単価564円、300個で単価360円、500個で単価330円。サイズなど変更、または箔押しの場合、別途型代＋箔版代が約5〜6万円〜

納期

約4週間（受注状況により変わる）

注意点

オリジナル印刷を施すことも可能。その旨を伝えれば、デザイン用の型図面データをメールで送付してくれる。ハトメの種類、材質、寸法などの変更も応相談

問い合わせ

有限会社加藤紙器製作所
東京都立川市一番町4-42-2
TEL：042-520-8583
http://www.box-katou.co.jp/

Ｖカット箱

厚さ2〜3mmの紙ボードに、Ｖ字カットや凹状の溝を加工し、組み立ててつくる「Ｖカット箱」。他の方式でつくられる箱とは違う、きっちりシャープで硬質な箱をつくることができる。

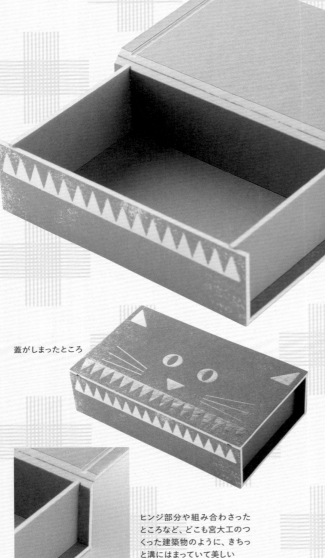

ブック式のＶカット箱。芯には紙パックリサイクル再生紙、表面にはＮＴラシャを貼り合わせた、蓋と身箱がヒンジ（蝶番）で一体となっている、Ｖカット箱としてはオーソドックスな形式
デザイン：岡田善敬（札幌大同印刷）

蓋がしまったところ

ヒンジ部分や組み合わさったところなど、どこも宮大工のつくった建築物のように、きちっと溝にはまっていて美しい

貼

箱、印刷箱、さまざまなパッケージを手がけている札幌の紙器会社・モリタ。同社のもっとも得意とするのがＶカットを使った、カッチリとしスクエアな仕上がりの「Ｖカット箱」だ。

厚さ2〜3ミリの紙ボードに、Ｖ字カットや凹状の溝を加工し、糊付けして組み立てる。木箱のようにも見えるスクエアな表情が特徴で、精度の良さ、重量感も感じる。モリタ株式会社ではこうした箱をつくることができる。

基本的に芯となる紙ボードの生地に上紙を貼り合わせ、Ｖカットを行う。その紙選びの仕方で、断面に別の色を見せたり意匠を凝らすことも可能だ。ロゴや模様などは箔押しで入れることが多いが、事前に印刷したものを生地と貼り合わせることもできる。形はブック式が多いが、他タイプも可能だ。

同社では箱のデザイン展「HAKO MART」を開催したり、自社オリジナル箱製品をつくったりと、箱づくり・箱デザインの広がりに向けた活動も幅広く行っている、頼りになる紙器会社なのだ。

Ｖカット箱を30個からオーダーできる。同社Webサイトでサイズや使う紙、形状、ロットなどを選んで自動見積もり、発注できるのもうれしい。

300個以上の場合は、フルオーダーでより細かく相談しながらＶカット箱をつくることができる。中に入れるものを伝えて、どんな形状・サイズのＶカット箱にするのが適しているか、相談しながら進めることで、一番いいＶカット箱をつくることができる。

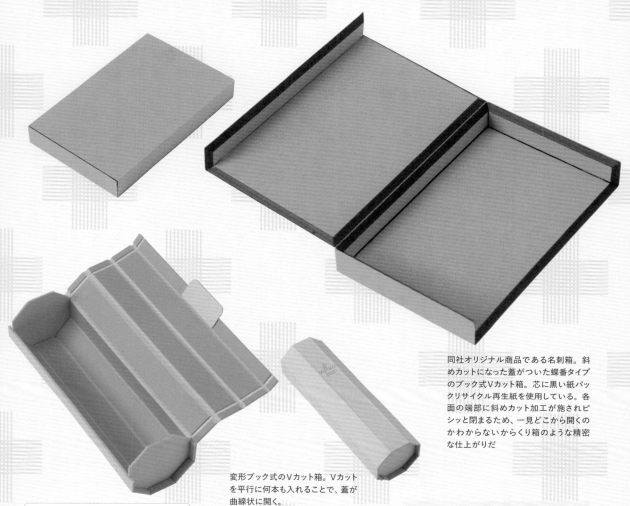

同社オリジナル商品である名刺箱。斜めカットになった蓋がついた蝶番タイプのブック式Vカット箱。芯に黒い紙パックリサイクル再生紙を使用している。各面の端部に斜めカット加工が施されピシッと閉まるため、一見どこから開くのかわからないからくり箱のような精密な仕上がりだ

変形ブック式のVカット箱。Vカットを平行に何本も入れることで、蓋が曲線状に開く。

こちらは貼箱の芯（生地）がVカットされている芯Vカット貼箱。写真のものは印籠式。製法は貼箱だが、生地をVカットにすることで、角がシャープに仕上がる
CI：神保真珠商店
デザイン：鈴木信輔（ボールド）／戸田祐希利（暮らすひと暮らすところ）

INFORMATION

最小ロット

仕様にもよるが30個からオーダー可能。経済ロットは500個〜

価格

幅150×奥行150×高さ100mmの水平フタタイプ100個の場合、単価481円〜（同社サイトにて、さまざまなサイズや紙での見積もりが自動計算できる）サンプル試作（有償）6000〜2万円程度（仕様による）

納期

仕様・ロットにもよるが1〜2ヵ月程度

注意点

ブック式、印籠式の身蓋箱をはじめさまざまな形が可能だが、どんな箱にしたいか、まずは気軽にご相談を

問い合わせ

モリタ株式会社
北海道札幌市白石区中央2条3-2-17
TEL：011-831-1151
https://www.hakop.jp/

特殊な紙での貼箱

めちゃくちゃ変わった柏原加工紙の紙を使って
貼箱をつくっているのが岩嵜紙器。
フルオーダー、セミオーダー、名入れボックスまで
幅広く対応してもらえる。

蓋と本体とに
分かれている身蓋箱タイプの貼箱

名入れ可能なのはこの3サイズ。
フルオーダーの場合はサイズもく
るみ紙も自由に選べる

岩嵜紙器のセミオーダー「コンビ
ニボックス」。他ではあまり見か
けない形の箱が多いのも嬉しい。
最低300個から、単価も100円以
下のものもありつくりやすい

柏原加工紙の加工紙を使ってつくられた、
岩嵜紙器のオリジナルボックス「Baggage
Box」。菱目糸入り紙や養生シートなどがく
るみ紙に使われている

貼

箱を中心にパッケージ製作を幅広く行なっている岩嵜紙器。形やサイズ、価格共別）。こんなに変わった紙で貼箱をつくってもらうのもいい。もともと用意されている抜き型を利用することで、初期コストをかけずに小ロットから紙箱がつくれる「コンビニボックス」というサービスも行っており、オリジナルなビジュアルを印刷した箱が300個からつくれる。こういったセミオーダーの箱はいろいろと行っている会社はあるが、岩嵜紙器のコンビニボックスは、貼箱・印刷箱（厚紙に直接印刷してそれを型抜き・箱に仕立てたもの）両方があり、かつ、形やサイズに魅力的なものが多いのが嬉しい。

そして同社では、もともと用意されている抜き型を利用することで、初期コストをかけずに小ロットから紙箱がつくれる「コンビニボックス」というサービスも行っている。その中でも本書が注目するのが、他ではちょっと見かけない加工紙を使った身蓋式の貼箱「Baggage Box」。柏原加工紙の無骨で工業的な雰囲気が、かっこいい貼箱に仕上がっている。紙の種類は3種類、サイズも3種類ある。これは同社のWebサイトで1つから購入可能なオリジナル商品だが、これにロゴなど名入れしてもらうことも可能だ（その場合はロット・上からくるむ紙などを自由に決めるフルオーダーが基本だが、自社開発のさまざまな箱の販売も行っている。

INFORMATION

最小ロット

300個〜

価格

岩嵜紙器で販売しているBaggage
Boxの価格は、A4サイズで1800円、
A4サイズで1300円、ポストカードサ
イズで1000円。名入れやフルオー
ダーの場合は別途

納期

Baggage Boxをそのまま購入する場
合はサイトですぐに購入可能。オリジ
ナルの場合は、一般的な貼箱と同程度

問い合わせ

株式会社岩嵜紙器
長崎県東彼杵郡波佐見町田ノ頭郷
201-1
TEL：0956-85-2127
Mail：info@total-package.jp
http://total-package.jp/

紙管箱

TAISEIの平巻紙管箱。縦に長いタイプから背の低いタイプまで、幅広いサイズでつくることができる

紙を巻いてつくる円筒形の紙管箱は、洋菓子や化粧品パッケージなどに人気だ。通常は高額な型代がかかるが、TAISEIでは対応サイズ内であれば型代不要で自在に変更できるのが大きな魅力だ。

箱

といえば四角いものが多いが、紙を巻いてつくる紙管箱は、その形だけでも個性的。

形は正円と楕円が作成可能。蓋と身、貼り合わせ部分の絵柄を合わせることが可能なのも、同社の技術力ならでは。紙も白板紙からクラフト系の紙まで、自由に選べる。

また、同社は高速のレーザーカット加工機を所有しているため、細かいレーザーカットで模様を入れることもできる。

サイズを変えられるのがうれしい。サイズの微調整にも対応でき、サンプル制作が簡単にできるのも大きな特徴だ。

紙管箱をつくる場合、普通は丸い金型に巻きつけて製造するため、オリジナルサイズでつくる場合は金型代として高額なコストがかかるが、TAISEIの平巻紙管は、タッチパネルで型のサイズが簡単に切り替えられる独自開発機の導入により、直径65〜300ミリ、高さ15〜250ミリの間であれば金型不要で自在にサイズが簡単に切り替えられる独自開発機の導入により、直径65〜300ミリ、高さ15〜250ミリの間であれば金型不要で自在に

INFORMATION

最小ロット

1000個〜。経済ロットは3000個〜

価格

3000個作成の場合、単価120円〜
※条件により異なるので、事前に相談を

納期

データ入稿後1ヵ月程度

注意点

データはIllustratorで入稿。事前にテンプレートを送ってもらい、デザインを配置するとよい。オフセット印刷、レーザーカット加工のほか、可能な印刷加工は、スクリーン印刷、箔押し、空押し。メタリック紙など、UVオフセット印刷が必要な素材の場合は、事前に相談を

問い合わせ

TAISEI株式会社
◎東京支店
東京都千代田区内神田2-5-5
TEL：03-5289-7337
◎大阪支店
大阪府大阪市中央区南船場2-3-2
TEL：06-6210-5193
http://www.taisei-p.co.jp/

Gフルートダンボール箱

右写真のGフルートダンボール箱は福永紙工が主催する「紙器研究所」が設計した斜め取っ手のキャリータイプ組箱

写真右から、表面の使用紙が「白C5」、白C5より白い「バスク」、「クラフト」。表裏・中層とも白C5のもの、バスクのもの、クラフトのもの、表が白C5で裏と中層がクラフトのものなど、さまざまなGフルートダンボールがある

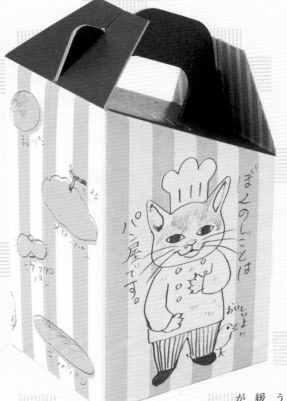

一見、普通の板紙に見えるが、断面を見ると波状のフルートが見え、ダンボールだということがわかる

厚さ0・9㎜ほどの極薄ダンボール「Gフルートダンボール」に直接オフセット印刷できるのが福永紙工。それを型抜きしてつくる組箱は、幅広い分野のパッケージに使える汎用性抜群の箱なのだ。

印刷した紙を型抜きして製函する組箱は、一般的に板紙を使用することが多いため、ダンボールに加工された状態に印刷し、すぐに型抜き→製函できるのが魅力だ。

サイズや箱の形式を指定してつくってもらうこともできるし、中に入れるものを伝えて相談し、形状から設計・提案してもらえる。

特に後者は、福永紙工の中にいるディレクターによって、最適なものを提案してもらえるのが心強い。

Gフルートダンボールは、在庫されているもの（通常は表裏が白、もしくはクラフトが多い）以外にも、表、裏、中層それぞれの紙を指定してつくってもらうことも可能だ。

ダンボールにオフセット印刷でダイレクトに印刷することができるため、板紙を使用することが多い。しかし、厚さ約0・9ミリと極薄なGフルートダンボールを使うと、薄くともダンボールなため緩衝性に富み、軽量化も測ることができる。

通常、ダンボールへの印刷はフレキソ印刷（凸版印刷）で行うが、オフセット印刷したい場合には別途刷ったものを貼り合わせる必要があった。しかし福永紙工ではGフルー

INFORMATION

最小ロット

仕様にもよるが1000個〜

価格

右上写真の箱での概算では、1000個の場合の単価202円、1500個の場合の単価145円、2000個の場合の単価116円。型代は別途で45000円程度

納期

数量にもよるが校了から10日程度

注意点

オリジナルのGフルートダンボールをつくる場合は、300m以上が基本ロット。また余裕のある納期で相談しよう。またその時在庫があるGフルートダンボールも変わってくるので要問い合わせ。

問い合わせ

福永紙工株式会社
東京都立川市錦町 6-10-4
TEL: 042-523-1515
Mali: info@fukunaga-print.co.jp
http://www.kaminokousakujo.jp/

ハンドル式ガチャBOX

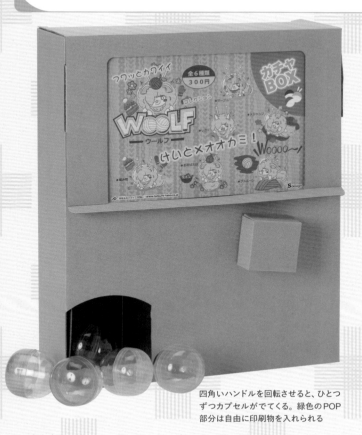

四角いハンドルを回転させると、ひとつずつカプセルがでてくる。緑色のPOP部分は自由に印刷物を入れられる

イベントやちょっとした催事にぴったりの、ダンボール製のガチャBOX。カプセルに自由にものを入れれば、どこでもすぐにガチャができる。ガチャの内容をPOPにして入れることができる。

数日間のイベントや小さな催事などで、ちょっとだけガチャをやりたい。そんなとき、一般的なガチャをレンタルするのもいいが、巽製函がパッケージをつくるノウハウで設計し開発した「ハンドル式ガチャBOX」も注目。ガチャBOX本体はすべてダンボールでできており、その組み立てにはテープ・のり・カッターなどを使うことなく、簡単に組み立て可能。本体の上蓋を開けて、カプセルを入れるだけなのでセットもカプセル補充も簡単だ。

サイズは幅400×奥行き232×高さ480ミリで、もともと用意されているカラーバリエーションは全部で6色。ガチャBOXの上半分部分にはガチャ内容などのPOPが入れられるように設計されており、オリジナルガチャをつくるのも簡単だ。このサイズ以外の大きなガチャBOXとなると、抜き型等を一からつくる必要がある。

使えるカプセルは直径70ミリタイプのみ。これも巽製函で一緒に購入可能だ。

箱を組み立て、カプセルをセットしたら、ガチャBOX前面につ いている、紙製の四角いハンドルを回転させる。するとひとつずつカプセルは下部左側の搬出口からコロコロっと出てくる仕組みだ。ダンボール製なので軽く持ち運びにも便利。ちょっとしたイベントにうってつけのガチャBOXだ。

もともと用意されているカラーバリエーションは全6色

POP箱セット

箱入り商品をそのまま陳列する際に便利な、外装箱の蓋がPOPになる仕掛けをもつ「POP箱セット」。あらかじめ抜き型が用意されているので、30セットという小ロットからでもつくれるのが強みだ。

小

箱をいくつかまとめてセットした箱を、販売時には蓋部分を折ってPOPにしてそのまま陳列できるPOP箱セット。市販のトレーディングカード等、この方式のパッケージは多くあるが、いざ自分でもつくりたいとなった際、一から設計するのは時間もお金もかかってしまう。そんなとき便利なのが、巽製函のPOP箱セット。あらかじめ外装用のPOP箱と中に入れる小箱がセットになって、そこにオリジナル印刷を入れたものを30セットからつくれる。

外装用のPOP箱は、中に入れる小箱を1列で入れる「1列POP箱」と、2列で入れる「2列POP箱」の2タイプ。それぞれ中に入れる小箱は6、8、10、12個と小箱の厚さを選べ、小箱のサイズは1列POP箱、2列POP箱共に幅68×高さ88ミリ、厚さは6

個セット用が25ミリ、8個セット用が19ミリ、10個セット用が15ミリ、12個セット用が15ミリ。12個セット用が15・5ミリ。商品に合わせた小箱サイズを選ぶことができる。

印刷タイプが基本だが、板紙の質感そのままの印刷なしタイプももちろんオーダーできる。

INFORMATION

最小ロット

30セット〜

価格

1列POP箱(小箱12個セット)30セット(印刷あり)の場合、65000円(税抜)

納期

データ入稿後、約2週間〜

注意点

POP箱の種類、中に入れる小箱の個数が決まったら、巽製函から展開図のテンプレートデータをもらってレイアウトし、入稿しよう

問い合わせ

巽製函株式会社
大阪府藤井寺市北條町10-12
TEL：072-939-0840
Mail：info@tatsumi-hako.co.jp
http://www.tatsumi-hako.co.jp

2列POP箱(小箱8個セット)。
輸送時は外装用のPOP箱の蓋は閉じてあるが、お店などに陳列する際に蓋を開き、もともと入っている切れ目・折り目で折ると、POP付きの陳列ボックスに早変わり

印刷なしタイプももちろん可能。こちらは大和板紙のカッパーレッドの板紙そのものでつくったPOP箱

1列POP箱
(小箱10個セット)

レーザーカット箱

B2サイズまで加工できるオンデマンド印刷機とレーザーカット機を使って、細かい絵柄のレーザーカットを施した組箱が、小ロットからつくることができる。

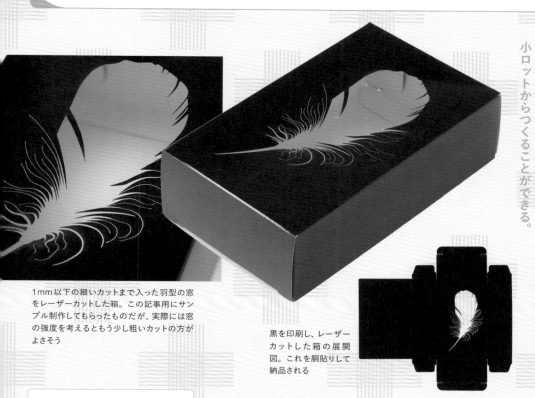

1mm以下の細いカットまで入った羽型の窓をレーザーカットした箱。この記事用にサンプル制作してもらったものだが、実際には窓の強度を考えるともう少し粗いカットの方がよさそう

黒を印刷し、レーザーカットした箱の展開図。これを胴貼りして納品される

INFORMATION

最小ロット

1個〜

価格

上写真のような細かいレーザーカットが入った組箱（印刷あり）100個の場合、単価350円程度。レーザーカットなしの100個の場合、単価280円程度

納期

最短で3営業日で出荷。難易度やコストにもよるので要問い合わせ

注意点

レーザーカット自体は非常に細かいものまで可能だが、それを箱にした際に、切り抜いた端部分が折れてしまったりと強度の問題もでてくるので、絵柄を見せて相談したい

問い合わせ

株式会社共進ペイパー＆パッケージ
兵庫県神戸市中央区元町通6-1-6
共進ビル
TEL：043-257-4656
Mail：ontact@hacoplay.jp
https://www.hacoplay.jp/

オリジナルの小型の組箱をつくる際、特に小ロットで力を発揮するのが、共進ペイパー＆パッケージが運営する「ハコプレ」だ。Web上にある基本形状からつくりたい箱を選ぶか、そこになければ「自由設計」という窓口から問い合わせてオリジナル形状をつくってもらうことも可能だ。Webに掲載されている基本形状は、あらかじめ抜き型が用意されているものもあるため、初期費用が抑えられるのがうれしい。2000個以下の箱づくりでコストメリットが大きい。

そんなハコプレを運営する共進ペイパー＆パッケージが新たにサービス開始するのが、オンデマンド印刷とレーザーカットによる極小ロットの箱製作だ。オンデマンド印刷機はB2ノビまで、レーザーカットはB2まで加工できるため、そのサイズ以内に入るパッケージであれば、抜き型をつくる必要なく、1個からつくってもらうことができる。通常は箱の形状をカットするのにレーザーカット機が使われるが、複雑な形の箱の窓を開けたいなどという要望にも、レーザーカット機ならではで応えてくれるのもうれしい。

印刷は現状はCMYKのみだが、今後、金銀も使えるようになるそう。より表現の幅が広がりそうだ

キャリー型地獄底箱

使用前は折りたたんだ状態のため、保管がしやすい。使用時に手で底を組み立てる

4枚を組み合わせて底面をつくる地獄箱。キャラメル箱よりも強度があるが、組み立てにはやや時間がかかる

これがキャリー型地獄底箱。使用紙はエースボール（米坪：270g/㎡）

©ingectar-e

ワインなどのミニボトルを贈るとき、ボトル用の紙袋を使用するのもいいが、板紙でつくった持ち手穴つきの箱であれば強度もあり、パッケージとしての役割も果たせる。

ミニボトルのパッケージとして、またキャリーバッグとしても使えるのが、コマガタで制作できるキャリー型地獄底箱だ。名前こそいかつい印象だが、側面1カ所をサックマシンで糊付けし、使用時に手作業で底を組み立てる「地獄底」の箱に、持ち手穴がついたもので、底に接着処理がないのでコストを抑えて製造することができる（地獄底は、アメリカンロック、底組み箱と呼ばれることもある）。

66×66×高さ200ミリという既存サイズであれば、型があるので、型代不要で制作可能。中に入れるものに応じて、ぴったりのサイズや形状でつくりたいというときには、中に入る製品や重さ、予算、配送箱も兼ねるのかなどの条件を伝えて相談することで、0・5ミリ単位でサイズを調整し、最適な形状と材質を提案してくれる。その場合は、まずサンプル箱を作成してもらい、確認した後に図面データを送ってもらって、そこにデザインをするという流れになる。

白板紙のほか、エースボールなどの色板紙も使用可能で、印刷なしの無地箱でも、オフセット印刷ありの化粧箱でもOK。パッケージのまま持ち帰りやすいので、ギフト用途のボトルにおすすめの箱である。

INFORMATION

最小ロット

500個～

価格

66×66×高さ200mmの箱を500個つくった場合、12万円（参考価格）。それ以外のサイズの場合は抜き型代別途。見積もり無料

納期

校了後、約12営業日程度

注意点

印刷はオフセット4色または特色対応可能。オリジナルサイズや形状で作成する場合は、内容物を送ってサンプル箱を作成してもらい、確認した後、図面データを送ってもらう。デザインデータはIllustratorで入稿。結束やダンボール梱包、配送までを依頼できる

問い合わせ

株式会社コマガタ
新潟県新潟市西蒲区小吉2127-3
TEL：0120-812-850
Mail：info@komagata.co.jp
http://www.komagata.co.jp/

カラフルダンボール箱

高級感を出したい
ときには箔押しや
空押しがおすすめ

フレキソ印刷は
素朴な味わいの
仕上がりになる

基本のラインナップは20色
（他の色も相談可）

水色	黒	グリーン	ブルー	スカイ
黄	日和	チョコ	ホープ	みどり
からし	日和	こげ茶	紺	バイオレット
オレンジ	ピンク	赤	ライトグリーン	ベージュ

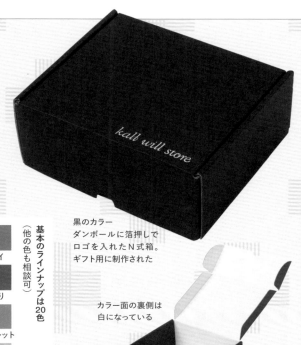

黒のカラー
ダンボールに箔押しで
ロゴを入れたN式箱。
ギフト用に制作された

カラー面の裏側は
白になっている

パッケージや輸送用に、丈夫なダンボール箱は便利な存在だ。茶色や白のイメージが強いが、コマガタでは20色以上のラインナップをそろえ、カラフルなダンボール箱を製造している。

ダンボールとは、波形に成形した中芯の原紙の片面、または両面にライナーを貼ったもののこと。しっかりしたつくりで、配送用によく用いられる。一般的に、紙の地色そのままのクラフト色のものが用いられるが、カラーライナーを貼った色とりどりのダンボール箱を頼めるのが、コマガタだ。

いくつかあるダンボールの厚みの種類のうち、主にE段と呼ばれる、厚さ約1・5ミリのカラーダンボール素材を使用。ダンボールの中では薄手なので、衣類や雑貨の梱包や配送用だけでなく、ギフト箱としても使われている。表ライナーや裏ライナーはもちろん、中芯をカラーにすることも可能だ。

みかん箱（A式）形状はカラーとサイズを選ぶセミオーダータイプで生産しており、その他オリジナル形状については内容物のサイズ、重さなどを考慮して、箱の設計から依頼できる。

印刷加工としては、高級感を出すのであれば、箔押しや空押し。そのほか、フレキソ印刷を行なうことも可能。フレキソ印刷はダンボール素材に直接印刷できる方法だが、樹脂版を用いた凸版印刷のため、複雑・細かい絵柄や写真などの再現は難しい。素朴な味わいがかわいい印刷なので、その味を活かしたシンプルなデザインや、ロゴなどを入れたいときにおすすめだ。

INFORMATION

最小ロット

500枚〜

価格

写真上の黒カラーダンボール箱（180×160×高さ80mm／N式）の場合、500枚で単価210円〜、初回抜き型代33000円（箔版代、送料別途）

納期

製造開始から発送まで約14営業日（完全受注生産）

注意点

フレキソ印刷を行なう場合、ダンボールの色に印刷色が影響を受けるので注意が必要。また、網点の重なりで色や階調表現をしたり、細かい文字の再現には不向きなので注意

問い合わせ

株式会社コマガタ
新潟県新潟市西蒲区小吉2127-3
TEL：0120-812-850
Mail：info@komagata.co.jp
http://www.komagata.co.jp/

ホッチキス箱

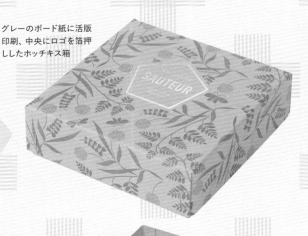

グレーのボード紙に活版印刷、中央にロゴを箔押ししたホッチキス箱

Fabricに活版印刷した糊どめ箱

使用できる紙は全13種類

四隅をホッチキスで留めたシンプルなつくり。ホッチキス色はシルバーとカッパーから選べる

クラフト感のあるしっかりとした厚紙に筋を入れ、四隅を糊やホッチキスで留めたシンプルな箱。羽車では、オフセット印刷のほか、活版印刷や箔押し加工などの印刷・加工で、この箱をつくることができる。

グレーやブラウンなど、しっかりとした厚みで素材感のある紙を型抜き・筋入れして組み立て、その四隅を糊やホッチキスで留めた箱。素朴なつくりだが、飾らない雰囲気と、そのシンプルさが大きな魅力となっている。

羽車の糊どめ箱・ホッチキス箱は、10個からオリジナルオーダーでつくることができる。最小サイズは内寸60×60×高さ25ミリ、最大サイズは515×758ミリに展開図が入るサイズ。規定サイズは8種類、一方で、中に入れるものにきちんとサイズを合わせたい場合、1ミリ単位でオリジナルサイズを指定することもできるのがうれしい。強度にこだ

わり、ホッチキスは短辺に留めて仕上げ、その位置も1つ1つきちんと合わせた丁寧なつくりが特徴だ。

使用できる紙は全13種類。5種類はグレー、ブラウン、サンド、チャコールグレー、ハイホワイトのボード紙。もう8種類は「Fabric」という同社のオリジナル紙で、表面に布が貼合されている。

印刷・加工は、オフセット印刷のほか、活版印刷や箔押し加工も可能（サイズによりオフセット印刷不可の場合あり）。シンプルで素朴なつくりの箱ながら、凝った印象に仕上げることができる。

INFORMATION

最小ロット

10個〜

価格

ボード紙グレー・印刷なしの場合で、展開図232×330mm以内10個で単価388円、30個で単価217円、50個以上で単価191円。その他、印刷・加工の内容により価格が異なる

納期

印刷・加工なしの場合、最短5営業日／印刷・加工ありの場合、校了後8営業日〜（印刷・加工の内容により異なる）

注意点

印刷・加工は表面のみ。オフセット印刷は1色まで、活版印刷は2色まで。展開図288×411mm以上はオフセット印刷不可のため、活版印刷または箔押しのみとなる

問い合わせ

株式会社羽車
大阪府堺市東区八下町3-50
TEL：0120-890-982
Mail：info@haguruma.co.jp
http://www.haguruma.co.jp/store/

156

平留め箱／角留め箱

箱の角を針金でとめた留箱。平面をそのまままっすぐ留めている「平留め箱」と、角をL字型に針金で留める「角留め箱」がある。特に「角留め箱」はつくれるところが少ないが、見た目の良さで注目の箱だ。

素材むき出しの箱をつくりたい。そんなときには、材料となる板紙を針金留めしただけで完成する留箱がおすすめ。貼箱を得意とする竹内紙器製作所では、この留め箱も得意。中にいれるものの重さやサイズ、形状などを聞き、それに最適な留め箱を提案してくれる。

留め箱は大きく分けて2つのタイプがある。ひとつは箱の側面を平らに留める「平留め箱」。留箱として一般的なタイプで、針金の太さは0・95ミリの細いタイプと1・5ミリの太いタイプの2つがあり、色も銀と銅の2種類がある。

もうひとつが、箱の側面をL字型に針金で留める「角留め箱」。るため、そのままだと強度があまりない。それを理解した上での受注であれば受けてくれる箱だ。特にこの角留め箱はつくれる会社が

昔の貼箱の芯としてつくられていたもので、実は仮留めの状態。本来はこの上に紙を貼って完成させ

今ではあまりない。しかし華奢ながら素材感にあふれた魅力ある箱で、似合う場合にはぜひ試してみたい箱だ。

平留め箱。材料の板紙を針金で留めている。箱の高さやサイズによって、留める箇所の個数が変わる。針金の色は銀と銅の2色あり

角留め箱。角をL字型に針金で留めている。もともとは貼箱の芯としてつかわれていたもので、強度があまりないため、それでもいいという場合にのみ受注可

INFORMATION

最小ロット

100個〜（それ以下も相談可）

価格

平留め箱（縦328×横238×高30mm、チップボール、10cm角以内の空押し1箇所）→100個で単価410円、200個で単価330円、300〜400個で単価290円、500個で単価280円

角留め箱（縦329×横242×高60mm、チップボール、10cm角以内の空押し1箇所、角留め1辺2箇所）→100個で単価680円、200個で単価580円、300個で単価540円、400個以上で単価520円

納期

仕様や個数、時期によって異なる

注意点

上記の価格は写真の大サイズの箱をつくった場合限定なので、使う素材や箱のかたち等によって価格は異なる。

問い合わせ

有限会社竹内紙器製作所
神奈川県横浜市金沢区幸浦2-12-8
TEL：045-784-6090
Mail：info@takeuchi-box.co.jp
http://www.takeuchi-box.co.jp/

オフセット印刷缶

密封・防湿性が高く、丈夫で、中身をしっかり保護できる缶。金属独特の質感も魅力的だ。そんな金属缶にオフセット印刷をして、オリジナルをつくることができるのだ。

オフセット印刷缶の既製型は豊富。同じ型でもサイズが小刻みで用意されているので、中身にぴったり合うものを見つけることができそうだ。ここに並べたのはほんの一例。キャンディやクッキーの缶、紅茶缶として重宝されているもの、蓋の形が凝っているものなど

お

シルバーの缶にCMYK＋白で印刷するのが基本。地のシルバーの影響を受けたくない部分には、白を刷るとよい。このデザインでは、金魚の部分には白が敷かれており、周囲の水色の部分は白を敷かず、カラーメタリックのように見せている

菓子やお茶など、湿気や光から守りたい商品のパッケージとして、見た目にも高級感のある缶は人気の容器の一つだ。既製品の缶を活用する方法もあるが、せっかくなら、オリジナルの絵柄を印刷した缶をつくってみたいもの。

印刷は、材料に下地加工をした後、CMYK＋白を印刷し、錆止めのニスと、ワックスで仕上げコーティングを行なう。その後、型を用いてプレスし、製缶するというのが製造の流れだ。

基本的には既製型を用いての加工となる（型を作成するとなると、つくってみたい。

缶の状態で、先に印刷することになる。メタリックな金属板の上に印刷するので、缶の地の影響を受けずに色を出したいときには下全状態の缶の絵柄をまず印刷する。また、ゴールドの板もある。900ミリ四方の板に、展開した材料はシルバーの板が最も一般的。光沢の特に強いもの、マットな質感（梨地）のものなどもある。

缶に印刷する前の状態、金属の板の状態で、先に印刷をすることも可能だ。この場合、缶に成形する前の状態、金属の板の面に白を敷く。色を透けさせて、メタリックカラーで見せたいときにはその部分には白を敷かない、という風にデータをつくるとよい。缶の内面や底面にも印刷することは可能だが、その分コストも上がることになる。

缶に印刷加工するにはいくつかの手法があるが、オフセットで印刷をすることも可能だ。この場合、デザイン用のテンプレートを送ってもらい、そこにデザインして入稿する。数百万かかってしまうため）。カタログなどで希望の形を選んでデザインし、缶の絵柄を印刷した缶をつくってみたい。ここぞというときに、ぜひつくってみたい。

紙の印刷に比べ、4色の製版代が約20万円と高額になるが、缶の独特の質感は、他では得られないもの。

INFORMATION

最小ロット

3000個〜

価格

◎製版校正代の目安
製版代15万円、校正代5万円。デザインや缶の大きさにより異なる

納期

約2〜3ヵ月程度

注意点

金属板は地色が銀のため、紙に印刷した場合とは色味が異なる。白を入れた場合の見え方の確認のためにも、金属板での校正をとるのがおすすめ。本番の印刷機と同等の色味を確認することができる。プレス成形のため、側面部は絵柄が多少変形する。形が変わって困る絵柄は、蓋の側面になる部分には入れないようにするとよい。

問い合わせ

側島製罐
愛知県海部郡大治町西条字附田89
TEL：052-442-5111
http://www.sobajima-daiwa.co.jp/

大和容器株式会社
兵庫県伊丹市東有岡2-43
TEL：072-782-0101
http://daiwa-yoki.com/

インクジェット印刷缶

インクジェット印刷缶。印刷範囲は蓋の外側のみ。胴の色は白、マロン、茶、バター、ブルー、ベビーピンクの6色から選択可能

CI：カフェシュクル（株式会社テスク）

パッケージとして、またそれ自体が雑貨としても使える印刷缶。オフセット印刷より、もう少し小ロットからつくりたいというときには、インクジェット印刷缶がおすすめだ。

中身を保護する機能に優れ、見た目の美粧性や高級感があれば、固定費をぐっと抑えて製作することが可能だ。

CMYK4色＋白の5色印刷。ツヤ仕上げとマット仕上げがあり、マット仕上げはより柔らかな印象となるので、その特徴に合ったデザインをするとよい。

製作の流れは、前ページのオフセット印刷缶と同様、まず、カタログなどを取り寄せてつくりたい缶の形を決め、デザイン用のテンプレートを送ってもらう。そこにデザインをして、データ入稿すればよい。校正缶は不可となるので、データ入稿の状態でインクジェット印刷機によって印刷し、プレス成形する。また、既製型のある形を選べ

ばよい。オフセット印刷缶と同様、材料が板の状態でインクジェット印刷機によって印刷し、プレス成形する。また、既製型のある形を選べ

から、それ自体が小物入れなどの雑貨として、中身を使った後にも取っておいて使いたくなる缶。オフセット印刷缶は仕上がりが美しいが、版代が約20万円ほどかかるため、小ロットでは単価が高くなりすぎてしまう。そんなときには、インクジェット印刷缶がおすすめだ。

ハーフメイド缶＋スクリーン印刷

左から缶の銘柄「ラフィーネ（シロ）」に3色刷り、缶の銘柄「ループ缶（ブラック）」に白1色刷り、缶の種類「コルン（ベージュ）」に3色刷りしたもの

缶の種類「プチ缶L」のシロ、クロに、それぞれ2色ずつ印刷したもの

円柱形のさまざまなタイプの缶を500本という小ロットからオリジナルサイズや色、素材でつくってもらえるのが、お茶どころ静岡で缶をつくっている静岡製缶だ。お茶や海苔の缶などにポピュラーに使われているかぶせふたタイプの「ソフト缶」、ソフト缶より蓋が浅い「コルン」（写真下右）、はめ込み式の蓋が特徴の「ラフィーネ」（写真左）、印籠式の「ループ缶」（写真中央）他、多くの種類がある。

それをベースに、素材や色、サイズを指定して500本からつくれるのが「ハーフメイド缶」。直径は58、64、75、82、98ミリがあり、高さは1ミリ単位で指定できる。ただ製造時に0・1〜0・2ミリ程度は誤差が出る可能性があるので覚えておこう。

また缶を回転させながら印刷できる、通称「回転シルク」と呼ばれるスクリーン印刷で、オリジナルデザインを印刷することもできる。こちらはより少なく、カタログに記載されたケース単位（入り数）でオーダーできる。種類やサイズによって異なるが1ケースはだいたい100本前後。ラフィーネ（高さ20センチ）60本、100グラムのお茶が入る高さ103センチのループ缶で120本。スクリーン印刷は1オーダー3000本まで。つまり1色印刷なら3000本、2色印刷なら1500本となる。ただ多色は見当ズレが起こりやすいので、デザインに注意したい。

500本からオリジナルサイズの円柱缶がつくれるオリジナル静岡製缶の「ハーフメイド缶」。さらにカタログ商品ならケース単位（100本前後）で「回転シルク」と呼ばれるスクリーン印刷を用いてオリジナルデザインが印刷できる。

INFORMATION

最小ロット

ハーフメイド缶は500個〜。スクリーン印刷はケース単位（1ケース100本前後が多いが、缶の種類によって異なる。同社のカタログにすべて記載あり）

価格

ハーフメイド缶は種類やサイズによって価格がかなり異なる。一例として上写真右の「コルン」の場合、500缶で総額10万円程度。スクリーン印刷は1箇所1色30円程度＋版代（1万円程度）

納期

ハーフメイド缶は1ヵ月半〜2ヵ月程度。スクリーン印刷は1ヵ月〜1ヵ月半程度

注意点

回転シルクは多色刷りすると、最大1mm程度、見当ズレする可能性があるので、それが目立たない絵柄にした方が良い

問い合わせ

静岡製缶有限会社
静岡県静岡市駿河区豊田2-8-8
TEL：054-287-0123
http://www.shizukan.co.jp/

チケット・商品券用袋

Cottonチョコレートに金の箔押しで、
華やかな印象

Cottonスノーホワイトに2色印刷。
指定色で印刷できる

既製の商品券袋は4種類。左から、シックな色目の
Cottonチョコレート、柔らかな質感のCottonスノー
ホワイト、華やかなコットンパール、素朴な質感の
晒クラフト

イベントや展覧会のチケットや、商品券。大切な人に渡すときには、質感のよい封筒に入れて渡したいもの。細長いチケットにきちんと合ったサイズの商品券袋だと、よりあらたまった印象を与える。

チケットや商品券など、細長い形状のものにぴったりな、チケット・商品券袋。大切な人に渡したいときや、価値あるものとして高級感を演出したいとき、その封筒が味気ないものだと雰囲気が出ない。羽車では、質感と風合いにこだわった4種類の紙を厳選したチケット・商品券袋を定番ラインナップとしてそろえている。4種類の用紙のうち、コットンスノーホワイト、晒クラフトは和にも洋にも使える白い紙素材。一方、華やかなイベントや、より高級感を出したいときには、コットンチョコレートやコットンパールスノーホワイトがおすすめだ。

180×90ミリの規格サイズであれば型代不要で多種多様な紙から選び、オリジナル（別注）で作成することもできる。可能な印刷・加工は、オフセット印刷、活版印刷、箔押し、エンボス加工となっている。箔色や印刷色の見本帳は、同社Webサイトから購入可能だ。

INFORMATION

最小ロット

100枚～

価格

Cottonチョコレートのチケット用封筒（ゴールドの箔押し1色）の場合、100枚16280円、500枚24585円（税込）／Cottonスノーホワイトのチケット用封筒にオフセット2色（特色1）印刷の場合、100枚13090円、500枚19580円

納期

校了後4営業日後に出荷

注意点

商品券袋のサイズは180×90mm。手紙を添えて郵送する場合は、長3カマス封筒（235×120mm）がおすすめ

問い合わせ

株式会社羽車
大阪府堺市東区八下町3-50
TEL：0120-890-982
Mail：info@haguruma.co.jp
http://www.haguruma.co.jp/store/

平袋

紙を2つ折りにして、両端を糊で留めただけのシンプルなつくりだが、その素朴さがなんともいい。ちょっと透けるぐらいの薄い紙でつくると、かわいさも格別なのだ。

ものの出し入れがしやすいよう、口部分は片側を短くずらしている

薄い紙でつくると、その透け感も大きな魅力となる。写真の耐油紙のほか、純白ロール紙も透けてかわいい仕上がりになりそうだ

薄手の耐油紙にオフセット4色印刷した平袋（白、未晒）。素朴でかわいい！

袋の印刷加工を得意とする長井紙業が新しく開始した別注平袋の製作。

中にものを出し入れしやすくなるのである。

幅を15～520ミリまで自由にサイズ設定できる可動式噴射ノズルをもつ製袋機を使用することによ、袋の口は片側を少しずらした形になっている。さらに、切り込みを入れることも可能だ（型代別途）。オフセット4色印刷で、白り、最小で幅15×深さ75ミリ、最大で幅520×高さ375ミリの平袋をつくることができるのだ。

形は正方形でも長方形でもどちらでもOK。糊のノズルは4本まで使用できるため、平袋の中をさらに糊で留めて、仕切りをつけることも可能。使用できる紙は耐油紙などの特色を使うこともできる。

おみやげ袋やポチ袋、薬袋といった用途や、仕切りをつけてカトラリー袋にしたり、片側のみ糊留めして紙ファイルやL型袋にしたりと、さまざまなものがつくれそや純白ロール紙、クラフト紙、上質紙などで、40ｇ／㎡の薄いものから使えるのがうれしい。両端を糊で留めただけの素朴なつくりのこの平袋は、ペラペラの薄い紙でつう。

箸

INFORMATION

最小ロット

1000枚～

価格

いずれもオフセット4色印刷で、未晒幅155×深さ115mmをつくった場合、1000枚で単価29円、5000枚で単価7.8円／白 幅140×深さ170mmをつくった場合、1000枚で単価32円、5000枚で単価9.2円

納期

データ入稿後、約2週間

注意点

データはIllustratorで作成。仕上がり寸法にトンボをつけて入稿すればよい。印刷ありの製袋の場合、紙は米坪40g/㎡以上から使用可能。糊幅に約2mm前後とられるので、内寸がその分小さくなる。食品対応可能

問い合わせ

長井紙業株式会社
東京都台東区蔵前4-17-6
TEL：03-3861-4551
http://www.nagai-tokyo.jp/

封筒型平袋（和紙）

風合いのよい和紙の封筒。薄めの和紙を用いて中面に印刷し、表からほんのり透けるのを楽しむことができるのが、こちらの封筒型和紙平袋だ。

封筒型和紙平袋。中面に印刷した絵柄がうっすらと透けて見える

きらきら光るレーヨン繊維を抄き込んだ、簀の目入りの雲竜紙の中面に色ベタを印刷。繊維の部分だけ色が表にも染みて、面白い仕上がりに

長井紙業の別注平袋のうち、封筒の抜き型を使用してつくれるのがこちらの封筒型平袋。しかも、和紙を使い、封筒の中面に絵柄を印刷してくれらはほんのりと絵柄が透けて見え、上品なかわいさのある封筒になるのだ。他社ではなかなかできないことだが、和紙印刷を得意とし、印刷から製袋まで一貫して社内で行なう同社ならでは。薄手の和紙を使って中面に印刷すると、表からはほんのりと絵柄が透けて見え、上品なかわいさのある封筒になる。

ナルのサイズでつくることもできる。

中面印刷は、オフセット、活版どちらも可能。オフセット印刷であれば、写真を用いたデザインなども可能だ。活版印刷の場合は、単色が望ましい。また、大礼紙や雲竜紙のようなレーヨン繊維を抄き込んだ和紙を用い、中面に色ベタを印刷すると、繊維部分だけ色が表にまで染みて、色つきの繊維を抄き込んだ紙のようになる。

和紙は長井紙業の見本帳のなかから選べる。見本帳は同社に問い合わせれば、送ってもらえる。もちろん、型代がかかってもよければ、オリジ

抜き型があるのは、幅125×長さ205ミリ（ベロを伸ばした状態で）という、ポストカードにちょうどいいサイズだ。

INFORMATION

最小ロット

5000枚〜

価格

上写真のような封筒をつくった場合、5000枚で単価10円

納期

データ入稿後、約2週間

注意点

データはIllustratorで作成。125×205mmのサイズで絵柄を送ると、封筒のテンプレートに当てはめてレイアウトしてくれる。使用する和紙は四六判65kg前後ぐらいが、透け感、封筒の使いやすさの両面から適している

問い合わせ

長井紙業株式会社
東京都台東区蔵前4-17-6
TEL：03-3861-4551
http://www.nagai-tokyo.jp/

アド！パック

メール便や郵送などに使う、板紙でできた封筒。オリジナル印刷を施したいと思っても、ロットが合わないということが多い。しかし高田紙器のアド・パックは、100部から表裏フルカラー印刷したオリジナル厚紙封筒がつくれる。

一般的に厚紙封筒のほぼ全面にオリジナル印刷をする場合、紙の状態で印刷をし、それを型抜き・製袋することが多い。しかしそうなるとそこのロット数をつくらないと、1枚あたりの単価が高くなってしまいがちだった。だがこのアド！パックは封筒になった状態で表裏印刷が可能なため、最小100部からオリジナル印刷できるのが特徴だ。

基本となる白タイプは、310g／㎡のコートボールを使用。印刷はオンデマンド印刷で、端から数ミリは印刷不可だが、それ以外は表裏とも印刷できる。見当精度もいいので、開封するジッパー部分に「OPEN」と入れるなど、細かいデザインができるのもうれしい。

サイズは、ベロを折ったときに縦245ミリ、横340ミリで、ゆうメールやクロネコDM便、飛脚ゆうメール便などの規格サイズに対応。ベロ部分が50ミリありジッパーの切れ目と裏面には封用の両面テープが付いている。基本の白以外に、白いコートボールの裏面（ネズミ色）を表側にしたグレータイプ、クラフト板紙を使ったクラフトタイプもある。

基本となる白いコートボールタイプ。端数ミリ以外は全面にレイアウトできる

裏面。折り目の内側部分にレイアウト可能

『デザインのひきだし』編集部
津田 淳子
株式会社グラフィック社
〒102-0073
東京都千代田区九段北1-14-17
T.03-3263-4579 F.03-5275-3579

見当精度がいいので、ジッパー部分の中にもレイアウトできる

同じサイズで、コートボールの裏面を面使いしたグレータイプ（写真左）と、クラフト板紙タイプもある。どちらも印刷が映えてかわいい

INFORMATION

最小ロット

100部〜

価格

100部の場合・片面印刷12000円、両面印刷15000円／200部片面印刷20000円、両面印刷26000円／1000部片面印刷80000円、両面印刷120000円（すべて封筒代、プリント代込み、税別、デザインデータ支給）

納期

通常営業日最短3日で作成（完全データ入稿の場合）

注意点

事前に印刷可能範囲が記されたIllustratorのテンプレートを入手してから、デザインした方がよい。オンデマンド印刷のため金銀や蛍光色などの特色は使用できない

問い合わせ

有限会社高田紙器製作所
東京都葛飾区堀切3-26-16
TEL：03-3693-2181
http://www.85223.com/

ペーパーフォルダー

使用できる用紙は、29種類から選べる

表紙に穴を開けたい場合はお問い合わせを

書類やリーフレット、会社案内やカタログなどをセットして、パッケージのように使えるのがペーパーフォルダーだ。化粧品やお茶のように厚みのないものであれば、試供品とその説明を一緒にセットして渡すという使い方もできる。

書類を包むパッケージであるペーパーフォルダー。プレスリリースを配布したり、試供品やノベルティと一緒にセットして商品説明をした

り、会社案内やツアーパンフレット、カタログなどをセットしたり。書類や冊子、厚みのあまりない商品などを入れて渡すことができる。

羽車では、A4サイズのペーパーフォルダーを、1ポケットと2ポケットの2種類から選んで、手軽につくることができる。素材や質感を重視してセレクトされた紙は29種類。その他A5、A6など4種類のサイズが揃う。オフセット印刷や活版印刷、箔押し加工、エンボス加工といった印刷・加工に対応している。中にセットする書類も合わせて制作することができ、統一感を出せるのもうれしい。

1ポケット（右側のみ）、2ポケットの2種類の既製品を用意

INFORMATION

最小ロット

100枚〜

価格

A4フォルダー1ポケット（ボード紙グレー270g/㎡）に活版1色印刷をした場合、100枚で23650円、300枚で34639円、500枚で45650円（税込）

納期

校了後8営業日〜出荷

注意点

大きさは名刺サイズ、A6、A5、A4用で全6種類。A4サイズのポケットには書類が15枚程収納できる。紙やサイズにより印刷加工の可否が変わるためお問い合わせを

問い合わせ

株式会社羽車
大阪府堺市東区八下町3-50
TEL：0120-890-982
Mail：info@haguruma.co.jp
http://www.haguruma.co.jp/store/

ペーパートレイ

ペンや小物を入れて卓上に置いておくとすてきなペーパートレイ。オリジナルの紙を使って、サイズや形も自由にオーダーすることができる。

ペーパートレイ六角形

ペーパートレイお盆型

ペーパートレイ長方形

ペーパートレイ角形

側面と底面を1枚の
上貼紙でつくったタイプ

小物整理などに活躍する卓上トレイ。これを紙製でつくれたらすごくいい。

加藤紙器製作所では、A4の書類入れなどに使えるサイズのお盆型、ペン入れなどに使いやすい外寸90×220ミリの長方形、小物入れにちょうどいいサイズの角形や六角形といったタイプで、オール紙製のトレイをつくってもらうことができる。

加藤紙器製作所のペーパートレイは、内側底面とそれ以外の部分の上貼紙が別パーツになっているため、内側底面と側面が連続柄にならないといけないものは向かない。底面と側面を1枚紙でつくることも不可能ではないが、難易度が高いため要相談にて作成可能。ここで紹介した以外の形やサイズにしたいときも相談にのってくれる。

藤紙器製作所に頼むこともできる。撥水性をもたせたいときにはPP貼り加工したものを使うこともできるが、上貼紙を膠糊で貼り付けるため、重なる面が擬似接着になり剥がれやすくなる可能性がある。

2ミリほどの厚みのある芯紙に、印刷や箔押し加工などを施した紙（上貼紙）を貼ってつくる。上貼紙は四六判70〜110キロ程度までの紙が適していて、印刷加工した紙を持ち込むことも、また印刷から加

INFORMATION

最小ロット
最小ロット100個〜、経済ロット500個〜

価格
それぞれ100個／500個のときの単価。
長方形：590円／330円〜・お盆型：650円／380円〜・六角形：620円／350円〜・角形：590円／300円〜（すべて抜き型・上貼紙代・送料別途）

納期
校了から3〜4週間程度

入稿データについて
上から貼る紙（上貼紙）への印刷から頼む場合は、フォントをアウトライン化したIllustratorファイルで入稿。手貼り加工のため、商品によって個体差がでる

問い合わせ
有限会社加藤紙器製作所
東京都立川市一番町4-42-2
TEL：042-520-8583
Mail：office@box-katou.co.jp
https://www.box-katou.co.jp/

いろいろ文具 & 刷りモノ & 紙玩具編

発泡印刷スタンプ

絵柄や文字部分など、スタンプにしたい箇所を特殊盛り上げ印刷したシートを切り取り、組み立ててポンと押せる。そんな冊子にも綴じ込める簡易スタンプは、オリジナルでつくるのにうってつけのグッズだ。

こどものころ雑誌付録などについていた、簡易スタンプを覚えているだろうか？

点線に沿って切り取り、折って、あとは自宅にあるスタンプ台でインクをつけてポンと押す。すると、凹凸ある特殊印刷部分がスタンプの凸版になって押せるという仕組みの簡易スタンプ。

実はこれ、スクリーン印刷による発泡印刷されたシート。熱で発泡する特殊な粒子を含んだインキをスクリーン印刷で刷り、熱をかけてその部分を膨らませる。そうするとそこが凸版となって、スタンプにできるというわけだ。

実際にゴムや樹脂などを腐食や成型してつくるスタンプに比べれば、凹凸も浅く、印影もシャープになりにくいが、オリジナルスタンプを雑誌付録などとして、またカードスタイルで配りたい、また

大量に比較的安価にスタンプをつくりたいときに、いいオリジナルアイテムだ。

発泡印刷スタンプを組み立てて、赤いスタンプ台で押したもの。予想以上にきれいに押せる

発泡印刷スタンプは、スタンプにしたい文字や絵柄を、熱をかけると発泡する特殊インキでスクリーン印刷する。発泡具合によって、文字や絵柄のシャープさ太さ、凹凸の高さなどが変わる

INFORMATION

最小ロット

1枚（シート）〜。しかし版代がかかるため経済ロットは500枚（シート）〜

価格

四六判四裁サイズでつくる場合、阪代：2〜2万5000円（1版）+加工賃：500シート通しで一式5〜6万円程度（用紙代は別途）

納期

データ入稿から、校正が必要な場合は中2日程度で出校、本生産は校了後中3日程度（部数によって変動あり）

入稿データについて

Ilustratorなどによるデータ入稿。発泡印刷スタンプにしたい部分は、絵柄を反転させておく

注意点

発泡印刷スタンプにしたい絵柄や文字は、その線の太さによって再現性が変わるので、校正刷りすることをおすすめする

問い合わせ

株式会社プロセスコバヤシ
東京都江戸川区南篠崎町3-10-11
TEL：03-3678-5911
Mail：info@pro-koba.co.jp
http://www.pro-koba.co.jp

ペーパークラフト

「切る、折る、貼る」といった工程を駆使して生まれるペーパークラフト。オリジナルキャラクターを立体化したり、子どもでも作れる模型を考えて、ワークショップで活用したりと、用途は様々。紙の可能性を感じられるアイテムだ。

留め具などの金具は一切使わずに、紙だけで作られた模型「ペーパークラフト」。環境に配した製品に注目が集まる今、リサイクル性や安全面においても、ペーパークラフトの需要が高まっている。

オーダー時に大切なのは、作りたいアイテムをできるだけ詳細に思い描くこと。写真資料やイラストなどのスケッチを準備しよう。その後、打ち合わせを元に設計した初回試作「ホワイトモデル」が作成される。用紙はリクエストもできるが、強度や組み立て工程を考慮した上で選定される。さらにディティールの変更や着彩の指定をし、完成までに平均して4回の試作を繰り返し、完成。ペーパークラフトは、制作のプロセスを楽しむアイテムなので、シートのまま納品される。

シートのタイプは2種類。切り抜き線を印刷し、作り手がハサミやカッターを使ってパーツを切り抜くタイプと、刃型抜きでミシン目のような点線を入れておき、手で抜けるようにするタイプとがある。ハサミで切り抜くタイプは制作費が抑えられ、細かなパーツを含む難易度の高いペーパークラフトに向いている。刃型抜きを施すタイプは、刃型代と製造工程がプラスされる分、制作費もアップ。デザインはシンプルなものに向いている。

最後は組み立て説明書を作成。シートの脇に書き込む場合もあれば、別紙を作成する場合もある。説明書づくりのノウハウもあるのが心強い。

INFORMATION

最小ロット

1個〜

価格

設計料10万〜＋印刷・加工費　写真のサッカーボールの場合、1000枚発注して単価500円程度。戦国武将シリーズの場合、1000枚発注して単価1000円程度で制作できる

納期

ホワイトモデルの試作がスタートしてから約2ヵ月

入稿データについて

データ制作の必要はなし

注意点

使用する紙は、ノリの貼り付けができるか、切り取りやすいかなどを考慮する必要があるため、推薦紙が提示される。自由には選べないので注意を

問い合わせ

株式会社 紙宇宙
東京都新宿区下宮比町2番14号
飯田橋KSビル 2F
TEL：03-3513-5810
Mail：inquiry@kamiuchu.jp
https://kamiuchu.jp

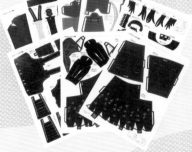

シート状で納品される。戦国武将シリーズは細かなパーツが多いため、刃型抜きはせず、自分でハサミやカッターで切り抜く仕様

単純な形から、複雑な模型まで再現できる

戦国武将シリーズのペーパークラフト。「伊達政宗のペーパークラフトを」というだけのオーダーから、衣装のデザインや顔の表情、ポーズなども提案してくれる

組み立て消しゴム

イワコーのオリジナル消しゴムの数々。お菓子のスポンジの質感など、かなりリアルだ。電車型の消しゴムは、プラスチック製の車輪がついていて、手で走らせて遊ぶことができる

動物や恐竜、お菓子や自動車などさまざまな形のカラフルな消しゴム。オリジナルキャラクターなど、好きな形で消しゴムをつくることができるのだ。ここで紹介するイワコーでは、「組み立て消しゴム」というタイプの消しゴムを製造している。

消

消しゴムのつくり方には、いくつか種類がある。たとえば一般的な四角い消しゴムは、四角いパッドのような容器に消しゴム液を流し、釜で焼いて、切って仕上げる。変わった形の消しゴムのなかでも、金太郎飴のように型から押し出してつくるタイプは「押し出し成形」と呼ばれる。

イワコーが手がけているのは、そのどちらでもない「組み立て消しゴム」というタイプだ。金太郎飴方式では、輪郭はオリジナルの形にできるが、押し出しながら切っていくため、断面は平らになる。一方で組み立て消しゴムの場合は、完全に3Dの立体物としてつくれるのだ。

オリジナルデザインで組み立て消しゴムをつくりたい場合、まず消しゴムをつくりたい場合、まずはイワコーにデザイン画を渡す。たとえば恐竜をつくりたいとき、平面の絵では描ききれない部分、見えないおなかはどうなっているのかなどができる限りわかるように、いろいろな角度からの絵や、ぬいぐるみなどを用意する。

するとイワコーでは原型製作を手がける原型師に依頼する。資料で説明しきれない質感のイメージなどは、口頭でも説明を加える。

次に、打ち合わせ内容をもとに、原型師が原型をつくる。原型師には、たとえば恐竜ならこの人、ケーキならこの人というように、得意分野がある。また、原型師によって、現在に使う材料も、スカル

INFORMATION

最小ロット

1万個〜

価格

オリジナルの場合、色数をおさえ、パーツを少なくしても、原型代・金型代・成形代などすべて合わせて少なくとも70〜100万円ぐらいかかる(金型代の比重が大きいため、1000個でも2000個でも価格はそれほど変わらない)

納期

原型・金型作成が40〜60日、その後、消しゴム量産日数が1万個で約20日間(難易度や部品点数によって、納期が大きく変わることがあり)

入稿データについて

消しゴムの場合は、データ入稿ではなく、デザイン画などの資料を渡す。シールや台紙をつくる場合はIllustratorでデータ入稿

注意点

製作できる消しゴムは、最大で150×100mmぐらいまで。ただし、大きくなるほど、コストは高くなる

問い合わせ

イワコー
埼玉県八潮市大瀬184
TEL：048-995-4099
https://www.iwako.com/

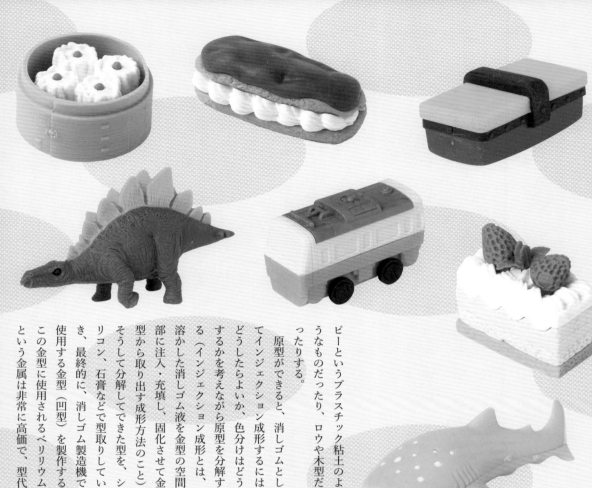

ピーというプラスチック粘土のようなものだったり、ロウや木型だったりする。

原型ができると、消しゴムとしてインジェクション成形するにはどうしたらよいか、色分けはどうするかを考えながら原型を分解する（インジェクション成形とは、溶かした消しゴム液を金型の空間部に注入・充填し、固化させて金型から取り出す成形方法のこと）。そうして分解してできた型を、シリコン、石膏などで型取りしていき、最終的に、消しゴム製造機で使用する金型（凹型）を製作する。この金型に使用されるベリリウムという金属は非常に高価で、型代

の多くを占める。

消しゴムの材料となるプラスチックのペレットには、あらかじめドライパウダーで色をつけておく。色はDICやPANTONEなどで指定してもよいし、色見本を渡せば近い色に調色してくれる（香り分をつけることも可能だ）。色づけした高温で溶かされ、金型に流し込まれて、消しゴムのパーツが出来上がる。

注意したいのは、機械1台では、一度に1色しか消しゴムをつくれないということ。このため、色数分の型と消しゴム（パーツ）が必要となる。

必要なパーツがすべてそろったら、最後に一つひとつ手作業で組み立てられて、組み立て消しゴムの完成となる。

製作費を大きく占めるのは型代となるため、色数を増やしたり、大きい消しゴムをつくると、その分コストが上がる。既存型を用いて消しゴムの色を変えるとか、仕上げに貼るシールを変えるだけの場合は、単価40円ぐらいで比較的手軽に製作可能だ。

なお、こうした特殊な形の消しゴムは「消えないのでは？」と思ってしまいがちだが、イワコーの組み立て消しゴムの消字率は87％。実はかなりきれいに消せるのだ。

既存型を用いて、貼るシールを変えたり、消しゴムの色を変えれば、比較的手軽にオリジナルをつくることが可能

江戸角凧

伝統紋様の「波兎」と「富士越の龍」。これらの絵柄を見ると色味の参考になる。極彩色だが、濃淡によってグラデーションも描ける。墨で線画を描いた後に着彩するのが特徴だ

髭文字で描かれた名前凧。写真は赤地に白の抜き文字を描いたもの。ここに札を描き入れ、生年月日などを加えるパターンもある

日本各地に数百種あると言われる和凧。職人が一枚一枚手描きで仕上げる伝統工芸だ。この和凧もオリジナルデザインを制作できる。定番の名入れ凧から、個性的な絵柄ものまで。墨と顔料を使った昔ながらの手法で描くため、オリジナルでも日本らしい表現になるのが魅力だ。

縦長の長方形は、江戸角凧の定番形。凧に付ける糸「糸目」は長く、しっぽは付けずに、揚げる時に凧の上部に「うなり」と呼ばれる弓矢のような長い竹を取り付けるのが江戸角凧の伝統的なスタイルだ。この江戸角凧を、オリジナルで制作できるのが「お江戸の凧屋さん 凧工房とき」。職人の土岐幹男さんは、1973年に名人・太田勝久さんに弟子入り。以来、江戸角凧の伝統技法を継承してきた。

オリジナルオーダーで最も多いのは名前凧。美しい髭文字を、墨と染料、顔料で描いてくれる。赤地に白抜き、赤地に白縁を取った黒文字がスタンダードだが、地色や文字色も相談できる。

オリジナルの絵柄で依頼する場合は、参考資料となる写真やイラストなどを用意。それを元に、職人が和紙に手描きでデザインを写していく。「波」や「鷹」などテーマだけを伝えて、絵柄を独自に考えてもらうこともできるが、細部まで綿密にデザインした和凧を制作したい場合は、サイズや使用できる色などを細かく打ち合わせる必要がある。

最小サイズのミニ凧は縦22cm×横14・3cmとA5用紙くらいの大きさだが、もちろん空にも揚げることができる。1点ものだけでなく、複数個のオーダーも可能。手描きなので納期を要するが、1点ずつ微妙に風合いが異なるのも魅力となる。

INFORMATION

最小ロット

1個〜

価格

◎ミニ名前凧(H22cm×W14.3cm) 1文字6050円、2文字6600円、3文字7150円
◎オリジナル絵柄凧 9350円〜
※「うなり」は含まない

納期

1〜2週間(年末の繁忙期は1〜2ヵ月)

入稿データについて

データ制作の必要はなし

注意点

凧絵はすべて手描き。参考資料は提示できるが、墨や顔料で描くため、色味やタッチは全く同じには再現できない

問い合わせ

お江戸の凧屋さん 凧工房とき
千葉県長生郡長生村本郷6220-3
TEL：0475-32-7708
Mail：info@kobo-toki.com
https://kobo-toki.com

かるた・花札

お正月になると無性に遊びたくなる、かるたや花札。日本の伝統的なカードゲームで、厚紙に裏貼り仕上げをした、丈夫な造りが特徴だ。一枚一枚、デザインが異なるため、作り甲斐もあり！ 200年以上の歴史を誇る、老舗が製造してくれるのも嬉しい。

創

業は1800年。京の都で花札を作ることから始まったという老舗「大石天狗堂」では、オリジナルのかるたや花札、百人一首など、日本のカードゲームを製造できる。

いろはかるたなら、読み札と取り札を各50枚デザイン。それを100枚分面付けし、一度に印刷する。校正も出すので、その時に文字チェックも可能だ。印刷された紙は型抜きで一度に裁断するため、札のサイズは規定通りでないといけない。かるたはH85mm×W85mm、花札はH53mm×W32・5mmと決まっている。コート紙や上質紙にオフセット印刷をするのが基本だが、印刷・加工が対応可能ならば和紙などの紙も相談できる。

カードゲームのカードは、手に取った時の厚みも重要だ。花札によく見る縁取りは、裏貼り仕上げ、といい、裏から薄い和紙や洋紙を貼り、合紙することで強度を持たせている。オリジナル発注の場合もこの仕様が一般的だが、コストを下げるために斤量のある紙に印刷し、断裁したそのままで完成させる方法もある。

最後は札箱だ。厚紙を折り込んで作る貼り箱の場合、2列に並べるか、田の字に並べるかの2タイプが選べる。他にプラスチック製の箱もあり。箱に仕舞えば、驚くほど本格的なオリジナルカードゲームが仕上がる。

田の字に収まるボックスに入れた、オリジナルかるた。大石天狗堂では強度のある裏貼り仕上げを推薦。断裁仕上げと比べて1.1～2倍の予算でできる

京都をテーマにした大石天狗堂のオリジナル花札

オリジナルデザインで制作した、花札の一種、株札。「キュウリ札」と名付けられ、オーダー元はお化けと生活舎/全日本妖怪推進委員会。プラスチックケースに入れると印象もモダンになる

INFORMATION

最小ロット

1個～

価格

いろはかるた・断裁仕上げ100組で単価3000円～。花札・裏貼り仕上げ100組で単価1500円～

納期

校了後1～1.5ヵ月

入稿データについて

Illustratorで入稿。リンク画像・配置画像含めCMYKカラーで作成。文字はすべてアウトライン化する

注意点

校正紙を一度出せるが、文字修正があった場合は、発注者がデータを修正し、完成データを再納品する

問い合わせ

大石天狗堂
京都市伏見区両替町2-350-1
TEL：075-603-8688
Mail：info@tengudo.jp
https://www.tengudo.jp

吹き戻し

昭和初期から全国で親しまれてきた、吹き戻し。ヘビ笛、吹き笛、ピロピロなどと呼ばれることもある。パーツの進化で1mもの長さに伸びたり、頭が19本に分かれた仕様も登場している。伸び縮みする特性を生かして、遊び心あるオリジナルアイテムを作ろう。

息を吹き込むと、ヒューという音とともに、くるくると巻かれた紙が伸びてゆく吹き戻し。現在、日本にある工房は2つ。そのうち、トップシェアを誇るのが「吹き戻しの里」だ。工場生産化で特許も取得しており、特注の国産針金による頭紙がスムーズに伸び縮みする。

オリジナルで作れる吹き戻しは2種類。頭紙のグラシン紙に独自のプリントを施すタイプと、吹き戻しに装着する紙製の面をデザインするタイプだ。面に穴を開けて吹き戻しを通すタイプは、規定形である丸形の面であれば、マイクロミシンで加工済みのA3用紙に社内の複合機で印刷するため、小ロットから注文できる。

頭紙のグラシン紙はグラビア印刷で3色刷りまで可能で、特色も指定できる。長さは約20cm～80cmまで。ジョイントを繋げれば頭の本数はいくらでも増やすことができ、既製品には19本も装着したアイテムもある。

持ち手の棒は約3～60cmの長さが選べ、既定のサイズ（約7cm）であれば巻き付けるシールをデザインすることもできる。

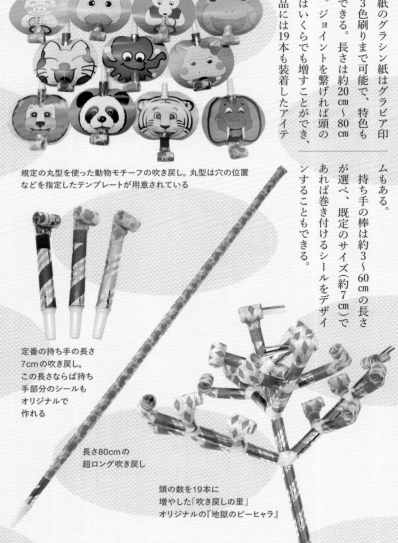

規定の丸型を使った動物モチーフの吹き戻し。丸型は穴の位置などを指定したテンプレートが用意されている

定番の持ち手の長さ7cmの吹き戻し。この長さならば持ち手部分のシールもオリジナルで作れる

長さ80cmの超ロング吹き戻し

頭の数を19本に増やした「吹き戻しの里」オリジナルの『地獄のピーヒャラ』

INFORMATION

最小ロット
1000個～（それ以下でも相談可）

価格
◎オリジナル頭紙吹き戻し：頭紙作費（型代、印刷代、紙代）20万円～＋パーツ代1本130円～×製造本数
◎オリジナル面付き吹き戻し：面型作費（型代、印刷代、紙代）10万円～＋パーツ代1本130円～×製造本数

納期
デザイン確定後1ヵ月～

入稿データについて
Illustratorで入稿。リンク画像・配置画像含めCMYKカラーで作成

注意点
頭紙のデザインは「連続模様」となっているのが好ましい。グラシン紙は1巻き4000m分を一度に印刷し、それを活用して何本の吹き戻しを作るかは発注者側次第。1度の印刷で約10万本分の頭紙が作れる

問い合わせ
株式会社 吹き戻しの里
兵庫県淡路市河内333-1
TEL：0799-74-3560
Mail：office@fukimodosi.org
https://www.fukimodosi.org

クラッカー

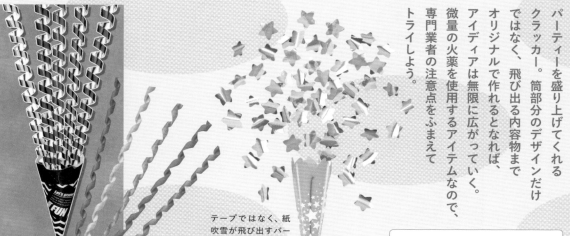

パーティーを盛り上げてくれるクラッカー。筒部分のデザインだけではなく、飛び出る内容物までオリジナルで作れるとなれば、アイディアは無限に広がっていく。微量の火薬を使用するアイテムなので、専門業者の注意点をふまえてトライしよう。

テープではなく、紙吹雪が飛び出すバージョンも。星型は既製品のひとつなので、応用すれば制作費を抑えられる

スタンダードタイプのクラッカー。飛び出すテープは既製品の中から1色だけを選ぶといったアレンジもできる

ヘッダー付きのOPP袋。オリジナルでもデザインできるがロットは3万枚〜

パーティーグッズの定番、クラッカー。ホイル紙にポップな色と模様を印刷したものが一般的だが、例えば、筒も飛び出すテープも白で統一した究極にシンプルなクラッカーや、紐を引くと中から虫型紙吹雪が飛び出るといった、びっくり要素のあるクラッカーなど、アイデア次第でユニークなアイテムが作れる。

手軽なのは、筒の部分のみにオリジナルデザインをプリントする仕様。紙はホイル紙とコート紙の2種類があり、飛び出す中身は既製品から選べる。中身まで全てオリジナルにすることも可能だが、その場合は内容物の飛び散る加減や安全性を調べる必要があり、試作をしてみて、完全に仕様が決まった段階から約9ヵ月後の納品となる。筒部分の長さは8cm〜10cmが定番だが、サイズを大きくすることも可能だ。

納品用にオリジナルデザインのヘッダ付きOPP袋を注文することも可能。ロット数は3万個からとなる。他には引き紐にリングを装着するオプションも。引き紐は火薬部分と密接に関わるため、規定の白糸しか使用できないことも覚えておこう。

INFORMATION

最小ロット

◎筒のみオリジナルデザイン10万個〜
◎飛び出す内容物も含めたオリジナル10万個〜

価格

◎筒のオリジナルデザインで既製の紙テープが飛び出すタイプを3個入りパックにした場合の単価100円〜
◎飛び出す内容物も含めたオリジナルは仕様確定後、要見積

納期

◎筒のみオリジナルデザインは仕様確定後、約6ヵ月
◎飛び出す内容物も含めたオリジナルは、仕様確定後、約9ヵ月

入稿データについて

Illustrator、またはPhotoshopで入稿。リンク画像・配置画像含めCMYKカラーで作成。文字はすべてアウトライン化する

注意点

微量の火薬を使うため、筒のデザインには規定の注意書きが必須。展開図のテンプレートに記載必須テキストが配置されている。仕様によって別途初期費用がかかる

問い合わせ

株式会社カネコ
愛媛県宇和島市伊吹町141-1
TEL：0895-25-1112
http://www.p-kaneko.co.jp

おりがみ

紙を折ってさまざまな形のものをつくるおりがみは、日本の伝統的な遊びの一つだ。1971年から自社工場でおりがみの製造を手がけるトーヨーは、「教育おりがみ」でおなじみのメーカー。オリジナルのキャラクターや動物、乗り物など好きな形のおりがみ制作を依頼することができるのだ。

1

枚の紙で遊べる日本の伝統的なおもちゃ、おりがみ。一般的によく使われるおりがみは、15×15センチのサイズだ。しかし4×4センチを最小として、菊判から取り都合のよいサイズであれば、好きな大きさでつくることが可能。折って遊ぶものなので、厚すぎても薄すぎても折りづらい。四六判換算で55キロぐらいの上質紙がほどよい厚みとなる。

オリジナルでおりがみをつくりたい場合は、展開図と折り図(折り方の手順の図解)制作と、それに合わせた絵柄の印刷へと進んでいく。

おりがみは、子どもが遊ぶことが多いため、日本玩具協会によって安全基準が設けられている。紙は基本的に、蛍光染料の入っていない上質紙が使用される。

また、印刷後、2つ折り表紙をつけてOPP袋に入れるのが通常のパッケージ。たとえば紙ケースに入れたいなど、違うパッケージをつくりたい場合は要相談だ。

完全なオリジナルではなく、折り鶴に絵柄を刷って、鶴の形になったときに翼に国旗などの模様が現れるおりがみも人気だ。

ラクターなど好きな形を折ることのできるおりがみをつくってみたいもの。

オリジナルの形をつくりたい場合は、トーヨーを通じて、おりがみ作家に依頼してもらう。たとえばカブトムシのおりがみをつくりたいと伝えると、まず試作が届く。その試作でOKであれば、……

厚すぎても薄すぎても折りづらい。

せっかくつくるのであれば、キャラクターなどの好きな形をつくりたい場合は、表紙だけをオリジナルデザインにする方法もあるが、

INFORMATION

最小ロット
3000部〜(仕様により異なる)

価格
スタンダードな無地のおりがみの製作コストを1とすると、完全オリジナル製作は2〜3倍(ただし仕様により異なるので、まずは問い合わせを)

納期
試作〜完成まで2ヵ月以上(仕様により大きく異なるので、問い合わせを)

入稿データについて
展開図のデータをもらって絵柄を当てはめ、Illustratorでデータ入稿

注意点
発注できるのは、基本的に法人のみ

問い合わせ
トーヨー 特販部
東京都足立区千住緑町2-12-12
TEL：03-3882-8161
Mail：oem@kidstoyo.co.jp
http://www.kidstoyo.co.jp/

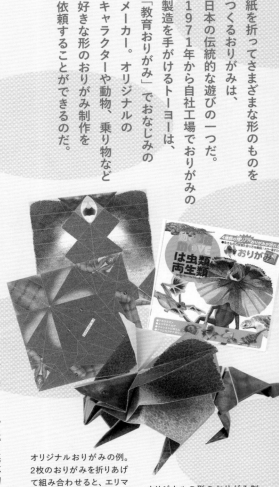

オリジナルおりがみの例。2枚のおりがみを折りあげて組み合わせると、エリマキトカゲになる

オリジナルの形のおりがみ制作を依頼すると、折り図も合わせて制作してくれる

折り鶴を折ると、真上から見たときに好きな絵柄が現れるというタイプも人気。写真はタイ国旗

トランプ

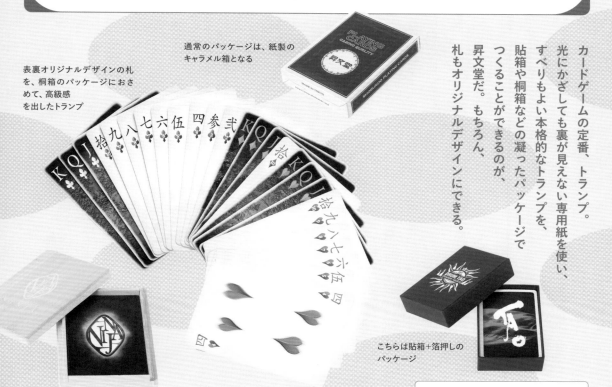

通常のパッケージは、紙製の
キャラメル箱となる

表裏オリジナルデザインの札
を、桐箱のパッケージにおさ
めて、高級感
を出したトランプ

こちらは貼箱+箔押しの
パッケージ

カードゲームの定番、トランプ。
光にかざしても裏が見えない専用紙を使い、
すべりもよい本格的なトランプを、
貼箱や桐箱などの凝ったパッケージで
つくることができるのが、
昇文堂だ。もちろん、
札もオリジナルデザインにできる。

数

字の札とジョーカー2枚
の合計54枚のカードで構
成されるトランプ。高級
カード紙や、光にかざしても裏が
透けて見えないトランプ専用紙を
使って、本格的なトランプをつく
れるのが昇文堂だ。高級カード紙
の場合は、ほどよい滑りになるよ
う、トランプニスという専用のニ
スをかけて仕上げられる。
サイズは国際基準のブリッジサ
イズ（58×89ミリ）と、カジノ用
のポーカーサイズ（63×89ミリ）
の2種類。札はブッシュ抜きで角
丸に加工されており、持ったとき
に痛くない形状になっているのも
本格的。カードの天地左右と角
Rの組み合わせで、全46種類の抜
き型サイズ表がウェブに掲載され

ているので、ここからつくりたい
サイズを選べば、型代不要で製作
できる。
パッケージは、紙製のキャラメ
ル箱タイプが通常だが、吊り下げ
られるタイプの吊り下げ用トラン
プ箱、プラスチックケースなどに
入れることもできる。また、桐箱
や貼箱などに箔押しをした特別仕
様のパッケージで、高級感を出す
ことも可能だ。
オリジナルデザインのトランプ
は、たとえば商品を印刷して商品
カタログにしたり、遊びながら覚
えられる楽しい図鑑や作品集とし
て活用されたり、キャラクターグ
ッズとして製作されたりしている。
商品サンプルは無料で送ってくれ
るので、まずは問い合わせを。

INFORMATION

最小ロット

300セット～

価格

両面オリジナルデザイン、オフセット印
刷のトランプを300セット、キャラメル
箱でつくった場合、単価1555円より
※今後値上げの可能性あり

納期

校正まで2～3日。校了後、20日間程度

入稿データについて

ウェブから版下データをダウンロード
した上で、Illustratorでデータ入稿

注意点

データには必ずトンボを入れること。ま
た、データ作成上の細かい注意事項が
あるので、必ずウェブで確認の上、デー
タを作成のこと

問い合わせ

昇文堂
東京都千代田区神田佐久間町4-6
齋田ビル
TEL：03-3862-0045
http://www.shobundo.org/

三角くじ

圧着タイプの「スッキリくじ」。ゴミが出ないのがいい。枚数や等級の数によって制作費が変わる

手で破って開くノーマルタイプくじ。紙は規定のもの以外、使用できない

昔ながらの三角くじにも、様々なバリエーションが生まれている。オーソドックスなアイテムだけに、オリジナルなら注目されること間違いなし。抽選箱も一緒にデザインすれば、イベントを華やかに演出してくれる。

抽選箱までオリジナルで作れば気分が高まる

町内会のお祭りなどで見かける三角くじ。正方形の紙を三角になるよう2つ折りにして貼り付けるというシンプルな構造だが、内側の文字が透けない印刷方法や、開封の仕方のバリエーションに、専門業者のノウハウが生かされている。

三角くじの種類には大きく2つあり、圧着タイプで簡単に開く「スッキリくじ」は、オフセット印刷による大量ロット用。1万枚印刷による大量ロット用。1万枚以上の発注が基本で、サイズは底辺70mm、斜辺50mm、マットコート157g8を使用する。

一方、ミシン目がなく、三角の周囲を手でちぎって開封する「ノーマルタイプくじ」は簡易印刷なら100枚〜3000枚、オフセット印刷なら3001枚〜オーダーが可能。サイズは70mm×70mmの二つ折りで、上質紙81gを使用。くじを開いた内側に記載する文言は10種類（10等級）まで同価格でオーダーできる。「1等」と書いたものを1枚、「2等」を3枚、「3等」を5枚などと枚数指定で注文するシステムだ。

デザイン時に重要なのは表面の文字色との1個から出力した紙を差し込む仕様で、簡易印刷で出力した紙を差し込む仕様で、白箱に透明のケースを被せたものに、抽選箱もお揃いでデザインしたい。くじを作ったら、抽選箱もお揃いでデザインしたい。テンプレートも準備されている。

「ノーマルタイプくじ」では透けないように、折り線部分に目隠しの黒ベタを印刷することも。目隠し位置を示したテンプレートも準備されている。

ので、表のベース色と合わせると一番簡単に透けを回避できる。「ノーマルタイプくじ」では透けないように、バランス。表が薄く、裏が濃いと中が透けてしまう。また裏は基本的に1Cな

バランス。表が薄く、裏が濃いと中が透けてしまう。また裏は基本的に1Cなので、表のベース色と合わせると一番簡単に透けを回避できる。

色と、裏面（内側）の文字色との

INFORMATION

最小ロット

◎スッキリくじ1万枚〜
◎ノーマルタイプくじ100枚〜
◎抽選箱1個〜

価格

◎スッキリくじ1/1c・1万枚・裏（中面）はアタリとハズレの2等級のみの場合で16万5000円〜
◎ノーマルタイプくじ1/1c・100枚で15300円〜
◎抽選箱1個1200円〜
※今後値上げの可能性あり

納期

スッキリくじ1万枚で校了・入金後14日前後
◎ノーマルタイプくじ〜3000枚まで校了・入金後7営業日前後
◎ノーマルタイプくじ3001枚〜校了・入金後10〜14営業日前後
◎抽選箱10枚以下5営業日前後、10〜50枚10日営業日前後

入稿データについて

Illustrator、またはPhotoshopで入稿。リンク画像・配置画像含めCMYKカラーで作成。文字はすべてアウトライン化する。裏（中面）は1Cのみ。目隠しをつけない場合は、面と裏を同色とし、裏を50%で指定

注意点

手作業で行うため、工場の込み具合で納期が前後する場合がある。まずは問い合わせを

エッチングクリップス

東郷青児の『望郷』を再現したオリジナルエッチングクリップ。額縁風のデザインで、より絵画らしさが表現されている

京都便利堂で販売している鳥獣戯画の「猿追い」エッチングクリップ。筆で描かれた質感も かなり細かく表現されている

SOMPO美術館のミュージアムショップで売られているオリジナルステンレスクリップ。ゴッホのあの名作がクリップに！

東武鉄道株式会社がノベルティ（非売品）として作成したもの。細かい線の再現性もすごい

INFORMATION

最小ロット

最小ロットは3000セット〜。台紙付などの場合、クリップ自体の最低ロットは1万ピース

価格

スライドケースに12ピース入り3000ケースで単価450円／ケース程度〜（為替により価格が変動する可能性あり）

納期

校正に10日、校了後2ヵ月程度〜

入稿データについて

エッチング加工で抜く箇所と凹む箇所を指定が可能。原則、打合せ・必要データを支給し、デザインフィルでデザインとなる。納品形態はクリップ単体でも、スライドケース入り、台紙＋OPP袋入などさまざまな形態で相談可能

問い合わせ

株式会社デザインフィル
コマーシャルデザイン事業部
東京都渋谷区恵比寿1-19-19
恵比寿ビジネスタワー9階
TEL：03-5789-8060
Mail：btob@designphil.co.jp
https://www.designphil.co.jp/btob/

クリップといえば、一般的には細い針金状の金属を曲げてつくられたものを思い浮かべる。でもデザインフィルでつくるエッチングクリップは、そうではなく、ステンレスの板をエッチング（腐食）させて形づくっているクリップだ。

針金を曲げてつくるのではなく、金属プレートを腐食して、抜く部分と凹む部分とを表現し製造するあたらしいタイプのクリップ。

絵柄を一番深く腐食させた部分は空洞となり、浅く腐食させたところは凹型になる。そのため、クリップとして挟む部分や穴を開けたい部分は深く、絵柄をデボスで表現したい部分は浅く腐食することで、グラフィカルなクリップをつくることができるのだ。　線を抜き際は最小幅0.2ミリ以上、凹みの線は最小幅0.15ミリ以上がいる。

クリップだけのオーダーも可能だし、仕切りがあるスライドケースに入れて仕上げてもらうこともできる。

ディークリップス

鳩サブレーでおなじみの株式会社豊島屋のオリジナルディークリップス。鎌倉本店限定で販売しているグッズ。鳩サブレーのフォルムのクリップがかわいい。シルバーと白の2色が1ケースに入っている

この形を見たらすぐわかる。国民的漫画作品・サザエさんの形のディークリップスは、一般社団法人長谷川町子美術館で販売されていたオリジナルグッズだ。(現在は販売終了)

列車の形のディークリップスが愛らしい、東武鉄道株式会社のノベルティ用ディークリップス(非売品)

誰でも使ったことのある針金が丸くなったゼムクリップ。それを丸型ではなく、オリジナルな形でつくることができるのがディークリップスだ。

デザインフィルが製造販売している、動物などさまざまな形のクリップを買ったことがある人も多いだろう。本書編集部でもかなりの種類を持っている。これ、こうして買えるだけかと思っていたら、オリジナルの形でオーダーすることもできるというのだ。それはうれしい!

このいろいろな形のゼムクリップ、正式な名前は「ディークリップス」というが、スライドケースにスクリーン印刷したオリジナルケースと一緒に頼むことも可能。1ケースにいくつ入れるかも応相談だ。

基本的には打ち合わせをしてつくりたい形を伝え、それに必要なデータなどを渡して、デザインフィルにデザインしてもらう。どんな形なら製造可能かということもあるし、クリップとしてちゃんと機能するかということも合わせて考える必要があるからだ。ただ形状によってクリップとしての強度は異なる。また形状の難易度によって、価格と納期が変動する。クリップはシルバーが基本だが、白などの色タイプも可能。クリップだけでもオーダーできるが、スライドケースに

INFORMATION

最小ロット
最小ロットは3000ケース〜(スライドケースに20ピース入ったタイプの場合)

価格
スライドケースに20ピース入り3000ケースで単価450円/ケース程度〜(為替により価格が変動する可能性あり)

納期
校正に10日、校了後2ヵ月程度〜

入稿データについて
原則、打合せ後に必要データを支給し、デザインフィルでデザインとなる

問い合わせ
株式会社デザインフィル
コマーシャルデザイン事業部
東京都渋谷区恵比寿1-19-19
恵比寿ビジネスタワー9階
TEL:03-5789-8060
Mail:btob@designphil.co.jp
https://www.designphil.co.jp/btob/

180

ピークリップス

特殊処理された強度の高い紙でつくられた紙製クリップ「ピークリップス」。色は4種類から選べ、さらにパルプモールドボックス入りでつくることもできる。

つくれるクリップのカラーは白、グレー、黒、赤褐色の4色。クリップ部分は型抜き、目や足のラインはデボスで表現されている

60mm四方程度のパルプモールドボックスに入れてセットすることもできる。蓋のロゴマークもオリジナルでいれることも可能

株式会社ビクセンのオリジナルピークリップス。大変強度のある紙なので、しっかり紙を挟むことができる

本書読者なら「金属より紙の方が好き！」というひとも多いかもしれない。

デボスラインがクリップの端まで見切れる、つまり裁ち落としになっているデザインは、クリップが割れてしまうことがあるため不可となる。使われている紙はかなりの強度があるが、形状によりクリップとしての強度が異なってくる。

そんなひとにおすすめなのは、デザインフィルの「ピークリップス」。これは特殊な強度のある紙でつくるクリップで、オリジナル形状に型抜くだけでなく、凹み部分をつくって絵柄表現も入れることができるのだ。

クリップだけのオーダーも可能だが、おすすめは小さくてかわいいパルプモールドに入れての仕上がり。クリップひとつをゴムに挟んでパッケージングすることもできるし、またコストは追加になるがパッド印刷でパッケージのフタ部分に絵柄や文字をいれることもできる。クリップだけでなくパッケージまでオール紙のグッズがつくれる。

選べるクリップのカラーは、白、黒、グレー、赤褐色の4色。抜きの部分とデボス部分を指定する。ちなみにデボス部分（凹み部分）は原則片面のみに加工可能。

INFORMATION

最小ロット
最小ロットは3000セット〜

価格
パルプモールドのケースにクリップ4色×4ピース＝16ピース入り3000ケースで単価470円／ケース程度〜（為替により価格が変動する可能性あり）

納期
校正に15日・校了後2.5ヵ月程度〜

入稿データについて
原則、打合せ・必要データを支給し、デザインフィルでデザインとなる。最終形態はクリップ単体でも、パルプモールドケース入り、台紙＋OPP袋入れなどさまざまな形態で相談可能

問い合わせ
株式会社デザインフィル
コマーシャルデザイン事業部
東京都渋谷区恵比寿1-19-19
恵比寿ビジネスタワー9階
TEL：03-5789-8060
Mail：btob@designphil.co.jp
https://www.designphil.co.jp/btob/

デザイン日付スタンプ

紙にスタンプしたところ。デザイン：根津小春（STUDIO PT.）

濃色の紙に金や銀でスタンプしても、よく映える。写真は黒い紙に金でスタンプしたところ

飾り枠をオリジナルデザインした日付スタンプ。丸型、小判型、角型があり、大きさも型によって数種類ずつある。写真は、左が角型、右が小判型

サンビーでは、スタンプパッドも取り扱っている

中央部分に入っている日付をくるくる回転させて、好きな日付をスタンプすることができる日付回転印。これをオリジナルの飾り枠をつけてつくることができる。

かわいい飾り枠のついた日付回転印は、日々の手帳に量産ももちろん可能。ゴムは、紙に捺すための「赤ゴム」と、ガラスやプラスチック、革、布など、水と空気以外には何でも捺せる「黒ゴム（布滅スタンプ）」がある。

スタンプは1個から作成でき、贈るカードなど、さまざまな場所に捺すと楽しいスタンプだ。この飾り枠を自由にデザインして、オリジナルスタンプをつくることができる。

ハンコやスタンプの製造販売を手がけているサンビーが行なっているもので、同社のカタログから好きなサイズ・形の日付印を選び、どこに何を捺すためのスタンプかを伝えて相談するとよい。中央の日付部分もオリジナルでつくることも可能だが、その場合はスタンプ1個の上代が1万5000円～と高価になる。

オリジナルスタンプをつくるためには何でも捺せる飾り枠を自由にデザインして、オリジナルスタンプをつくることができる。

その有効印面内にデザインを作成してサンビーに送付。そのデータで印面作成可能かどうかのチェックを受けた後、試作へと進む。

問い合わせをすると、デザイン用のテンプレートを送ってくれる。

INFORMATION

最小ロット

最小ロットは1個～、経済ロットは100個～

価格

日付印の参考販売価格は、18mmサイズの角型または24×36mmの小判型で1個あたり4000円。これに印面制作代が加わる

納期

校了から2週間程度

入稿データについて

フォントをアウトライン化したIllustratorデータ（CS5以下）。ゴム印はスタンプインクを付着させて捺印するため、捺し圧やスタンプインクの付着量によって、ツブレやにじみが生じる。このため、線の細さ・線の間隔0.5mm以上、文字サイズ5pt以上で構成された、モノクロ2諧調データで作成のこと。また、法人以外の場合は、小売店を紹介してもらっての製作となる。まずは問い合わせを

問い合わせ

サンビー・株式会社
東京都台東区浅草橋3-16-4
TEL：03-3861-3316
Mail：gotokyo@sanby.co.jp
https://www.sanby.co.jp/

クリアスタンプ

透明な樹脂でできたスタンプを、透明なプラスチックやアクリルでできたスタンプベースに自由にレイアウトして捺せるクリアスタンプ。人気急上昇中のスタンプだ。

【使い方】①絵柄が印刷された剥離フィルムにクリアスタンプが吸着している（吸着力が落ちたら水洗いすれば復活）②剥離フィルムからクリアスタンプを剥がす。フィルムにくっついていた面に吸着性がある　③別売りの透明アクリル台（スタンプベース）にクリアスタンプを貼り付けて使用する

貼って剥がせるクリアスタンプは、使用するスタンプの種類やレイアウトを変えて何度でも使えるのが魅力。写真の左と右は、スタンプを入れかえて捺したもの

INFORMATION

最小ロット

最小ロットはシートサイズにより異なる（シートの中にスタンプが何個入っても同じ）。70×50mmは200枚、100×70mmは100枚、150×100mmは50枚。各サイズとも、最小ロットが注文の1単位となる

価格

シートサイズ70×50mmで単価425円〜、100×70mmで単価850円〜、150×100mmで単価1700円〜（完全データ支給、消費税・送料別途）
※クリアスタンプ、シートへの裏印刷（黒1色）、シートカットのみの場合

納期

入稿後3週間程度

入稿データについて

フォントをアウトライン化したIllustratorデータで入稿（モノクロ2階調）。写真スタンプを作成する場合は、高解像度のTIFFまたはJPEGデータ（写真の場合、別途、データ加工料が必要）。1個のクリアスタンプの最小サイズは10mm角程度。スタンプ同士は5mmの間隔をあけて配置すること。独立した線は幅0.5pt以上に設定。その他、入稿データの詳細については、別途問い合わせを

問い合わせ

株式会社渡辺護三堂
東京都中央区新富2-14-4
住友新富ビル1階
TEL：03-6262-8031
Mail：miki@gosando.com
https://gosando.co.jp

クリアスタンプは、厚みのある透明な樹脂でできたスタンプだ。平滑面に吸着する性質を持っており、特別な接着剤がなくてもプラスチックやアクリルにくっつき、何度でも貼って剥がして使用することができる。このため、アクリル台などのスタンプベース上に、複数のスタンプを組み合わせて好きなレイアウトをつくり、何度でもレイアウトを変えて捺すことが可能なのだ。スタンプ自体が透明樹脂のため、透明なスタンプベースを使用すると、用紙位置を確認しながら思い通りの位置にスタンプを捺すことができ、何度も色を変えて重ね捺ししたいというときにも便利だ。

もとはアメリカでスクラップブッキング用に誕生して人気となり、近年、日本でも手帳やカードのデコレーショングッズとして話題になっている。多くは海外製で、国内で製造している会社は少ないが、渡辺護三堂は数少ない国内製造会社。フレキソ印刷の製版で長年培った技術を持ち、小さい絵柄や写真など、細かい表現も得意だ。

写真データを網点化してスタンプにすることもできる（デザインによって60線まで再現可能）

せと刺繍ワッペン

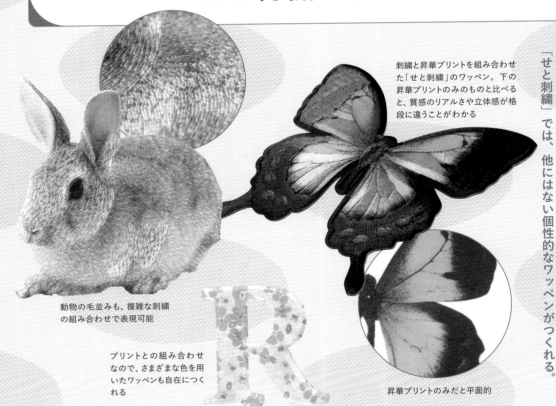

刺繍と昇華プリントを組み合わせた「せと刺繍」のワッペン。下の昇華プリントのみのものと比べると、質感のリアルさや立体感が格段に違うことがわかる

動物の毛並みも、複雑な刺繍の組み合わせで表現可能

プリントとの組み合わせなので、さまざまな色を用いたワッペンも自在につくれる

昇華プリントのみだと平面的

エンブレムやロゴマーク、キャラクターなどのモチーフを刺繍したワッペンは、長く愛されているグッズの一つ。「せと刺繍」では、他にはない個性的なワッペンがつくれる。

刺繍と昇華プリントを組み合わせた「せと刺繍」は、各種刺繍を手がけるオーキッドのオリジナル加工だ。そもそも刺繍は、さまざまな色の糸でデザインを表現できる加工方法だが、グラデーションや写真などの複雑な色彩表現は難しかった。そこでオーキッドが開発したのが、白糸で刺繍をした後に昇華プリントを重ねることで、多彩な色彩表現や、本物のような立体感を持たせることができる「せと刺繍」という方法だ。ベースの白糸刺繍は、サテン縫い、タタミ縫い、縁取刺繍、チドリ掛けといった刺繍のあらゆる糸の振り方を組み合わせて行う。このため、蝶の羽や動物の毛並みのような質感もリアルに再現できる。プリントで色を表現するので、多色刺繍も自由自在だ。ワッペンを注文するときには、まず生地を選び、縁のカット方法を選んで、最後に裏面の加工方法を選ぶ。アイロンワッペンのほか、マジックテープやクリップ仕上げなども可能だ。

せと刺繍は、白糸刺繍と昇華プリントの組み合わせ。さまざまな刺繍方法の組み合わせで、白糸の段階で立体感はかなり表現されている

INFORMATION

最小ロット
最小ロットは100個、経済ロットは300個〜

価格
5cm角サイズの「せと刺繍」ワッペンを300枚制作の場合、単価550円〜（別途、刺繍データ作成費10000〜20000円程度が必要。デザインによって価格は変わる）

納期
約3週間

入稿データについて
フォントをアウトライン化したIllustratorデータ（ai形式）や、jpeg形式の画像データなどで入稿。厳密な色合わせは難しい

問い合わせ
株式会社オーキッド
香川県高松市六条町1122-3
TEL：087-868-3600
Mail：info@emb-factory.com
https://orchid-1988.com/

せと刺繍ブローチ

複雑なグラデーションや立体感を表現できる「せと刺繍」では、ブローチのような小物をつくることも可能。小さくても存在感のある仕上がりになる。

さまざまな「せと刺繍」のブローチ。複雑で細かい絵柄もきれいに表現できる

白

糸刺繍のベースに昇華プリントで絵柄を印刷することにより、複雑な色彩や立体感の表現を可能にする「せと刺繍」。これを用いて、ワッペンだけでなく、ブローチのような小物をつくることもできる。

たとえば写真の鳥かごのインコ（上段中央）のように絵柄の一部分に刺繍を入れると（この場合は、インコと鳥かご。とまり木はプリントのみ）、存在感をもたせたい部分とそうでない部分に差をつけた、奥行きある表現になる。

ブローチもワッペンも、せと刺繍を注文する場合は、まず生地選びからスタートする。主な生地としては、光沢と高級感があるエ

ンブクロス、ソフトでユニフォームなどによく使用されるツイール、光沢のない起毛生地であるフェルト、全体的につやのあるサテンなどがある。

ブローチの台座は、基本的には用意されたものを使用することになるが、好きな台座を持ち込むことも可能（ただし、必ず事前相談のこと）。

〈 生地の種類 〉

エンブクロス　　ツイール

フェルト　　サテン

INFORMATION

最小ロット
最小ロットは100個〜、経済ロットは500個〜

価格
5cm角のサイズで500個制作の場合、単価1100円程度（台座代含む）
（別途、刺繍データ作成費12000〜25000円程度が必要。デザインによって価格は変わる）

納期
約5週間

入稿データについて
フォントをアウトライン化したIllustratorデータ（ai形式）や、jpeg形式の画像データなどで入稿。厳密な色合わせは難しい

問い合わせ
株式会社オーキッド
香川県高松市六条町1122-3
TEL：087-868-3600
Mail：info@emb-factory.com
https://orchid-1988.com/

IMシルクスクリーンの布もの

●外五つ折り
別名「ジャバラ4山」。ジャバラに折る際の折り目が4つあるタイプ。折りが増えるごとに「外六つ折り」「外七つ折り」となっていく。

IMシルクスクリーンでつくったTシャツ。細かい文字や線、ベタの入ったデザインだが、印刷品質は高く、従来のスクリーン印刷と遜色ない仕上がり。小ロットから手軽にスクリーン印刷の布ものが注文できるのはうれしい！

●8ページ折り
4つ折りのこと。表裏合わせて8面になるため8ページ折りと呼ばれている。

Tシャツやコットンバッグなどの布ものに、シンプルな単色でパキッと絵柄を出したいときに用いられるスクリーン印刷。なかでも–IMシルクスクリーンは、版代0円という画期的な印刷なのだ。

INFORMATION

最小ロット

最小ロット、経済ロットともに1枚〜

価格

ホワイトTシャツの右胸、左胸いずれかにプリントの場合（加工範囲10×10cm）単価1980円〜、10枚注文した場合、単価715円〜（税込）

納期

最短5営業日で出荷

入稿データについて

完全データの場合は、PSD、AI、PDF形式のファイルにて入稿（フォントはアウトライン化。1mm以下の線や文字は潰れる可能性があるので注意）。また、イメージ・マジックが運営する「オリジナルプリント.jp」サイト内のデザインツールでもデータ入稿可能（対応形式はJPG、PNG、GIF、BMP、AI、PSD、PDF、EPS）。印刷色はサイトに掲載の基本15色から選択。完全データ入稿かつ30枚以上の注文の場合は、DICやPANTONEにより好きな色を指定できる（調色無料）。IMシルクスクリーンで作成できる各アイテムの詳細は下記を参照
●Tシャツ：https://originalprint.jp/tshirts/p/490
●長袖Tシャツ：https://originalprint.jp/long-sleeved-tshirt/p/490
●パーカー：https://originalprint.jp/parka/p/490
●バッグ各種：https://originalprint.jp/bag/p/490
●マスク：https://originalprint.jp/hygiene/p/490

問い合わせ

オリジナルプリント.jp
（株式会社イメージ・マジック）
東京都文京区小石川1-3-11 5F
TEL：0120-962-969
Mail：support@originalprint.jp

布ものに印刷する代表的な方法としては、スクリーン印刷やインクジェット印刷などがある。メッシュ状の版にインキをのせ、スキージでかきだして印刷するスクリーン印刷は、対象物にガッツリとインキを盛ることができるため、絵柄をくっきりと見せたい、色をパキッとのせたいというときに適した印刷方法だ。ただし従来のスクリーン印刷では1色につき一般的に5000〜10000円ほどの版代が必要だったため、小ロットには向かず、主に大ロット向けに使われてきた手法だった。

ところがイメージ・マジックが開発した「IMシルクスクリーン」は、独自開発の特殊な製版方法によって、製版の時間とコストを従来の10分の1以下に抑えることに成功。「版代0円」でスクリーン印刷が行なえるようにした。

印刷仕上がりの品質も高く、細かい絵柄もきれいに再現できる。印刷色は金・銀・白を含む基本15色からの選択になるが、完全データ入稿かつ30枚以上注文の場合はDICなどで好きな色を指定可能。無料で調色してくれる。

プレミアムインクジェットの布もの

左がプレミアムインクジェット、右が通常のインクジェット。白いTシャツに黒を印刷すると、通常のインクジェットではグレーっぽく、少しぼやけた感じになるが、プレミアムインクジェットでは濃く、鮮明に再現される

左がプレミアムインクジェット、右が通常のインクジェット。通常のインクジェットではインクが生地に染み込むため、色が沈みがちになる

My Favorite

プレミアムインクジェットでプリントした「COTTON HERITAGE5.5oz プレミアムプリントTシャツ」。印刷範囲は胸・背中中央の場合35.5×40cm。タグもオリジナルで作成可能
写真・デザイン：池田晶紀＋ASA＋ゆかい

カラフルな写真やイラストをデザインした布ものをつくりたいときには、インクジェットプリントがおすすめ。プレミアムインクジェットは、インクジェットプリントの発色をより良くした印刷方法だ。

写真やフルカラーのイラストをプリントしたTシャツやバッグをつくりたい。そんなときに用いられるのがインクジェットプリントだ。ただし通常のインクジェットプリントは、生地にダイレクトにインクを噴射する方式のため、印刷色が生地色の影響を受けやすい。たとえば、白や生成りの生地に黒をプリントするとグレーっぽくなり、なんとなくぼやっとした印象になる。

これをパキッと表現したい、もっと色鮮やかにプリントしたいというときにおすすめなのがイメージ・マジックが独自開発した「プレミアムインクジェット」。ざっくりと言うと、生地の表面に特殊

な染料で膜を張り、その上にインクをのせるイメージの印刷手法だ。下地を敷いているためインクが布地に直に染み込まず、生地色の影響を受けないのが特徴。「フルカラープリントした布ものがつくりたいけど、インクジェットはぼやっとする」と思っていた人に、ぜひ試してほしい印刷だ。通常のインクジェットよりも少し高いぐらいの価格帯でつくれる。

コットンバッグプリントの比較。プレミアムインクジェット（写真左）は細部まで鮮やか

INFORMATION

最小ロット

最小ロット、経済ロットともに1枚〜

価格

プレミアムプリントTシャツ前面、背面のいずれか1カ所加工の場合、単価2090円〜、10枚注文した場合、単価1980円〜（税込）

納期

最短4営業日で出荷

入稿データについて

イメージ・マジックが運営する「オリジナルプリント.jp」サイト内のデザインツールでデータ入稿可能（対応形式はJPG、PNG、GIF、BMP、AI、PSD、PDF、EPS）

問い合わせ

オリジナルプリント.jp
（株式会社イメージ・マジック）
東京都文京区小石川1-3-11 5F
TEL：0120-962-969
Mail：support@originalprint.jp
https://originalprint.jp/premium
（プレミアムインクジェット対応商品一覧）

全面プリントスニーカー

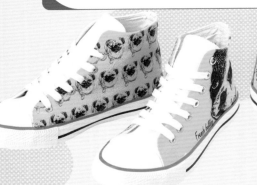

白いハイカットスニーカーにインクジェットで全面印刷。左右それぞれ外側内側を違うデザインにすることもできる（写真上のスニーカーは4面それぞれ別デザイン）。レディース（23、24、25cm）、メンズ（26、27cm）の5サイズ展開

加工の特性上、かかと部分には印刷が入りづらく、ぼやけが生じやすいので注意

黒が鮮明にくっきりプリントできるインクジェットを使用

小ロット対応のインクジェットプリントなので、1足からフルカラーで印刷可能

男女問わず幅広い年齢層の人が履いているスニーカー。ほかにはないオリジナルデザインを全面にプリントしたスニーカーをつくることができる。

定番ファッションアイテムとして、年齢や性別を問わず幅広い層の人が持っているスニーカー。シンプルな白いコットン地のハイカットスニーカーの外側、内側側面にフルカラーデザインをプリントし、1足からオリジナルで制作できるのが、イメージ・マジックのサービスだ。

複雑な形状をした既製品のスニーカーに全面プリントをするのは難易度の高いこと。ワンポイントでロゴやイラストをプリントできるサービスはあっても、全面となると、対応している印刷会社はあまりない。しかしイメージ・マジックでは、特殊な治具を用い、両足外側内側側面の4面すべてに印刷を可能にした。左右で違う色にしたり、4面それぞれを違うデザインにできるのもうれしい。

印刷方法は、インクジェット。通常のインクジェットプリントに比べて発色が鮮やかで、黒がぼやけずくっきりと印刷できるのが特徴。オンデマンド転写も選べて、こちらはベロ部分や靴ひもにも印刷できる。ベースとなるスニーカーは1種類だが、プリントする絵柄によってガラリと表情が変わる。イラストやロゴ、写真をプリントして、オリジナルブランドのアイテムや記念品など、さまざまな用途におすすめのグッズだ。

INFORMATION

最小ロット

最小ロット、経済ロットともに1足〜

価格

◎インクジェット印刷　1足4面プリントの場合、単価6600円〜、50足4面プリントの場合、単価6050円〜（靴代含む、税込）
◎オンデマンド転写　1足8カ所印刷の場合、単価10340円、50足8カ所印刷の場合、単価8322円（靴代含む、税込）
※ロット数やプリントする個所数により、価格は異なる

納期

最短4営業日で出荷

入稿データについて

イメージ・マジックが運営する「オリジナルプリント.jp」サイト内のデザインツールでデータ入稿可能（対応形式はJPG、PNG、GIF、BMP、AI、PSD、PDF、EPS）。印刷方法の関係上、かかと付近はプリントがうまくのらない場合がある。完成したスニーカーは、漂白剤や漂白性の強い洗剤の使用、直射日光、乾燥機、ドライヤー、ストーブでの乾燥は避けること。プリント面を強く擦ると衣類に色移りする恐れがあるので注意

問い合わせ

オリジナルプリント.jp
（株式会社イメージ・マジック）
東京都文京区小石川1-3-11 5F
TEL：0120-962-969
Mail：support@originalprint.jp

ボードゲーム

このボードにはナフキン柄をエンボス。ロールエンボスは全部で12種類から選べる

チップの表面にもそれぞれ加工が。左はロールエンボス（石目）、中はロールエンボス（絹目）、右はツヤPP加工

ボード（盤）の上でチップ（駒）やカードを動かしたり、めくったりして遊ぶボードゲーム。愛好家の多いグッズだ。

ゲーム用のボードやチップ（駒）、カード、化粧箱を製作できる。写真はモリカワ（BGM）のオリジナルゲーム「ボードゲーム工場〜魔女と弟子たち〜」の一部。ゲームデザイン：上杉真人（I was game）、イラスト・グラフィックデザイン：MATSUDA98、コーディネーター：福夕郎、企画・製造：盤上遊戯製作所

カードの表面にはロールエンボス加工（LB）

INFORMATION

最小ロット

最小ロット200セット〜、経済ロット500セット〜

価格

カード50枚＋20mm円形チップ12枚＋化粧箱＋B5取説1枚＋箱詰めシュリンク包装までの場合（絹目エンボス加工あり）、200セットで単価1550円、500セットで単価1050円（税別）。このほか、ウェブサイトの自動計算ページで、欲しい部材を選択すると見積り金額を確認することができる

納期

入稿から1〜1.5ヵ月（発注内容により異なる）

入稿データについて

フォントをアウトライン化したIllustratorデータ（aiデータ。テンプレート支給）。部材やサイズ、加工内容で価格は大きく変わる。箱だけなど、一部の部材だけの注文も可能。複数種類のカードを1セットごとにそろえて帯留めする「丁合い」も依頼できる（注文がない場合は、カードの種類ごとに分かれた状態で届く）

問い合わせ

株式会社モリカワ内　盤上遊戯製作所
愛知県名古屋市西区菊井1-21-1
TEL：052-571-3306
Mail：info@boardgamemill.jp
https://boardgamemill.jp/

専用のボード上で、チップやカードなどを使って遊ぶボードゲーム。対象年齢は幼い子どもから大人まで幅広く、世界中で愛されていることから、オリジナルのキャラクターや世界観でボードゲームをつくりたいというニーズも多い。せっかくつくるなら、商業用メジャーゲームのようなクオリティでつくりたい人が多いのではないだろうか。

紙加工会社のモリカワが運営する「盤上遊戯製作所（BGM）」は、まさにこうしたニーズに応えたボードゲームづくりを行なっている。設計したゲーム内容に則して、必要となるゲームボード、ゲームチップ、カード、化粧箱とい

った品目の製作を依頼できる。大きな特徴の一つが印刷加工品質。小ロットでもオフセット印刷を行い、紙を何枚も貼り合わせて好みの厚さにする合紙加工や、紙の表面全面に凹凸で模様をつけるロールエンボス加工、UVニスやPP貼りによる光沢加工、型抜き加工などを、必要に応じて組み合わせられる。特にロールエンボス加工は、ボードやカードに高級感を与える。この加工がボードゲームを一気にプロ仕様に近づけるポイントなのだ。

まずはゲーム内容や必要な部材の種類と数量を伝え、相談を。紙の取り都合なども加味して、効率よく見積もりや設計をしてくれる。

おみくじ

多田紙工でつくれる「おみくじ」。今回は、天地60mm、左右26mmの仕上がりで作成（開くと左右253mm）。糊づけ部分には印刷が入らないようにするため、内容をデザインできるのは、25×60mmの7面分となる

A3に5面付の印刷となるため、今回はこれを5面×2パターンで10種類のおみくじを作成。カラフルで楽しい雰囲気になった

日本人にとって古くからなじみの深い「おみくじ」。神社やお寺に行ったら必ず引くという人も多いのではないだろうか。この「おみくじ」を、イベントなどを盛り上げる楽しいグッズとしてつくることができる。

個人の運勢や吉凶を占うために、神社やお寺などで引く「おみくじ」。日本人にとっては、もっとも身近な占いともいえるのではないだろうか。

このおみくじをオリジナルでつくることができるのが、多田紙工だ。小さなサイズに紙を折れる「ミニ折機」に糊付けユニットをつけた機械を持っており、折りから糊づけまでを1ラインで加工することができるのである。

紙を折っただけでなく糊づけをされていることで、おみくじが箱の中で開いてしまうことがない。一方で、剥離糊を使用しているので、開くときに糊づけ部分が破れ

ず、きれいにはがすことができる。印刷はオンデマンドで行う。A3判に5面付けとなり、5面をそれぞれ違うデザインにすれば5種類の「くじ」がつくれる。これを2パターン、3パターンつくって印刷すれば、10種類、15種類とさまざまな内容の「くじ」にすることが可能だ。ちょっとずついろいろ印刷できるのは、オンデマンド印刷ならではの強みといえるだろう。

おみくじが箱の中などで開いてしまわないよう、剥離糊で糊付けしている

INFORMATION

最小ロット

100部～

価格

60×26mm仕上がり（展開時60×253mm）、上質紙A判35kg、両面4色印刷の場合、100部39000円～、500部51000円～、1000部67000円～

納期

1000部までの場合、10日間程度（状況により変動）

入稿データについて

フォントをアウトライン化したIllustratorデータでPDF入稿。糊がつく部分には印刷を入れないこと。事前に問い合わせをしてテンプレートを送付してもらい、そこにデザインするとよい。モノクロ印刷も対応可能。発送代は別途実費。おみくじの内容ごとに部数調整したり、用紙やおみくじサイズを変更したい場合は要相談。大ロット対応も可能だ

問い合わせ

株式会社多田紙工
埼玉県さいたま市南区松本1-16-1
TEL：048-863-7987
Mail：webinfo@tadashikou.co.jp
http://www.tadashikou.co.jp/

アルミ定規〈15cm〉

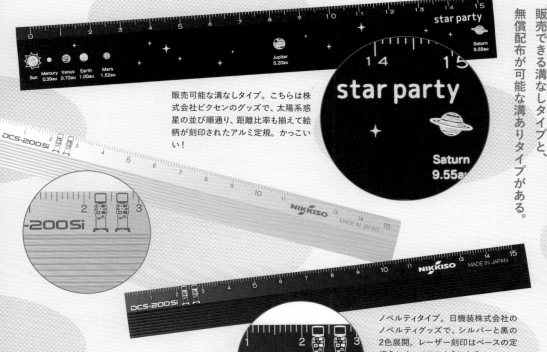

販売可能な溝なしタイプ。こちらは株式会社ビクセンのグッズで、太陽系惑星の並び順通り、距離比率も揃えて絵柄が刻印されたアルミ定規。かっこいい！

ノベルティタイプ。日機装株式会社のノベルティグッズで、シルバーと黒の2色展開。レーザー刻印はベースの定規色によってこのようになる

アルミの定規に好きな絵柄やロゴ、はてはメモリまでも自由に刻印してつくれるアルミ定規。販売できる溝なしタイプと、無償配布が可能な溝ありタイプがある。

オリジナルでつくれる定規（写真下のタイプ）で、こちらはノベルティグッズとして無償配布することはできるが、原則として販売はできない。

どちらのタイプも加工はレーザー刻印のみのため、削った部分、つまり文字やメモリ、絵柄などに色指定はできない。

溝のない販売できるタイプは、定規の色は黒、シルバー、ブロンズから選択可能。溝のある販売不可タイプは黒、シルバーの2色から選べる。長さはどちらも15センチの定規。

アルミ定規は2タイプあり、ひとつは定規下半分に溝がないタイプで、オリジナルグッズとして販売可能だ。もうひとつが溝のあるタイプ

は一般的にプラスチック製に印刷したタイプが多いが、ここで紹介するデザインフィルの定規は、金属（アルミ）製。軽くてシャープな印象がかっこいい、一味違ったグッズになる定規だ。軽く耐久性に優れたアルミ性で、摩擦で消えないレーザー刻印目盛りで、末長く使うことができる。

定規の目盛り間隔は自由に設定でき、例えばポイント尺のように、1ポイント単位で目盛りを打つということも可能だ。

INFORMATION

最小ロット

最小ロットは500本〜（溝なしタイプ＝販売可能なものは1000本〜）、経済ロットは3000本〜

価格

3000本で単価200円程度〜

納期

校正に10日、校了後45日程度

入稿データについて

アウトライン化したIllustratorデータで入稿（ai形式＋出力見本のPDF）、もしくは打合せののちデザインフィルでデザイン

問い合わせ

株式会社デザインフィル
コマーシャルデザイン事業部
東京都渋谷区恵比寿1-19-19
恵比寿ビジネスタワー9階
TEL：03-5789-8060
Mail：btob@designphil.co.jp
https://www.designphil.co.jp/btob/

オンデマンドレンチキュラー缶バッジ

カナダ・バンクーバー在住のクラフトアーティストである水島ひねさんの作品をお借りしてつくったレンチキュラー缶バッチ。それぞれ入れる画像数を変えている

一番シンプルに2種の画像でつくったもの。見る角度によってきれいに絵柄が変わる。かわいい!

丸型に型抜いたレンチキュラーシートを透明フィルムで覆って缶バッチに仕上げる

見るだけで楽しくなるマル・ビのレンチキュラー。見る角度によって絵柄が変わって見える極小ロットからつくれるのもうれしいグッズだ。

見る角度によって絵柄が変わって見えるレンチキュラーを缶バッチにできる! それもオンデマンド印刷なので10個からという極小ロットからつくれるのもうれしいグッズだ。

見ているだけで楽しくなるチェンジングや、絵柄が交互に見えるチェンジングや、絵柄が連続して動いて見えるアニメーションの他に、複数の平面絵柄が階層状に重なっているような立体感となる3Dタイプも可能。どの場合も完全データで入稿する必要があり、3Dタイプは遠近別にレイヤーを分けて、異なる絵柄が切り替わって見えるチェンジやアニメーションは最大10コマ分の画像を用意する。

缶バッチ自体は直径57ミリだが、絵柄は直径55・5ミリに塗り足し（裁ち落とし分）3ミリを加えた61・5ミリで作成する。

マル・ビのレンチキュラー。見る角度によって絵柄が変わるチェンジングタイプや、絵柄が変わるチェンジングタイプや、入れるコマ数を多くしてアニメーションのように動いて見えるタイプなど、多彩な種類で精度の高いレンチキュラーに定評のある会社だ。

これらはUVオフセット印刷機でつくるが、今回紹介するのはオンデマンド印刷機でレンチキュラーシートをつくり、それを直径57ミリの缶バッチに仕立てるというグッズ。オンデマンドで刷るため、10個という極小ロットからつくれるのも大きな特徴だ。レンチキュラーは2つの絵柄が端は巻き込まれて見えづらくなることもあり、絵柄は直径55・5

INFORMATION

最小ロット
最小ロット10個〜、経済ロット500個〜

価格
100個の場合で単価430円、300個の場合で単価220円、500個の場合で単価184円

納期
データ入稿から7〜10営業日程度

入稿データについて
Illustrator、Photoshopデータで入稿。マル・ビのWebサイトにデータ作成の注意事項が載っているので参照（https://www.yosey.co.jp/service/lenti/lenti_howto/）

問い合わせ
株式会社マル・ビ
東京都新宿区赤城下町45
TEL：03-5229-4202
Mail：k-shirakura@yosey.co.jp
https://www.yosey.co.jp

レコード&ジャケット

あたたかみのある音とモノとしての存在感から、近年、人気が再燃しているアナログレコード。レコードとジャケットを、オリジナルデザインで1枚から作成できる、うれしいサービスがある。

透明レコードもある

Side A
Love Song

Side A
Memory of Children
Side B
Flower

レコード全体に絵柄をプリントしたピクチャー盤の製作も可能

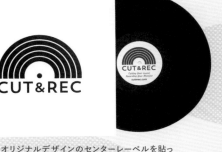

オリジナルデザインのセンターレーベルを貼ったレコードと、両面印刷したジャケットの組み合わせ、レコードは、7、10、12インチの3種類のサイズを選ぶことができる

INFORMATION

最小ロット

最小ロットは1枚〜。最大で10枚程度の注文が多い（今後、大ロットにも対応の予定）

価格

7インチレコード3800円〜、10インチレコード4800円〜、12インチレコード：5800円〜、センターレーベル製作+1000円、ジャケット製作+3000円、ピクチャー盤+4000円。音源収録は1曲につき+500円（すべて税抜）。また、2枚以上の注文は総額から10%OFF

納期

注文完了から15営業日程度で商品発送（注文が混み合っている場合は、納期が前後する場合もあり）

入稿データについて

データは、フォントをアウトライン化したIllustratorデータでPDF入稿、またはオンラインデザインツールで作成。製作料金はトッピング方式のため、注文内容に応じて初期費用に加算される

問い合わせ

合同会社サウンドロープ
CUT&RECチーム
Mail：contact@cutnrec.com
https://cutnrec.com

デジタルデバイスで音楽を聴くスタイルが広がるなか、高音質で聴けるレコードだ。もちろん、盤かを選ぶことができる。そして、音にあたたかみがあること、モノとして存在感があり、身近に置いておきたくなることがその理由の一端だろう。また、レコードジャケットはアートとしても長く愛されてきた。そんなレコードとジャケットを1枚からつくれるのが「CUT&REC」のオンラインサービスだ。

レコードは、レーベルにデザインを印刷する黒や透明のレコード盤か、レコードの盤面にデザインを印刷するピクチャー盤から選ぶことができる。ジャケットのデザイン性に加えて、「音」でも伝えるグッズは、受け取った人の心により響くものになりそうだ。

近年、人気が再燃しているアナログレコードの人気が再燃しているアナログレコード。自作の音楽やメッセージの音源ファイルを入稿すれば、レコード盤にカッティングしてくれる。ジャケットは、両面に印刷可能。用途としては、ミュージシャンやアーティストが自らの音楽作品やライブ録音を収録するケースが最も多いが、そのほか、お祝いメッセージや朗読、環境音など、音楽以外を収録したレコードの作成も増えているという。

スクリーンプリントグラス

2色印刷も可能

SCANDINAVIAN CRAFT BEER 2019

©在日スウェーデン商工会議所

無機顔料インキでスクリーン印刷したグラス。右から、タンブラー、ワイングラス、ショットグラス。インキの盛れるスクリーン印刷なので、くっきりした仕上がり。※印刷が見えやすいよう、紅茶を注いで撮影

オリジナルデザインを鮮明に印刷して、繰り返し洗っても剥がれないグラスをつくりたい！ そんなときには、専用インキを使ったスクリーンプリントグラスがおすすめだ。

INFORMATION

最小ロット

最小ロットは48個、経済ロットは500個以上

価格

タンブラー100個に片面1色印刷した場合、製版代（1版）9000円＋印刷代 単価240円（グラス代別途）。グラス持ち込みも可能。おおまかなグラス代は、山上スクリーン運営のグラスプリントサイト「モノスル」で確認できる。https://monosul.silkscreen.co.jp/item/

納期

通常、校了から2週間〜3週間（混雑時4週間以上）

入稿データについて

データは、フォントをアウトライン化したIllustratorデータ（epsまたはai形式、CS5以下）。再現可能な線幅0.15mm以上。抜き文字も同じく線幅0.15以上。0.15mm以下の場合は、かすれたり、再現できない可能性がある。色は指定の基本色から選ぶか、DIC、PANTONE指定も可能

問い合わせ

株式会社山上スクリーン印刷
新潟県三条市三貫地新田880-4
TEL：0256-38-1438
Mail：info@silkscreen.co.jp
https://www.silkscreen.co.jp/product/glass.html

ガラス素材へのプリントには、パッド印刷、スクリーン印刷、UVインクジェットなどいくつかの方法があるが、ガラスにしっかりと密着し、長く使えて高級感のある仕上がりにしたいなら、無機顔料インキを使ったスクリーン印刷がおすすめだ。専用のインキで印刷した後、焼成炉で600度ほどの高温で焼き付けるので、インキの中に入っている細かなガラスの粒子が印刷被対象物のガラス素材と溶け合うように密着した仕上がりになる。このため、硬いもので擦っても剥がれる心配がなく、半永久的に退色しない。

山上スクリーンのグラスプリントは、好きなグラスを持ち込んで印刷してもらうことが可能なだけでなく、同社がそろえるラインナップの中からグラスを選んで印刷を依頼することも可能。プリント範囲はグラスの形状により異なるが、タンブラーやショットグラスは全面印刷も可能だ（ただし、上下約10ミリ、背面10〜20ミリの隙間ができる）。

グラス形状のラインナップも豊富。既存グラスのラインナップについて詳しくは、山上スクリーン運営サイト「モノスル」を参照のこと
https://monosul.silkscreen.co.jp/

ペーパータグ

基本的にすべて機械生産でつくれるペーパータグ。エースボールにオフセットによる特色金1色で印刷。肩部分を斜めカットしているが型抜きではなく切り落として加工している。玉付け（補強紙）、そこに通した黒い綿糸も機械で加工可能だ

こちらは機械生産ではできない箇所が多々あるペーパータグ。2枚の紙（ブンペルのバークとクラフト）にそれぞれ片面1色印刷。抜き型をつくって型抜きし、2枚重ねてハトメを打つ（手作業）。そこに麻紐を通すのだが、これも紐の種類が機械NGなもののため手作業で通して留めている

商品説明や価格などの情報を示すだけでなく、ブランドイメージを表現する役割を持つ「ペーパータグ」。デザインはアイデア次第だが、機械で作成できるものや、手作業が必要になるものなど、さまざまなタイプがある。

荷札や下げ札などとも呼ばれる「ペーパータグ」。これを自由な形や仕様でオリジナル制作してくれるのが、清水ネームだ。ペーパータグをつくる場合に決める仕様は、大きく分けて3つある。①紙、②印刷、③加工・装飾だ。

①の紙はファンシーペーパーや板紙の紙見本帳から自由に選ぶことができるが、ペーパータグとしてよく使われるのは四六判で220〜260キロ、厚さで0・3〜4ミリ程度のものだ。これはサイズや紙質によって変わるので一概には言えないが、あまり薄いと強度が足りなくなり、四六判で200キロ以下は薄く感じることが多いだろう。また複数枚の紙を貼り合わせた「合紙」を使うこともある。②の印刷は、オフセット印刷、オンデマンド印刷、スクリーン印刷（ニス厚盛りなど）、箔押し、空押しなどから

INFORMATION

最小ロット

100枚からでもつくれるが、推奨するロットは、オフセット印刷タイプ・箔押しタイプ・空押しタイプ・スクリーン印刷タイプはそれぞれ1000〜、オンデマンド印刷タイプは300〜

価格

仕様により全くことなってくるので要問い合わせ。一例として、一般的な板紙に片面箔押ししたものは1000枚で5万円弱程度。1万枚以上のロットになれば単価10円以下になることもある

納期

オフセット印刷やオンデマンド印刷タイプで約10日〜、その他の加工では約2週間〜

入稿データについて

加工や装飾などの仕様によって、すべて機械でできるのか、手作業が入るのかなど変わるので、あらかじめ確認を

問い合わせ

清水ネーム株式会社
東京都中央区日本橋浜町1-10-2
TEL：03-3861-9100
http://shimizu-name.co.jp/

マルタック

糊付けせずに封がしまる紐つき封筒。その紐部分を、シールで貼れるタイプとしてつくられたのが白金化成の「マルタック」だ。印刷を入れて、オリジナルデザインにすることができる。

ルタックにスクリーン印刷でオリジナルデザインを入れたもの。スクリーン印刷なのであまり細かな絵柄は難しい。新23号は1ケースに3000セット入り、新25号は1ケース2000セット入り。どちらもケース単位でオーダーできる。

紙製のマルタックにオフセット4色印刷できるのが「キャラクタータック」。UVオフセット印刷なので小ロットだと割高になる。5000セット程度のオーダーが多い。ただ5000セットとはいえ、1シートに10セットのマルタックが面付されるので、すべて違う柄にし、10柄×500セットにすることも可能だ。

封筒はもちろん、パッケージなどにもアイデア次第で使えるマルタックだ。

旧

来はボタン状の丸い紙に紐を噛ませ、ハトメで留めるという方法でつくられていたが、利便性よく改良して開発されたのが、白金化成のマルタック。裏がシールになっているので、マルタックを封筒や箱にペタッと貼るだけで留め具が完成するのだ。発売以来長く使われているが、このマルタックをオリジナルでつくることができる。

その前提となる常備品から紹介しよう。一番ベーシックなのがPVCを使ったマルタックで、サイズ違いで直径23ミリの新23号と直径25ミリの新25号がある。色はどちらも白と茶だ。新25号には紐がタコ糸になっているタイプもある。

他にも新23号の色違いタイプで、グレー、黄色、透明もある。オリジナルでつくれる「マルタック印刷タイプ」は、常備品のマルタックに比べて、留め具の形を丸以外にすることもできるが、その場合は抜き型からつくる必要があり、初期費用がかかってくる。

編集部が使っている、マルタックつきの封筒。何度も開け閉めできるので便利

INFORMATION

最小ロット
新23号へのスクリーン印刷タイプは3000セット〜、キャラクタータックは5000セット〜

価格
新23号へのスクリーン印刷タイプ3000セットで、単価25円弱+版代+インキ代。リピートの場合は版代+インキ代は不要。色ベタの場合は初回から版代不要

納期
データ入稿してから3〜4週間程度

入稿データについて
基本的には10セットが剥離紙に貼られた状態での封筒会社や紙器会社に納品される。見本帳も用意されているので必要な場合は白金化成に問い合わせを

問い合わせ
白金化成株式会社
東京都台東区元浅草4-1-12
TEL：03-3847-8953
http://www.shilogane.co.jp/

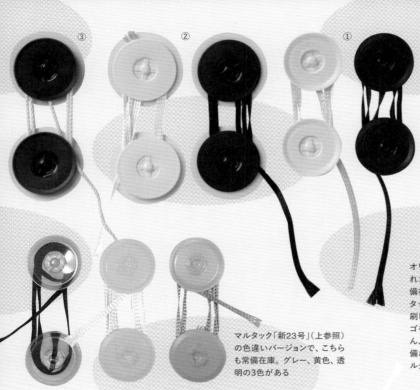

常備在庫のマルタック
①は一番ベーシックなサイズで「新23号」丸部分の直径が23mm。茶色と白があり、紐の長さは37cm

②は①より一回り大きい「新25号」マル部分の直径が25mm。こちらも茶色と白があり、紐の長さは37cm

③は②と同じサイズで、紐がタコ糸になっている「新25号(タコ糸タイプ)」。①②が一般的な封筒に使われるのを想定したものに対して、こちらは紙器やダンボール用途としてつくられたもの。タコ糸の長さは常備在庫としては37cmと52cmの2サイズ

マルタック「新23号」(上参照)の色違いバージョンで、こちらも常備在庫。グレー、黄色、透明の3色がある

オリジナルの印刷を入れた「印刷タイプ」。常備在庫されているマルタックにスクリーン印刷している。文字やロゴを入れるのはもちろん、ベタ刷りすれば常備されていない色のマルタックにもできる

エコマルタック。キャラクタータックのベースともなっている商品で、マルタックの上部パーツ(丸い上皿部分)に紙とPVCフィルムを使うことでプラスチックの比率を軽減したタイプ

キャラクタータック。オフセット印刷でオリジナルデザインを施したもの。ベースは紙だ

白金化成で用意している紐は、白、黒、茶、赤、グレーの5色。それ以外の色にしたい場合は特注となる

紐を巻く部分を丸以外の形にすることもできなくはない。ただし元となる抜き型から特注でつくる必要がある

活版印刷のペーパータグ

パッケージを装飾したり、ブランドタグやメッセージタグなど、紙に紐を通した下げ札は、包装にアクセントを加えてくれる。羽車では活版印刷をはじめ、エッジカラーや合紙などさまざまな印刷・加工のタグを制作できる。

布の質感を活かしたオリジナル素材「Fabric」を正方形に断裁したタグ。紐は長さを選ぶこともできる

ボード紙オレンジに活版印刷、ダイカット加工をしたタグ

厚手の紙に紐を通したペーパータグ。装飾目的だけでなく、メッセージを書き込んだりブランド名や商品名を入れるなど、機能面でも必要とされる包装・梱包ツールだ。

羽車のペーパータグは、厚手の板紙からトレーシングペーパーのような薄めの紙まで、同社が厳選した紙の中から選んでつくることができる。サイズは55×91ミリ、50×91ミリ、55×55ミリなどの断裁でつくるタイプと、角丸や上辺の角だけ落とすなどダイカットで細かく選べる。また、活版印刷、オフセット印刷、箔押し加工、エンボス加工、エッジカラー加工（小口染め）といった豊富な印刷・加工を選べるのも特徴だ。

商品を入れる箱とトータルコーディネートするために、箱と一緒に注文する人も増えているという。また、商品に取り付けたときの雰囲気を見るため、実際の商品を持参してショールームを訪ねて見てみる、ということとも可能だ。気になる人は、まずは問合せを。

既存型があるものが51サイズ。それ以外にも、最大148×210ミリ、最小15×20ミリの中で、好きな形に断裁や型抜きすることができる（型代別途）。穴の大きさが選べる。紐とタグを別々に納品するのか、紐をタグに結ぶ場合の結び方はどうするのかなどきめ細かく選べる。紐は19種類から選ぶことは3ミリ、紐は19種類から選ぶこと

ペーパータグに使用できる用紙

使用できる紐の一部

INFORMATION

最小ロット

100枚〜

価格

ボード紙オレンジ表面のみ活版1色印刷、ダイカット加工（既製型使用）し、紐結びありの場合、100枚21032円、300枚24607円（税込）／オリジナル紙「Fabric」を55×55mm、表面のみオフセット1色印刷で、紐結びありの場合、100枚13134円、300枚17556円（税込）

納期

紐結びしないときは校了後5営業日〜、紐結びまでするとき校了後8営業日〜に出荷

問い合わせ

株式会社羽車
大阪府堺市東区八下町3-50
TEL：0120-890-982
Mail：info@haguruma.co.jp
http://www.haguruma.co.jp/store/

アクセサリー台紙

mouette

Bonne chance vient
tous les jours

ブラウンのボード紙で、落ち着いた印象のピアス台紙。活版1色印刷＋ダイカット加工

Let's enjoy playing
more everyday

BLOWBALL

Let's enjoy playing
more everyday

BLOWBALL

白いクッション紙に活版2色印刷をし、紙の側面にエッジカラー加工で色をつけたピアス台紙。ピアス取り付け用の穴の位置がオリジナルのため、別途有料のオリジナル型を作成している

ピアスやイヤリング、ネックレスやブレスレットなどを販売するときは、イメージに合わせてオリジナルの台紙をつくりたいもの。印刷・加工を施した台紙をつくりたいときに、おすすめのアイテムだ。

アクセサリーを販売するとき、そのままOPP袋などに入れることもあるが、ブランドロゴやデザインを印刷・加工したオリジナルの台紙に取り付ければ、より印象がよくなるもの。

羽車では既製型のアクセサリー台紙をいくつか用意しており、これを利用すれば、抜き型代がかからずに制作が可能だ。90×65ミリの長方形タイプ、90×90ミリの正方形タイプ、直径90ミリの丸型タイプがあり、ピアスを取り付ける穴があいた「ピアス台紙」は穴の位置がそれぞれ2種類、ネックレスやブレスレットのチェーンをかける切り込みが紙の端に入った「ネックレス台紙」は1種類が用意されている。もちろん、もっと違うオリジナルの形でつくりたいというときは、型代が別途かかるが、好みの形に型抜きすることが可能だ。

印刷・加工は、オフセット印刷、活版印刷、箔押し加工、エンボス加工、エッジカラー加工に対応している。

INFORMATION

最小ロット

100枚〜

価格

丸型のボード紙（既製型）に活版1色印刷の場合、100枚15906円、300枚19118円（税込）／活版2色印刷＋エッジカラー加工＋ダイカット加工、90×65mmのクッション紙を使用した場合、100枚43505円、300枚50215円（税込）　※オリジナル型代13200円（税込）含む

納期

上記の丸型ボード紙の場合、校了後6営業日後に出荷、活版2色印刷＋エッジカラー＋ダイカットの場合は校了後10営業日後に出荷

問い合わせ

株式会社羽車
大阪府堺市東区八下町3-50
TEL：0120-890-982
Mail：info@haguruma.co.jp
http://www.haguruma.co.jp/store/

装丁：名久井直子
装画：ナミサトリ
本文デザイン：中澤耕平（STUDIO PT.）／寺脇裕子
写真：弘田 充
編集：今井夕華
編集補助：清水優季
元記事編集：雪 朱里
企画・編集：津田淳子（グラフィック社）

文具&紙ものグッズのつくり方

2022年12月25日 初版第1刷発行

『デザインのひきだし』編集部　編
発行者：西川正伸
発行所：グラフィック社
　　　　〒102-0073
　　　　東京都千代田区九段北1-14-17
　　　　tel.03-3263-4318（代表）　03-3263-4579（編集）
　　　　fax.03-3263-5297
　　　　郵便振替　00130-6-114345
　　　　http://www.graphicsha.co.jp/
印刷・製本：図書印刷株式会社

ISBN978-4-7661-3738-5　C3070
Printed in Japan